ROMAN ART

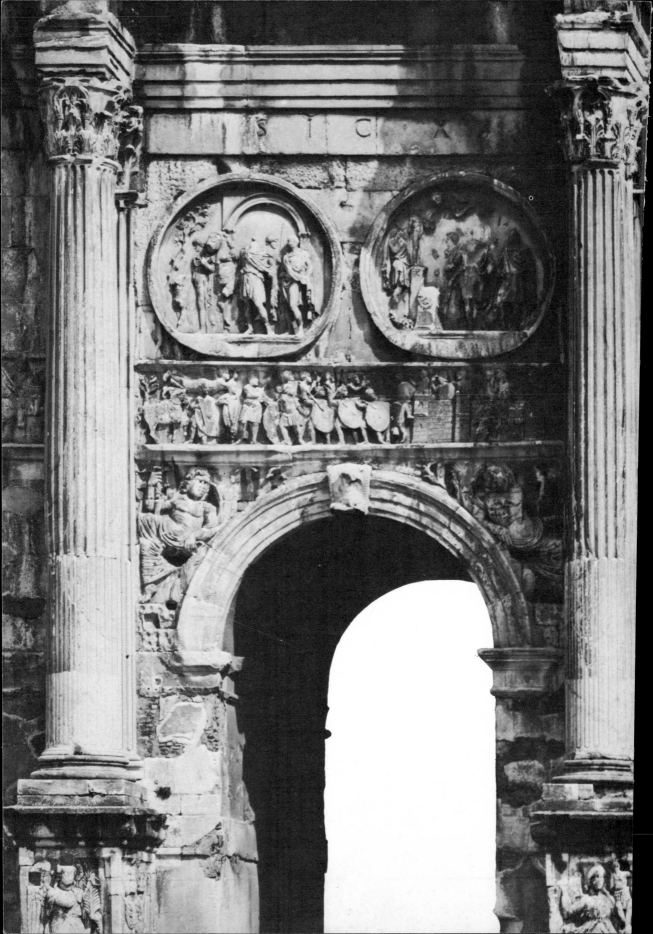

ROMAN ART

from the Republic
to Constantine

by

Richard Brilliant

Readers Union
Group of Book Clubs
Newton Abbot

For
Stephanie
Livia
Franca
Myron

————————

This edition was published in 1974 by Readers Union by arrangement with Phaidon Press Ltd, London
© Full particulars of Readers Union are obtainable from Readers Union Ltd, PO Box 6, Newton Abbot, Devon
All rights reserved

Printed in Great Britain by Butler & Tanner Ltd, Frome and London

Contents

Part Two · Into The History of Art

Preface

'WHENEVER any illustrious man dies, he is carried at his funeral into the forum to the so-called rostra, sometimes conspicuous in an upright position and more rarely reclined. Here with all the people standing around, a grown-up son, if he has left one who happens to be present, if not some other relative mounts the rostra and discourses on the virtues and successful achievements of the dead. As a consequence the multitude and not only those who had a part in these achievements, but those also who had none, when the facts are recalled to their minds and brought before their eyes, are moved to such sympathy that the loss seems not to be confined to the mourners, but a public one affecting the whole people. Next after the interment and the performance of the usual ceremonies, they place the image of the departed in the most conspicuous position in the house, enclosed in a wooden shrine. This image is a mask reproducing with remarkable fidelity both the features and the complexion of the deceased. On the occasion of public sacrifices they display these images, and decorate them with much care, and when any distinguished member of the family dies they take them to the funeral, putting them on men who seem to them to bear the closest resemblance to the original in stature and carriage. These representatives wear togas, with a purple border if the deceased was a consul or praetor, whole purple if he was a censor, and embroidered with gold if he had celebrated or achieved anything similar. They all ride in chariots preceded by the fasces, axes, and other insignia by which the different magistrates were wont to be accompanied according to the respective dignity of the offices of state held by each during his life; and when they arrive at the rostra they all seat themselves in a row on ivory chairs. There could not easily be a more ennobling spectacle for a young man who aspires to fame and virtue. For who would not be inspired by the sight of the images of men renowned for their excellence, all together and as if alive and breathing? What spectacle could be more glorious than this? Besides, he who makes the oration over the man about to be buried, when he finished speaking of him recounts the successes and exploits of the rest whose images are present, beginning from the most ancient. By this means, by the constant renewal of the good report of brave men, the celebrity of those who performed noble deeds is rendered immortal, while at the same time the fame of those who did good services to their country becomes known to the people and a heritage for future generations.'

Polybius, *The Histories*, VII. 53, 54 (transl. W. R. Paton, Loeb Library ed.)

Polybius, an aristocratic Greek held in gracious exile at Rome, wrote this passage in the mid-second century B.C. while attempting to characterize the essential quality of Roman life to his fellow Greeks as they succumbed to the spread of Roman power. In it he presented the primary socio-political role of the public act among the Romans as a ritualized art of tendentious demonstration. For the imperious

Romans of the Republic or Empire, the historical records of great events or of distinguished careers, publicly displayed, had a peculiar social value because such records or manifestations not only preserved great achievements and thereby established the worthiness of their performers, but also provided useful models for the benefit of subsequent achievers.

In the service of this moralizing historicism, works of Roman art and architecture came into being largely as self-conscious monuments, bearing heavy burdens of commemoration or advertisement, establishing goals of conspicuous possession and power to be attained, and making direct signals of political and economic status. Roman art, therefore, emerged out of an elaborately ritualized social milieu, often dominated by the objectives of conspicuous consumption symptomatic of middle-class culture. Even more, Roman art and Roman artists sought to maximize psychological effects by intensifying the impact of an immediate visual experience. The creation of those effects and the manipulation of the beholder's share led to many of the greatest accomplishments of Roman art and to the domination of propaganda and rhetoric over its forms. In a sense, there are no 'minor' arts among the Romans although some of their arts were small in scale—because almost every item from coins and costume to baths and boulevards seems to have been charged with attention-getting devices and with messages of self-justification. The analysis of these devices and the identification of these messages constitute the principal objectives of this book.

The Roman conception of the work of art as a vehicle for conveying meaningful images, charged with near-animate force and living on the connection between aggressive object and sensitized observer, has a strangely modern ring. Furthermore, the ancient Roman state must be characterized as a mass society, largely illiterate, formed out of elements distinguished by socio-economic class, language, regional culture, and religion; this society was dominated by an urban élite and by an encompassing political system, dependent, in turn, on a swelling bureaucracy, an authoritarian leadership, and a politicized military apparatus. Essential to the integrated continuance of that system was a rapid, pervasive, and effective means of communication reaching all levels of society in all parts of the Roman Empire. Great architectural commissions, programmes of urban development, public monuments of all kinds, portraits of dignitaries—mass or locally produced, but dependent on models or patterns established by the leadership, located in a few great centres, most especially in Rome itself—constituted such a means of communication, making known to the Roman citizen everywhere the presence of the state and the ambitious programmes of its leaders. If the twentieth century marks the greatest development in sophisticated means of visual communication within the context of a variegated mass society, ever subject to political pressures, the first rationalized application of these techniques to the calculated persuasion of a disparate mass audience occurred under the Romans, and their works of art were its primary agents. In Polybius' words, 'the fame of those who did good services to their country becomes known'.

Rome, Spring 1973 *Richard Brilliant*
Columbia University, Winter 1973/1974

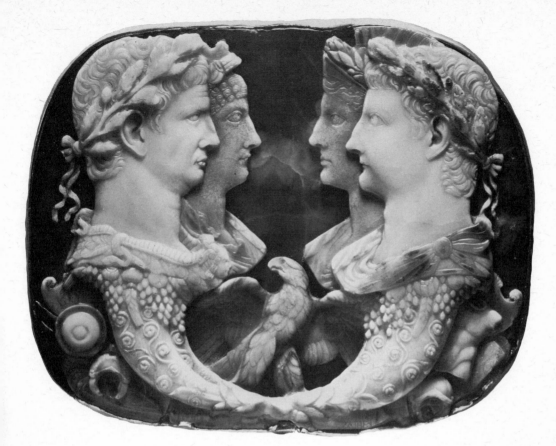

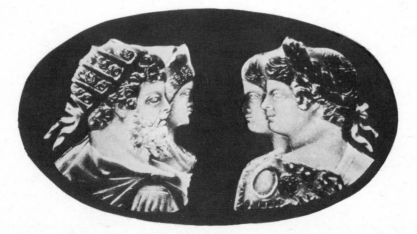

Above: Onyx cameo with portraits of Claudius, Agrippina the Younger, Tiberius and Livia (?). About A.D. 50. Vienna, Kunsthistorisches Museum. Below: Sardonyx cameo with portraits of Septimius Severus, Julia Domna, Caracalla, and Geta. A.D. 205–211. Paris, Cabinet des Médailles

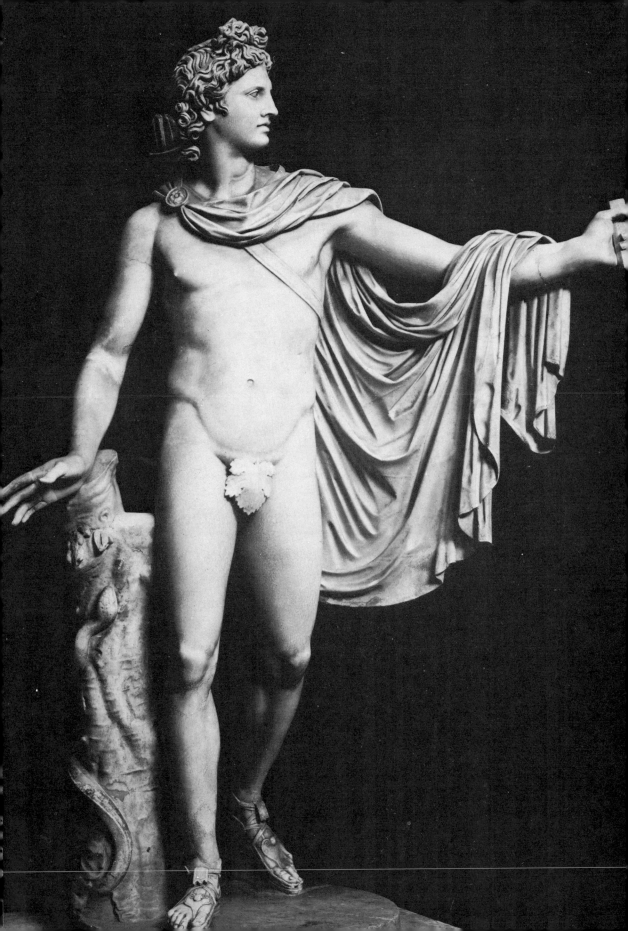

Introduction

ROMAN ART is the art of the ancient metropolitan city of Rome and of the vast Roman Empire created over hundreds of years for patrons distinguished by class, cultural, and regional differences. Works of Roman art survive in all media and in great diversity, preserved in the chill galleries of museums and in the magnificent ruins scattered throughout the Mediterranean and western Europe. Once the product of an urban, ecumenical society, Roman art was treasured in the Middle Ages and in the Renaissance, because Roman monuments maintained the physical presence of classical antiquity. Now these monuments stand alone and in their own right, stripped of their post-antique role as preservers of an idealized past that has faded away. However, if Roman art has lost the authority of the past, its works may have gained a new prestige as models for the present, with great states governing mass-societies living in cities. The analogous response of Roman artists to this condition was to develop a positive imagery of man and his deeds in their own likenesses, to organize physically and psychologically the natural environment through architecture and planning, and to comprehend the symbolic relationship between the citizen and the state in an iconography of power. Still, the Roman monuments, the sculptures, paintings, and coins, are no less to be admired and studied because of their intrinsic aesthetic qualities and meanings. The perception of these qualities and the understanding of Roman art as a coherent style have been impaired by distance, which is a problem of art history, but also by prejudice and uncertainty among the historiographers.

Fig. A Apollo Belvedere: an expression of Antonine taste. Rome, Vatican

Two centuries ago J. J. Winckelmann presented his history of ancient art to a cultivated audience of German and Italian connoisseurs and antiquarians centred in Rome. Acutely sensitive to the visual properties of works of art, Winckelmann created a new humanistic discipline, the history of art, as a field of inquiry and as a source of inspiration for contemporary artists. Yet he did so in a way that was undisciplined in historical method, pursued aesthetic goals, and mixed subjectivity and idealism in a mythical concept of antiquity, dominated by fifth- and fourth-century Greek art. His idealization of Greek classic sculpture, available to him through ancient texts and Roman copies, created a categorical model of aesthetic perfection that was fundamental to the development of neo-classical taste in the late eighteenth century. Moreover, Winckelmann's purified vision of antiquity broke the unitary conception of the Greco-Roman world, formed in the Renaissance, while it established an ideal standard against which all other works of Greek and Roman art seemed to fall short.

This tyranny of classic Greece over the historiography of ancient art penetrated the minds of the collectors and scholars who subsequently dominated the field of classical studies with detrimental effect on the appreciation and recognition of hellenistic and Roman art. Although Winckelmann himself admitted the existence of Roman art, even if unsure of its nature and disinterested in its forms, his successors saw such little merit in the works of Roman antiquity that many of them came to see this period as a decadent interval between Greece and the Middle Ages, lacking any definite character. They were willing to study selectively only Roman architectural monuments, portraits, replicas of lost Greek masterpieces. How these objects had come into existence and for what purpose remained unframed and unanswered questions. Symbolic of the critical and intellectual problems underlying this philhellenic bias is the deliberate choice of the Apollo Belvedere (Fig. A) by Winckelmann as embodying the very highest ideal of Greek art, the perfect image of beauty. But the Apollo Belvedere is not a Greek original nor a replica of a Greek statue; it is a second-century Imperial pastiche, derived from fourth-century Greek models, selectively modified by an unknown artist and his patron to satisfy their own contemporary Roman taste.

Nevertheless, because of the intellectual power of Winckelmann's conception of antiquity, during the nineteenth century Roman art struggled for recognition, if not acceptance, in a scholarly and critical community fixated on classic Greece. Large, obtrusive objects such as Roman buildings and statues stubbornly existed all over western Europe and attracted increasing attention when the intellectual climate that had ignored or deprecated their presence began to change. The monuments of Roman architecture, often magnificently preserved, had been deeply admired by architects since the Renaissance who adapted them as well as precepts of Roman urban planning, drawn partly from Vitruvius, for their own work. If Piranesi, Robert Wood, and Robert Adam made Roman architecture better known through their great, widely distributed volumes, the French Empire adopted the magnificence of Roman Imperial architecture as the basis of its own style in the early nineteenth century, with the result that Roman monuments became important

both as models and in their own right as distinguished works of architecture. Similarly, Roman civic design in its less grandiloquent, utilitarian aspects was progressively uncovered with the excavations of Pompei and Herculaneum.

These excavations also brought to light the Roman arts of interior decoration, especially wall-painting, floor mosaics, and furniture. Significantly, once it was recognized that many of the Pompeian paintings represent Greek myths and seemed to be replicas or close versions of Greek originals, interest in Pompeian painting shifted from the study of the paintings themselves in their own time and place—i.e. Roman—to their value as affording evidence of the non-existent Greek paintings of the classic period. This tendentious, often exclusive dichotomy between 'Greek' and 'Roman' as applied to works of art produced in a Roman context similarly affected the classification of many antique sculptures and their arrangement in the growing public collections. For the most doctrinaire philhellenes, what was good was Greek and stood in the front galleries, while what was bad had to be Roman and was put at the back. Admittedly, Italian fine-grained marble wears less well than the Greek with its lively surface, but the distinction did not rest on the state of preservation; it rested on the state of grace as defined by Winckelmann. Slowly, however, some museums began to adapt their collections to a loose chronological arrangement which included hellenistic and Roman art, if they had any, while other museums, most notably the Vatican and the Lateran, emphasized positively their Roman works, partly because they had so many, partly because of local pride, which stimulated a more favourable critical attitude. Certainly the wealth of the antique collections in Rome itself, and the still living presence of great Imperial monuments, encouraged the Italian partisanship of the importance of Roman art, a partisanship that became more widely diffused with the establishment of foreign academies in the city with their artists and scholars.

Roman coins, medallions, precious gems and cameos, and portrait busts had been prized since the Middle Ages. As survivals of antiquity and as works of art, these objects were considered authentic, economically valuable, well made, and even handsome, while their portability, augmented in the Renaissance and after by descriptive catalogues, brought them to the attention of a wide public. If the engraved gems carried an enormous repertory of classical myths and legends, ample sustenance for the antiquarian and the mythographer, the coins and medallions were prime historical documents because they were politically motivated and bore the images of the Roman rulers with identifying legends. These numismatic portraits, complemented by the abundant sculptured portraits of public and private persons, vitalized the images of the admired historical personages familiar to a cultivated public already steeped in Latin literature, which had enjoyed great prestige and critical repute throughout the centuries. When the American and French revolutionaries turned to the Roman Republic for historical models and precedents, the images also took on a new modular value as a constituent element in Neo-classicism, while Cicero and the Roman lawyers were evoked by Napoleon in his revision of the civil code, which then passed through Europe. Furthermore, the institutional interests of the Roman historians began to exert a profound influence in the later nineteenth

century, especially on Theodor Mommsen, who came to examine Roman Republican history and the emergence of Rome as a world state because they were intrinsically interesting and also valuable in the contemporary world. In a sense, it was this deepening appreciation of the ancient Romans and of their achievements, never lost but partly submerged under the Greek tide, that made possible the recognition of an equivalent value in the works of fine art made by and for such a society.

It may be fairly said that Roman art history began in 1895 with the Austrian Franz Wickhoff, who was looking for something else when he wrote on the *Vienna Genesis*. His search for the sources of continuous narrative illustration took him ultimately to the Roman triumphal monuments of the first and second centuries, especially the Columns of Trajan and Marcus Aurelius. For Wickhoff the Romans had invented the continuous narrative as a tendentious pictorial motif in painting and relief sculpture, and it was this discovery that stimulated him to consider Roman art as a definite and definable phenomenon, and to characterize its existence; above all, he asserted that Roman art did exist, historically but not exclusively dependent on Greek models, and worthy of analysis as a distinct style. Furthermore, under the influence of contemporary art, especially Impressionism, with its tentative rejection of the rationally ordered vision hallowed by the academic artists, Wickhoff was particularly sensitive to certain visual, non-tectonic elements which he first observed in Flavian art and regarded as equally original and profoundly important because they differed so radically from the objectified view of the world fundamental to Greek art. From his perception of 'impressionism' as a Roman technique of visual construction, somewhat loosely defined, Wickhoff proceeded to characterize Roman art for the first time as an historical style, going far beyond the limited acceptance and favour previously given to Roman architecture and coinage as typically Roman media of expression, or to portraiture as a typical Roman motif. If his definitions are no longer accepted and his conception of continuous narrative is challenged, his efforts to isolate and describe Roman art opened up a field of inquiry that remains still fruitful and still challenging.

Wickhoff's discovery, or more properly rediscovery, of Roman art did not result in an effective working definition of what constituted 'Roman art', nor did he establish its geographical range, since he was primarily concerned with a few great monuments, commissioned by the state and produced in Rome in a relatively brief span of years. Any style may be considered to be a peculiar, special amalgam of forms and messages, reflecting through expressive analogy the total social context in which it is created. Then Roman art, variously conceived as the art of Rome, as the art of the Roman Empire, or as an imprecise mixture of the two, presents a very difficult problem of definition because Roman art was produced for socially and culturally diverse patrons over great distances of time and space, not without disruptive change. Bedevilled by the questions 'What is Roman art?' and 'What is Roman about Roman art?' many scholars since Wickhoff have turned away from these theoretical issues to the descriptive presentation of the works of art themselves, loosely acknowledged as being Roman without further explanation; in this context 'Roman' means made between *c*. 300 B.C. and A.D. 400 in Rome or in those parts of

the Roman Empire penetrated to some degree by Mediterranean civilization. Many useful monographs, catalogues, and archaeological reports have appeared in the last three generations to provide the constituent elements of a Roman mosaic whose final shape is unclear. But Wickhoff also made no real attempt to define the temporal boundaries of Roman art as a distinct style and, therefore, avoided treating a central problem in the history of any style, establishing the times of coming to be and passing away. Motivated by the desire to frame a normative concept of Roman art, a number of art historians tried to fix the shape of Roman style in time. They did so either by an investigation of its origins, seeking to discover when Roman art became coherent and independent of its sources, or through the identification and interpretation of a drastic stylistic change that occurred in the late Empire, when the purposes and forms of artistic expression seem to have been wholly reoriented. It is to the understanding of this late development that Wickhoff's great contemporary, Alois Riegl, made his contribution.

In 1901 Riegl published a seminal book (revised in 1927) on late Roman ornament and decorative arts, based on a meticulous analysis of objects found in Roman provincial sites located in the Austro–Hungarian Empire. To his surprise he had discovered that many of these objects, together with their ornamental designs, much more closely resembled early medieval art than the Mediterranean art of Rome. Furthermore, he realized that a great shift had taken place in the arts of the late Roman Empire from a solid, three-dimensional system of design toward abstract, linear patterns; these patterns were dependent on purified optical rather than tactile effects and relied heavily on sharp contrasts between light and dark, which in turn reduced the apparent substance of shapes as well as the spatial properties of the figure-ground relationship in ornament. Although this observation is of profound importance in establishing the terminal history of Roman art, Riegl's awareness of the intimate relationship between ornament and the high arts of a period led him to comprehend the totality of style which is manifest in all its works of art. If this latter concept has become a basic principle of art history, his recognition of the pervasive character of the change in late Roman art stimulated the closer examination of its later phases, often called 'Late Antique' by subsequent writers to characterize this terminal period of Imperial art when it was passing away, while something else, Medieval art, was coming to be.

Between the two World Wars a number of German scholars, in particular G. Rodenwaldt, K. Lehmann, and M. Wegner, followed Riegl's lead and sought to define the scope and character of Late Antique art, although there was considerable disagreement about when Late Antique began and where and how and why. Rodenwaldt, deeply influenced by expressionist tendencies in German literature and art, and aware of the cultural alienation of central Europe after 1918, found the beginnings of the Late Antique in the psychological and intellectual crisis of the Antonine period, which he called an age of anxiety; according to his view of Roman civilization, when the social and political fabric of society began to crumble under barbarian attack and economic weakness, and society became uncertain of the current and future worth of its own traditions and institutions, then the people,

including their leaders, were alienated from their artistic traditions as well. The resultant disinterest in contemporary life and the concomitant search for other-worldly salvation ruptured the humanistic framework of classical civilization and the arts which responded to that rational, positive vision of the world. As H. P. L'Orange later pointed out, the highly ordered society of the Tetrarchs and of Constantine had its direct analogy in the dehumanized, irrational, schematic, and hieratic art of the late third and early fourth centuries. Subsequently, the escape into Christianity, as documented by A. Grabar and M. Bonicatti, led directly into the supramundane, spiritualized images of the early Middle Ages.

However, the concept of the Late Antique itself, used as a term to indicate a transitional period in the translation of one style into another, demanded at least a tacit recognition of the unitary character of the antique Greco–Roman civilization as the standard against which change could be measured. Since that standard was Mediterranean hellenistic, which remained a living artistic tradition until the second or third century A.D., and in the eastern Empire even later, the Roman character of Roman art and its independence as a discrete style had once more to be defined or rejected. Symptomatic of the latter attitude is the book by J. M. C. Toynbee, *The Hadrianic School: A Chapter in the History of Greek Art* (1934), which treated the neo-Hellenic art of the Emperor Hadrian both as an Imperial revival and as a continuation of Greek art during the Empire. H. Jucker and G. Becatti have shown how deeply Rome was indebted to Greece for artists and models in the late Republic and early Empire, while the upper-class Romans until the Severan dynasty fell under the influence of pro-Hellenic aestheticians and taste-makers. Yet what was produced at Rome, even by Greek artists for hellenized Roman patrons, can be distinguished from Greek works by programme, imagery, purpose, and even style, because Romans were not Greeks and had a different view of the world. Indeed, Roman art from *c.* 300 B.C. to *c.* A.D. 400 seems to have been characteristically both eclectic and narcissistic, looking equally to Greece and to its own past for inspiration and models, which were then transformed in adaptation. Although this oscillation between diverse pasts and the present obscures the developmental history of Roman art and challenges its pristine originality, the deliberate re-use of the past to affect the present is a constant feature of Roman political and religious life, a product of the Romans' peculiarly active view of making history. If creative eclecticism may be considered a fundamental ingredient of Roman culture, then the persistent appearances of Greek influence do not in themselves deny the individuality of a Roman art.

In order to understand how Greek artistic models were romanized, scholars in the 1920s and 1930s began to consider how and when a definable Roman art had come into being at Rome, capable of absorbing and transforming the different traditions received from its neighbours in Italy and from the Greeks. Stimulated by the rapidly developing fields of Etruscan and Italian archaeology, and to a certain degree by nationalist pride, P. Ducati and others investigated and described the artistic character of the Etruscan and Italic peoples who surrounded early Rome, first governed its territory, provided artists and works of art for the Romans, and

in the third century B.C. fell under Roman sway. M. Pallottino in *Civiltà artistica etrusco–italica* (1971) has summarized two generations' work in Italian archaeology, now an increasingly complex field, and revealed the mixed artistic environment, itself partly hellenized, out of which subsequently Roman culture and art emerged. Given the intrinsic importance of the Italic cultures themselves, Italian archaeology has become less tendentiously concerned with establishing the antecedents of Roman art, while adding to our specific knowledge of the thin layer of hellenic cultivation lying upon a substratum of primitive, non-rational directness, totally un-Greek in character. At the same time, the historical evolution of Roman style in Rome from its impoverished origins (eighth to sixth century B.C.), through a long period of intensive, unsophisticated borrowing (sixth to first century B.C.), to the effort of consolidation and redirection in the late Republic and early Empire has been critically treated by R. Bianchi Bandinelli, Pallottino, B. Schweitzer, and O. Vessberg.

The indigenous, 'primitive' quality in Italic and Roman art may have been the transforming agent that profoundly affected the reception of elegant Greek models and provided the resistant core of stylistic development in Rome. This distinguishing quality is manifest in a concern for the explicit representation of the facts and not the illusions of appearance, in a disregard for the organic coherency of the human body, in a preference for abstract forms and potent, magical images, and in the separation of surface and structure in architecture and sculpture. These features are the very opposite of the rational, humanistic tenets of Greek art. Furthermore, their expressionistic tendencies and emphatic symbolism drew the attention of several German art historians interested in the phenomenological aspects of cultural and artistic dynamics. Various theoretical explanations of the difference between Greek and Roman sensibility have been offered, unfortunately all too often in poetic, abstract language difficult of precise, critical application. Among the most significant of these theories may be mentioned the structural analysis of Italic form by G. Kaschnitz-Weinberg, the categorization of the transcendental nature of Roman art by B. Schweitzer and K. Schefold, and the pursuit of the imagery of force as an endemic theme by H. Kähler.

Although these theories faced the issue of what was functionally Roman in Roman art and thereby helped to define the parameters of the style, they tended to ignore the ostensibly hybrid character of Roman art, which seemed to weaken its integrity. Roman art is seemingly divisible into an upper-class or patrician current, cultivated in the Greek manner, and another, much more closely bound to the indigenous Italo–Roman traditions and associated with the middle class or plebeians at Rome and in the provinces of the Empire. This division was unrecognized in E. Strong's still useful book on Roman sculpture (1926), which equated the art of the great patrons, who were deeply hellenized, and the art of the state, dominated by the same cultivated patricians, with the history of Roman art. However, the lines of this division, the reasons for their existence and ultimate disappearance, and their role in the creation of Roman art have been fully presented by R. Bianchi Bandinelli in a series of penetrating articles and books, culminating in his *Rome: The Center of Power* (1970) and *Rome: The Late Empire* (1971).

Bianchi Bandinelli suggested that the Roman kernel of Roman art rested latently on the exercise of plebeian taste, which clung to the old, Italic traditions despite the apparent, but superficial dominance of the hellenized patricians with their veneer of Greek cultivation. In his view Roman art fully matured in the Late Antique period after the plebeians had come into power in the early third century A.D. Then the Greek models were either totally absorbed or rejected and the apparent hybrid condition ceased to exist, except as a private, patrician affectation. At the same time, Roman art became truly Imperial, since the taste of the plebeians corresponded to the artistic horizons of the art patrons in the provinces, especially in the western provinces of the Empire. Other Italian scholars, such as S. Ferri, A. Frova, and G. Mansuelli, had recognized the importance of Roman provincial art in the West, but Bianchi Bandinelli put together the effect of class divisions in Rome on taste and patronage, the emergence of non-hellenized leadership in the Empire, and the defined parameters of Roman art into a stimulating, synthetic conception of a cultivated metropolitan art that became popular and universal. As it did so, Roman art in turn became the ultimate foundation for the medieval art of the West.

This recent critical examination of Roman art has provided a working definition of its historical shape as a style, even if the definition can be challenged. The Roman monuments themselves remain obstinate in their individuality, in their thematic and formal associations, and in their own temporal circumstances. It is to them and in context that the modern student and amateur of Roman art must come in order to gain comprehension and pleasure.

Part I
Major Themes in Roman Art

Chapter I

Roman Architecture

a. Materials Roman architecture depended on the close association between the abstract and pragmatic principles of architectural design, as they evolved historically and deliberately, and the elaborate techniques of large-scale construction which utilized many different skills and materials. Among these skills were those of the *engineer* in handling concrete, siting, hydraulics, and central heating, of the *carpenter* in the erection of scaffolding and framing devices, of the *mason* in cutting blocks and sheets of stone and fitting them together, of the *brick-* and *tile-layer* in setting the cover of floors, walls, ceilings, and roofs, of the *plasterer* for walls, ceilings, and cisterns, of the *plumber* in placing water-systems and drains, and of *decorators* who specialized in mosaics, paintings, stucco ornament, glass, sculpture, and metal fixtures. This wealth of skills, techniques, and materials was unprecedented in the history of Mediterranean architecture.

Such an army of artisans, technicians, and artists would only be employed in the execution of grand projects, commissioned by wealthy patrons, by proud cities throughout the Empire, or by the Roman state and its leaders, but selected skills and materials could be called upon at any time. This gave the Roman architect an opportunity to exploit his resources in an architecture characterized by visual splendor and psychological impact, and deeply affected the nature of Roman buildings by complicating the relationship between the static and decorative functions of architectural members. The vital role played by the available building materials in the making of Roman architecture can be clarified by grouping these materials into four categories, according to their specific properties as natural solids, or as semi-artificial, artificial, or insubstantial creations.

Natural solids include wood, cut stone, and stone rubble. Wood, which fell increasingly into short supply as a building material in the Mediterranean region, was used in several distinct ways, once the simple post-and-lintel domestic architecture of the early Republic had changed to other methods of construction in the cities if not in the countryside. Primarily, wood retained its value as a building material for villas in rural locations and also for town houses in the western provinces, such as Gaul and Britain, where it was more plentiful; wooden beams were also used for the upper storeys of town houses in Delos and Pompei and for tenements in Ostia and Rome. In the latter buildings wood was restricted to floors, covered by tiles, and ceilings because it is light and relatively easy to work, but frequent fires indicate its great weakness. The Romans used wooden beams for the rafters and roofing of large public buildings, especially rectangular temples and basilicas, where a sizeable interior space had to be covered but not by vaulting; engineers relied on wood for foundations in marshy soil in the form of piles beneath stone piers and concrete masses or as rafts under paved roads. A secondary application of wood was due to its ease of handling for temporary or relatively frivolous purposes, such as garden pavilions, supports for cloth awnings in parks or at the amphitheatre, and especially on ceremonial or festive occasions. Parades, triumphal processions, religious festivals, and funerals often required a sumptuous but immediate architecture, sometimes, as in the *rogus* or funeral pyre, to be totally destroyed and sometimes, as for triumphal arches or sacred enclosures, to be subsequently replaced by permanent structures; an example of the latter is the Ara Pacis Augustae (Fig. I.1), which preserves in marble part of its original wooden form. But wood also had an important ancillary role for builders in the form of machines for lifting, scaffolding, frames for concrete moulds, and the centering for complex vaults.

The Romans used all the products of the Mediterranean quarries for their architecture, but cut stone, apart from the inexpensive tufa, fulfilled a limited repertory of support functions, restricted for the most part to fortifications, aqueducts, bridges, arches, and piers (Fig. I.2), except in the hellenized east with its old masonry traditions. Tufa, a soft volcanic rock that hardens on exposure to air, was abundant in Italy and remained in favour as a building material because it was cheap and easy to use; tufa, cut in large, regular blocks, was used for walls (Fig. I.52), foundations, and piers from the fourth century B.C., and in small blocks of different shapes was combined with other materials for light walls and wall surfaces. Various kinds of limestone were adopted either as a primary material in the form of polygonal

Fig. I.1 Ara Pacis Augustae, Rome. 13–9 B.C.

Fig. I.2 Pont du Gard, Nîmes, Southern France. Built by Agrippa, late I century B.C.

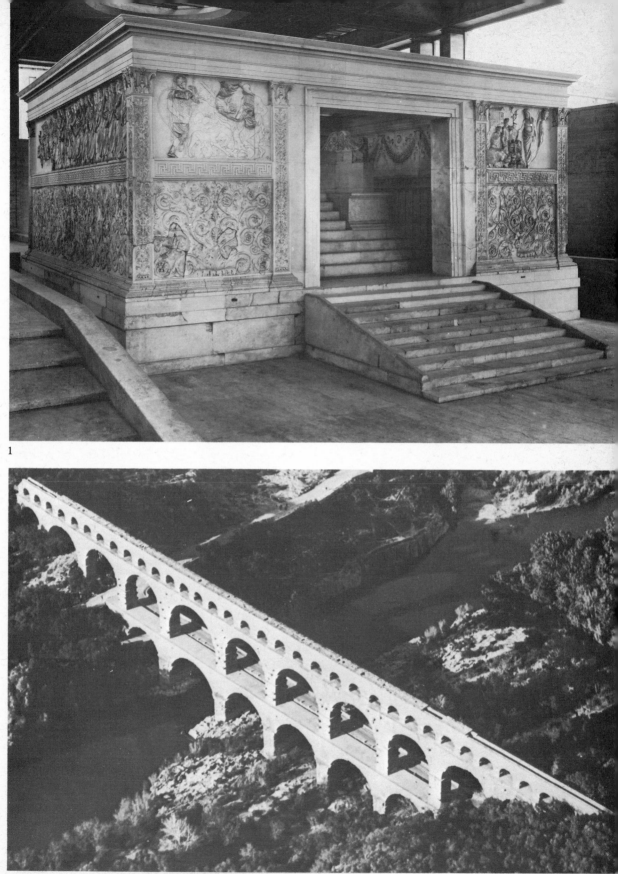

1

2

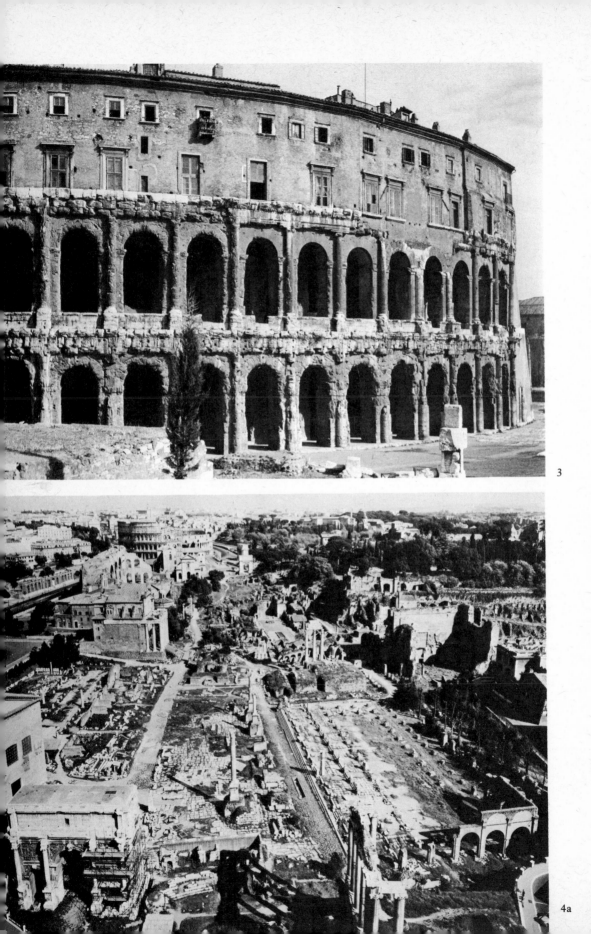

3

4a

blocks for fortifications, as regular ashlar masonry (*opus quadratum*) in exposed walls, or as columns, bases, capitals, entablatures, and corners for decoration and reinforcement in tufa architecture (Fig. I.3); the limestone available for building around Rome was mainly calcareous travertine. Although Augustus claimed to have transformed Rome from a city of brick into one of marble, marble itself was rarely used in Roman architecture except as an ostentatious replacement for limestone (Fig. I.4a), for enriched surface ornament, and for sheathing in thin veneers, often richly coloured. Stone veneers in marble and other costly, tinted stone, composed in elaborate abstract and figured patterns for floor and wall decoration, were very popular in later Roman architecture (Fig. I.23); this technique of surface ornament is called *opus sectile*. Harder varieties of rock, such as diorite, basalt, and porphyry, often taken from Egyptian quarries, were also cut into decorative veneers and mouldings as well as monolithic columns (Fig. I.7b), while diorite in the form of irregular blocks of grey *selce* became the durable paving of many Roman roads (Fig. I.5).

Stone rubble did not stand alone as a building material but formed an integral ingredient in the making of the semi-artificial substance, Roman concrete, as it developed from the second century B.C. Roman concrete is a made material, composed of cement, created from a changing recipe of lime, clay, and grit, which when mixed with water and rubble-fill in certain proportions will harden or cure into a solid, dense mass capable of supporting great weights; the shape of that mass is determined by the wooden mould or frame into which the wet concrete has been poured. These cement mixtures, *opus caementicum*, were Roman improvements on a

Fig. I.3 The Theatre of Marcellus, Rome. About 13 B.C.

Fig. I.4a The Forum Romanum from the Capitol towards the Arch of Titus

Fig. I.4b Plan of the Forum Romanum in the time of Constantine

1 Temple of Concord. 2 Temple of Vespasian. 3 Temple of Saturn. 4 Basilica Julia. 5 Temple of Castor. 6 Arch of Augustus. 7 Temple of Vesta. 8 House of the Vestal Virgins. 9 Arch of Titus. 10 Temple of Venus and Roma. 11 Basilica of Maxentius. 12 Temple of Romulus. 13 Temple of Antoninus and Faustina. 14 Regia. 15 Temple of the Divine Caesar. 16 Basilica Aemilia. 17 Curia Senatus. 18 Rostra. 19 Arch of Septimius Severus. 20 Forum Julium.

building technique learned from their Italian neighbours and they freed architecture from the demands of a rectilinear support system, introduced the three-dimensional curve as a dramatic and spatial possibility in architectural design, and made the construction of vast projects inexpensive and rapid. In sum, the development of Roman concrete revolutionized ancient architecture. However, concrete must be protected against moisture, and for this reason the Romans invented a number of surfacing techniques—in addition to stone veneers—which utilized small pieces of stone and other materials set into the concrete face while it was wet so that they would make a firmly bonded skin when the concrete dried out. These techniques developed from the insertion of irregularly shaped, pointed pieces of stone (*opus incertum*) in the late second century B.C. to the adoption of regular, four-sided pyramidal blocks of stone, usually tufa, set in regular patterns (*opus reticulatum*) shortly after 100 B.C. Brick facing (*opus testaceum*) became the fashion in the early Empire (Fig. I.6a) and lasted until the fourth century, although earlier another technique was introduced, *opus mixtum*, which applied combinations of brick, stone, and tufa facings in decorative patterns of great beauty. These techniques are important for dating Roman buildings, especially in the Republican period, but their greater significance lies in the establishment of a fundamental distinction in Roman architectural design between the structure of a building, formed out of poured concrete, and its visual surface, covered with various materials for protection, decoration, and impressive embellishment. It should be noted that *opus incertum*, *reticulatum*, and *mixtum* were themselves usually covered by plaster, wherever exposed to view.

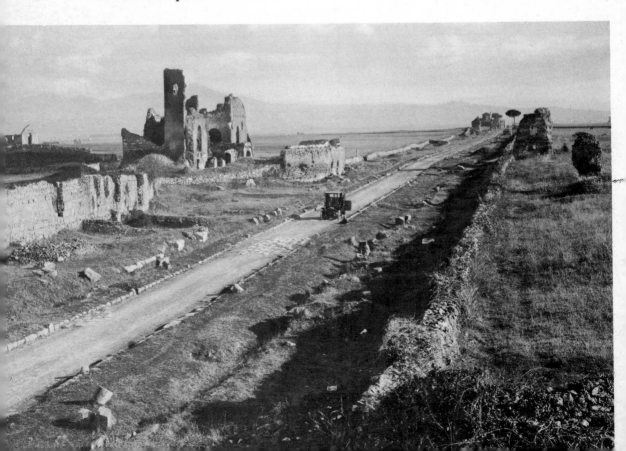

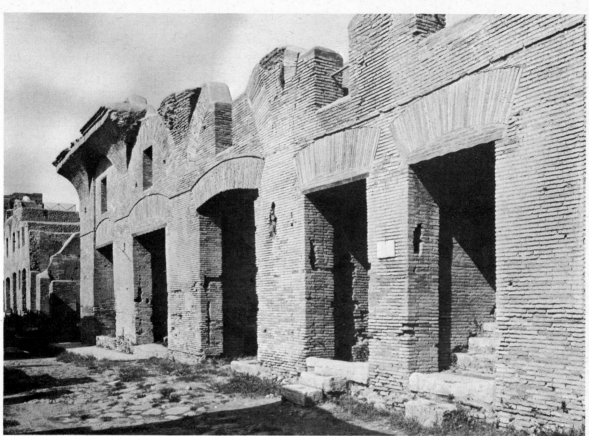

Fig. I.5 I and II century tombs along the Via Appia

Fig. I.6a Casa di Diana and adjacent street in Ostia. Mid-II century A.D.

Fig. I.6b Casa di Diana in Ostia: axonometric reconstruction

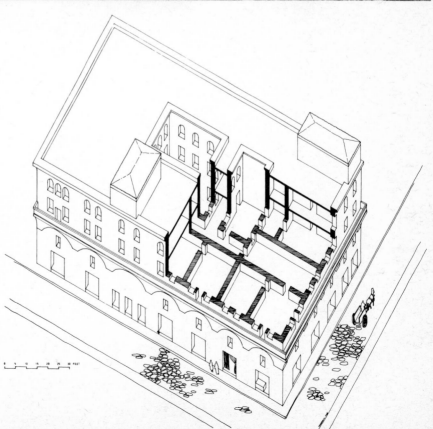

Concrete was also adapted for vaulting to replace wood with its risk of fire and load limitations; moreover, it was inexpensive and permitted the construction of walls and vaults in a continuous process. Such vaults could be given a great variety of different shapes, free the ground plan from the dominance of the rectangle (cf. Fig. I.47), span great open spaces (Fig. I.7b–d), and suggest through flowing curves both horizontal and vertical movement Figs. I.8, 19). Roman builders developed lighter forms of concrete for vaulting in order to reduce the weight of the material on the wooden centering while wet and on its own static capacities when dry. Vault-fill was often made up of very light materials, such as pumice and even hollow clay pots, and brick ribs appeared in some later Roman vaults not as free-standing supports but as integral parts of the concrete mass to support the vault while the concrete hardened.

Roman architecture utilized the full range of artificial, man-made products developed by antique technology and industry. Fired clay (*terra cotta*) was a favourite material from the very beginning, serving for gutters, water-spouts, decorative plaques, mouldings, architectural sculpture (Fig. I.9), and pipes and tubing for plumbing and heating. Clay tiles were primary roofing and flooring materials, while bricks performed an essential role in the construction and surfacing of Roman buildings; the changing dimensions and fineness of bricks, as laid in different amounts and qualities of mortar, have been of great value in dating Roman Imperial

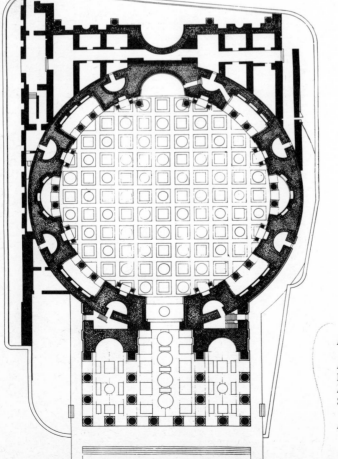

7a

Fig. I.7a Hadrian's Pantheon. Plan

Fig. I.7b Hadrian's Pantheon, Rome. Begun A.D. 118–119, completed by Antoninus Pius, restored by Septimius Severus

Fig. I.7c–d Hadrian's Pantheon

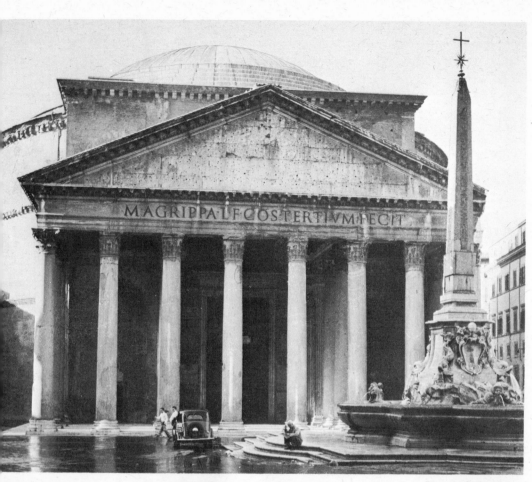

7b

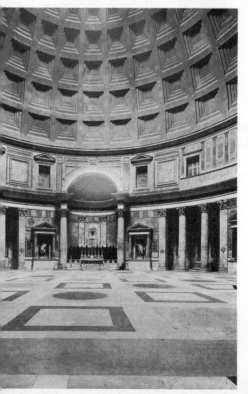

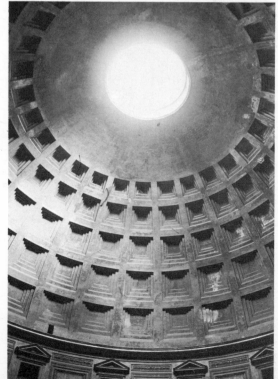

7d

7c

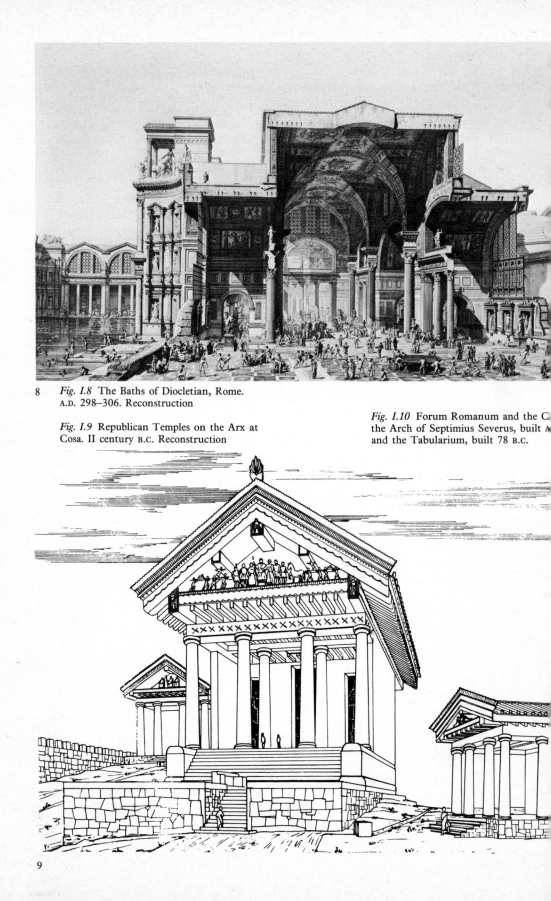

8 *Fig. I.8* The Baths of Diocletian, Rome.
A.D. 298–306. Reconstruction

Fig. I.9 Republican Temples on the Arx at
Cosa. II century B.C. Reconstruction

Fig. I.10 Forum Romanum and the C
the Arch of Septimius Severus, built A
and the Tabularium, built 78 B.C.

architecture, often clearly dated by brick-stamps, preserved by the thousands in evidence of the enormous brick industry in the service of Imperial building programmes. Iron and lead were used for dowels and clamps in *opus quadratum* and in holding stone veneers in place, while bronze, frequently gilded, was available for architectural sculpture, fixtures, and inscriptions (Fig. I.10); builders also relied on lead sheets for waterproofing and on lead pipes for plumbing, especially in thermal establishments. Hard stucco covered walls and cisterns with a tight, impermeable layer, often smooth and painted, but frequently moulded on walls and ceilings into complex, decorative compositions (Figs. I.11, 12). Plaster served similar purposes and was widely used as a general wall covering, particularly as a surface for painting (Fig. I.14a) and as the finishing layer in wattle-and-daub domestic architecture. Glass pieces appear together with stone to constitute the *tesserae* of Roman floor and wall mosaics (*opera musiva*) (Figs. III.10–20), while sheet glass, although rare and expensive, came into vogue in Imperial times for windows (Fig. I.13, 14b) and was occasionally painted for even greater decorative effect as indicated by the painted glass panel recovered from the sea off Kenchreai.

The insubstantial material out of which many of the great works of Roman architecture were constructed is space, conceived and applied as a positive, definite in shape and forcing harder substances to conform (Figs. I.15, 16, 19a). If concrete actualized the physical means of exploiting space, especially in the interiors of Roman buildings and building complexes, architects from the late Republic onward had thought about architecture as a field for spatial constructions. The process was ambivalent at first. Vaulting and its ancillary supports made possible the liberation of the plan and elevation, which in turn led to an emphasis on spatial definition and

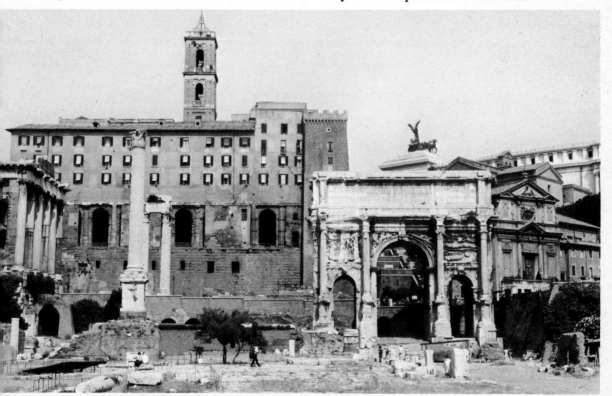

10

11

12

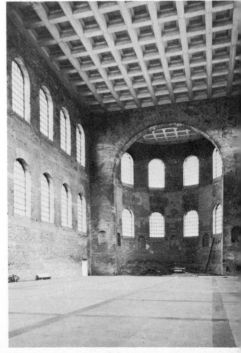

13

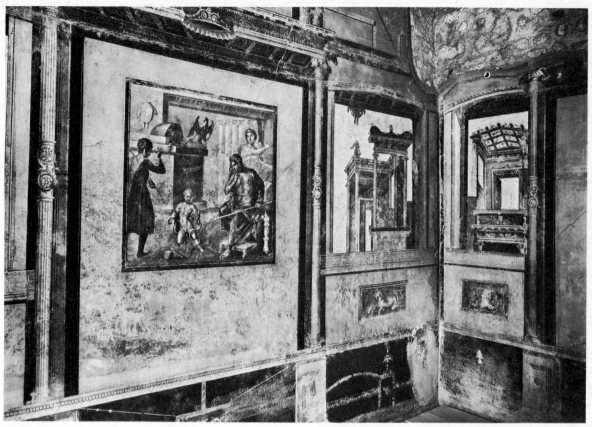

14a

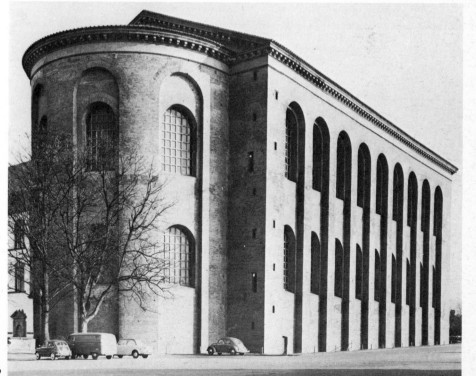

Fig. I.11 Stucco decoration in the Tomb of the Valerii on the Via latina, Rome. Third quarter of II century A.D.

Fig. I.12 Sala della Volta Dorata in the Domus Aurea of Nero, A.D. 64–68. XVI century drawing by Francesco d'Ollanda

Fig. I.13 Aula Palatina, Trier: interior

Fig. I.14a Painted cubiculum in the House of the Vettii in Pompei. About A.D. 70

Fig. I.14b Aula Palatina, Trier. Early IV century A.D.

14b

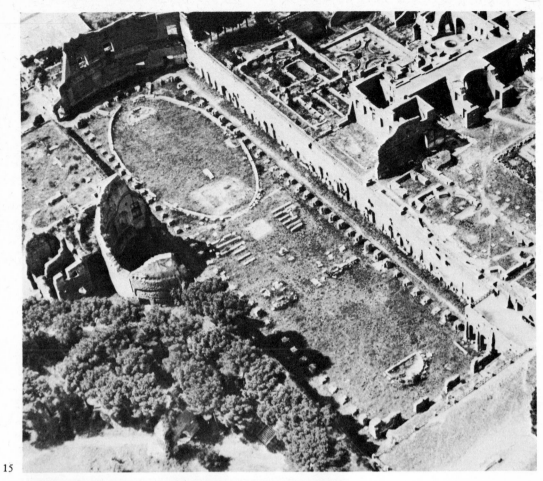

15

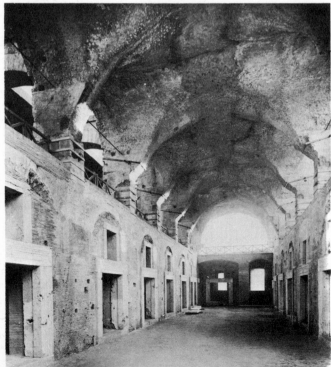

16

Fig. I.15 Domus Augustana (or Domus Flavia) on the Palatine, Rome, and view of the Hippodrome Garden. About A.D. 90–95

Fig. I.16 Aula in Trajan's Market, Rome. About A.D. 110

Fig. I.17 Trajan's Market in Rome: axonometric reconstruction

Fig. I.18 Domus Aurea of Nero, Rome: the octagonal dining hall. A.D. 64–68

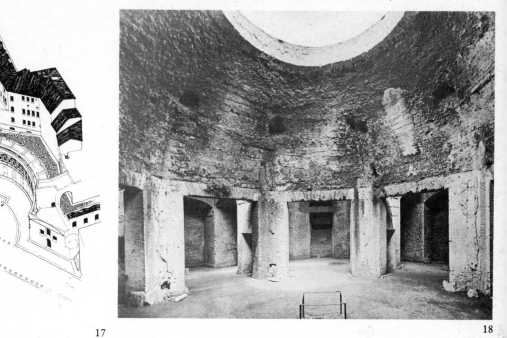

17 18

association, characterized by sequence, rhythm, and movement (Fig. I.17). By Nero's time, however, the techniques of vaulting had been mastered and great architects began to construct their buildings as cumulative spaces (Fig. I.18), pushing upward (Figs. I.8, 19a, b), sinuously flowing (Fig. I.47), horizontally directional (Fig. I.13), measurably all-inclusive (Fig. I.20a, b), and universal (Fig. I.7b, c). In many of these buildings, walls and vaults came to be treated as thin membranes, stretched over well-defined, coherent spaces and cut by windows, whose light further dematerialized their appearance. When floors, walls, and ceilings were sheathed in rich stone veneers, mosaics, and paintings, as was the practice in late Roman architecture, then space, suffused with light and scintillating colour, perfected itself as the basic material of architectural design (Figs. I.21, 23).

b. Space, Plan, and Scale Roman architects depended on two-dimensional ground plans for the development and execution of their designs, as indicated by Vitruvius and indirectly in the surviving fragments of the city plan of Rome (*Forma Urbis Romae*), which dates from the Severan period. The frequent repetition of building types and space patterns in Roman architecture further reveals the existence of plans as part of the architect's professional equipment, and certainly some form of detailed working drawings were necessary for the direction of building activity in large-scale projects. In addition, accurate surveying was an essential skill in the division of agricultural land (centuriation), in the placement of roads and aqueducts, and in the siting of grand building complexes on difficult terrain. If all these uses demonstrate the importance of plans as a tool in the design and construction of buildings, Roman architecture itself suggests that plans had a profound symbolic function, expressing a psychological preference for order not only in

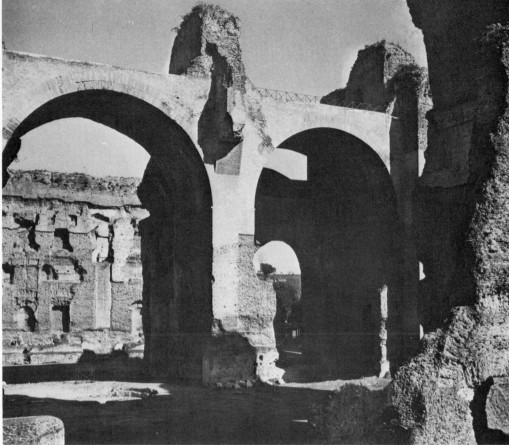

19a

composition but as a method of rationalizing and structuring the casual aspects of experience.

Some form of linear development seems to have been the most prevalent system of organization. The single-celled Roman temple, erected on a high podium and entered from the front through a deep porch (Figs. I.22, 40), best illustrates the

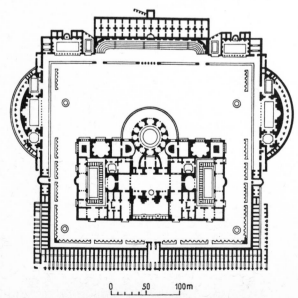

Fig. I.19a The Baths of Caracalla, Rome: the tepidarium. A.D. 212–216

Fig. I.19b The Baths of Caracalla, Rome: plan

Fig. I.20a The Basilica of Maxentius-Constantine. Built A.D. 306–315

Fig. I.20b The Basilica of Maxentius-Constantine: axonometric reconstruction

19b

0 50 100m

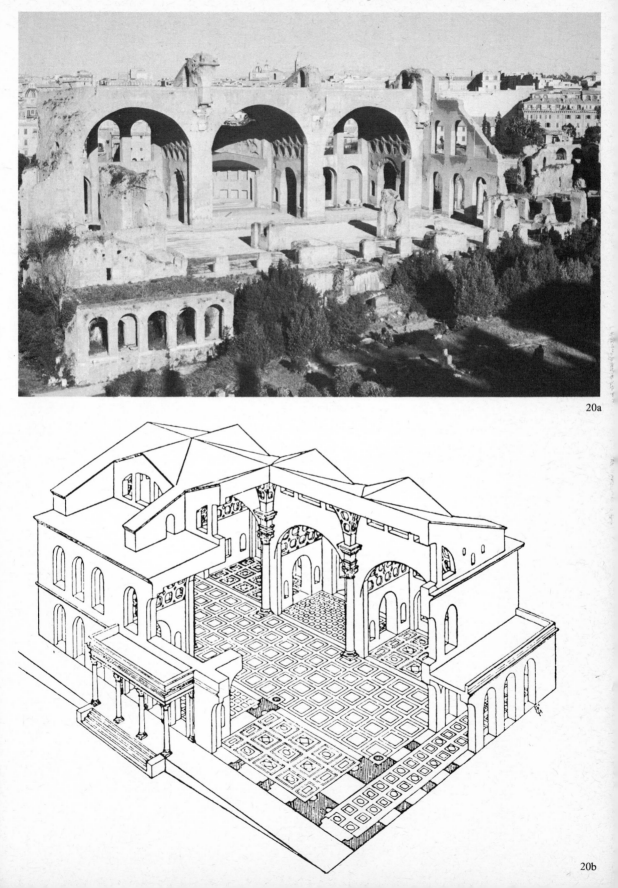

20a

20b

simple, box-like plan, partly open, organized along a single, directional axis that terminates in the cult image at the back of the cella. In Roman urban planning the corresponding scheme governs the avenue that leads insistently to an eye-filling monument, often a triumphal arch (see p. 66). Even in this limited scheme the direction of movement and of sight may be reversible, since in the Republican period (Fig. I.9) the porch could be used by priests for viewing the outward sky in searching the flights of birds for omens. Something of this reversal of direction along a single axis is evident in the plan of the Temple of Venus and Roma, Rome (Figs. I.4b, 24), rebuilt by Maxentius in the early fourth century A.D. after an original Hadrianic design.

Roman domestic architecture often complicated the single, direct line of movement by agglutinative clusters of small units, arranged around rectangular spaces that fall more or less along an axis. The Latin house-type of small rooms, placed almost symmetrically around the atrium, open to the sky (Fig. I.25) established this pattern. From it one mode of architectural design led toward compartmentalized schemes, exemplified by warehouses and tenements (Fig. I.36) in the large cities of Italy and ultimately in the highly structured order of the Basilica of Maxentius in Rome (Fig. I.20b). The design features of the atrium house also matured into the great town houses of the Republic (Fig. I.26a, b) that combined atrium and Greek peristyle in flexible but progressive arrangements, dependent on directional movement and deliberate fluctuations between compression and release. Similar developments affected the plans of country villas, such as those of Valerius Flaccus in Tivoli and of Catullus on Lake Garda, the second-century Villa di Sette Bassi

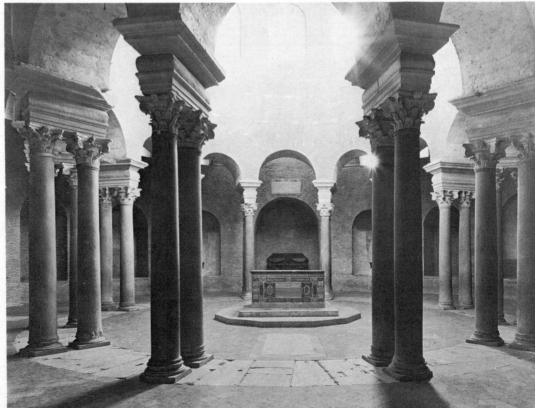

21

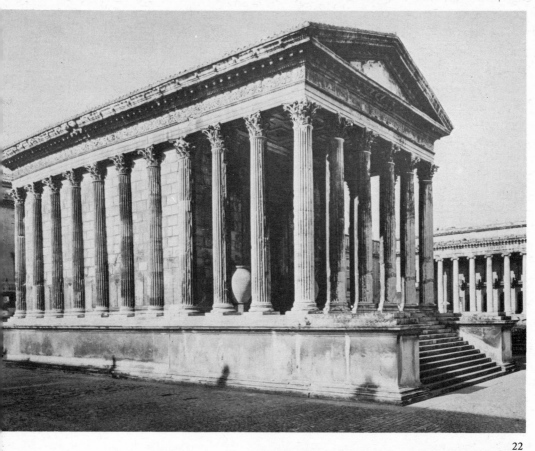

22

Fig. I.21 S. Costanza, Rome. A.D. 325–350

Fig. I.22 The Maison Carrée, Nîmes, Southern France. Built under Agrippa, about 20 B.C.

Fig. I.23 Opus sectile wall from a Christian building near Porta Marina, Ostia. Early IV century A.D.

23

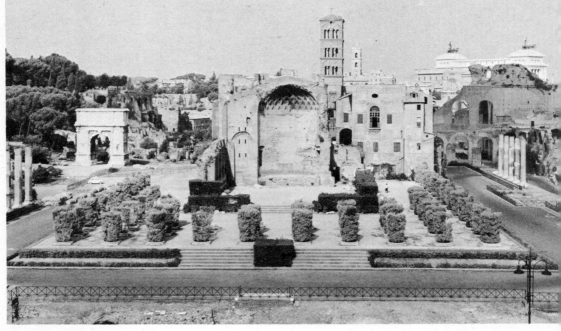

24

Fig. I.24 The Temple of Venus and Roma, Rome. Original A.D. 121–135, rebuilt A.D. 307–313

Fig. I.25 Schematic plan of a IV–III century B.C. house in Pompei

Fig. I.26a The House of the Faun, Pompei. II century B.C. to A.D. 79

Fig. I.26b Plan of Region VI of Pompei, including the House of the Faun

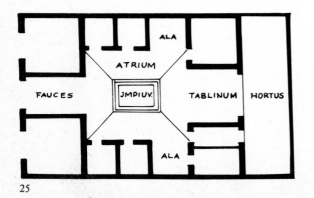

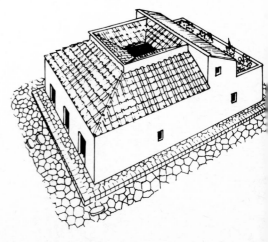

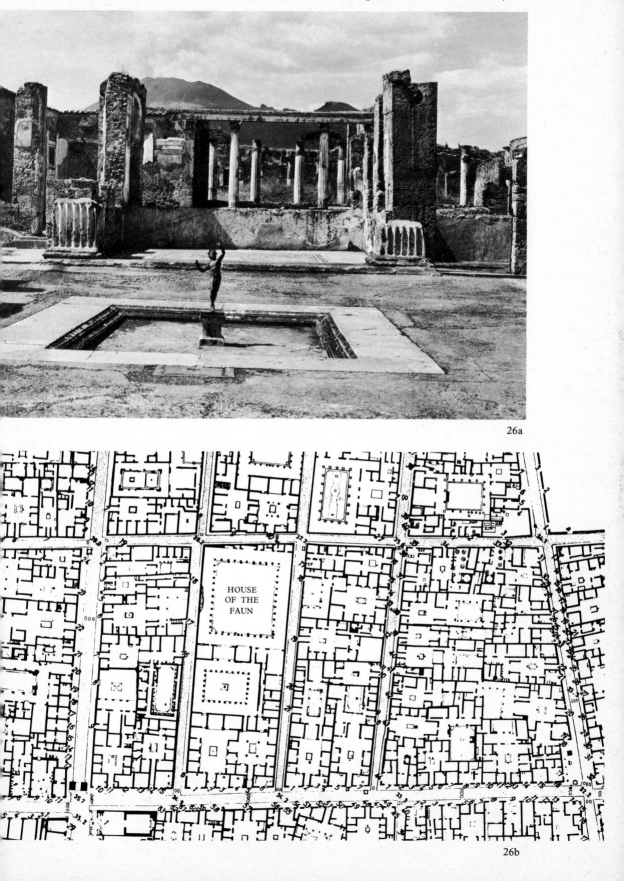

26a

HOUSE
OF THE
FAUN

26b

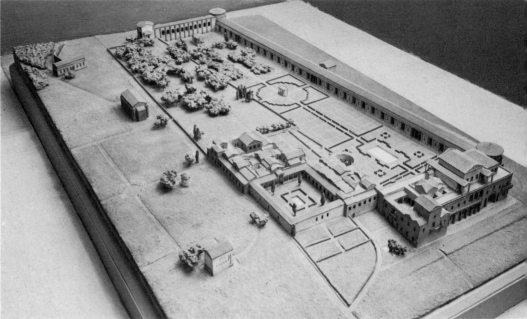

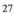27

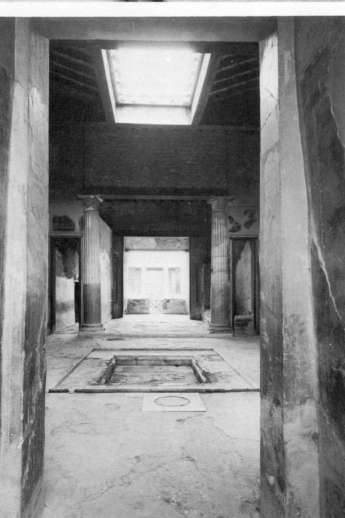

28

Fig. I.27 Villa di Sette Bassi, Vi▮
Latina, Rome. A.D. 150–175. Mc▮
Rome, Museo della Civiltà Rom▮

Fig. I.28 The House of Menand▮
at Pompei. II century B.C. to A.D▮
View through atrium into perist▮

Fig. I.29a The Forum of Pompe▮
final form in A.D. 79

Fig. I.29b Pompei: general plan

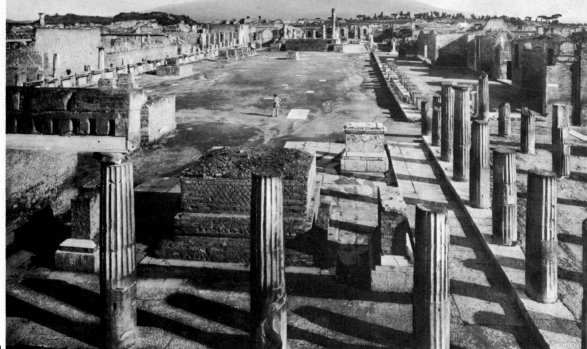

29a

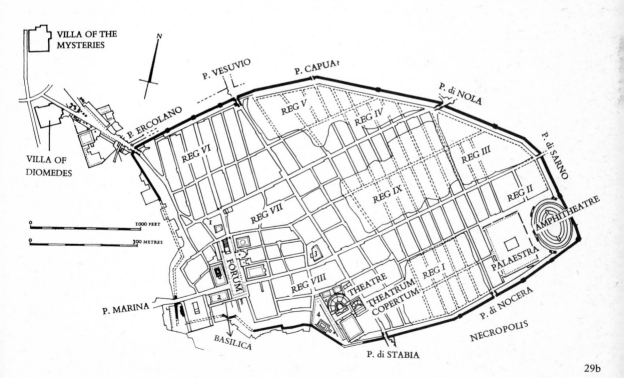

29b

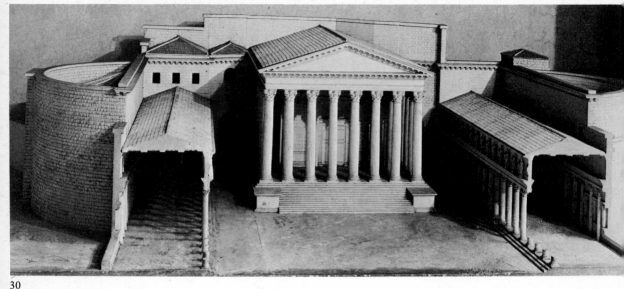

30

Fig. I.30 Forum Augusti, Rome. Consecrated in 2 B.C. Model. Rome, Museo della Civiltà Romana

Fig. I.31 The Imperial Fora, Rome: general plan

Fig. I.32 The sanctuary of Heliopolitan Zeus, Baalbek. Temple I century A.D., sanctuary mid-II century A.D., entrance and hexagonal court early or mid-III century A.D. Reconstruction by B. Schulz

outside Rome (Fig. I.27), and even the elegant apartment houses of Rome and Ostia (Fig. I.58).

One of the more interesting and important features of this flexible scheme, which alternates densities of enclosure and intensities of light, is the architect's desire to translate rhythmic variations in a linear plan into a carefully controlled, rich sequence of dramatic, emotional experiences. If the House of Menander in Pompei (Fig. I.28) reveals the possibilities of this concept in a private residence, Hadrian's Piazza d'Oro (Fig. I.47) reaches the very limits of exciting variation. The sequential quality of such an emotionally oriented design was deeply appreciated by architects commissioned to design public spaces in which the public could be manipulated. The Forum of Pompei (Fig. I.29) and the Forum Julium in Rome (Fig. I.31) display the civic application of this design, while the Temple of Zeus at Baalbek (Fig. I.32) adapts it for the enhancement of a religious experience. However, the focus of these public spaces, on the Temple of the Capitoline Triad at Pompei (Fig. I.29a), on the Temple of Venus in Caesar's Forum, on the shrine of the great hidden god at Baalbek, was no doubt influenced also by an extended scheme of planning which was emphatically linear, symmetrical, and conclusive. These tendentious elements characterize the typical Roman forensic basilica at Pompei (Fig. I.29b), at Rome (Fig. I.31), and at Leptis Magna (Fig. I.33a, b), the basilical audience halls of palatial residences such as that of Domitian on the Palatine (Fig. I.34) and the Aula Palatina in Trier (Fig. I.13), and also the Forum Augusti in Rome (Figs. I.30, 31). In all

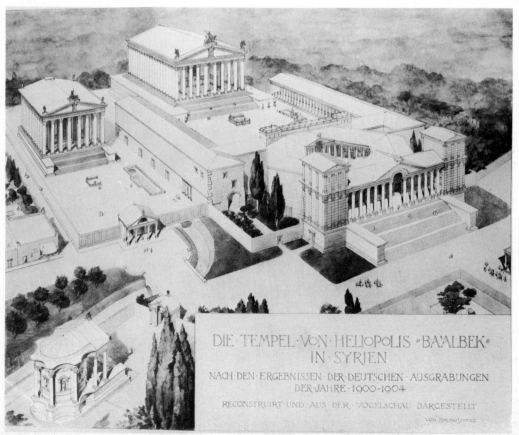

32

these works of architecture, the focus of attention lay at the head of the central axis in a person, an image, or a grand symbol.

However, the Forum Augustum also belongs to a more complicated class of planning scheme, adapted for large-scale complexes and organized symmetrically around a central axis, directionally conclusive but cut at right angles by subordinate cross-axes. Here, the central axis of the composition which ends in the statue of Mars Ultor, set in the apse of his Temple, is crossed by an axial arm, running from the centre of one exedra to the other through the façade of the Temple. If the classic example of this kind of plan may be found in the Forum Traiani (Fig. I.31), many of its principles of organization had already come into being in the plan of the Republican architectural masterpiece, the Sanctuary of Fortuna Primigenia at Palestrina (Fig. I.35a, b). Apollodorus of Damascus, who probably designed Trajan's Forum and the ancillary but separate Market (Fig. I.17), elaborated the tendentious rigour of the central axis of the Forum (passing from the triumphal entrance-way through the equestrian statue of Trajan in the centre of the open court, the central portal of the Basilica Ulpia, the Column (Fig. II.43), into the Temple of Divus Traianus at the rear) by crossing axes at important points of intersection: from one exedra to the other at the equestrian statue, from one apse of the Basilica to the other at the centre, from one Library to the other at the Column. As in the house of Menander (Fig. I.28), the architect also varied the density of his architectural environment by contrasting open and closed spaces of different sizes and proportions, defined by columnar screens and open façades of varying degrees of penetrability, texture, and height; he also used the terminal curve. Although

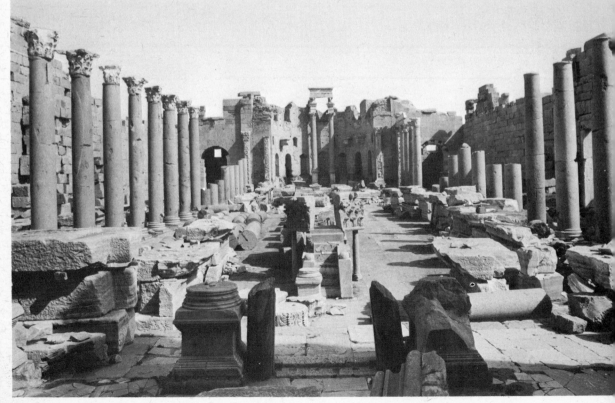

33a

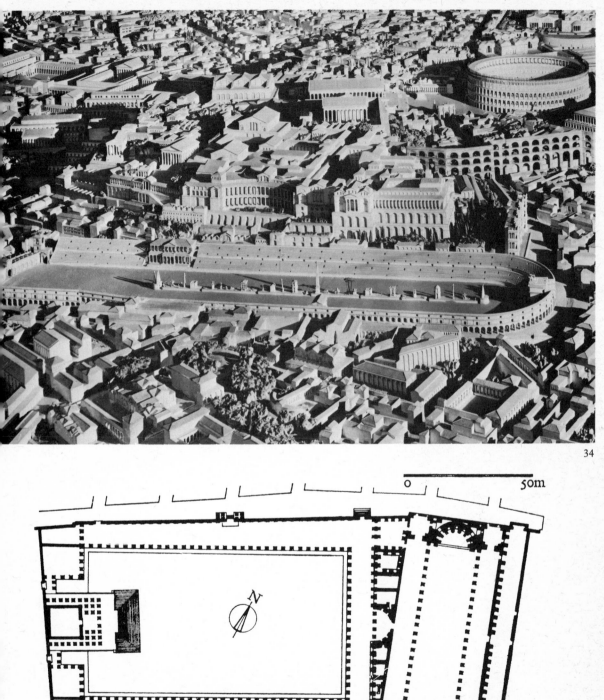

34

33b

Fig. I.33a The Severan Basilica, Leptis Magna.
A.D. 203–211

Fig. I.34 Circus Maximus and Domus Augustana,
Rome. Model. Rome, Museo della Civiltà Romana

Fig. I.33b The Severan Forum and Basilica,
Leptis Magna: plan

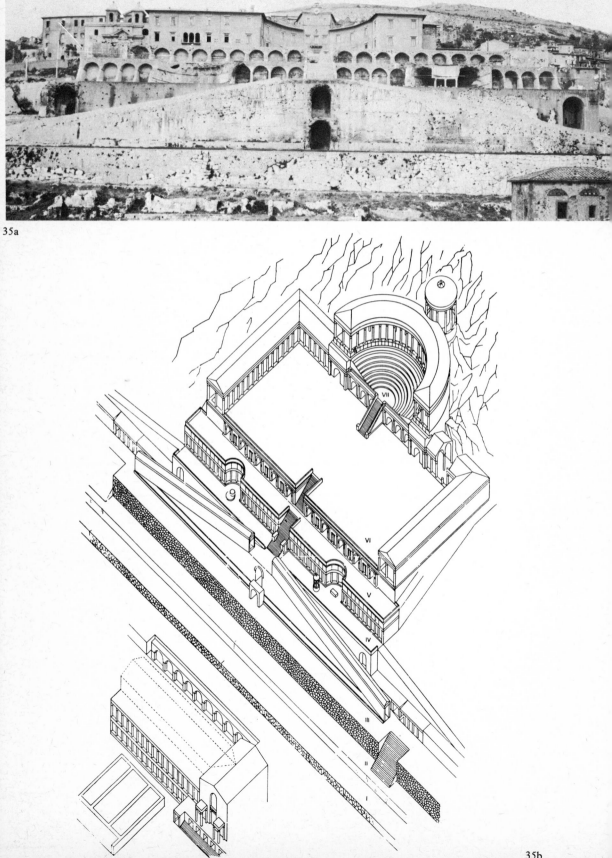

35a

35b

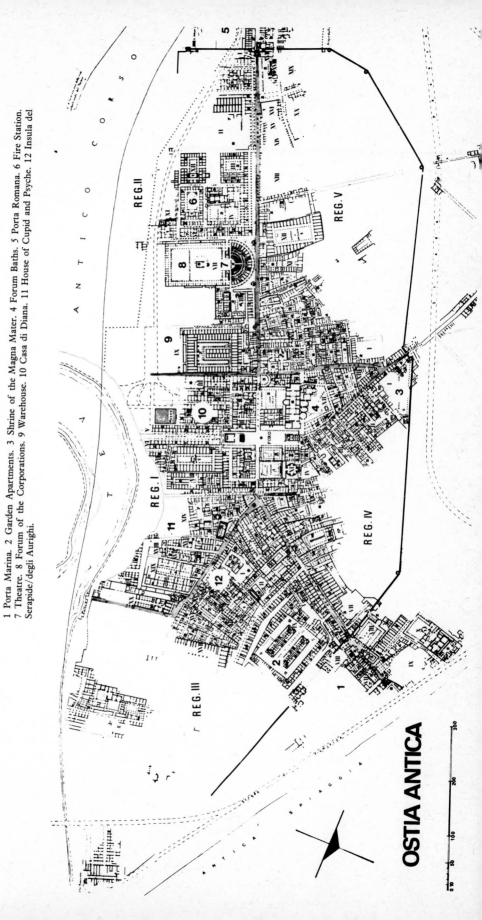

1 Porta Marina. 2 Garden Apartments. 3 Shrine of the Magna Mater. 4 Forum Baths. 5 Porta Romana. 6 Fire Station. 7 Theatre. 8 Forum of the Corporations. 9 Warehouse. 10 Casa di Diana. 11 House of Cupid and Psyche. 12 Insula del Serapide/degli Aurighi.

Fig. I.35a The Sanctuary of Fortuna Primigenia, Palestrina. Late II century B.C. or possibly under Sulla, about 80 B.C.

Fig. I.35b The Sanctuary of Fortuna Primigenia, Palestrina: axonometric reconstruction

Fig. I.36 Ostia: general plan to IV century A.D.

OSTIA ANTICA

Trajan's Forum is primarily an open, visually coherent form, the abstract, aesthetic content of this design may be appreciated from its adoption for the great Imperial baths, as indicated by the Baths of Caracalla (Fig. I.19b) and Diocletian (Fig. I.8) in Rome. The same principles of organization apply, even if only the architect could have experienced directly the grandiose, symmetrical scheme in the contemplation of his ground-plan. Buildings of such an enormous scale created a total, self-inclusive architectural world, where the existence of this regularizing, cross-axial system would have been felt intuitively by the spectator-user as he passed from one part of the complex into another and perceived the repetition of forms and the reflective orientation of a coherent design.

Axial symmetry may have been the primary syntactical expression of Roman

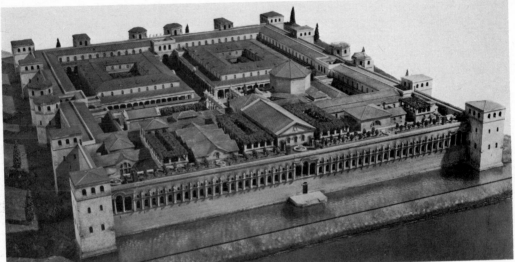

37a

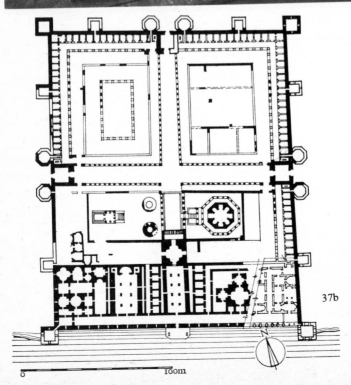

37b

Fig. I.37a The Palace of Diocletian, Split. About A.D. 305. Model. Rome, Museo della Civiltà Romana

Fig. I.37b The Palace of Diocletian, Split: plan

0 100m

architecture, but it was not exclusive. Radial symmetry also existed in several forms, organized around a centre which may be open and free or occupied, but for which the term 'central planning' is inadequate. The first and simplest variety of radial planning appears in the regular quadrate scheme adopted for the *castrum*, used for military purposes and for the establishment of regular, fortified towers in the foundation of Ostia (Fig. I.36), of Aosta and Turin in northern Italy, Timgad in Africa, and many other places in the western Empire. In its pure form this quadrate plan was divided into four equal parts by the intersection of two main avenues, the *cardo* and the *decumanus*, although in practice absolute symmetry rarely existed, since the forum was usually located *at* but not *on* the central intersection; Diocletian's palatial villa at Split on the Dalmatian coast also employed this scheme (Fig. I.37a, b). The pure form, however, may be found as the organizing principle in the component parts of large complexes, such as the lower garden of the Domus Flavia on the Palatine (Fig. I.34), the great open square in Trajan's Forum (Fig. I.31), and in forensic basilicas with facing apses such as the Basilica Ulpia in the same Forum. Regular polygons with more than four sides provide another instance of radial planning and are well represented in a famous Roman building type, the *macellum* or food market, exemplified by the well-preserved macella in Leptis Magna (Fig. I.38a, b). The same kind of radial scheme was used for the Mausoleum of Diocletian at Split (Fig. I.37b) and similar monuments.

From Nero's time Roman architects tended to prefer octagonal plans because such a plan eased the transition from a multi-angular base to a circular, domical vault, as may be seen in the octagonal dining hall of the Domus Aurea (Fig. I.18) or in the decagonal garden pavilion called the Temple of Minerva Medica (Fig. I.39a, b). The Pantheon represents the full perfection of this scheme (Fig. I.7a), not because the interior is in fact polygonal but because the placement of apses, niches, and intervening walls offers the partial illusion of an octagon completing itself in a circle. Indeed, the Pantheon itself is the classic example of the primary radial plan, that of the round, centrally planned building which supports a circular dome. In addition to Neronian and Flavian experiments in vaulting, the precedents for the Pantheon lie in two kinds of central plans, both of which depend on the cylinder and have their origins in the Republic. The first of these, exemplified by so-called 'Temples of Vesta' (Fig. I.40), consist of round buildings with one entrance, surrounded by a circular colonnade, and with a tile-covered wooden roof. The second precedent may be found in the form of cylindrical tombs, such as that of Caecilia Metella on the Via Appia (Fig. I.41) and Hadrian's own Mausoleum, the Castle Sant' Angelo. In the second, third, and fourth centuries the centrally planned, domed cylinder was applied to a variety of purposes, including the *caldaria* or hot rooms of large baths (Fig. I.19b), for transitional vestibules like the 'Tempio di Romulo' in the Roman Forum (Fig. I.4b), and for a number of Imperial tombs around Rome, of which the best preserved is the Tomb of Romulus, son of Maxentius, on the Via Appia. Sta Costanza on the Via Nomentana (Fig. I.21) offers an important fourth-century modification of this scheme, utilizing the centrally planned, domed cylinder together with an interior, circular colonnade, almost as if the

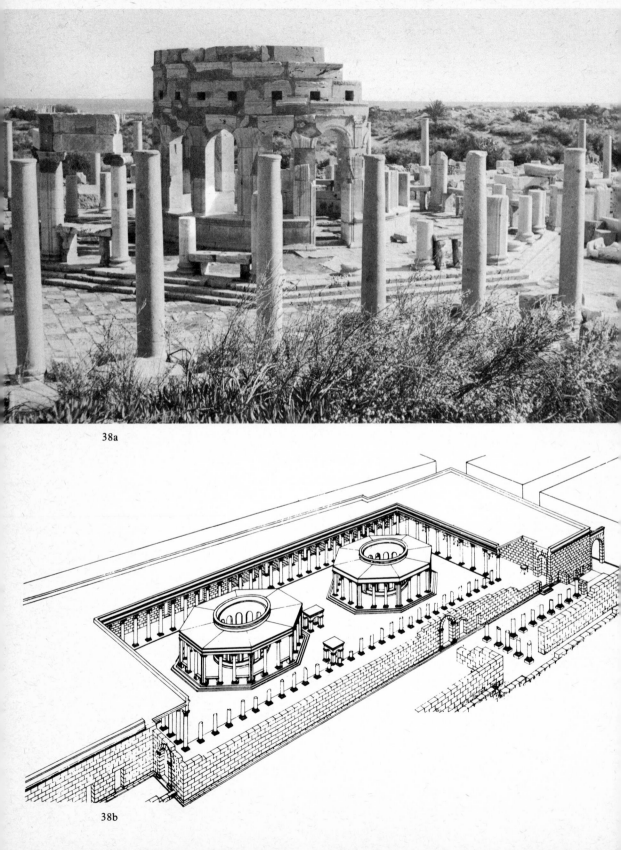

38a

38b

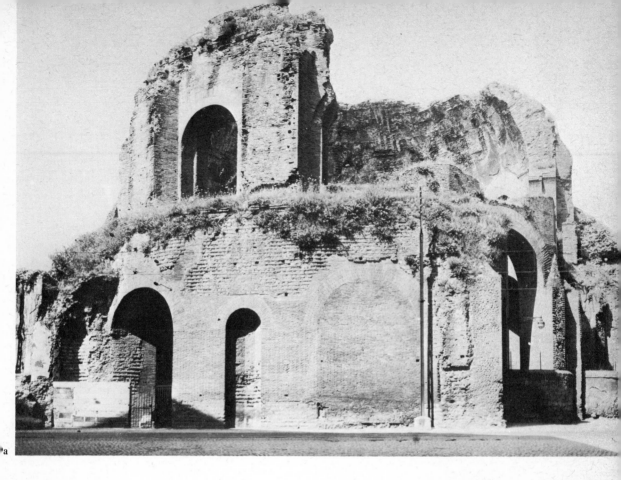

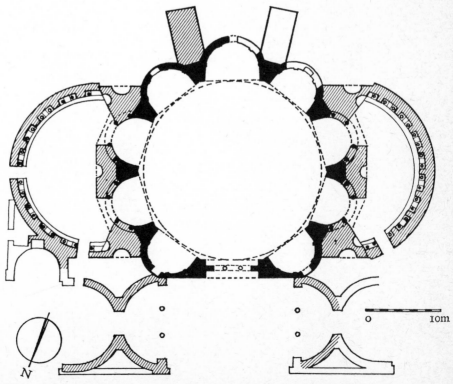

Fig. I.38a The Market (Macellum Augustum), Leptis Magna. Late I century B.C.

Fig. I.38b. Macellum Augustum, Leptis Magna: reconstruction

Fig. I.39a The 'Temple of Minerva Medica', a garden pavilion, Rome. Built early IV century A.D.

Fig. I.39b 'Minerva Medica', Rome: plan

N

0 10m

39b

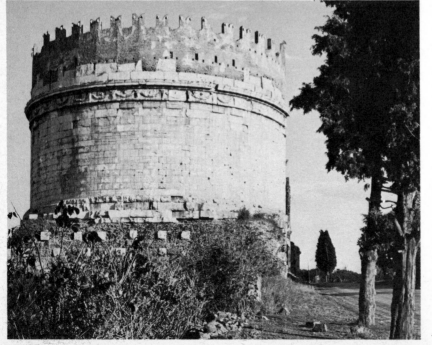

Fig. I.40 The Temples of 'Ves
of 'Fortuna Virilis', Rome.
Built II century B.C.,
the Temple of Vesta reconstru
under Hadrian

Fig. I.41 The Tomb of
Caecilia Metella, Via Appia.
About 40 B.C.

Fig. I.42 'Teatro Marittimo'
or Private Retreat, Hadrian's
Villa, Tivoli. A.D. 125–130

41

Temple of Vesta type were turned inside out. This mixture, combined with increased fenestration at the upper level of the cylinder and abundant mosaic decoration, contributed to the variegated light effects that characterize late Roman architecture.

Instead of the enclosed feeling engendered by such centralized buildings, it was possible to make a round plan expansive by opening up the periphery. At least, it was possible for Hadrian in the design of the 'Teatro Marittimo', his island of retreat, surrounded by a watery moat and a circular colonnade, in his Villa at Tivoli (Figs. 1.42, 47). If this remains a unique achievement in Roman architecture, the expansive effect of a central, radial plan could also be attained in the elliptical designs, adopted most successfully for Roman amphitheatres everywhere (Figs. 1.43, 44). Expansiveness, suitable to the scale of these facilities for public entertainment, also complemented the permeability of these grand structures, opened to ventilation and human traffic in every direction. A rare application of the same principle to urban design may be seen in the elliptically shaped forum at Gerash in Syria (Fig. 1.45), formed at the intersection of major, porticated streets. The truncated circular or elliptical schemes, adopted for Roman theatres (Figs. 1.60, 61), odeons, circuses, and stadiums, are products of the combination of linear, conclusive, and radial schemes. Roman hippodrome gardens follow the same pattern (Fig. 1.15) as do a number of Roman seaside villas, wrapped in airy porticoes around curving bays (Fig. 1.46).

Linear and radial plans, however varied, permitted the Roman architect only

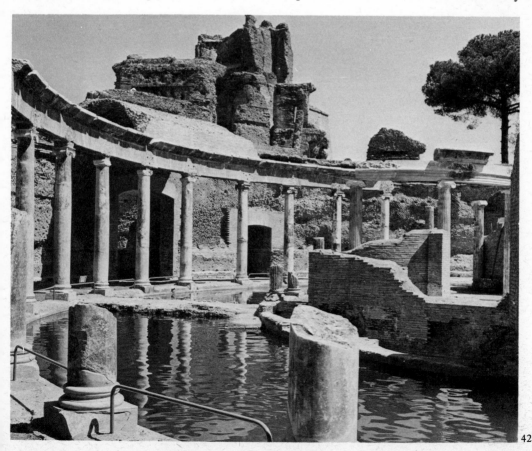

42

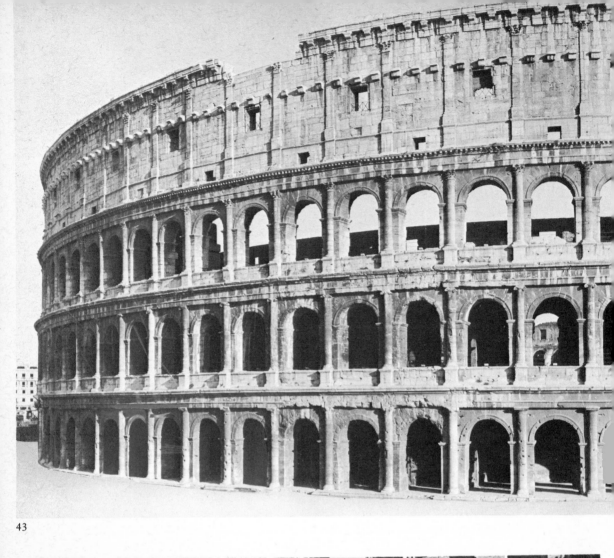

43

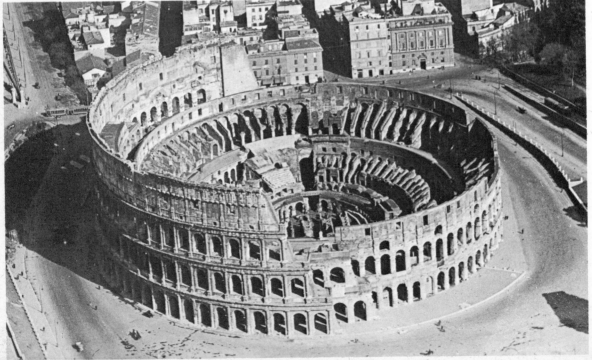

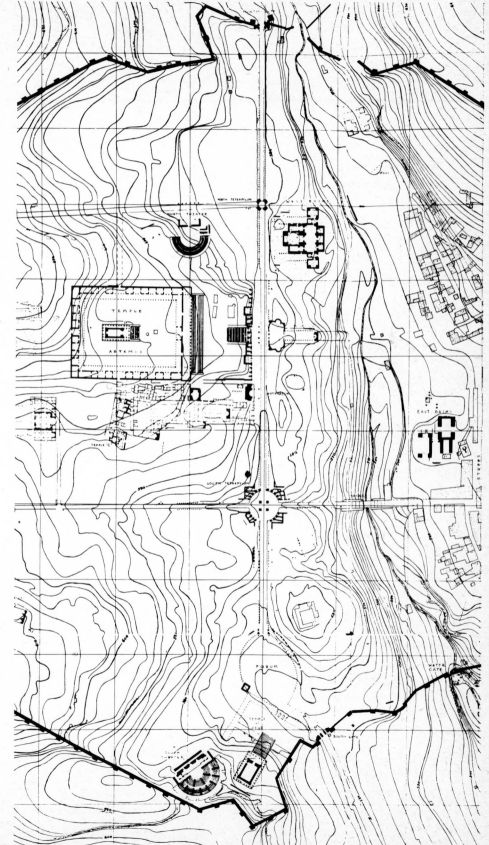

Figs. I.43–44 The Flavian Arena or Colosseum, Rome. A.D. 70–80

Fig. I.45 The centre of Gerash, Syria. Mid-II century A.D. Plan after Kraeling

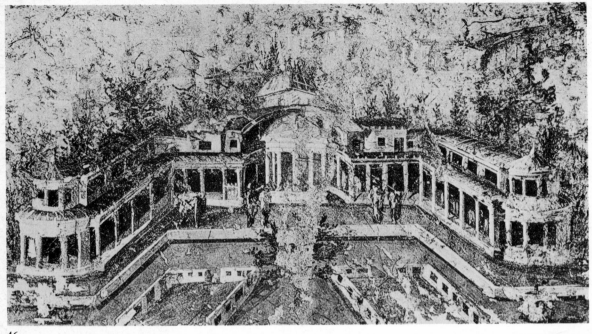

46

limited flexibility within a formalized situation. There existed another kind of planning, which might be called 'nodular' and which developed from the irregular, natural movements of processions and of the pedestrian, punctuated by significant pauses. The articulation of the processional way, adapted for ritual activities including the parade of the triumphator, affected the extension of the Via Sacra at Rome, which passed from the Circus Maximus over the Velia into the Roman Forum, then up the Capitoline Hill to the Temple of Jupiter (Fig. 1.4b). Although this path had a natural origin in the topography and primitive history of Rome, it evolved programmatically but without consistent planning over the centuries. Yet the Via Sacra itself was studded, at points of juncture where direction and elevation changed, with many different monuments; these became nodes of affirmative action (*celebratio*) and arrest, while the intervals between were spaces for passage. This kind of organization, although apparently casual, was closely tied to the Roman concept of the ostentatious public monument and greatly influenced the development of Roman urbanism, while it also informed the character of architectural planning. The House of Menander (Fig. 1.28) presents the formation of a nodular arrangement in terms of alternating effects posed in a linear sequence. The next step in complexity was achieved in the planning of the Domus Flavia on the Palatine (Fig. 1.34), where a large building complex, charged with the functions of governmental headquarters and of regal residence, was divided into semi-autonomous segments. Each segment served as a nucleated cluster, dependent on the exercise of a specific function but related to each other by the Imperial presence and by clearly established paths of transition. The apogee of this kind of nodular planning in a non-urban context is again to be found in Hadrianic architecture, specifically in his villa at Tivoli (Fig. 1.47). Because of the variety of Hadrian's own interests, the suburban Villa Hadriana is formed out of a loose aggregate of nodular

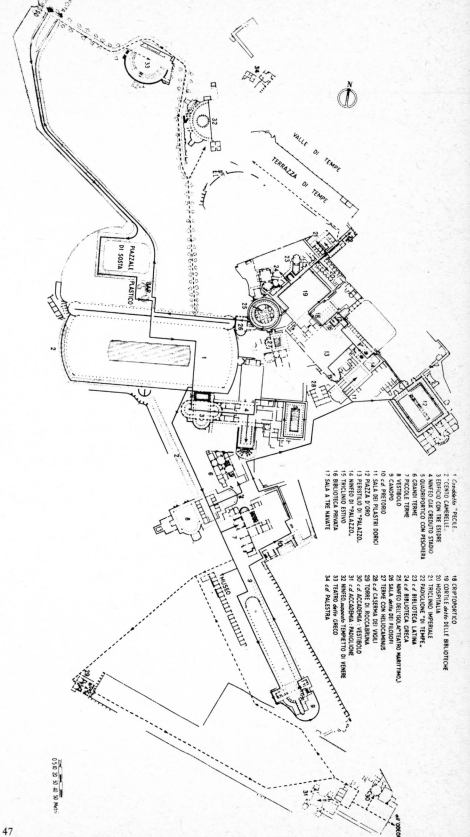

1 *Candello* "PECILE."
2 "CENTO CAMERELLE".
3 EDIFICIO CON TRE ESEDRE
4 NINFEO GIÀ CREDUTO STADIO
5 QUADRIPORTICO CON PESCHIERA
6 GRANDI TERME
7 PICCOLE TERME
8 VESTIBOLO
9 CANOPO
10 *c.d* PRETORIO
11 SALA DEI PILASTRI DORICI
12 PIAZZA D'ORO
13 PERISTILIO DI "PALAZZO"
14 NINFEO DI "PALAZZO"
15 TRICLINIO ESTIVO
16 BIBLIOTECA PRIVATA
17 SALA A TRE NAVATE
18 CRIPTOPORTICO
19 CORTILE *detto* DELLE BIBLIOTECHE
20 HOSPITALIA
21 TRICLINIO IMPERIALE
22 PADIGLIONE "DI TEMPE"
23 *c.d* BIBLIOTECA LATINA
24 *c.d* BIBLIOTECA GRECA
25 NINFEO DELL'"ISOLA" *(TEATRO MARITTIMO)*
26 SALA *detta* DEI FILOSOFI
27 TERME CON HELIOCAMINUS
28 *c.d* CASERMA DEI VIGILI
29 TORRE DI ROCCABRUNA
30 *c.d* ACCADEMIA - VESTIBOLO
31 *c.d* ACCADEMIA - PADIGLIONE
32 NINFEO, *supposto* TEMPIETTO DI VENERE
33 TEATRO *detto* GRECO
34 *c.d* PALESTRA

Fig. I.46 A Seaside Villa: wall-painting from the House of Lucretius Fronto, Pompei. Naples, Museo Nazionale

Fig. I.47 Hadrian's Villa, Tivoli. A.D. 118–138. Plan

47

subcomplexes, relatively isolated into suggestive environments in the form of architectural topoi. The whole ensemble is tied together by the natural connections of the rolling countryside and by the rhetorical character of the vagrant Emperor, but each zone or node is distinct. However, by the fourth century this intimate relationship with the land was abandoned in favour of a compressed, internalized environment, well characterized by the Villa at Piazza Armerina (Fig. I.48), whose compositional principle is agglutinative.

c. City-Planning and City Architecture Roman urban patterns fluctuated between chaos and rigid order, all within the context of the Mediterranean town as it had evolved under special climatic conditions and with the benefits of Greek urbanification. Narrow streets filled with activity, high densities of population enclosed in shuttered houses, and lavishly appointed public places characterized these towns as did the sharp class distinctions and strong civic pride of their inhabitants. For the Romans, the city was the centre of life, charged with an especial holiness and separated from the outside world by a magic line, the *pomerium*, the ritual boundary within which no one could be buried. But the cities of the Empire were not all Roman cities; many of them had been absorbed fully developed, especially in the hellenized east, while others in Africa and the western provinces remained with clearly stratified divisions between indigenous and Roman elements. Imperial cities can be categorized, not too firmly, under a number of rubrics: metropolis (Alexandria, Antioch, Rome), decayed cultural centre (Athens, Taranto, Syracuse), major regional centre (Ephesus, Miletus, Pergamon, Cyrene, Leptis Magna, Timgad, Italica, Lyons, London, Sirmium, etc.), important market town (Naples, Aquileia, Sabratha, Pompei), industrial port (Marseilles, Ostia, Pozzuoli, Brindisi, Zadar), resort (Herculaneum, Baiae), military establishment (York, Cologne, Ravenna, Dura Europos), and cult centre (Eleusis, Palestrina, Edessa, Jerusalem); neither the list of categories nor of places is complete. Often these functional roles overlapped, as in Lyons–Lugdunum, but whatever their primary function, all these cities possessed the appurtenances of civilized, urban life, affected only by local traditions and finances.

Roman cities may be viewed as organized or disorganized efforts of urbanization under Roman auspices and using Roman building types and techniques. Planning in the main followed hellenistic traditions in its emphasis upon the rectangular grid, created by a network of major and minor streets intersecting at right angles and creating quadrangular blocks or *insulae*, with some blocks left over for public structures and spaces. In some cases where earlier towns existed, the grid was applied only to the newly developed areas of the city and the distinction as at Pompei (Fig. I.29b) is often very marked; here theory and convenience under the guise of modernization interrupted the coherent fabric of the pre-existing town. The grid, combined with a regular quadrate scheme and organized around the intersection of *cardo* and *decumanus* (the principal north–south, east–west avenues), was also used in the planting of new foundations after the apparent model of the military *castrum* or legionary fortress. In Aosta and Turin that plan still governs the

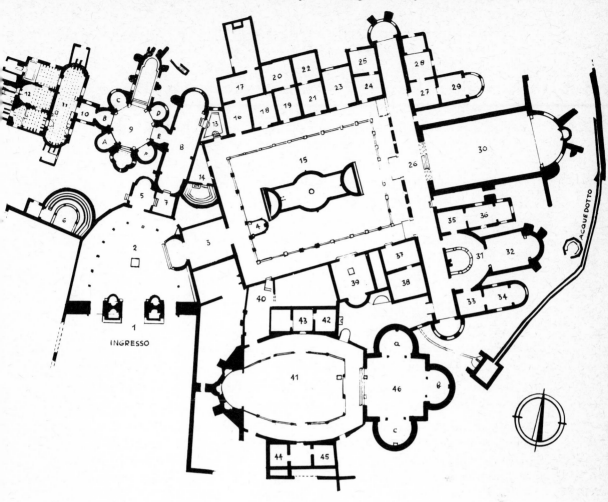

Fig. I.48 Villa at Piazza Armerina, Sicily. Early IV century A.D. Plan

centre of the modern city; elsewhere, at Ostia (Fig. I.36) and Timgad, which died in late antiquity, the *castrum* was only the historical core of a successful plantation which subsequently grew in ribbon extensions along the principal avenues leading away from the city centre into the countryside or towards other towns. If these extensions indicate the important relation between the main in-town streets and the exurban highways, it is often true that the *cardo* and the *decumanus* share a common orientation with the division of the agricultural lands around the city into regular lots (centuriation). Furthermore, at both Timgad and Ostia, although the ribbon extensions are out of phase with the castral system, as suburban regions they depend on a grid system organized around the major avenue.

As always, Rome itself provides the exception, as the great unplanned metropolis buffeted by fits of order and regional development. Rome was unplanned in the sense that the city as a whole 'just growed', determined largely by topography, available water, and accidents of history. However, regions of the city had periods of Imperial supervision and reorganization, especially after the great fire of A.D. 64, while large-scale Imperial building projects necessarily introduced some limited

aspects of planning into restricted areas. Augustus built up the Campus Martius, the Flavians the Coelian and Palatine hills, Trajan the Suburra, Maxentius the upper Forum, and all the Imperial patrons of the great public baths transformed the vast zones of construction by their enterprise, but these were costly, piecemeal operations. Only Nero attempted to replan the city and to replace the old civic centre, but he was assassinated.

Roman urban architecture is not limited by urban boundaries nor by any fixed typology of building, although Roman cities had definite boundaries and a number of building types were specifically urban. The distinction rests on the presence of an urban function which the architectural element provides as a service to the citizens. Such services may be categorized according to the role of the constituent element in the total urban situation rather than by architectural type: (1) water supply and disposal; (2) walls and gates; (3) streets; (4) centres of political, administrative, legal, and cultural activity; (5) religious centres; (6) food storage and distribution; public assistance facilities; (7) housing; (8) public recreation and amusement.

Vitruvius in his treatise on architecture emphasized the importance of careful siting in the foundation of new cities to ensure the protection of the inhabitants from enemy attack, from climatic hazards, and from want. He counted among the highest priorities of urban life the provision of an adequate water supply together with an adequate drainage system, and he laid their charge on the architect-engineer. Accordingly, the great aqueducts that run for miles across the countryside are elements of urban architecture, built in the service of the citizenry and using the technical resources of Roman masonry and concrete construction. Knowledge of hydraulics and very accurate surveying brought abundant supplies of fresh water toward the city through great channels under the pressure of gravity feed. Where necessary, these channels went underground or rose on high arches, maintaining the even flow and passing over natural obstacles, often in combination with that other urban artery, the road (Fig. I.2). The aqueducts entered the city at various points, sometimes in clusters as at the Porta Maggiore in Rome (Fig. I.50), and then led to selected stations or water castles, which distributed the water to public and private baths, fountains, various public facilities, and to some residences. Great fountains appeared in many Imperial cities as a symbol of magnificence that also cooled the air in summer, while demonstrating the abundance of the municipal service (cf. the Great Fountain at Miletus, Fig. III.3). The ubiquitous small fountain for domestic consumption was usually located at intersections for more efficient distribution (Fig. I.49), although some water was piped into the larger tenements at Ostia. At Rome and elsewhere, new aqueducts were caused by, and also stimulated, city growth, especially in the regions most accessible to the distribution system of the new line.

Running water also supplied the public latrine, that great convenience of town life, carefully placed near the forum or in the public baths, where it was most needed. The latrine itself depended on the existence of a decent drainage system, which although less magnificent than the water supply was equally necessary to

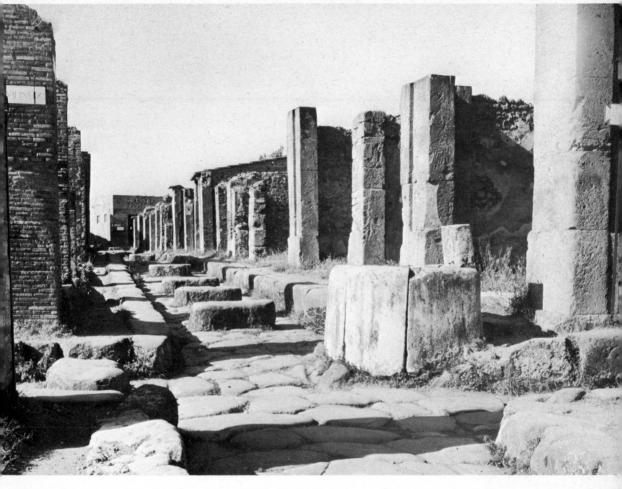

Fig. I.49 Intersection of Via degli Augustali and Vicolo Storto, Pompei

carry off used water and the rain. Collecting drains carried water into great sewers, like the Cloaca Maxima in Rome, which discharged downstream or downhill. Some of these sewer drains were tightly constructed in ashlar courses of fine masonry (e.g. Cologne), surmounted by a narrow barrel vault, while others were more modestly built of brick or tile.

City walls are inclusive and exclusive barriers, constructed with great effort and expense, and called into being as protection against possible attack. The Romans built city walls during the dangerous period of the early Republic, when they founded new towns (colonies) in recently subjected territory, and in the time of civil unrest and barbarian invasion that began in the mid-third century A.D. The height and depth of the wall, the frequency and type of defensive towers or bastions, the existence of artillery platforms and manned battlements, and the materials employed in construction all varied with location, topography, urgency, and period. The forms, however, depended largely on contemporary developments in purely military architecture, invented for the fortified legionary camp, the garrison in hostile country, or the fort along the Imperial frontier (*limes*). The wooden palisaded fort at

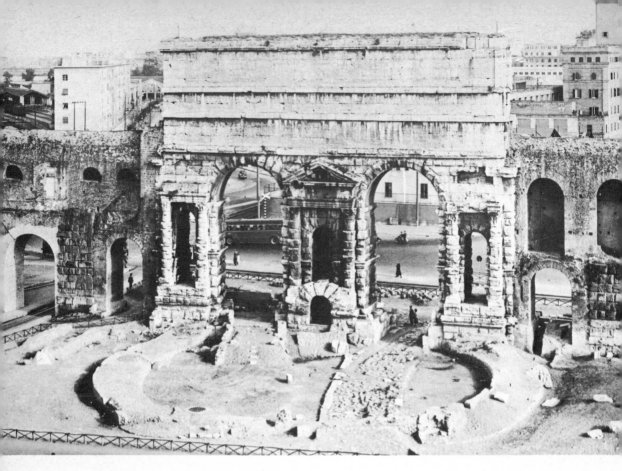

Fig. I.50 Porta Maggiore, Rome. Built under Claudius, A.D. 41–52

Saalburg on the German *limes* and the great stone fort at Housesteads on Hadrian's Wall in Britain reveal some of the strategic conceptions and design features of this military architecture.

In the early centuries of the Republic the Romans had two available models of city walls to choose from. Central Italian towns of the fourth century B.C. relied on polygonal limestone masonry to build their high, thick defensive walls, and the Romans used this type of construction in building the wall of their early third-century colony, Cosa, on the coast about one hundred miles north of Rome. The other available model had been developed by Greek military architects in the form of regular ashlar walls with square bastions, which were used to protect Greek towns all over southern Italy and Sicily. In the fourth century B.C. the Romans adopted this type for their own Servian Wall, erected after the Gallic sack of their hitherto defenseless city. The Servian Wall, which still survives on the Aventine and in a few other places, was built of the inexpensive tufa, the material employed in the third century for the walls of Pyrgi, Ardea, Falerii Novi (Fig. I.52), and the castrum at Ostia. During the late Republican and early Imperial period of colonization, many city walls were built of cut stone, often limestone set around a rubble concrete core. The most famous example of this kind of defensive construction is Hadrian's Wall, which stretches as a barrier across northern Britain from the Tyne

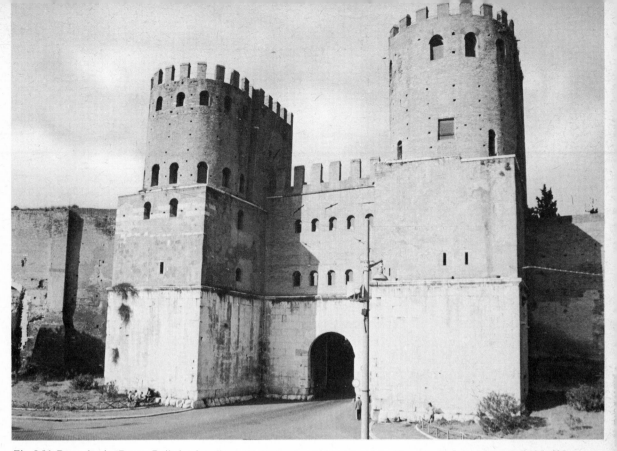

Fig. I.51 Porta Appia, Rome. Built by Aurelian, A.D. 275, extensively restored by Honorius and Arcadius, A.D. 401–402

bank at Newcastle (Segedunum) on the east to the mouth of the Eden beyond Carlisle at Bowness (Maia) on the west, a distance of seventy-three miles.

When the barbarian incursions began to be considered serious in the mid-third century A.D., old city walls, dilapidated by years of neglect, were rebuilt and reinforced with new towers and artillery platforms all over the northern frontier regions. At Rome, Aurelian built his great wall around the city in A.D. 275, incorporating most of the urban area but excluding some outlying districts and cutting some of the old roads in order to limit access. This lofty wall, faced with brick and punctuated by many towers and elaborately fortified gates (Fig. I.51), defended the city with reasonable success until 1870. The Aurelian Wall still stands for several miles, preserving not only its ancient character but demonstrating the kind of late Roman defensive walling that was erected to protect the cities of Gaul and along the Rhine and Danube.

Gates are the weak points in a city's defences. The Romans took over the hellenistic practice of protecting a gate by flanking it with tall towers, while creating at the same time an inner, secondary gate at some distance away but connected to the city wall; an attacker who forced the outer gate would be trapped in the small court-yard in front of the inner gate and vulnerable to the defenders stationed on the walls all around him. This scheme with variations was generally used by Imperial

architects, who also opened one or two storeyed galleries over the outer gate in order to permit the concentration of the defending force right over the point of greatest danger. Nevertheless, the development of such portals with galleries did not serve only defensive purposes: the fenestration of the galleries and their architectural embellishment also monumentalized the entrance into the city.

Such open-storeyed gates survive in Autun, Trier, Verona, Susa, and in the Porta Appia (Fig. I.51), Porta Latina, and Porta S. Paolo in Rome. Their appearance in Roman architecture goes back to the time of Augustus and before and proves the ceremonial importance possessed by the city gate as the impressive, symbolic and actual place of transition from the country to the city. The Claudian Porta Maggiore (Fig. I.50) still retains much of that impressive quality, enhanced by the robust, rusticated masonry and the enormous inscription. This declaratory tradition, the motif of the architecturally impressive gate, and the technique of the arch have their origins in Etruscan practice, where the arcuated gate, adorned with apotropaic images, was considered as the plane of division between the sacred city and the profane outer world. Etruscan city gates at Volterra and Perugía (Fig. II.37) preserve the form of this symbolic architecture, as do the Roman foundations at Falerii Novi (Fig. I.52) and at Rimini (Fig. II.38); the latter, an Augustan monument, leads on directly to the Roman triumphal arch (see pp. 119 ff.).

Roman city gates were also used as customs barrier for the levying of duties on goods imported into the city and could serve to control traffic, as Caesar tried to do in Rome by restricting the entrance of wheeled carts to certain hours of the day.

Fig. I.52 Porta Giove, Falerii Novi. III century B.C.

Although these gates could have one, two, or three passageways, often connected, the triple opening, formed of a large central archway flanked by two smaller ones, became common by the late Republic (e.g. Spello); this scheme continued into the Empire as an effective way to separate vehicular and pedestrian traffic. If the city gate is the plane of division, it also marks the point of junction where the highway and the city street come together.

The nature of the Roman street scene can be historically recaptured from the physical remains of excavated cities and from Juvenal's caustic comments, but the hurly-burly vitality of that scene may be vicariously experienced in modern Naples. There, crowded residential quarters with irregular, narrow streets, flanked by small shops and filled with people, are traversed or bounded by large avenues, lined with sidewalks and imposing buildings, which lead to great plazas, reserved for official, formal activity; fountains, whose scale depends on the nobility of their location, are abundant, but there is no vegetation as every surface is covered with building materials; churches, palaces, and cultural facilities are the nodal centres of the city. The impression of Naples is that of an intensely cultivated urban environment with strong class divisions, marked by diverse residential patterns, but united by the density of texture and by a common participation in the ceremonies of city life. Ancient Rome and the large cities of the Empire anticipated this kind of urban culture, in which the street, the avenue, and the plaza were the open arenas of public life.

Planning, whether deliberate or natural, largely determined the shape of the street and its orientation. The orthogonal, Hippodamian plan predicated a grid system, defined by two series of parallel streets, varying in width and meeting at right angles to form rectangular blocks. In Rome no such system existed but rather a state of natural chaos, determined by history, custom, and topography, which seemed to eschew the right-angled intersection. Tenement districts in Transtiberina, in the Campus Martius, on the Suburra, were rabbit warrens of narrow, winding, nameless streets; without a name there was no address, and finding a specific location depended on familiarity or the presence of some major monument which gave a district its generic name. Other streets followed the vagaries of topography, while great avenues prolonged the consular highways into the city from the gates or were imposed by master builders, beginning with Agrippa, for purposes of ceremonial propaganda, development, or the systematization of a zone (Nero and Trajan). Most Roman cities fell somewhere between these poles of street pattern, but in no case was the network monotonous because of the life in the street, the continual variations in scale, and the frequency of nodal points of contact and assembly.

Indicative of the dual function of the Roman street as an artery of communication and as a locus for community activity, the use and maintenance of the street was often subjected to control by a board of magistrates (Fig. VI.24). These magistrates, selected among the property owners along the street, were responsible for keeping their section clean and in good repair, but they also served the altars dedicated to the gods of the *compita* or street district, who were analogous to the *lares* and *penates* of the domestic household. *Compita* and compital altars have been

found in Rome and Ostia, and testify to the organization of the street as a place and not merely as a passage. The city government usually promulgated ordinances controlling traffic, width of streets, paving requirements, height of adjacent buildings, and even the projection of shop stalls and overhanging balconies into the right-of-way.

The great city avenues cannot be readily categorized, although in the planned Roman town the *cardo* and the *decumanus* were often distinguished by greater width and by the scale of their appointments. This is especially true around the urban centre or when either of these streets is the prolongation of the exurban highway (Fig. 1.36), but the manner of elaboration depends on a variety of factors, including climate and finances. Simple distinctions could be effected by widening the street, providing sidewalks and kerbs as well as stepping-stones (Fig. 1.49), and embellishing the ubiquitous fountains. Perhaps the most spectacular transformation of the street occurred in its development as a boulevard, paved in limestone or marble blocks, and lined with covered porticoes which separate vehicular and pedestrian traffic while permitting the latter free circulation in all weather conditions. Porticated boulevards were developed in hellenistic architecture and became a common, if luxurious, feature of the grander towns of the Greek east, such as Miletus, Ephesus, Aphrodisias, Apamea, Antioch, and Gerash (Fig. 1.45), of Timgad and Leptis Magna in Africa, of Rome and Ostia (Fig. 1.36) in Italy, and even of oriental Palmyra (Fig. 1.53). Timgad and Palmyra still preserve the sumptuous, climactic effect of such splendid avenues, which culminate in great, focusing monuments like triumphal arches, while Leptis and Ephesus in the great porticated way joining the harbour with the town offer an extraordinarily rich urbanist connection

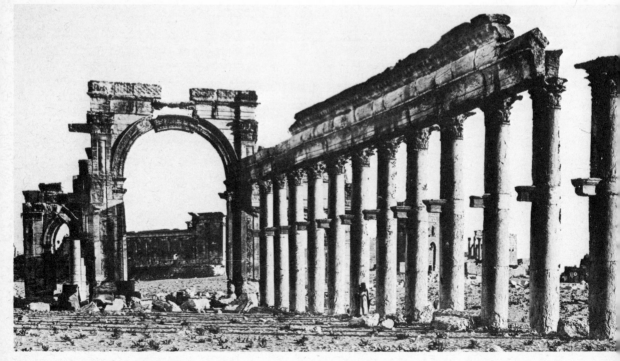

Fig. I.53 Porticated street with projecting corbels for honorary statues, Palmyra. Mid-II century A.D.

between the port-city and the sea. On the whole, this use of the porticated avenue also developed the spatial properties and textures of the street by enlarging the street at ground level as the adjacent buildings projected forward through the portico (e.g. Ostia). In this way a fluid interchange between the street and the flanking edifice was created and the street then functioned more completely as an architectural environment rather than as a stream bed. Since these porticated avenues also lead to or by the great centres of public administration, commerce, and entertainment, the semi-continuous frontage offered a spectacular, variegated façade to the passer-by. The permeable design of the Basilica Julia in the Roman Forum (Fig. I.4a, b) and the adjustment of building complex to street network, shown in the Severan Forum at Leptis Magna (Fig. I.33b), indicate how profoundly the Roman architect considered the intersection of building and street as a basic problem in the erection of urban structures.

In Roman urbanism the forum with its appendant buildings constituted the city centre because it was there that the principal public activities of the citizenry were congregated. Essentially, the typical Roman forum consists of a large open court, usually rectangular in plan, with a temple on a high podium on one end facing municipal offices on the other while flanking the long sides a number of other civic buildings are to be found, including markets, law courts, the bureau of weights and measures, public baths, luxury shops, and a variety of temples and cults. The Forum at Pompei (Fig. I.29a, b) is so arranged and equipped, possessing as well a peripheral colonnade and an abundant amount of public monuments in the form of altars, statues, equestrian figures, and inscriptions in honour of great benefactors of the state and city. If Cosa, Lucus Feroniae, and Alba Fucens in their fora reveal a less elaborate composition, characteristic of a number of Republican towns and small colonies, Pompei demonstrates the coming together of precedents in the hellenistic agora with Roman urban institutions and a preference for lineal order. The insertion of the Pompeian Forum into the street system not only enhances its in-gathering powers but governs also the ambivalent orientation of many of its ancillary buildings—the basilica, the Temple of Apollo, the great market—which can be reached both from the Forum directly and from the neighbouring streets. At Pompei, the small Temple of Vespasian on one side marks a partial interruption in the traditional Republican polarity of Jupiter temple and Curia, the one in honour of the Capitoline triad as symbol of the state, the other embodying in the site of the town council the self-governing city. In a number of Imperial fora, exemplified by the remodelled Forum at Ostia (Fig. I.36), the curia may be displaced by a temple to Augustus and Roma; in others, the Temple of Jupiter Capitolinus may contain images of the ruling Emperor and his family, but the polar arrangement remains fairly constant.

The Forum Romanum (Fig. I.4a, b) grew up with Republican Rome and, although many of its monuments are Imperial, its lack of plan is the direct result of a long period of unsystematic development as the prime meeting place of the citizens beside the Via Sacra at the foot of the Capitol, on which rose the ancient Temple of Jupiter Optimus Capitolinus. The constituent elements of the Pompeian Forum are all found here, but strung out in slight disarray and without either symbolically or

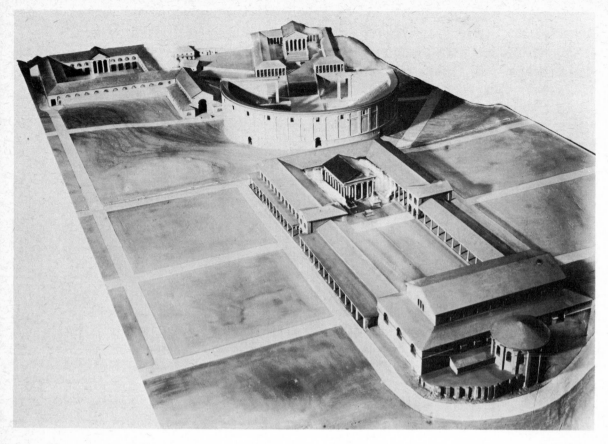

Fig. I.54 The Forum at Augst, Switzerland. Antonine period, the Curia added early III century A.D. Model. Augst, Museum

formally balanced relationships. It is precisely this lack of dignified order, complicated by the jungle of commemorative monuments which filled the open spaces and lined the processional routes in the Forum Romanum, that the original designers of the Imperial Fora of Caesar, Augustus, and Trajan (Fig. I.31) attempted to rectify. Their emphasis on a focused, regularized scheme, organized within well-defined limits and concentrating on the creation of a monumental, grandiose effect, set the model for the coherent fora of the middle Empire, as exemplified by the second-century Forum at Augst in Switzerland (Fig. I.54) and the Severan Forum at Leptis Magna (Figs. I.33b; III.4a, b). If Apollodorus achieved the total mastery of rationalized, sequential, and hieratic design in Trajan's Forum at Rome, the unknown architect of the Severan Forum had simplified that model in plan while loosening the restraints of its decoration. He used imported masons from Asia Minor (Aphrodisias), trained in the richly ornamental vocabulary of late hellenistic architecture, and developed a new taste for theatrical effects through dislocations of scale, the introduction of massed columns and arcades, and exaggerated contrasts between horizontal and vertical accents in his composition of ornament (see pp. 129 ff.).

There remain three principal expressions of urban architecture, the religious monument, housing, and the entertainment facility. Of these, the most stereotyped

was the restricted repertory adopted for religious purposes, dominated in Roman architecture by the frontal temple on a high podium (Fig. I.22) with four, six, and even eight columns across the façade, with single or multiple cellas, and with or without interior apses to receive the cult image. Such temples could be presented as isolated, free-standing monuments (Fig. I.40), surrounded by single or double colonnades (Fig. I.24), contained within a U-shaped precinct (e.g. Temple of Dea Caelestis, Dougga), or in groups as in the Largo Argentina in Rome and in Ostia. Temples of the state cult and of the great gods tended to be sumptuously decorated, as the Temple of Mars Ultor in the Forum of Augustus (Fig. I.30), but so too were small aediculated shrines or *sacella*, dedicated to the lesser numens and composed in the form of a small rectangular building or façade with a gable and two-columned porch.

Foreign cults in the provinces often employed unusual, particularized forms of sacred architecture, ranging from the dramatic ensemble of the great temple at Baalbek (Fig. I.32) with its hidden sanctum to the Celtic 'house temples' of Gaul and Britain with their simple, blocky cella surrounded by a contiguous portico or verandah. Private cults and the celebration of the mysteries took place in a variety of sacred environments, often hidden in the houses of devotees, as in the Villa of the Mysteries at Pompei (Fig. I.55) or in the Synagogue at Dura Europos. Not all synagogues were hidden; those of Ostia and especially Sardis were large basilicas, built with care and considerable expense above ground and evidently devoted to their religious function. However, before Constantine the Christian cult was celebrated only in hidden places with no distinctive architecture of its own, while Mithraism, Christianity's great competitor, found similar refuge in public and private buildings all over the Empire. These faiths and the worship of Isis, Cybele, and the Great Mother (cf. Ostia plan, Fig. I.36) were usually practised in secret communion, but their cult centres did develop individual patterns for seating the congregants and the priests, for the placement of the cult images, and for the performance of sacred rites of profound importance in the later development of monumental Early Christian architecture. Furthermore, the secret character of these cults with their frequent domestic reference was in keeping with those private aspects of the citizen's life which were fulfilled within the confines of his own residence.

The city-dweller could establish that residence in one of a considerable variety of housing types, evolved in Roman domestic architecture to suit different purses, classes, and times.

To those who could afford them, Roman town houses offered enclosure and release. Enclosure, effected by high blank walls at street level with very few openings, characterized the Mediterranean house in its Greek or Italic form; it assured the privacy of the householder and gave him protection from the confusion of the street and the summer's heat. Release was achieved in a profoundly psychological manner through the combination of a private environment for the conduct of family life and the physical opening out of the house to light and air, to the sky and to nature (Figs. I.26a, b, 25, 28). The clear separation between public

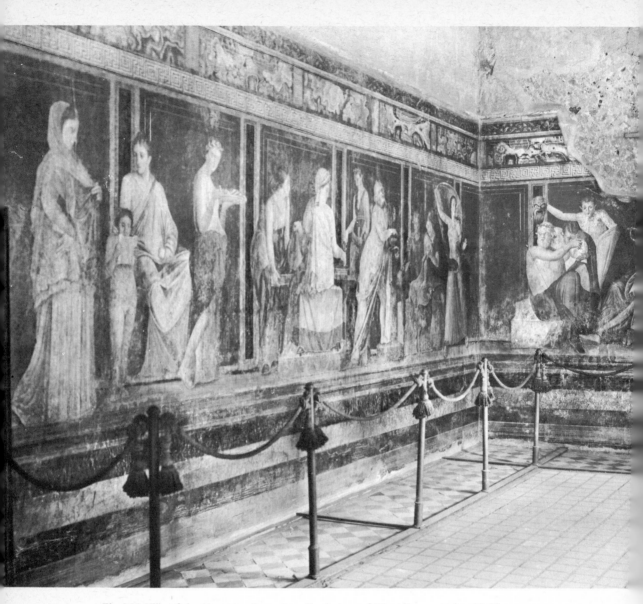

Fig. I.55 Villa of the Mysteries, Pompei: wall-paintings of Dionysiac mysteries. 40–30 B.C.

and private business was the cultural norm of Italian and Roman towns, even where, as in Pompei (Figs. I.26b, 49), street-facing shops could be an indivisible part of the householder's property and were used either by himself or rented out to others. Such shops, however, had no access to the house, which could be entered only through a narrow, well-protected doorway, almost like a fortress.

The Italic or old Roman house, as demonstrated by the Casa del Chirurgo and the Casa di Sallustio at Pompei—or by the older portions of the Casa di Pansa, del Fauno, dei Vettii, di Menandro—took the form of a constricted rectangle entered from the front and dominated by a large central chamber, partially open to the sky through a funnel-like arrangement of the roof (the *compluvium*). This chamber, the *atrium*, was furnished more or less elegantly with a pool-cistern (*impluvium*) directly beneath the roof-opening to receive the rain; small cellular rooms lined the sides of

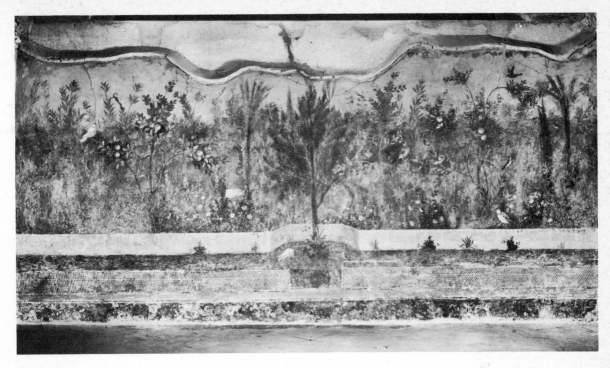

Fig. I.56 Livia's Garden House, Prima Porta: wall-painting. Late I century B.C.

the atrium which led into a squarish, partly open room, the *tablinum*, serving in the traditional Roman house for formal assemblies of the family and as a salon. Despite the elaborate decoration and two-storeyed elevation of some of these houses (Fig. I.28) and the open *compluvium*, the interior was dark, self-contained, and compressed, as the limited, inwardly sloping source of light and air over the atrium was insufficient to achieve satisfactory release. However, Greek domestic architecture had developed in a different direction, extending the real dimensions of the house and expanding its psychological horizon through the creation of an inner peristyle, often accompanied by the addition of extra storeys, balconies, and projecting open loggias. The resident community of Italian businessmen on Delos lived in many of these late hellenistic houses and brought home the new concepts of their design and decoration.

When the Greek peristyle was added to the Italic house and combined with a garden (e.g. Fig. I.26a, b), a totally new experience of the domestic situation became possible. Vision was extended both horizontally and vertically, and the corresponding psychological release was further intensified by the late Republican development of a new architectural style of decorative wall-painting (see pp. 149 ff.), which further extended by illusion the visual boundaries of the domestic environment (Figs. I.57; III.23, 24). The *tablinum* also gave way to *triclinia* for small dinner parties and to the *oecus*, as in the Casa di Pansa, a lofty salon and dining pavilion, based on hellenistic, especially Alexandrian models, which came into use for lavish entertainments, especially in the warm weather. From the *oecus*, the prospect of the inner façade of the house would have been greatly enriched by the artfully shaped selection of nature, the garden (Fig. I.56), complemented by the vast expanse of sky above.

Indeed, some houses such as that of Loreius Tibertinus at Pompei almost became appendages of their gardens, a tendency that was developed even further in the design of Roman country villas. If the interior garden offered a controlled perspective of nature inside the house, upper balconies and lofty, open loggias not only invited the cooling afternoon breeze and opened the outer mantle of the house at a safe distance above the street, they also gave a fine view over the city and beyond. Understandably, the open loggia was quickly taken up for Roman seaside villas and for seaward-facing houses in coastal towns, as in the Casa dei Cervi at Herculaneum. The light, airy effect of a group of these houses has been captured by the painter of the elegant townscape in the *cubiculum* (bedroom) from the Villa at Boscoreale (Fig. 1.57).

Poor people could not afford such houses and lived, instead, either directly above their shops, in squalid dwellings like those on the Via della Foce in Ostia, or in cramped apartments on the top floors of multi-storeyed tenements, built of brick-faced concrete. The Casa di Diana in Ostia is a classic example of such a tenement, set close to the town centre and to the great warehouses filled with the foodstuffs for Rome, on which the economic life of the city depended, and flanked by streets lined with small shops of different kinds (Fig. 1.6a, b). Middle-class tenants occupied the larger apartments on the lower floors; these apartments were well ventilated with large windows and even balconies, and often followed an L-shaped plan, arranged around a central courtyard. Some tenements had piped water at the courtyard level, where there might also be located a common latrine. Since tenements provided ample opportunities for real-estate speculation and shoddy building practices, builders were subject to legal controls regulating height (four to five floors), materials, fireproofing, and sanitation.

In the second century A.D. at Ostia multiple dwellings became more elegant and desirable, as demonstrated by two outstanding developments. Perhaps the more exclusive project could be considered the garden apartments located near the Porta Marina (Fig. 1.36); these consist of two rectangular blocks of commodious flats, set parallel to each other and isolated within a quiet garden bounded by a wall, which forms the back of rows of shops serving the streets on all four sides of the city block or *insula*. The precedent for the repetition of identical apartment units, carefully arranged with party-walls in even blocks, may go back to Greek fourth-century B.C. architecture, as at Olynthus, although the suburban-urban garden situation is completely Roman. The second development, comparable to the elaborate condominium-cum-club apartments of today, motivated the erection of the palatial Insula di Serapide e degli Aurighi nearby (Fig. 1.58), comprising two large multi-storeyed units arranged around spacious courtyards with balconies and loggias, and connected to each other by a well-appointed bath establishment, probably reserved for the tenants. The spectacular opulence of this Insula may have been anticipated by extravagant tendencies in the elaboration and decoration of the architectural environment, possibly anticipated in the Casa delle Colonne at Tolmeita in Cyrenaica, generally attributed to the Flavian period but now thought by some to be an example of late hellenistic sumptuosity. The presence of the bath in the Insula di Serapide e degli Aurighi points to the increasing self-sufficiency of these apartment

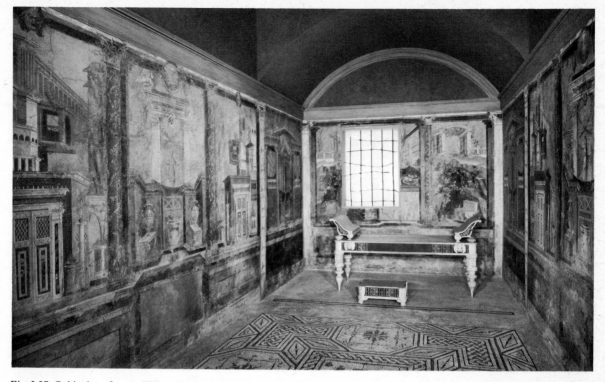

Fig. I.57 Cubiculum from a Villa at Boscoreale: wall-paintings showing villa and houses. New York, Metropolitan Museum of Art

Fig. I.58 The Insula di Serapide and the Insula degli Aurighi, connected by the Baths of the Sette Sapienti, Ostia. Hadrianic (A.D. 117–138) and later. Reconstruction

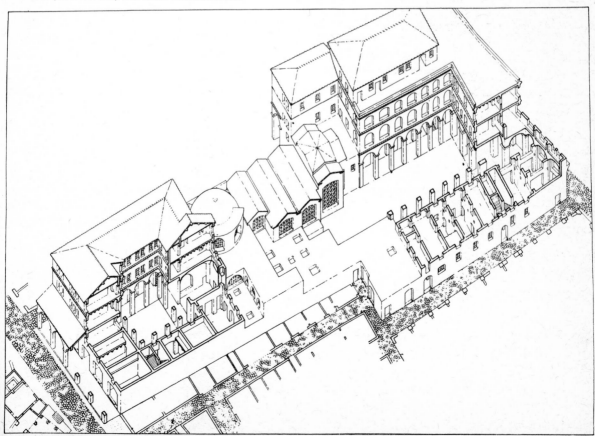

buildings as environments for living as well as to the abundance of public water. It was this availability of water coupled with a developed taste for luxurious ornament that led to the creation of a number of splendid private fountains in some of the late Roman houses at Ostia, as shown by the richly inlaid wall of water in the House of Cupid and Psyche (Fig. I.59).

For the very rich there was an alternative to the elegant town house in the suburban villa set in parks within the city limits or immediately outside, adjacent to a major highway. Most of the urban-suburban villas on the Pincio and Quirinale in Rome have totally disappeared, while the suburban villas such as those of Maxentius and of the Quintilii on the Via Appia or the Villa dei Pisoni in Herculaneum have

Fig. I.59 The House of Cupid and Psyche, Ostia: fountain-nymphaeum. Early IV century A.D.

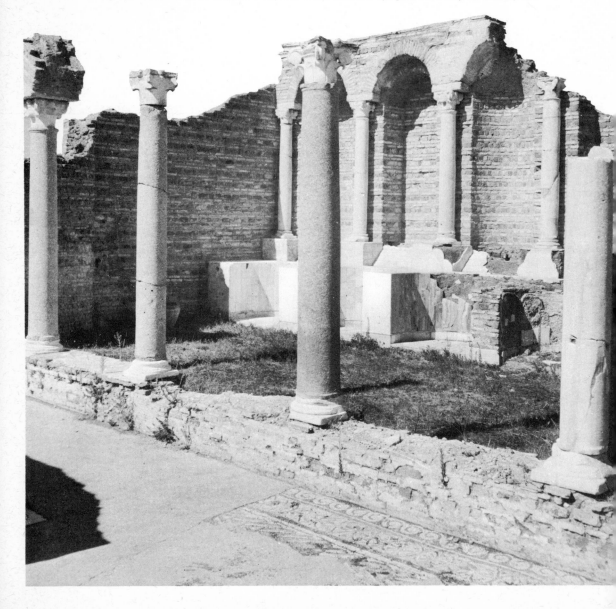

been insufficiently excavated. Something of their rich character survives in the well-preserved Villa di Diomede on the outskirts of Pompei, set at an angle to the Strada dei Sepolcri (the Street of Tombs). The house proper overlooks a large, porticated and sunken garden set coolly below as a private reserve of nature, while from the same vantage point it is possible to look beyond the confines of the villa towards the sea in the west. Thus several horizontal prospects were successively available to the viewer, who could therefore place himself and the house in a variety of ever larger contexts of nature. Something of this complex attitude was taken up by Vignola in the design of the sixteenth-century Villa Giulia in Rome, but perhaps not fortuitously since he also designed the Villa Farnese on the edge of the Palatine directly on the site of Tiberius' and Caligula's palatial house, which overlooked the Forum and the City beyond. This suburban, prospective aesthetic triumphed in Nero's aborted project for the Golden House (Domus Aurea) when he turned the centre of Rome into a garden after the fire of A.D. 64 in order to establish the proper landscape setting for his sumptuous, sprawling residence. The Golden House with its different wings stretched from the Oppian to the Coelian to the Palatine with a spur leading toward the Roman Forum, while the Colosseum now occupies the site of a great artificial lake, which originally enhanced the rural character of the remade landscape. The design fully realizes a control over nature without limit, since the landscape and all its constituent elements are man-made as if the suburban countryside had been re-created within the city's borders. Just as the owner of the town house-cum-garden was the master of that part of nature contained actually and visually within the confines of his house, so Nero was the master of another natural environment, now projected on a colossal scale, and symbolized in this vast suburban-urban estate by a gilded bronze statue of the Emperor, a hundred feet tall (Fig. II.3), which once stood gleaming beside the lake.

If the Golden House was a private amusement of the Emperor made public, the pursuit of public entertainment by all levels of society stimulated the extraordinary development of an amusement architecture for the Roman towns. A number of different building types evolved to serve this Roman desire for amusement and spectacle, including the theatre, odeon, amphitheatre, stadium, circus, and public bath. All of these specialized facilities, except the amphitheatre, had their direct source in Greek urban architecture, but the developed typology, scale, and construction techniques were Roman and so were the thirst for extravagant display and the delight in violent, coarse, but passive entertainment. The Roman theatre and its smaller, covered version, the odeon, rarely presented the great works of Greek and Latin playwrights, because their audiences preferred scatalogical skits and dances, burlesques, mimes, and theatrics. Horseshoe-shaped stadia were devoted to contests between professional athletes, although Domitian in his stadium in Rome, now known as the Piazza Navona, tried to elevate the contests to an intellectual and cultural plane, in the Greek manner. The bloody, popular shows of the amphitheatre or arena are well known, but the circus with its violent chariot races and the no less violent crowds, partisanly urging on their favourite drivers and teams (red, blue, green, white), could be equally savage. If such activities provided the town-dweller

with the opportunity to release his own feelings vicariously and within a confined situation determined by architecture, then the public baths offered a more peaceful avenue of escape within the comfortable atmosphere of a social club, which was usually sexually restricted. A large public bath, such as the Baths of Caracalla in Rome (Fig. I.19a, b), could make available the following services: a swimming pool (*natatio* or *frigidarium*), warm (*tepidarium*) and hot (*caldarium*) baths, a comfortable place to undress (*apodyterium*), an open court for exercising (*palaestra*), restaurants, libraries, pavilions of different kinds, a stadium for sports and sport-watching, sunrooms, central heating for year-round use, and outside the bath-building proper gardens with groves of trees (*xystoi*) for pleasant strolling and philosophical discourse (when desired). The whole complex was self-contained, defined by precinct walls, while outside on either side of the main entrance were shops selling the usual things, and girls.

Such attractions drew crowds, and because they drew crowds they were often built by cities as an expression of status and by rich or powerful patrons as an obvious instrument of public policy, of politics and propaganda. Wealthy citizens and smart politicians, including the Emperors, contributed funds for the construction and maintenance of these buildings, for the support of entertainers, and for free tickets, often distributed among the citizens to gain their vote or enthusiastic favour. These factors encouraged not only the appearance of theatres, arenas, and public baths all over the Roman world, but also the significant urbanistic development of entertainment centres where two or more of these facilities might cluster together, as in Arles (Fig. I.60). For much the same reasons, given the common purpose of these buildings and the necessity of moving and containing large masses of people, relatively uniform building types were created by the Roman architects and were used all over the Empire, adapted to the local climate, available building materials, and resources. This explains the close resemblance between the theatres of Aspendos (Fig. I.61a) on the south Turkish coast and Orange in the Rhone Valley, and also the fundamental similarity of the theatre of Marcellus in Rome (Fig. I.3), and the Roman theatres of Arles in France, Stobi in the Balkans, Miletus in Asia Minor, and Sabratha (Fig. I.61b) and Leptis Magna in Africa, although they were built over a 200-year period, beginning in the late first century B.C. A further explanation for the close similarity of forms, beyond the rule of function, may lie in the existence of model plans as part of the architects' repertory, although such plans have not survived. The same observations apply to the great oval amphitheatres of Nîmes and Arles, of Pola, Verona, Capua, and Pozzuoli, of the Colosseum (Fig. I.44) and of El Djem in Tunisia. Indeed, the arena of El Djem is especially well preserved precisely because it is and always was isolated. This enormous structure, set in the middle of nowhere and therefore bereft of the usual urban context, must have drawn on the population of the neighbouring towns for attendance at the games, put on by local promoters using travelling gladiatorial troupes. The arena at Pompei, the oldest surviving Roman amphitheatre, must have operated in the same way, drawing from the local towns often with violent results, as indicated in the Pompeian wall-painting describing the riot between the

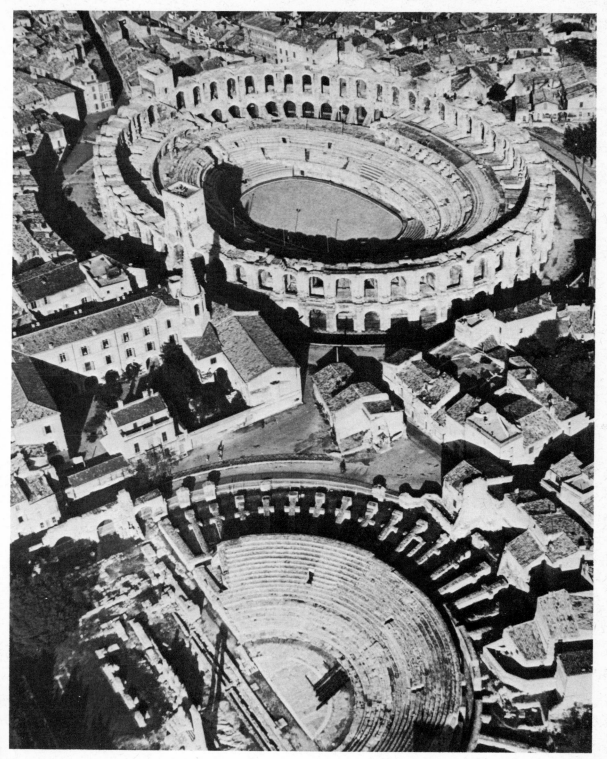

Fig. I.60 Arena and Theatre, Arles, Southern France. Late I century B.C.

Pompeians and the Nocerans (Fig. I.62), which led to the closing of the arena for several years.

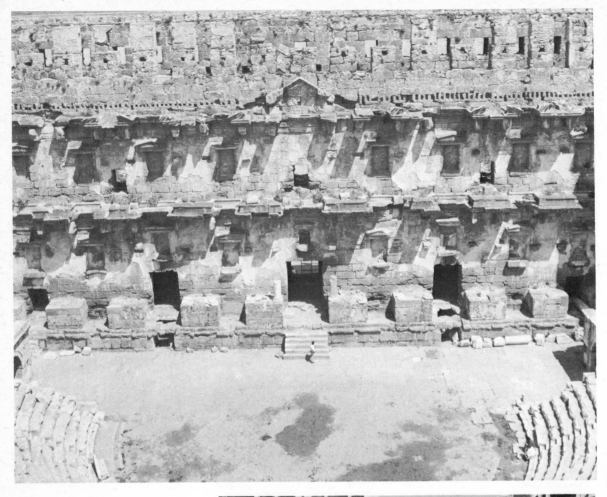

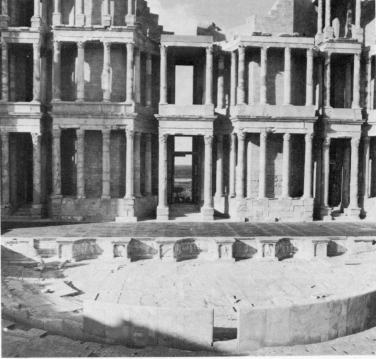

Fig. I.61a The Roman
Theatre, Aspendos, Turkey.
Mid-II century A.D.

Fig. I.61b The Roman Theatre
at Sabratha, Libya: scenae
frons. Early III century A.D.

Variations in plan do occur in arena design from regular ellipses to elongated ovals to circles, but they are probably more limited than the varieties of plan and elevation encountered in the public baths. *Balnea* or small baths, consisting usually of small plunge-pools tightly grouped with an *apodyterium*, can be found either as an in-house establishment in some of the grander residences and villas (e.g. Villa at Piazza Armerina, Fig. 1.48) or, as in Rome, scattered about the city as business enterprises with admittance on the payment of a fee. Others (Fig. 1.36) might be inserted into pre-existing buildings, such as old warehouses with central courtyards, which would permit a more ample installation of the basic units of the public bath, the closed, usually vaulted rooms for dressing, sweating, and bathing, and the open court for exercise. However, many public baths, including both the Central and the Stabian (Fig. 1.29b) Baths at Pompei, were composed in this way from the very beginning, although often more elegantly decorated with mosaic floors, painted and stuccoed walls and ceilings, and colonnades. Although large baths were built for Hadrian at Tivoli (Fig. 1.47) and for Septimius Severus on the Palatine (Fig. 1.34), Roman architects developed a specific bath type which was bilaterally symmetrical and sequential and probably goes back to the Baths of Agrippa, located on the edge of the Campus Martius behind the Pantheon. This 'Imperial bath type' monumentalized the concept of the bath as an elaborate ritual, aggrandized the interior environment in a manner befitting the exalted patron, and dominated that region of the city in which it was placed. The Baths of Trajan, Caracalla (Fig. 1.19a, b), Diocletian (Fig. 1.8), and Constantine in Rome followed this pattern, as did the Antonine Baths in Carthage, and the fourth-century Baths at Trier. Great complexes such as these Imperial baths became prime centres of activity in the city, stimulating growth around them, while symbolizing the gross resources of the Empire and the pervasive taste for the spectacular that informs much of Roman architecture.

d. Façadism and the Spectacular Glitter is one principle of Roman architecture and rhetoric is another. If the desire for ostentatious display led to the elaboration of the decorated surface and to the creation of the stunning façade as an architectural motif, the awesome, grandiose scale of buildings set an impressive stage for the presentation of great actors and weighty assertions. In this sense Roman architecture may be considered an art of demonstration and revelation, dominated by insistence rather than by subtle persuasion and leading to cumulative effects. The Elder Pliny's concept of the honorific column as a device to elevate the great personage (*super ceteros mortales*) also explains the spectacular monumentality of Roman architecture and the ideological basis of its pretentiousness.

From the Circus Maximus in Rome the 250,000 spectators could look up from the chariot races to the magnificent façade of the Imperial palace, rising above lofty terraces along the edge of the Palatine (Fig. 1.34). The palace rose tier on tier, lavishly appointed and gleaming, symbolizing the Imperial presence to the crowd below, the scope of his power suggested, as well, by the eye-filling lateral extension of its wings. In this theatrical situation one senses the Roman architect's conception

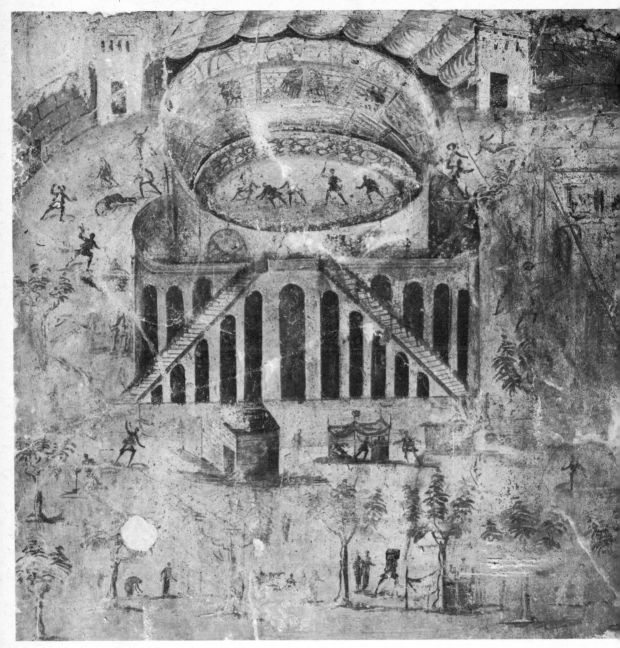

Fig. I.62 A Riot between Pompeians and Nocerans in the Arena of Pompei: wall-painting from Pompei. About A.D. 70. Naples, Museo Nazionale

of the façade as a distinct image which could be manipulated for maximum psychological effect. This attitude, however, is old in Roman architecture, since it also governs the cumulative, crescendo effect of the enormous canted façade of the Sanctuary of Fortuna at Palestrina (Fig. I.35), where the hillside was converted into a vast stage for the presentation of a great ritual drama, culminating in the hidden oracle above. Other late Republican sanctuaries at Terracina, Tivoli, and Sulmona offered similar architectural theatre, if less stupendous, and so too might have the Roman Forum and Capitol if Sulla's building project had ever been realized.

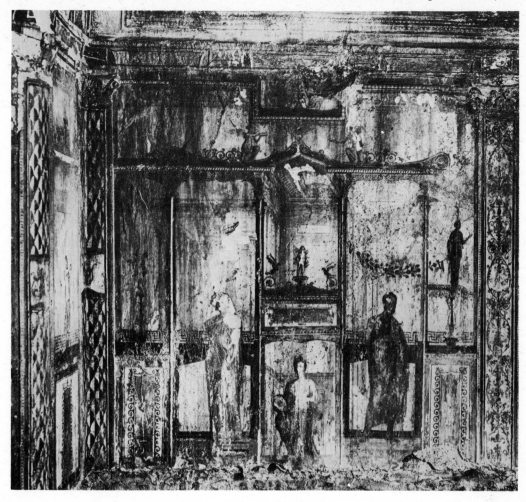

Fig. I.63 The Domus Aurea of Nero, Rome: Fourth-Style wall-painting. A.D. 64–68

One element of that project, the Tabularium or Hall of Records, was built and survives incorporated into the back of the Palazzo Senatorio on the slope of the Capitoline Hill (Fig. I.10). This building had the practical purpose of housing the state archives, but it also served to monumentalize the border of Forum and Capitol, establishing with a noble façade the importance of the Capitol as the site of the great Temple of Jupiter. In the latter capacity, the Tabularium may be considered to stand as a significant wall, much in the same way as a triumphal arch may be seen as a monumental billboard, proclaiming through a variety of messages the image of military success (see pp. 119 ff.). The *scenae frons* of the Roman theatre (Fig. I.61a, b) played a similar role with its extravagant decoration of columns and entablatures in coloured marbles, abundant statuary in various materials, and even fountains. Although the *scenae frons* thus created a conditioning environment for the lively performances of the Roman theatre that took place on the adjacent stage, the lavish, colourful display of the *scenae frons* appeared as a visual delight to be enjoyed in its own right, analogous to the purely visual enjoyment obtained from many fourth-style wall-paintings (Figs. I.63; III.26) without regard to their ancillary

function as decoration. Screens of this kind enriched Roman theatres everywhere, and the interior façades of the great baths (Fig. I.8, 19); a comparable effect was achieved in dressing up the exterior arcades of the amphitheatres with statuary and metal fixtures of all kinds (Fig. I.64). Great fountains also adopted the *scenae frons* as a foil for the rushing water, but also as a magnificent screen in the manner of the Septizodium or Septizonium which once stood on the south-east corner of the Palatine facing the Porta Capena and the head of the great south road, the Via Appia (Fig. I.34). That fountain was erected under Septimius Severus to cover the exposed flank of the Palatine and the Imperial palace with a monumental, free-standing façade, and possibly also to impress his fellow countrymen from Leptis Magna who might come up to Rome from the south. Although such a façade serves architecturally as a protective screen and urbanistically as an impressive public monument, the Septizodium had a profound symbolic value as the Imperial mark. That symbolic function was more fully developed in the late Roman architecture when the iconography of majesty pervaded the programmes of Roman art. In the Palace of Diocletian at Split access to the august presence of the Emperor was gained only by following a ritualized approach through a great courtyard which brought the suppliant visitor up before a grand façade marked by an arcuated lintel over the door (Fig. I.65). This particular façade marked the actual entrance to the Emperor in audience, but more significantly the façade with arcuated lintel represented specifically the epiphany of the Imperial lord, enthroned majestically behind the wall, in a purely symbolic way. Thus, the apotheosis of the façade as a disembodied, symbolic form dominated by its image value was complete.

A similar repertory of tendentious architectural images was formed through the placement of the focal point of interest at the greatest possible height, a kind of 'acmeitis'. The elevated position of the Capitolium in the Roman Fora (Fig. I.29a), the tall Roman tombs (cf. Fig. II.6), the statue of Augustus on top of his Mausoleum in Rome, the soaring Villa Iovis of Tiberius on Capri, the honorific statues set on high podia or on columnar bases (Figs. II.43, 45), all responded to this uplifting pressure. Just as the eye, feet, and psyche of the pilgrim at Palestrina were upward bound in their movements, so too were these faculties drawn to the gilded statue of Trajan, poised on top of his Column (Fig. I.66) above the great Forum (Fig. II.43). Indeed, it is very likely that this image of the optimal Emperor was

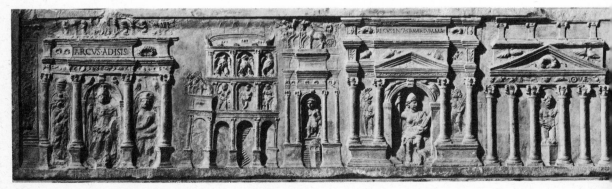

65

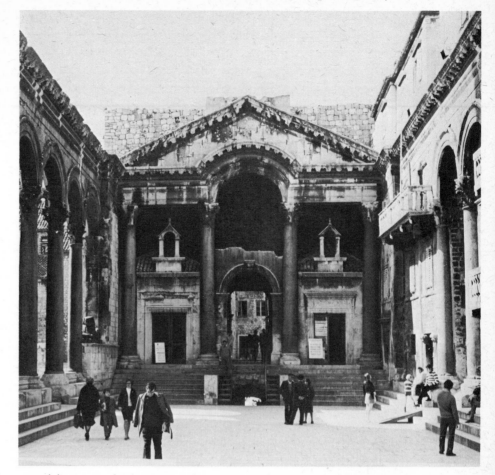

Fig. I.64 Relief with triumphal arches and other monuments, from the Funerary Monument of the Haterii, Rome. Early II century A.D. Vatican, Museo Gregoriano Profano

Fig. I.65 The Vestibule of Diocletian's Palace, Split: view towards the entrance to the audience chamber. About A.D. 305

visible to the Roman citizen at the moment he entered the Forum through its triumphal gate and looked up over the ceremonial façade of the Basilica Ulpia to see Trajan in heavenly epiphany. Conversely, when the Emperor sat in his lofty, splendid box (*pulvinar*), overlooking the crowd in the Circus Maximus from the vantage point of his Palatine palace (Fig. I.34), he was set on high above mortal men. This is spectacular staging that transcends architecture, and it is very Roman.

'Then, as he [Constantius II] surveyed the section of this city [Rome] and its suburbs, lying within the summits of the seven hills, along their slopes, or on level ground, he thought that whatever first met his gaze towered above all the rest: the sanctuaries of Tarpeian Jove so far surpassing as things divine excel those of earth; the baths built up in the manner of provinces; the huge bulk of the amphitheatre, strengthened by its framework of Tiburtine stone, to whose top human eyesight barely ascends; the Pantheon like a rounded city-district, vaulted over in lofty beauty; and the exalted columns which rise with platforms to which one may mount, and bear the likenesses of former emperors; the Temple of the City [Venus and Roma], the Forum of Peace, the Theatre of Pompey, the Odeon, the Stadium. . . .

But when he came to the Forum of Trajan, a construction unique under the

heavens, . . . he stood fast in amazement, turning his attention to the gigantic complex about him, beggaring description and never again to be imitated by mortal men. . . .

So then, when the emperor had viewed many objects with awe and amazement, he complained of Fame as either incapable or spiteful, because while always exaggerating everything, in describing what there is in Rome, she becomes shabby.'

Ammianus Marcellinus XVI.10.14, 15, 17 (transl. J. C Rolfe, Loeb Library ed., vol. I, 1935)

Fig. I.66 Denarius reverse showing Trajan's Column. About A.D. 113

Chapter II
Triumphal Monuments and Ostentatious Display

WITH the words, 'Arma virumque cano', Virgil began his national epic, the *Aeneid*, and summed up the aspirations of the great Roman leaders to be outstanding, to be celebrated and powerful among contemporaries, and to be remembered by posterity. Although there were many paths to distinction, success in war was considered the prime source of fame because war provided the best opportunity for the demonstration of *virtus*, that positive spiritual quality existing within certain individuals as a favour from the gods. Fame itself was the ultimate basis and goal of political ambition, justifying the authority (*auctoritas*) of political leaders and the heads of the great families. However, the possibility of military distinction varied directly according to the rank of the successful officer, culminating in the triumph granted to the holder of *imperium* (the commanding general's power) who had won victory over a foreign enemy. The celebration of the ceremonial triumph in Rome formed a veritable apotheosis of the martial achievement, presented to the people as a dazzling military parade along the Sacra Via to the Capitol (Fig. I.4a, b) with trains of spoils and captives offered in tangible proof of victory (Fig. II.1b), the whole symbolized by the appearance of the *triumphator* in his gleaming chariot (Fig. II.1a), dressed in the robes of Jupiter. Often the soldiers of the victorious general carried large paintings, describing his and their exploits in battle and on campaign, while temporary triumphal arches and trophies of captured weapons were erected along the parade route to add greater splendour to the occasion. But if divine providence (*providentia*) and good fortune (*fortuna*) stood behind victory and the triumphator, so too did a slave who whispered in his ear, 'Sic transit gloria mundi', warning him of the brevity of fame despite the immediate glory of victory and the stunning spectacle of the *pompa triumphalis*.

It was to defeat this transiency of glory and fame that distinguished Romans commissioned a vast number of triumphal and commemorative monuments and celebrations. The anniversary of a great victory could be celebrated with extravagant games in the arena (*ludi victoriae*), public holidays with free gifts for the citizenry, extensive numismatic issues, and in the late Empire by monuments marking the association of victory and the accession of the ruler (e.g. Fig. II.2). Victors built temples to Honos (Honour), to Virtus, and to Mars Ultor (Fig. I.30) at Rome, altars to Fortuna Redux and to Pax (Fig. I.1), and even temples at the site of battle as in the Augustan dedication to Apollo at Actium. The Imperial Fora of Caesar, Augustus, and Trajan (Fig. I.31) were similarly generated, while triumphal arches, columns, monumental trophies, bombastic inscriptions, and standing or equestrian statues of commanders in cuirass appeared all over the Empire as a

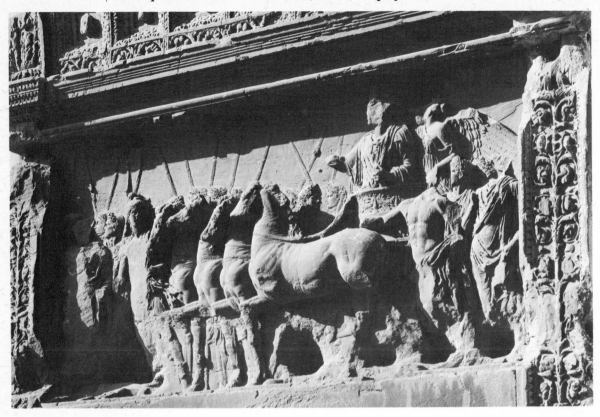

Fig. II.1a The Arch of Titus, Rome. Passageway relief: The Entrance of Titus in his Triumphal Chariot. About A.D. 90

manifesto of the Roman power and of the powerful Roman. Perhaps the apogee of this deliberate programme of public self-praise was reached in the testamentary memoirs of Augustus, the *Res Gestae Divi Augusti*, preserved on the walls of the Temple of Roma and Augustus in Ankara; the lost original was engraved on two bronze pillars set up at Rome to 'Record the achievements of the Divine Augustus by which he brought the whole world under the rule of the Roman people'. If publicity was politically motivated and propaganda effective in shaping public opinion, behind this wealth of self-laudatory monuments lay the desire to assert the importance of an act and of a career as permanent facts of history by translating them into some tangible form. For this reason, the *damnatio memoriae*, an official decree condemning an individual to historical oblivion as well as to public disgrace, effected the removal of all physical traces of the offender in an Orwellian approach to the making and unmaking of history. The condemned person literally disappeared from sight because his name was blotted out on inscriptions (e.g. Arch of Septimius Severus, Roman Forum), his monuments and images were destroyed (e.g. the Golden House of Nero), his head was replaced or obliterated in sculptures, paintings, and even coins. Thus his public and historic existence ceased. Nero, Domitian, and Geta suffered this infamy most severely, but so did rebels, rivals, old friends now out of favour, and rejected women. Indeed, the very thoroughness of this damnation to obscurity and invisibility is the strongest possible

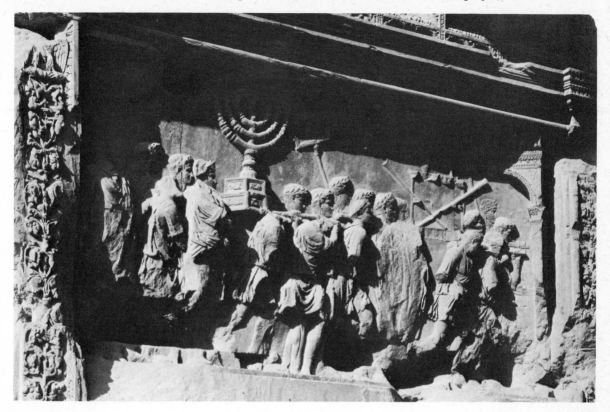

Fig. II.1b The Arch of Titus, Rome. Passageway relief: The Procession of Spoils in the Judean Triumph. About A.D. 90

proof of the great significance of *celebratio* as the profligate source of ostentatious, personalized works of art and architecture among the Romans.

Opportunities for display were found in extravagant gestures of conspicuous consumption of a unique, repetitive, or permanent character. Temporary monuments, erected for great occasions such as triumphs and funerals, offered to the Roman public a spectacular, if ephemeral body of structures and images, culminating in the soaring drama of the Imperial funeral pyre, or *rogus*. The appearance of the *rogus* can be recovered from representations on the reverses of Imperial coins over the legend, *Consecratio*, but its function as spectacle can be best appreciated from the long description of Septimius Severus' funeral and apotheosis (Herodian IV.2). Impressive ostentation could also be developed as a style of life available to the rich, in a manner parodied by Petronius in the *Satyricon*, or in grandiose acts of public largess which took the form of games or shows in the arena (Fig. II.3) and the ceremonial distribution of free food or money to the people (Fig. II.46b). The most permanent form of conspicuous self-advertisement was the donation of inscribed, monumental amenities such as baths, theatres, arenas, basilicas, fountains, porticoes, aqueducts, and gates (Fig. I.50) to fellow citizens and dependants. In the timocratic society of the Romans showing-off was costly, since expenditures were directly proportional to the exercise of power and authority. However, anyone with even modest means could compete for some degree of attention under circumstances

2

Fig. II.2 Decennial base from a Tetrarchic monument. Rome, Forum Romanum. A.D. 303

Fig. II.3 The Colosseum in use and, alongside, the colossal statue of Sol. Reverse of a sestertius minted A.D. 238–244

Fig. II.4a The Tomb of Eurysaces the Baker, Rome. Second half of I century B.C.

Fig. II.4b The stele of Eurysaces and his wife Atistia from their tomb

3

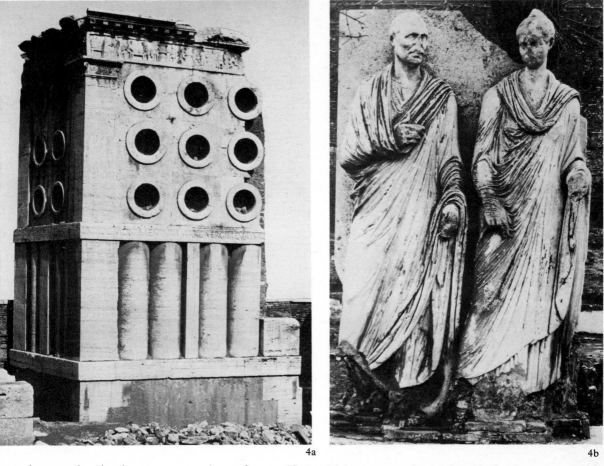

4a 4b

where only the best presentation of oneself would be expected and justified: the sepulchral monument.

a. Sepulchral monuments: Tombs and Sarcophagi The preservation of the physical remains as well as of the memory of the deceased defines the double purpose of the sepulchral monument. If the Romans developed complex architectural forms on Greek and Etruscan models to house the dead in tombs or mausolea, they also elaborated an enormous repertory of iconographic and decorative patterns to express their concepts of life and death through the media of painting, sculpture, and mosaic. Although the imagery of the late Roman sepulchral monuments was increasingly preoccupied with the afterlife, in the Republic and Early Empire such monuments were primarily devoted to the struggle against oblivion in so far as the available means would allow. A perfect example of this tendency is preserved in the Tomb of M. Virgilius Eurysaces (Fig. II.4a), erected in the late Republic beside the Via Casilina just beyond the *pomerium*, the ritual boundary of Rome within which no burial was permitted. Both the conspicuous site of the tomb and its entire repertory of forms are devoted to the continuous presentation of Eurysaces to his fellow citizens in perpetuity: the peculiar shape of the tomb recapitulates the form of a great oven for baking bread, since Eurysaces made his fortune as a baker for

Caesar's armies; to drive this point home a narrative relief around the tomb describes the operations of baking and selling bread as the data of his personal history, much in the same way as triumphal monuments were hung with explanatory reliefs (e.g. Figs. I.10; II.43–45; IV.35–37); the identification of the distinguished deceased was established not only by the prominent inscription but also by a sculptured portrait of himself, dressed in the toga of the Roman citizen and accompanied by his wife Atistia (Fig. II.4b), completing thereby the record of his career with his status as a married man of substance. If the precedents for this great interest in specific facts of life and personal appearance may be found in Etruscan sarcophagi and cinerary urns from Tarquinia, Chiusi, and Volterra (Fig. VI.7), the placement of the ostentatious tomb beside the great public road follows a more widely diffused Mediterranean custom evident well before the Roman conquest at Greek and Italian sites.

Roman tombs fall into a number of types affected in part by local practice, available funds, and the relative popularity of cremation or inhumation. These types range from the simple, rectangular concrete and/or stone containers, surmounted by inscriptions and some kind of sculptural ornament, that appear in abundance along the Via Appia and outside Capua, Pozzuoli, Ostia, and Pompei (Figs. I.5; II.6) to grandiose mausolea dominated by circular elements. Although the circular tomb may have its architectural source in the Etruscan tumulus-tomb preserved at Cerveteri and elsewhere at archaic sites in Latium, the type rarely occurred as a pure form in Roman sepulchral monuments outside of its most perfect realization in the Mausoleum of Augustus at Rome. A variation of this type, comprising a tumulus raised on a low cylinder, may have been adopted for cenotaphs in the western Empire as well as for the Trajanic Trophy erected at Adamklissi in Rumania (Fig. II.5), celebrating the victory over the Dacians.

However, the cylinder itself became a popular and distinctive tomb type, either in a relatively undifferentiated form—e.g. the Tomb of Caecilia Metella on the Via Appia (Fig. I.41), the Tomb of Munatius Plancus at Gaeta, and the Mausoleum of Hadrian—or raised on a square base as in several tombs along the consular highways around Rome and outside of Pozzuoli and Capua. A number of first- and second-century A.D. tombs show the increasing elaboration of this two-storeyed scheme, which manipulates the elements of a circle above a square, but rarely with the richness of the tomb known as 'La Connochia' (Fig. II.6), still preserved alongside the Via Appia at Capua. Another version of this type but with the cylinder transformed into a round, colonnaded temple set on a square base was also used for the Augustan Trophy of the Alps at La Turbie on the Riviera, possibly suggesting the connection in symbolic terms between victory in war and over death. In this last context the ultimate symbolic manifestation was achieved in the Column of Trajan, erected as an extended cylinder topped by an image of the Emperor and standing on a square base, which under Hadrian became the depository of Trajan's ashes; this triumphant sepulchre could exist within the limits of the *pomerium* only because Trajan had become a *divus* or god and was therefore exempted from the prohibition of burial. One other type of tomb incorporated round forms: it consisted of the

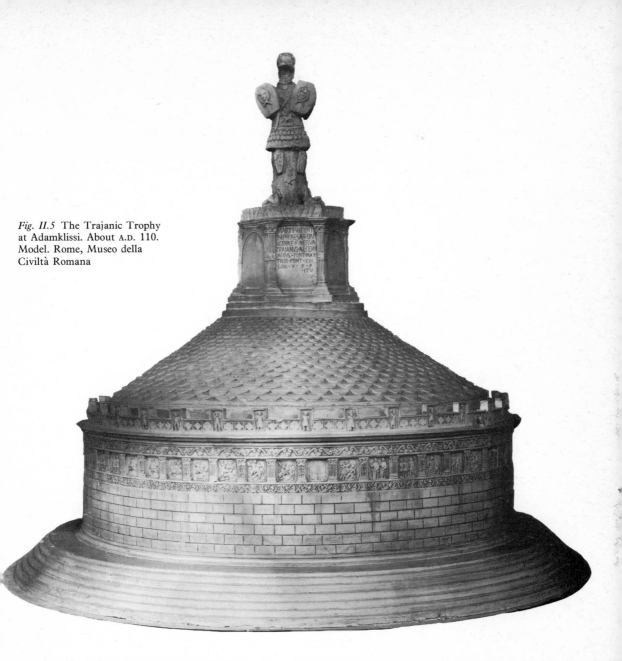

Fig. II.5 The Trajanic Trophy
at Adamklissi. About A.D. 110.
Model. Rome, Museo della
Civiltà Romana

circular, vaulted mausoleum developed in the manner of Hadrian's Pantheon (Fig.
I.7b) and impressively preserved in the late Imperial tombs of Gordian, Romulus,
and Helen around Rome. The vast domed hollow of Galerius' tomb at Salonika,
now the Church of St George, follows this pattern and so, in their own ways, do the
polygonal mausoleum of Diocletian at Split (Fig. I.37a, b), the concentric scheme of
Sta Costanza in Rome (Fig. I.21), and the centrally planned, Constantinian project
for the Holy Sepulchre in Jerusalem. Although these sumptuous mausolea may truly
represent the acme of Roman sepulchral architecture, they were too costly to be
widely used as models and, therefore, their importance rests largely on their con-
siderable artistic merits and on their acknowledged influence on the subsequent
development of European architecture.

Of the three remaining Roman tomb types the tower-tomb or cenotaph directly achieved visibility because of the height attained by piling several architectural elements one on top of the other. The model for the tower-tomb may be found in the prestigious Mausoleum at Halicarnassus or in the earlier Anatolian traditions on which it depended. Tombs of this kind, however, were erected during the Roman period in Thrace, along the Danube Valley and the middle and lower Rhine at Igel, in southern France (Fig. II.7), and even at Dougga in Tunisia. For the most part these towers consist of superimposed selections from classical architecture, combining round and rectangular porticoes, open and closed storeys, pyramidal or conical superstructure, and elaborate architectural decorations, usually set on square or rectangular masonry bases. If the combinations are often grotesque travesties of the principles of classical architecture, the scheme was a very successful device to achieve height under the colour of an elevated style. Occasionally, as in the Julian Monument at St Rémy, probably a cenotaph erected in the late Republic, the handling of the architecture and sculpture is much more sensitive, possibly because of the well-established tradition of hellenistic art in the lower Rhone Valley. A more limited form of the tower-tomb also occurred in the Roman towns of the Po Valley and at Aquileia, where a tetra-style façade or open portico filled with statuary was placed on top of a simple masonry podium. Here again the model may have been developed in Lycia in south-west Turkey sometime around 400 B.C. and then disseminated widely, penetrating even into the Punic areas of Tunisia and Libya, as at Ghirzeh.

The tradition of brick-faced concrete architecture was strong in Latium and Campania, and in these regions another tomb type evolved, patterned after the cella of the smaller Roman temples or *sacella*. This type was rectangular in plan, presented a handsome façade to the cemetery street, and contained a lower and upper chamber; the upper chamber, often fitted with an apse at the rear, *loculi* or niches along the sides, and a barrel vault above concealed under a gabled roof, contained the bodies of the dead in sarcophagi or their ashes in cinerary urns. Many of these tombs still stand at Ostia and Pozzuoli and along the Via Appia between Rome and Albano, while the best preserved of them, a masterpiece of brick-work and terracotta ornament, is the Tomb of Annia Regilla, built for the wife of Herodes Atticus in the mid-second century A.D. In the same sepulchral zone south of Rome there are also several *columbaria* (Fig. II.8) or dove-cotes, so called because of their many small openings; these columbaria were constructed by associations of freedmen as a common repository for their ashes, and each small niche held a cinerary urn, protected by a covering inscription, and sometimes embellished with a portrait bust of the deceased. If the niches of the columbaria were translated into an impressive ensemble by virtue of numbers, the desire for association that led groups of freedmen to bury their dead together also influenced the formation of clustered burials among the poor, hidden away in subterranean catacombs around Rome and other central Italian cities. However, by the third and fourth centuries the early Christian communities had also begun to develop larger, more impressive quarters underground with regular galleries for burial, cult rooms for ceremonies, and an elaborate

Fig. II.6 'La Connocchia', tomb on the Via Appia south of Capua. Late I century A.D.

Fig. II.7 Julian Monument at St Rémy-de-Provence. 40–30 B.C.

symbolic decoration painted on the walls and ceilings. This development seems to have been anticipated by another tomb type, the *hypogeum*, a semi-subterranean or subterranean tomb, consisting of a number of rectangular burial chambers, connected by narrow corridors and radiating out from larger rooms possibly used for assembly or cult. Hypogea were built in many parts of the Mediterranean as well as in Italy, and often possessed a splendid interior decoration as if to compensate for their obscurity. They were richly ornamented with decorative and mythological paintings, brightly coloured mosaics, and magnificent stucco mouldings (Fig. I.11), thereby fulfilling a private urge for splendid surroundings befitting the deceased in his mortal guise and on the threshold of immortality. Whatever the quality of the work, the decorations of tombs, mausolea, hypogea, and catacombs were charged with symbolic meanings relevant to the aspirations of the dead and of their survivors, and stimulated the appearance of an enormous repertory of figured images in the service of the sepulchre.

These images can be divided typologically into two distinct classes, depending on whether they were visible to the general public on the outside of the tomb or

8

were concealed within and available only to those most concerned with the deceased. The first class includes funerary portraits in all media and grave stelae, including those with putative portraits. For the most part these works were made locally, a factor of considerable significance for the analysis of types, their diffusion, and the development of regional or provincial styles in the Empire. Given the positive emphasis of such sepulchral monuments, funerary statues in the round or in high relief (Fig. II.4b) appeared everywhere, especially in the more deeply hellenized areas of the Mediterranean littoral, and were based on the honorific types developed for the celebration of worthy men and women in public places (Figs. II.9, 11). In the late Empire, however, this representation of the deceased as a civic worthy often gave way before the imagery of anxiety, developed as an expression of alienation from the world by those who sought salvation from the gods (Fig. II.12). Similar tendencies

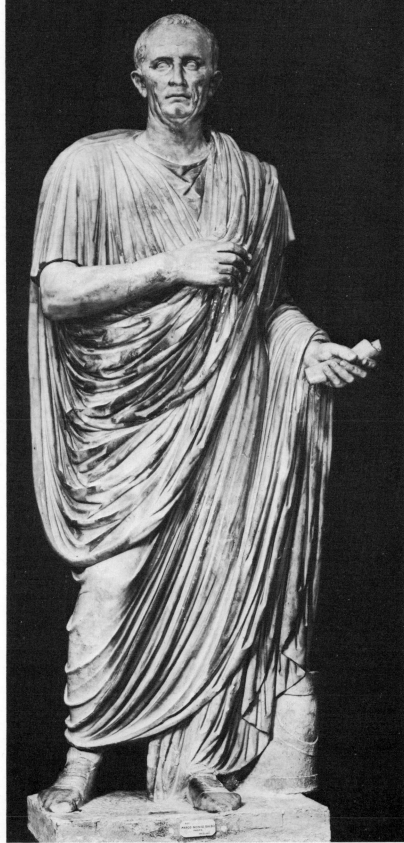

Fig. II.8
Columbarium
of freedmen,
Vigna Codini,
Rome. Late
I century B.C.

Fig. II.9 Togate
statue of a Roman
citizen, from
Herculaneum.
Mid-I century A.D.
Naples, Museo
Nazionale

9

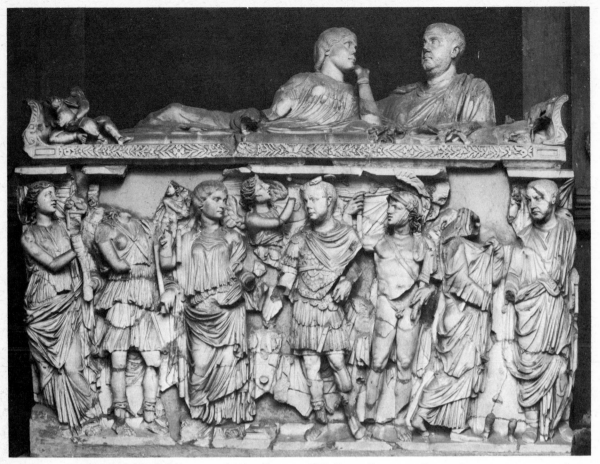

Fig. II.10 The Balbinus sarcophagus. About A.D. 238. Rome, Praetextus Catacomb

can be observed in the treatment of funerary busts, as is evident in the contrast between a late Etrusco-Roman pair (Fig. VI.7) and the intimate portraits of Balbinus and his wife from the lid of the Balbinus sarcophagus in Rome (Fig. II.10). The latter has much in common with the harsh stiffness of the Fayuum portraits (Fig. II.13a, b), conceived as *momenti mori,* and with the hieratic frontality of Palmyrene tomb figures (Fig. II.14).

 Grave stelae or tomb-markers, carved in relief and bearing inscriptions, were set up throughout the Roman Empire; they were especially popular in Greece, Thrace, the Danubian provinces, Rhenish Germany, the military zones of Britain, Gaul, eastern Spain, and Italy. Stelae could take the form of simple vertical slabs of local stone, crudely carved in low relief, fine marble or limestone orthostats with many figures sensitively composed, long horizontal blocks containing a family gallery (Fig. II.17), grandiose aediculated schemes (Fig. II.16), and other combinations; some were painted (Fig. II.15). Most of these compositional formats and many of the iconographical themes they contain had been invented by the Greeks, but the proliferating evolution of the grave stele as an independent artistic motif in the Roman Empire has not yet been described despite a number of excellent regional catalogues. Iconographically, Roman grave stelae may be broken down into a

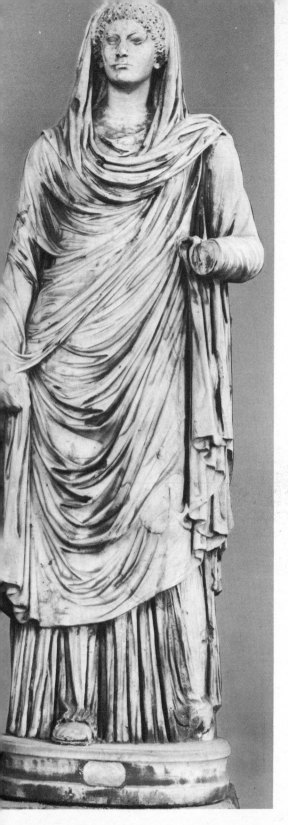

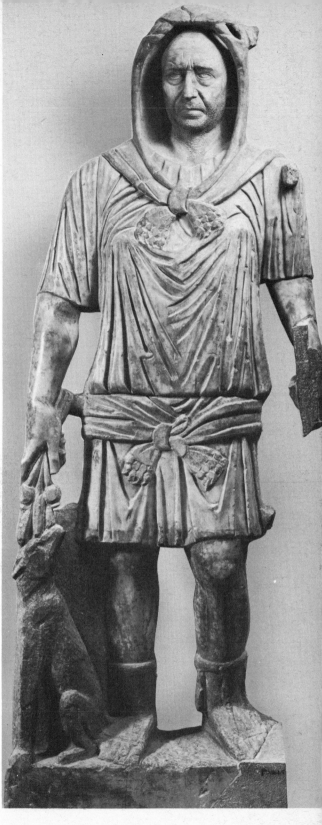

1 Vestal Virgin from the House of the Vestal Virgins
Forum Romanum. Mid-II century A.D.
Museo Nazionale delle Terme

Fig. II.12 Tunisian farmer wrapped in the
protective mantle of Hercules.
Mid-III century A.D. Tunis, Bardo Museum

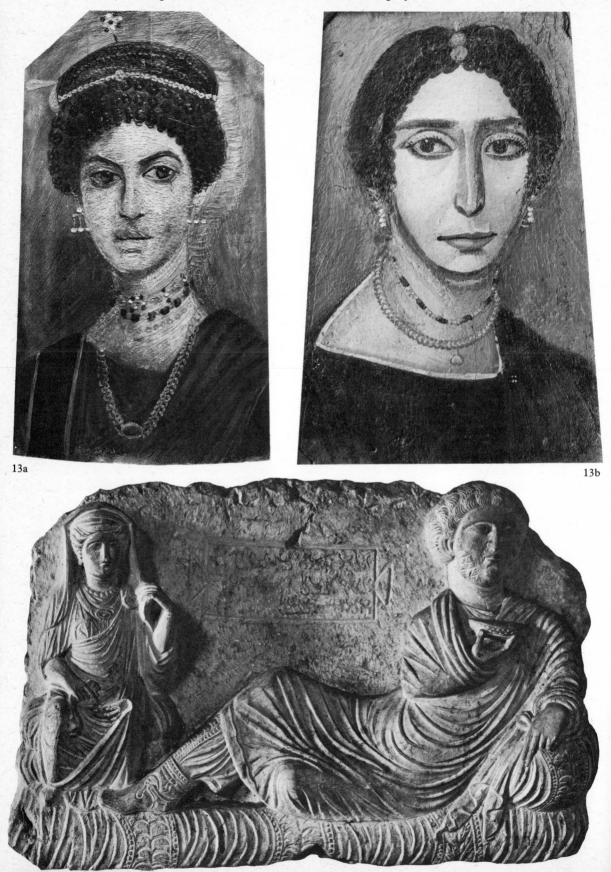

13a

13b

14

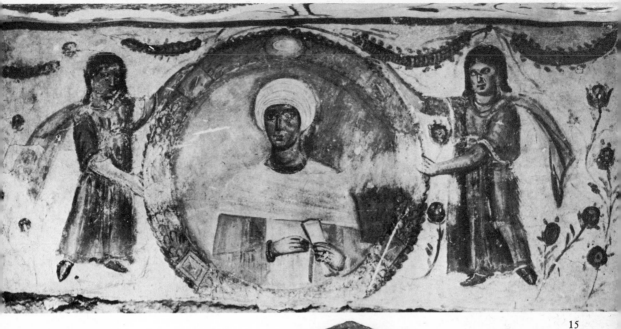

15

Two sepulchral portraits in encaustic, from the Fayum:

Fig. II.13a 'Bejewelled Maiden'. Late I century A.D. Edinburgh, Royal Scottish Museum

Fig. II.13b 'La Dame au Fayum'. Early III century A.D. Paris, Louvre

Fig. II.14 Tomb relief from Palmyra. Mid-II century A.D. Paris, Louvre

Fig. II.15 Tomb painting. IV century A.D. Gargaresh, Tripolitania

Fig. II.16 Provincial grave stele from South Shields, England. Second half of II century A.D. South Shields, Museum

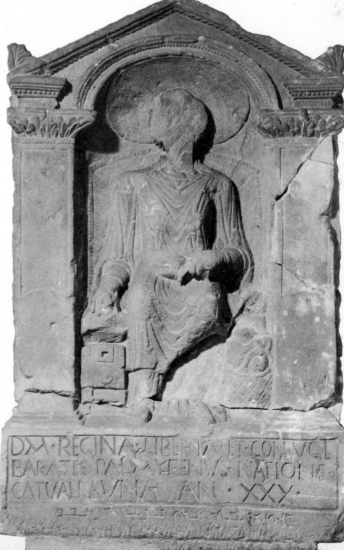

16

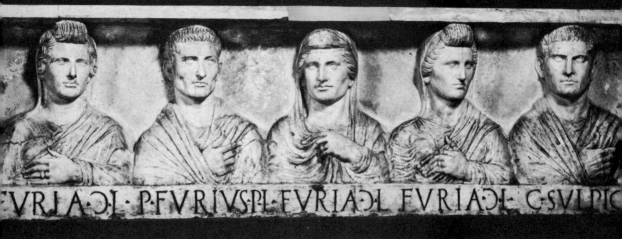

17

number of distinct but overlapping types: full figures standing, sitting, reclining, or moving, and busts sometimes placed in tondi; single persons, husband and wife with or without children, or the extended family often including servants and freedmen; the deceased as citizen, virtuous wife (*pudicitia* type, draped, veiled, with left hand on chin), priest(ess), magistrate, artisan, merchant or soldier; the funerary banquet or other ritual act; the hero. In the latter capacity, the deceased, usually a soldier, might appear as himself at some great moment of his life (e.g. the stele of Tib. Claudius Maximus, captor of Decebalus, from Philippi in Macedonia), as a cavalry-man spearing a barbarian in a conventionalized representation, or identified with the Thracian Rider god or the Dioscuri in a metaphorical connection. Although the hero's mantle may be justified in a few instances, the symbolic import of this imagery relates directly to the triumphant concept of *mors in victoria* in the defeat of death and to the divine protector who carries the soul up into the heavens.

After inhumation became the preferred burial custom *c.* A.D. 100, the marble sarcophagus gratified the desire for a prestigious, costly coffin, covered with an imagery of hope, while offering to the Roman sculptor a rich field for the display of his skill in relief decoration. Unlike the grave stelae, sarcophagi seem to have been made in relatively few centres, either located in cities with a well-established artistic tradition and an active clientele (e.g. Athens, Rome–Ostia) or beside quarries that provided good sculptural stone (e.g. Aphrodisias in Asia Minor). This situation encouraged the growth of the workshops specializing in sarcophagi for local consumption or export and bound to certain kinds of marble, a well-defined repertory of designs, compositions, and figured motifs. The abundance of unfinished pieces (cf. Fig. II.18), some recovered from the cargoes of sunken ships, indicates that sarcophagi were frequently shipped out in rough or semi-finished condition to be completed at the site of eventual sale, often with the portrait of the client. Furthermore, these workshops seem to have possessed a distinctive stock-in-trade as well as a number of favourite patterns and subjects that scholars are beginning to isolate and identify in an effort to trace the sources of the thousands of surviving sarcophagi, the

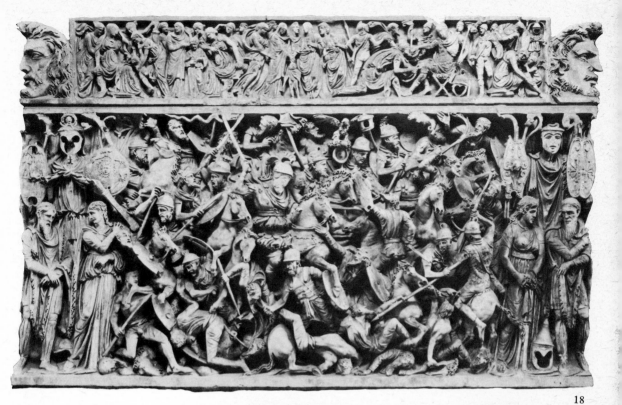

18

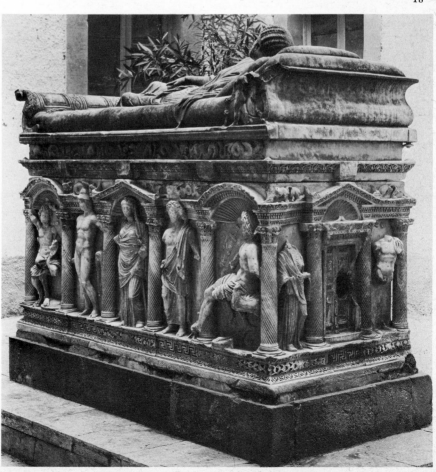

Fig. II.17 Grave relief of the Gens Furia, Rome. Late I century B.C. Vatican, Museo Gregoriano Profano

Fig. II.18 The Portonaccio Battle sarcophagus. A.D. 175–180. Rome, Museo delle Terme

Fig. II.19 Columnar sarcophagus from Melfi. A.D. 175–185. Melfi

19

recensions of motifs, and the peculiarities of style. When this is achieved, the history of Imperial sculpture will have to be rewritten.

A sarcophagus is composed of two parts, the rectangular box, to receive the body or bodies, and the lid, both of which may be elaborately carved. Despite the persistence of the basic type, invented in ancient Egypt and adopted by the Greeks, Imperial sarcophagi fall into distinct patterns, located by regional preference although specific examples are widely dispersed because of the export trade. 'Attic' sarcophagi were largely, but not exclusively, produced in Athens in direct descent from fourth-century and hellenistic models: the box was carved on all four sides in consistently high relief, usually representing mythological subjects; the lid was shaped into the form of a gabled roof, suggesting that the sarcophagus had become a temple housing the remains of the deceased, further protected by the apotropaic figures or sphinxes, lions, etc., placed at the corners (cf. Fig. II.21a, b). 'Asiatic' sarcophagi present a variation of the Attic type as developed in the hellenistic Greek cities of western Asia Minor: the continuous frieze on the box is broken by a strongly rhythmical treatment of the reliefs, leading to vertical divisions of the field and the creation of deep sculptural spaces; the two principal versions thus produced were the garland-and-putto sarcophagus and the columnar sarcophagus, the latter often conceived architecturally and treated as a stage or *scenae frons* with aediculae and niches containing large figures carved almost in the round (Fig. II.19). The third major type is the 'Roman' or 'Western' sarcophagus, featuring a box carved on three sides only, the fourth side being placed against the wall of the tomb; usually only the front is richly and deeply carved in a figured frieze, while the ends were more summarily treated, sometimes with purely ornamental or symbolic motifs; the lid was left flat, often with satyr's masks at the corners and a narrow band of relief on the front, complementing in some way the imagery of the principal relief below. However, by the third and fourth centuries because of the movement of peoples, pieces, and sculptors within the Empire, these types tended to conflate and to be less regionally determined. A great number of variations also came into existence, including the bathtub sarcophagus, the strigillated or wave sarcophagi, the double-frieze sarcophagus often focused around a tondo or central shell-niche for the portraits of the dead (Fig. II.20) and the transformation of the lid into a couch or bed, on which recline the deceased husband and wife (Figs. II.10, 19).

A nearly complete repertory of these patterns appears on an extravagant late second-century sarcophagus discovered at Velletri south of Rome (Fig. II.21a, b). This monument is large and heavy with very fussy but crude carving, making shipment from abroad both difficult and risky, and yet despite its Italian provenance the Velletri sarcophagus has more in common with eastern models than with anything western. It is much earlier than any other double-frieze sarcophagus known, but the quality of the work makes this piece unlikely as the original model of that type. Furthermore, seemingly in response to the client's wish to protect himself with all the gods, cults, and signs imaginable, the sarcophagus is covered with a conflated, abstruse, confused imagery as if both patron and sculptor wanted to display their knowledge of the repertory used in the decoration and information of the main

friezes of Imperial sarcophagi. Whether it is a product of religious syncretism or bad taste, the Velletri sarcophagus is an excellent example of the problems of dating, stylistic definition, and iconographic explication encountered in the study of this great corpus of ancient sculpture.

The classification of Roman sarcophagi by subject matter, the method adopted in the nineteenth century by Carl Robert, has served to draw attention to the great variety of topics and themes used. In addition, the typological analysis of this subject matter has been found useful by scholars interested in the transformation of myth, in ancient religion and the changing concepts of the after-life, in the meta-phorical constructions of classical narratives, and in the relationships between source-models and their descendants. Although such treatment sometimes obscures the perception of quality and stylistic change or ignores the significance of formal patterns in all-over design and panel composition, a typology of subjects does present the florilegium of Roman sepulchral motifs. It also illuminates the pro-grammes of sarcophagus decoration in the late Empire and establishes their relative popularity.

Mythological and legendary subjects, primarily derived from Greek sources, offered the greatest selection of themes and were most highly favoured. The authors of the corpus of ancient sarcophagus reliefs (*Die antiken Sarkophagreliefs*) have arranged this rich material by story and protagonist, indicating the Greek precedents in narrative and in image wherever possible; Roman usage is established by well-chosen examples, extended by the reproduction of Renaissance drawings illustrating both lost and surviving sarcophagi. What is missing, however, is a corpus

Fig. II.20 The Two-Brothers sarcophagus. Early IV century A.D. Vatican, Museo Gregoriano Cristiano

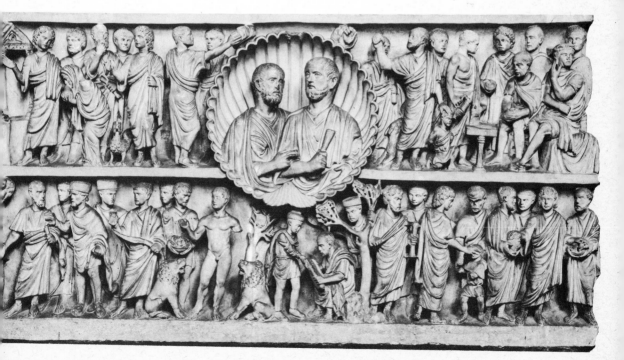

of drawings, paintings, or pattern books developed by individual workshops in the creation of their repertory. This repertory can only be re-established historically through a critical examination of patterns of composition and imagery in the sarcophagi themselves, but the process has only just begun. However, something of the mechanism of transfer from Greek story-line to relief sculpture may be grasped from the analogous compositions of the late Etruscan cinerary urns, especially well preserved at Volterra (Fig. VI.4), which reproduce in sequential episodes large segments of Greek myths and legends.

Mythological subject matter was drawn from the passionate affairs of the gods (Cybele; Mars and Rhea Silvia; Mars and Venus), from the personal intervention of divinities in the human situation (Diana and Actaeon; the Rape of the Daughters of Leucippus by the Dioscuri; the Judgement of Paris), and from the consequences of divine intervention in the lives of Greek heroes, especially around the time of the Trojan War (Meleager and the Calydonian Boar; Achilles; Medea and Jason; Hippolytus and Phaedra). There are many other topics, but their variety is no greater than the complexities of their symbolic meaning, as demonstrated by F. Cumont. However, it does seem that the narrative conditions the method of presentation much less than the techniques of composition, concepts of time, and stylistic developments affect the narrative. A Roman second-century sarcophagus in the Louvre presents the story of Diana and Actaeon broken up into constituent scenes on the front and sides, a disposition comparable to the scenic divisions of narrative adopted by the Etruscans in the decoration of cinerary urns centuries

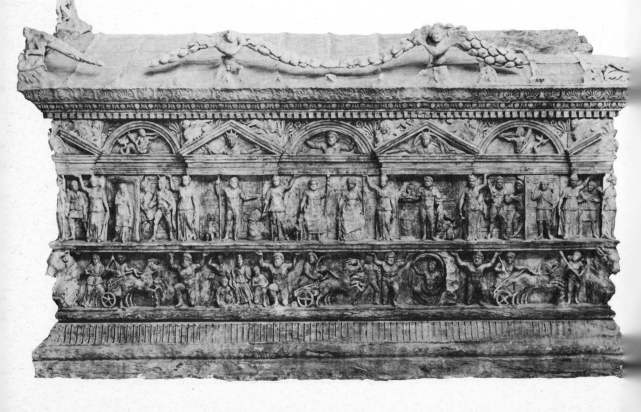

before. At the same time, many Attic or atticizing sarcophagi of the second and third centuries, such as that of Hippolytus and Phaedra in Agrigento (Fig. II.22), combine most of the elements of this tragic tale into a single large frieze on the front of the sarcophagus; the compositive elements of the story are identified iconographically and by grouping figures together rather than by external divisions. Sarcophagi representing the Amazonomachy, the Centauromachy, or Greeks fighting Barbarians usually follow the pattern of an undifferentiated, continuous frieze, although in certain instances the Amazonomachy may be interrupted by the heroic pair of Achilles and the dying Penthesilea, queen of the Amazons. But sarcophagi illustrating the Labours of Hercules fall into two distinct groups, according to the preference of the originating workshop: either as a continuous frieze with the Labours individualized by compositional effects (Fig. II.23), or with the Labours isolated from one another by framing devices as in the Hercules sarcophagus in the Galleria Borghese, Rome. Marine subjects, featuring delightful and ferocious denizens of the sea—some of them imaginary and others, like the dolphin, friendly to man—formed a decorative subclass of mythological sarcophagi, whose importance may have depended on the character of the sea as a source and ultimate repository of life.

Dionysiac sarcophagi make another large group, comprised of very distinct themes. Traditional mythology had its repertory of Dionysiac motifs, perhaps the most significant being that representing the rescue of Ariadne from rocky Naxos by Dionysus. The notion of rescue was particularly important in Dionysiac ritual and

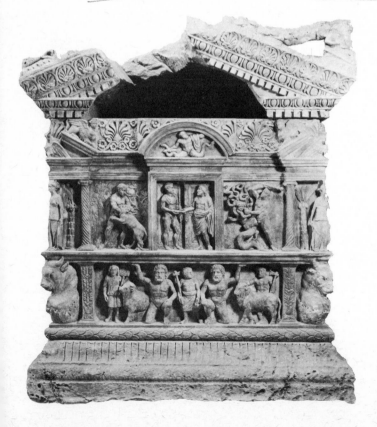

Fig. II.21a–b Templum sarcophagus. Third quarter of II century A.D. Velletri, Museo Civico

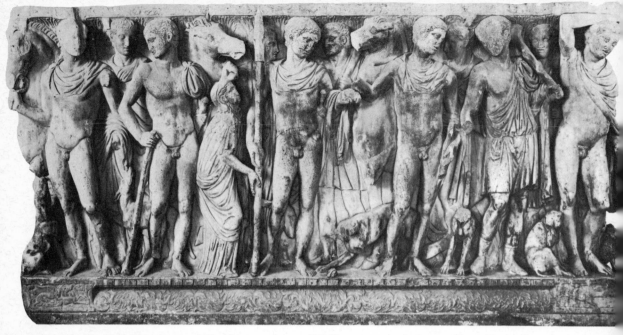

Fig. II.22 Hippolytus and Phaedra sarcophagus. Mid-II century A.D. Agrigento, Museo Nazionale

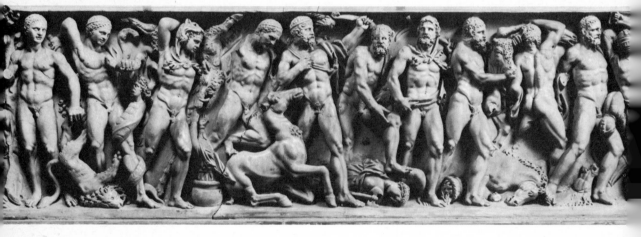

Fig. II.23 Sarcophagus with the Labours of Hercules. Early III century A.D. Mantua, Palazzo Ducale

belief, since the god enjoyed great popularity as a saviour who released men and women from earthly troubles and brought them to a pleasantly sensual world, to paradise. If ecstasy was mirrored in the cavorting, female figure of the Maenad, released from care by the wine and dancing in the cortège of the god, then the path of salvation was splendidly revealed in the Triumph of Dionysus, especially on sarcophagi representing his Indian Triumph (Fig. II.24) in proof that his powers had been made manifest everywhere. Release and the possibility of salvation were also treated as renewable or recurrent events. Season sarcophagi (Fig. II.25) extended the concept of the recurrent cycle of the seasons (and of the ages) under the favourable mantle of Dionysus and the joys of the harvest. This last idea, coupled with the *vendemnia* or grape-harvest in anticipation of the wine and the liberating

celebration of the Dionysiac rituals, led to the enormous popularity of the Garland-and-Putto sarcophagus and of the representation of the Vendemnia with Putti gathering the grapes and making them into wine. These motifs were very much alive in Late Antiquity, appearing not only in fourth-century sarcophagi such as that of Sta Costantina (or Costanza) in the Vatican Museum, but also in the mosaics of the annular vault of Sta Costanza in Rome (Fig. II.26) and in the painted decoration of late Roman tombs. Dionysus did, indeed, smooth the way to a pleasant paradise, but there were other paths to immortality depicted on Roman sarcophagi.

Romans in the West presented themselves as merciful or triumphant battle leaders, in the metaphorical guise of the virtuous hunter, and through brief biographical sketches of their careers as dignitaries and married citizens; wherever possible, the protagonists bore the specific portraits of the deceased. Battle sarcophagi (Figs. II.18, 27) drew equally on the repertory of triumphal monuments (see pp. 124 ff., 192 ff., 257) and on the mythical conflicts between Greeks and Amazons (or Barbarians). They emerge in the later Antonine period, possibly as a result of the continuous wars and their opportunities for distinguished military careers, and they disappear after the mid-third century when the iconography of military victory was taken over completely by the Emperors. If this motif was used to advertise the achievements of the

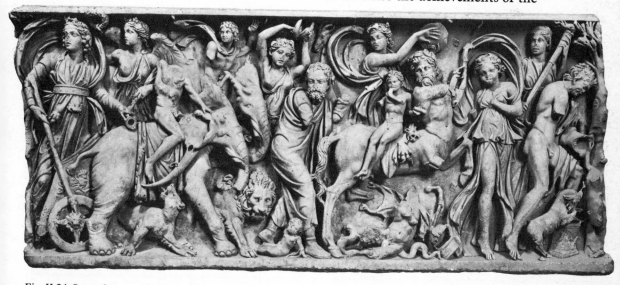

Fig. II.24 Sarcophagus with the Indian Triumph of Dionysus. Early III century A.D. Vatican, Museo Gregoriano Profano

deceased and to suggest another kind of victory, the analogous Hunt sarcophagus symbolized more explicitly the metaphorical triumph over death, because the hunt had become a near-ritual in which the virtue of the heroicized dead could be displayed. In the confrontation between man and lion, the most popular of the hunt motifs, the honoured dead was depicted as a brave, successful hunter, encouraged by a doughty female, personifying *Virtus*. Although the Roman Hunt sarcophagi have some connection with the mythological repertory, especially with the tragic hero Meleager, the motif was largely dependent on the developing Imperial iconography of the chase with its emphasis on the virtue of the hunter, already evident under

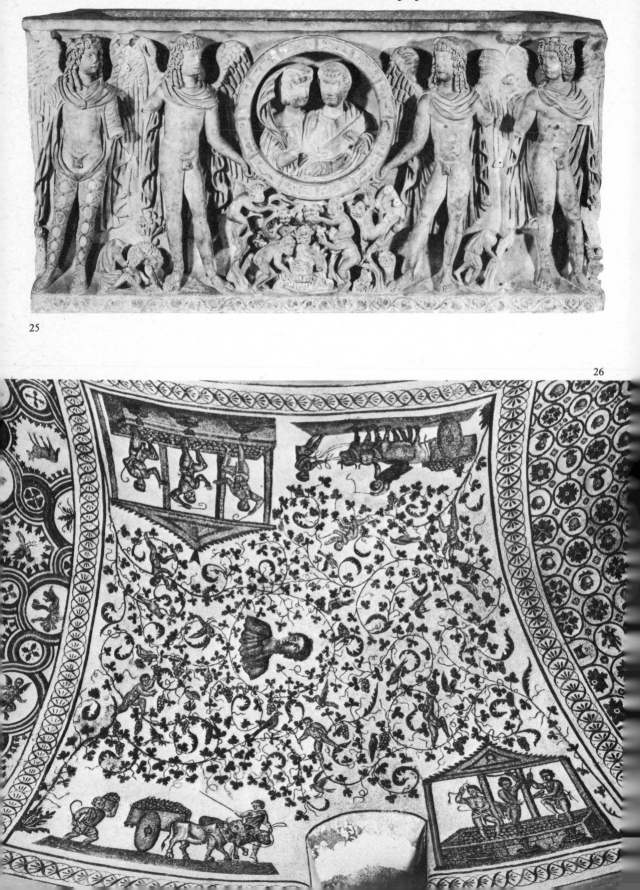

25

26

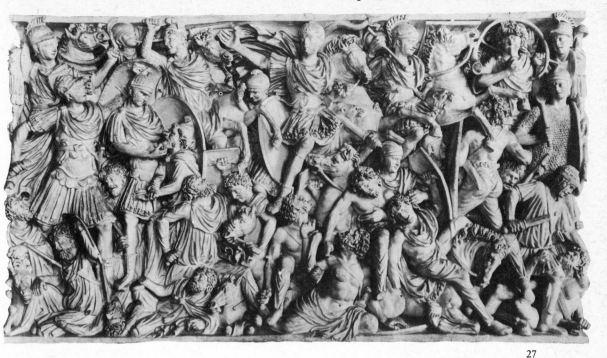

27

Fig. II.25 Sarcophagus of the Seasons. A.D. 300–320. Washington, D.C., Dumbarton Oaks Collection
Fig. II.26 S. Costanza, Rome: vault mosaic of grape harvest. About A.D. 320
Fig. II.27 The Ludovisi Battle sarcophagus. About A.D. 250. Rome, Museo delle Terme

Hadrian (Figs. II.46a–b). Other sarcophagi showed the deceased in the role of the clement conqueror (Fig. II.28), a part originally created for Achilles and later for Alexander the Great but adapted subsequently as a vehicle to ennoble the dead as a person of exemplary spiritual qualities. For much the same reason, the Biographical sarcophagi (Fig. II.10) often depicted the deceased in the special, distinguished aspects of his career: successful officer, pious citizen, proud husband in the company of his wife. These Biographical sarcophagi are equivalent to the Tomb of Eurysaces (Fig. II.4a, b), if less blatant.

The less topical subject-grouping of Roman sarcophagi leans toward a more abstract representation of spiritual values and characters. This general category of spiritualized sarcophagi seems to respond to the intentions of patron and sculptor to emphasize the non-terrestrial sphere and the possibility of eternity. Images of Aion, the figuration of the great cycle of cosmic time, appear on these sarcophagi, often within the circle of the zodiac, while on others the descent through the Gates of Hades is shown as a locus in the translation of the soul (Fig. II.21a, b); in this context sometimes mythological material from the myth of Orpheus and Eurydice or Alcestis is drawn upon to enrich the meaning of the passage from life to death. Another theme in this group of sarcophagi expresses spirituality as an aesthetic concept (or conceit) in the form of the Muse sarcophagus, much favoured in the Asiatic workshops. The philosopher sarcophagi (Figs. II.29; V.19) fall within this class and are so named because the principal relief is dominated by a seated, bearded, draped figure holding a scroll, symbolizing the virtuous, spiritual life of

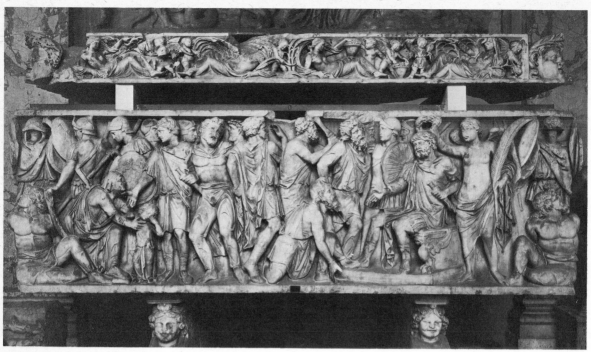

28

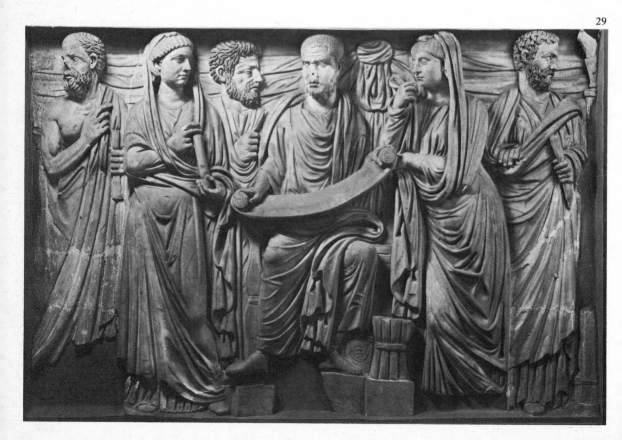

29

the mind, which rises beyond the world to a higher realm of value. If the image of the philosopher subsequently evolved into the Evangelist portrait, the thrust of this spiritualized body of sarcophagi stimulated the elaborate repertories of the Early Christian sarcophagi, beginning in the late third century. Figures and patterns were still derived from classical models, but a new subject matter, drawn from the miraculous narratives of the Bible, and a new faith created and exploited a different imagery of triumph and glory, not of the individual but of his God (Fig. II.20). Yet even here the hieratic forms adopted by the Early Christian artist depended on models previously developed for the awesome display of the triumphant Imperator in Roman art.

b. Triumphal Monuments: Statues, Trophies, Arches, Columns Augustus in his *Res Gestae* proudly disclaimed the eighty silver statues set up in Rome representing him on foot, on horseback, and in chariots. His rejection of them was a gesture of false modesty, consistent with his carefully cultivated image of reticent virtue, but the fact that they existed at all, and in precious metal, indicates the spectacular abundance of such honorific statues at Rome and in the Empire. Although many of the types and characteristic motifs of Roman triumphal monuments had come into prominence in the late Republic, often inspired by hellenistic models, Augustus firmly established the apparatus of triumphant display, because he held all power and recognized the value of advertising military success as a means of maintaining it. The relationship between political power, demonstrable virtue, and military victory was, perhaps, never more clearly manifested than by a gilded statue of *Victoria* which Augustus placed inside the Curia at the edge of the Forum. A later bronze statue of Victoria, set up in the Forum at Brescia by Vespasian, probably

Fig. II.28 The 'Clementia' sarcophagus. About A.D. 170. Vatican, Belvedere

Fig. II.29 The 'Plotinus' sarcophagus. A.D. 260–270. Vatican, Museo Gregoriano Profano

Fig. II.30 The façade of the Curia Senatus in the Forum Romanum, on the reverse of a denarius of Augustus

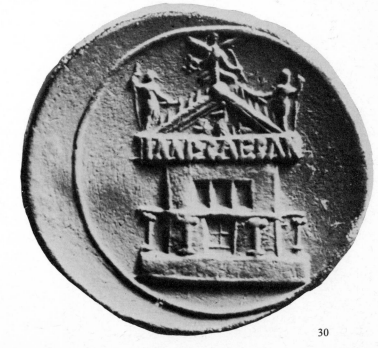

30

followed the Augustan figure, which was shown in the act of writing down the Emperor's great deeds on a gleaming shield, the *clipeus virtutis*. Furthermore, since the Senate House was closed to most Romans, the message was reinforced by another statue of Victoria, placed as an acroterial figure at the top of the Curia so that it might be seen by the crowds in the Forum below (Fig. II.30).

The cuirass statue was a Greek invention, quickly adopted by Roman generals to honour themselves after successful campaigns against the Greeks in the late Republic (cf. Fig. II.31). Although hellenistic artists had developed the decorated cuirass as a field for ornament and symbolic display, always subservient to the forms of the human body beneath, the Roman sculptors treated the cuirass almost as an independent form, capable of bearing the most elaborate, allusive images. The cuirass statue of Augustus from Prima Porta (Fig. II.32) bears such a panoply of signs, symbols, and personifications that its meaning is still uncertain; but scholars agree

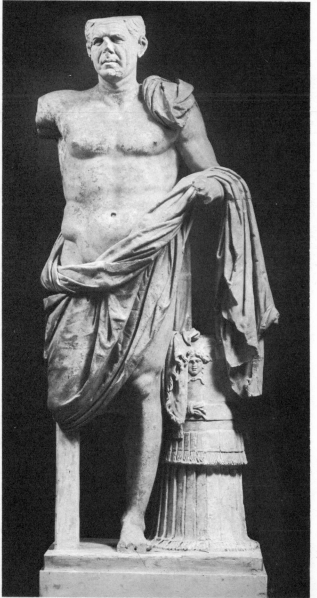

Fig. II.31 Statue of a Republican general, from Tivoli. 75–50 B.C.

Fig. II.32 Statue of Augustus, from Prima Porta. Tiberian copy of a late I century B.C. original. Vatican

31

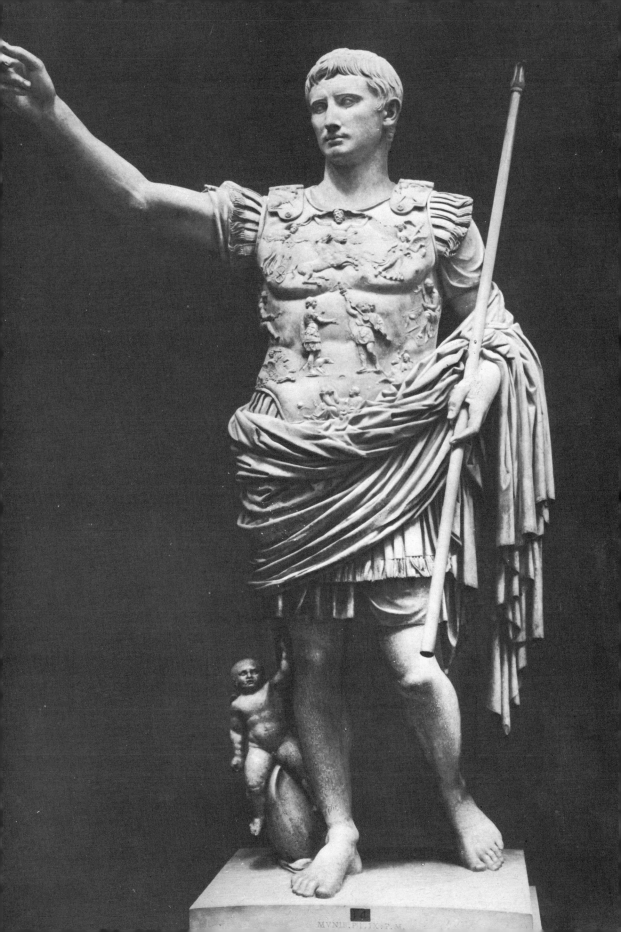

that the images refer to an eastern victory, probably over the Parthians, which has been treated as a cosmic event bringing prosperity and the Roman Peace to the world. Although this Augustan statue is uniquely complex, the tradition of the cuirass statue as a triumphant image persisted throughout the Roman Empire and lasted until the Byzantine period. Frequently, the Imperial cuirass bore a self-enforcing device, designed in heraldic symmetry and consisting of winged Victories holding wreaths or crowns or globes out toward a central trophy.

Equestrian statues, the proverbial 'man on horseback', stood prominently on high inscribed podia in Roman public places everywhere. Here, too, the original inspiration was Greek, but the Romans used that heroic image self-consciously and deliberately to heroicize individuals and as an attribute of their authority rather than as representative of their previous career. The great man on the standing horse became a familiar sign of power and the platform for the demonstration of his prestige, almost as a symbol of high office. Roman artists, however, also applied the motif to more active situations. The colossal equestrian statue of Domitian, celebrated by the poet Statius (*Silvae* I.1), stood shining in the Forum before the Temple of Caesar, resting his front leg on the crouching figure of a defeated barbarian as an explicit symbol of victory. Although Domitian's statue does not survive, the type appears frequently on the reverse of Roman coins of the second to fourth centuries and probably influenced the composition of the gilded, equestrian statue of Marcus Aurelius on the Capitoline in Rome (Fig. II.33). The Aurelian statue apparently once had a bronze barbarian beneath the front hoof, the brutality of triumph somewhat mitigated by the Emperor's gesture of clemency; the equestrian statue of Septimius Severus in Pavia, known as the Regisole and destroyed by the French in 1797, was similarly furnished with a barbarian prop. Another type took a still more active form, as indicated by a Domitianic coin struck in honour of his German victory; the Imperial rider is depicted rearing over a fallen enemy, whom he is about to destroy. This ferocious motif of unequivocal triumph also enjoyed great favour as a reverse on Roman coins and medallions, possibly indicating its continuity as a sculptural type. It was inserted specifically as a recognizable image of victory in larger compositions, including the Trajanic relief in the passageway of the Constantinian Arch in Rome and in the centre of the Ludovisi Battle sarcophagus (Fig. II.27).

Hellenistic commanders had the custom of building trophies (*tropaea*) out of captured weapons and armour right on the battlefield after a great victory. This practice appealed to Roman generals, and probably as early as 121 B.C. Fabius Maximus and Domitius Ahenobarbus erected such a trophy in Gaul to celebrate their defeat of the Allobroges (Florus, *Epit.* I.37.6). At La Turbie above Nice and Menton, Augustus built a permanent, monumental trophy to commemorate his pacification of the Ligurian Alps, and thus went beyond the limitations of the Greek trophy as a piled display of captured arms, now incorporated as a symbolic image in relief panels affixed to the sides of the monument. What is significant also is not so much the making of the trophy itself, but rather its placement as a permanent reminder of the Roman victory in the land of the vanquished foe.

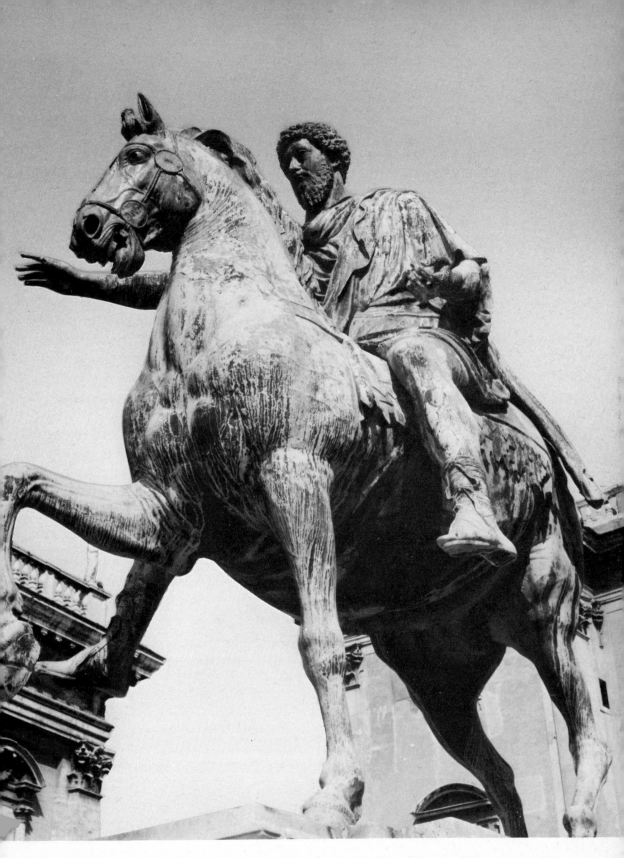

Fig. II.33 The bronze equestrian statue of Marcus Aurelius on the Capitol, Rome. About A.D. 176

However, the same result had already been achieved by Aemilius Paullus when he placed his monumental pillar, complete with inscription and heroic battle frieze, in the centre of the pan-Hellenic shrine of Delphi in order to celebrate his victory over Macedonia in 168 B.C. Almost three hundred years later Trajan did the same by erecting his trophy at Adamklissi (Figs. II.5; VI.36) right in the centre of the conquered Dacian territory just annexed to the Empire as a province.

A different intent moved the Roman emperors to erect trophies in Rome, far from the battlefield. Such trophies functioned as pure triumphal monuments, directly comparable to the great triumphal arches, and were set up in various parts of the city, but especially in the Forum and on the Capitol. The sculptural decoration of one of these trophies survives in two piles of arms with barbarian captives, carved in marble and now to be seen on the Renaissance balustrade of the Campidoglio (Fig. II.34). These pieces come from a monumentally conceived trophy erected by Domitian in honour of his German triumph, and other fragments of the same monument have been probably identified among the eighteenth-century ensembles of antiquities displayed 'al Piranesi' behind the cortile of the Palazzo Farnese in Rome. Among these fragments are the remains of a colossal cuirass statue of the Emperor, and one can imagine the heroic, martial figure of Domitian standing in some lofty position flanked on either side by these German trophies in testimony to his success and good fortune. Whoever designed the Column of Trajan may have followed the idea in a slightly different direction when he created the reliefs, covered with the representation of Dacian arms and standards, as the trophaic base for the column shaft and the elevated statue of Trajan high above (Fig. II.43).

Again, the Augustan image-makers may have originated the conception of the trophy as a basis for majesty, given the evidence of the magnificent Gemma Augustea in Vienna (Fig. II.35). The field of the Gemma Augustea is divided carefully into two parts: below are the soon-to-be conventional figures of defeated barbarians, shown in the presence of Roman soldiers engaged in the erection of a trophy; in the upper register, Tiberius appears directly above the trophy pole, stepping out of his chariot after celebrating his Pannonian (?) triumph, while an heroic Augustus sits in Jovian majesty next to the personified Roma and waits to receive him. This composition articulates the connection between victory in the field (the trophy), the battlefield commander (Tiberius), and the ultimate source of victory, good fortune, and power (Augustus as *princeps*). Indeed, the subsequent Julio–Claudian emperors never rid themselves of this iconographic chain of relationships, witness the passage from the trophaic barbarians below to the victorious commander (Germanicus?) coming into the presence of Tiberius, now Emperor, in the middle register, to Augustus as a presiding Divus above, as represented in the analogous Grand Camée de France in Paris. The same idea was expressed in Augustan court silver such as the Boscoreale Cups (Fig. II.36), one of which presents Augustus enthroned in majesty and receiving a Victoriola from Venus in the company of Mars for a victory over the barbarians won by Tiberius. Both the Gems and the Cups suggest an enrichment of the trophy beyond its function to signal the physical possession of the treasure and persons of the defeated enemy as well as of

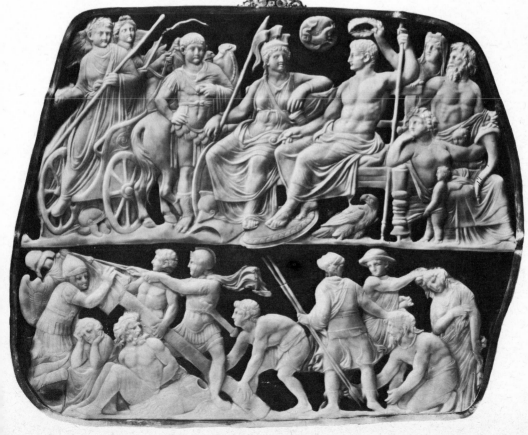

Fig. II.34 The Germanic Trophy of Domitian ('Trofeo di Mario'), now on the balustrade of the Capitol, Rome. About A.D. 83

Fig. II.35 'Gemma Augustea'. Augustan period, or possibly Claudian, about A.D. 41. Vienna, Kunsthistorisches Museum

34

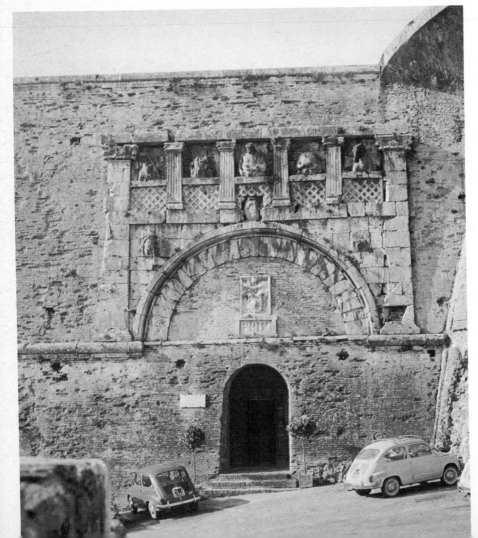

Fig. II.36 Augustus in majesty, on a silver cup from the Boscoreale Treasure. Late I century B.C. Paris, Rothschild Collection

Fig. II.37 Porta Marzia, Perugia. Mid-I century B.C.

their territory. Just as possession means control, an extension of the idea of the trophy occurred in the representation of the conquered province as a captive bound in submission. The *Judaea capta* coins of Vespasian are trophaic symbols, now given the widest possible distribution and no less effective despite their small scale than the grand Arch of Titus (Figs. II.1a, b; I.4a), devoted to the celebration of the same triumph.

Roman triumphal arches probably derive their architectural form from the elaborated portals of the Etruscans (Fig. II.37) and their honorific function from the primitive ceremonies of the Etrusco–Latin triumph with its temporary displays. But Roman triumphal arches are not primarily gates, although some of them served in that capacity, nor are they passageways despite their open, arcuated bays, nor are they true buildings even if many of them were massive structures. Instead, they must be considered independent show-pieces, eye-stopping billboards covered with tendentiously contrived messages and carefully placed for maximum visual impact. Above all, they stood as monumental instruments of propaganda in the permanent service of the triumphant Imperator and of the Roman state both at Rome and in the wide Empire.

Triumphal arches bear a topical relationship to the triumph that engendered them, and where they survive the inscriptions and architectural sculpture (if any) define and illustrate the purposes and justification of the commission. However, as an architectural motif this monument has many forms, determined not by the generating occasion but rather by the available space, funds, and designs. Probably the first triumphal arch built of stone was the Fornix Fabianus, erected over the Via Sacra beside the Regia in the Roman Forum by Fabius Maximus to celebrate his victory of 121 B.C. It consisted of a thin stone membrane punctured by a single arched opening and established the type of the single-bayed triumphal arch for centuries. With the enormous increase in commissions, beginning with Augustus, this type developed rapidly toward greater monumentality and splendour: it became thicker in Aosta and taller at Susa, picked up architectural embellishment at Rimini (Fig. II.38), and began to present articulated façades, first delicately as at Pola, Cavaillon, and St Chamas, later more robustly in the Arch of Titus at Rome (Fig. I.4a) and in the Beneventan Arch of Trajan (Fig. II.39), and still later destructively in the triumphal arches of North Africa. Twinned arches were primarily honorific adaptations of architectural patterns created for city-gates, but the three-bayed triumphal arch, itself derived from Roman city-gates like those of Cosa and Spello, became very important for major commissions because of its greater size and visual weight. The Parthian Arch of Augustus, erected in the Forum beside the Temple of Caesar (Fig. II.40), had three bays, although only the central bay was arched. However, the Arch of Tiberius in Orange (Fig. II.41) demonstrates the impressive potential of the three-bayed triumphal arch, which also underwent progressive surface and ornamental elaboration in the third (Fig. I.10) and fourth (Fig. II.42) centuries. The quadrifrons arch, developed as a superbly urban monument by being sited at the intersection of two avenues, forms the final type of Roman triumphal arch; its great advantage lay in the possession of four façades, open for messages

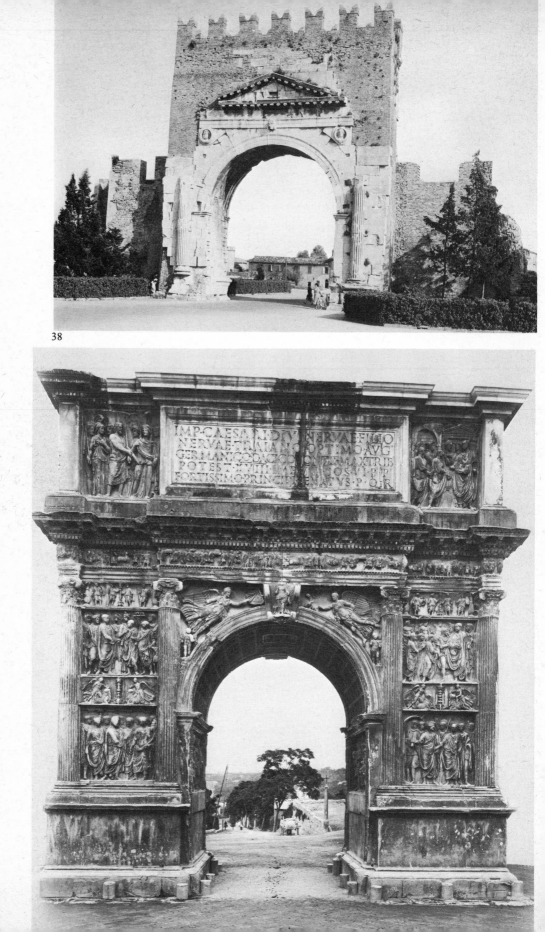

38

Fig. II.38 Augustan arch, Rimini. About 20 B.C.

Fig. II.39 The Arch of Trajan, Benevento. A.D. 114–117

Fig. II.40 The Parthian Arch of Augustus, in the Forum Romanum, on the reverse of a denarius of Augustus. 19 B.C.

Fig. II.41 The Arch of Tiberius, Orange, Southern France. About A.D. 25

40

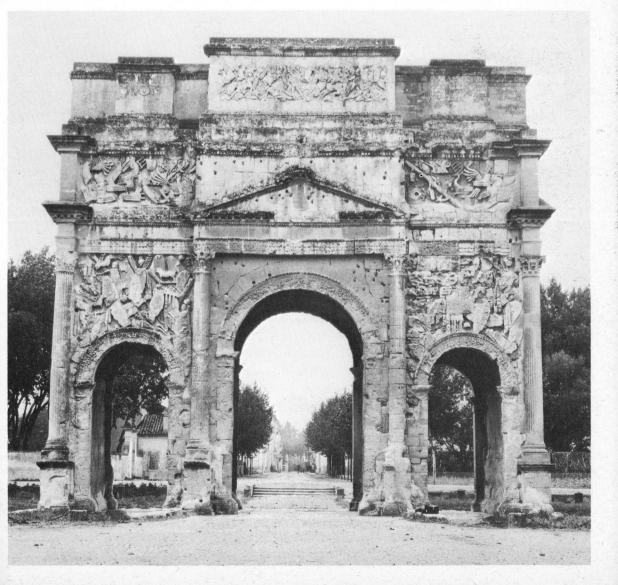

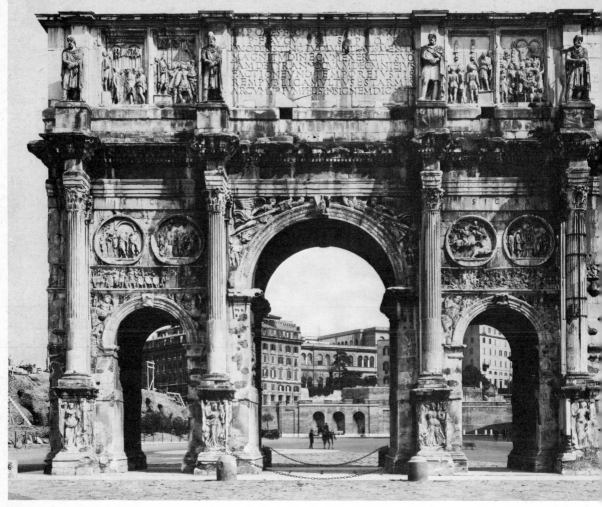

42

and capable of maximizing effect. Domitian adopted this form for his Porta Triumphalis, conceived as the acme of triumphal monuments, and this type was also used by Marcus Aurelius and Lucius Verus at Tripoli, by Septimius Severus at Leptis Magna, by Galerius at Salonika, and in the Constantinian Arch of Janus at Rome.

The decoration of Roman triumphal arches moved in the direction of ever greater complexity, either by the multiplication of architectural elements including the application of decorated mouldings, heavy cornices, and free-standing columns, or by progressively covering every available surface with sculptural ornament. In order to achieve this result, Roman designers developed a repertory of ornamental motifs, determined by subject matter, shape of field, and location, often apportioned among different sculptors' workshops brought together, sometimes discordantly, to execute a single commission.

At the top of the arch, brightly visible at a distance, a number of gilded bronze sculptures were often placed (Fig. II.40). They comprised a triumphal chariot

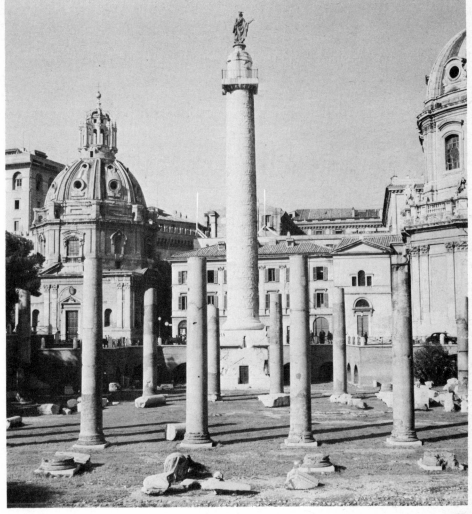

Fig. II.42 The Arch of Constantine, Rome. A.D. 315

Fig. II.43 The Column of Trajan, Rome, seen through the Basilica Ulpia. About A.D. 110

carrying the triumphator(s) in the company of Victoria personified, and flanked by subsidiary figures representing the conquered enemy; the chariot might be a biga or quadriga drawn by horses, except for the Domitianic Porta Triumphalis, where elephants pulled the triumphal chariot. The attic was reserved for the dedicatory inscription (Fig. I.10), filled with the names and titles of the triumphator, complimentary adjectives about his worthiness, fortune, and invincibility, a reference to his specific military achievement, and a record of the Senatorial decree. Although these large inscriptions were meant to be read by the public, the gilded bronze letters, flashing in the sunlight, also served as a beacon to catch the attention. The attic of the Arch of Constantine (Fig. II.42) was, however, invaded by panel reliefs and by the statues of captive barbarians which flanked the inscription over the central bay. The spandrels, voussoirs, and keystones of the arches formed a semi-autonomous zone of decoration, dominated by symbolic imagery. Again the Parthian Arch of Augustus may have set the pattern of a decorated keystone, flanked by figures of winged Victories holding out standards or emblems

of different kinds; this combination appears in the Arch of Titus, and also in the Arches of Trajan, Septimius Severus, and Constantine, where personifications of the Seasons were added to suggest the millennial character of victory. The spandrels of the side bays on the Arches of Septimius (Fig. IV.35) and Constantine also bore personifications of river deities, possibly derived from the Beneventan Arch of Trajan and representing the ecumenical scope of the Imperial triumph.

The body of the triumphal arch was divided into zones of sculptural ornament: the piers, the podia of free-standing columns (if any), and the passageways. Both the Arches of Titus and Trajan carried a continuous frieze below the principal cornice, describing the triumphal procession in relatively low relief; this frieze was broken up into four short registers on the Roman Arch of Septimius and disappeared on the Arch of Constantine to be replaced by a narrow band of narrative relief. The piers might be left bare, or occupied by niches intended for sculpture (Fig. I.4a), or covered with unframed reliefs (Fig. II.41), or filled with precisely defined panels of high relief sculpture (Figs. II.39, 42; IV.35). The application of the relief panel to the pier may have originated in the abortive design of the Parthian Arch of Nero, preserved on a sestertius, or possibly even earlier in the lost Britannic Arch of Claudius, fragments of whose sculptural decoration survive in the Galleria Borghese in Rome. The idea may have been derived ultimately from the public display of paintings illustrating successful military operations in the field that were exhibited during the triumphal ceremony. The gaudy visual effect of this advertising campaign may still be gauged from the Arch of Constantine with its porphyry inlays around the panels, or from the Arch of Galerius, completely covered by busy registers and panels of relief sculpture. This last Arch and the quadrifrons Arch of Septimius Severus in Leptis Magna also carried panels of relief around the piers into the passageways, possibly because of the isolation of the individual pier in this architectural type. However, a number of other arches also presented figured panels of relief in the passageways, either as the principal field of decoration as in the Arch of Titus (Fig. II.1a, b) or as a complementary participant in a more complicated programme, exemplified by the Arches of Trajan and Constantine (Figs. II.39, 42; V.13). The vaults of the passageways contained, as well, a richly ornamental decoration, formed of deeply carved coffers punctuated by flowers, interrupted at the top of the vault in the Arches of Titus and Trajan by a small relief panel. That of Trajan shows the cuirassed Emperor crowned by Victoria, while the Titus panel represents the Apotheosis of the Emperor borne up to heaven on the back of an eagle; this motif of apotheosis indicates that the Arch of Titus is a posthumous dedication, made by Domitian his brother and successor, and thus combines the honorific purposes of triumphal arch and cenotaph.

Both the Roman Arches of Septimius and of Constantine exhibit panels of figured relief on the podia of their free-standing columns. The later monument displays the repetitive figure of Victoria on the front panels, but along the sides of the podia appear crowded figures of Roman soldiers and their captives, reinforcing the image-value of the statues of barbarian prisoners placed directly above on top of the columns (Fig. II.42). This design probably comes from the podia panels of the

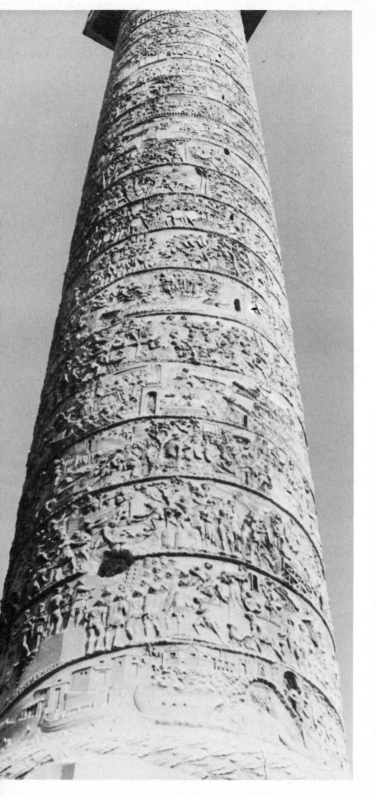

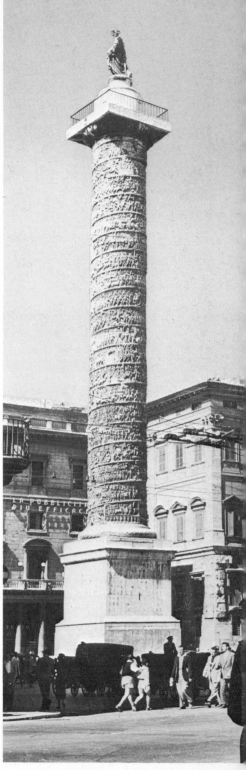

Fig. II.44 The Column of Trajan, Rome, seen from below as originally visible

Fig. II.45 The Column of Marcus Aurelius, Rome. A.D. 180–192

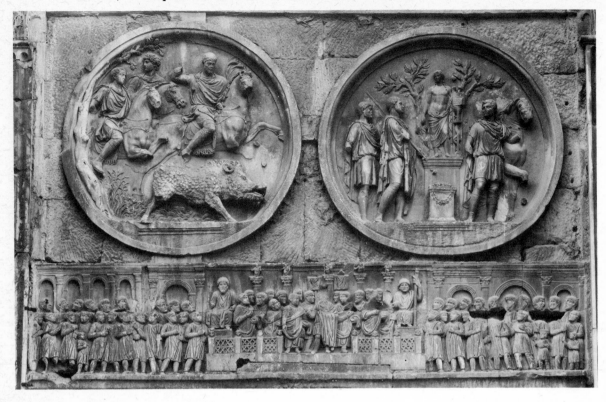

Fig. II.46a–b Constantinian *adlocutio* and Constantinian *largitio* friezes with Hadrianic tondi, above, on the Arch of Constantine, Rome. Hadrianic tondi A.D. 130, Constantinian portraits substituted about A.D. 315

nearby Severan Arch (Fig. I.10), which have no symbolic manifestation of Victoria to interrupt the steady march of Roman soldiers and their Parthian prisoners, moving toward the central bay as if to suggest the continuous procession of the triumph. It is possible that the designer of the Severan Arch may have developed this scheme in order to tie together the two faces of this monument, otherwise so visually distinct. The association of these ambivalent façades had been previously effected by contiguity, repetition, and symbolic reflection, lacking anything but the simplest treatment of the ends, which remained inactive connections between the façades. However, in the Constantinian Arch the ends were activated, being transformed into energized surfaces for the support of important panels of relief fully integrated into the composition and iconographic scheme of the major façades. Apparently this transformation of the traditional arrangement emulated the circumferential continuity of imagery achieved long before by that other great triumphal monument, the free-standing honorific column.

Here, again, the Greeks were the first to use the independent column to commemorate a glorious achievement or to elevate the emblem of a city in a crowded place, but the Romans turned this simple device into a symbolic image in the service of proud victors. By the end of the Republican period, the Forum and the Rostra were crowded with small, commemorative columns, whose form has been preserved on the reverses of a number of Roman denarii. Their general character is

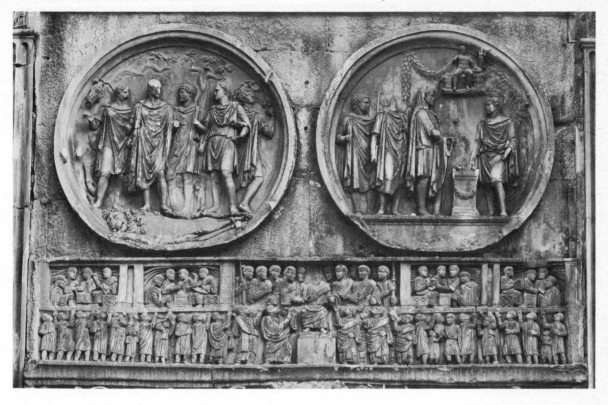

evident from the reproduction of the lost column erected by Augustus to celebrate his naval victory at Actium and issued as a coin reverse for greater publicity; the column, hung with the prows (*rostra*) of captured ships, rose on a base and supported a statue of the Imperator. This simple scheme persisted for more than a century with little variation, until some genius—possibly Apollodorus of Damascus—invented the helical column covered with narrative reliefs as a stunning monument to Trajan's conquest of Dacia (Figs. II.43, 44; I.66; IV.36a–c). One must imagine the column in its original appearance, rising above its trophaic base, girdled with the virtuous wreath of victory; the column shaft was wrapped with a ribbon of relief, continuously spiralling upward, arranged into scenes which carried the narrative the Dacian campaign, dominated by the repeated ceremonial presence of the Emperor. The reliefs were once painted to enhance their topical and topographical accuracy, and it is very likely that Trajan, too, was distinguished pictorially by gilded armour and purple cloaks, so that he might remain clearly visible until the very top, one hundred feet away. And above everything there stood his gleaming statue in a carefully orchestrated epiphany of triumph. This well-contrived scenario was a masterpiece of visual design, taken up as a model for the later Column of Marcus Aurelius (Figs. II.45; IV.37a–c) and subsequently transferred to the New Rome, Constantinople, where it inspired the Columns of Theodosius and Arcadius. Although the composition of the helical reliefs and the iconographic structure of the scenes are of great importance in the history of Roman art (see pp. 192 ff.), they must be considered as an historical prop, ancillary to the main purpose of the triumphal

column: to present the heroic conqueror as a person of extraordinary distinction, separated from lesser men by the splendour of his deeds.

Roman wars were fought to maintain the Roman Peace, or so stated the propaganda, and a number of important monuments came into existence with mixed messages of triumph and concord. The precedent had been set in the old Republican custom of closing the gates of the Temple of Janus as a sign of peace, when a great war had been brought to a successful conclusion. Augustus, the artful maker of images, transformed the Pax Romana into the Pax Augusta when he commissioned the Ara Pacis Augustae, the Altar of Augustan Peace, and thus brought to an end several decades of foreign and civil wars (Fig. I.1). Although ostensibly not a triumphal monument, both the Ara Pacis and the contemporary Forum Augustum (Fig. I.30) were elegant, prestigious symbols of the new peaceful harmony, brought to the world by Augustus, because he was so virtuous, so favoured by good fortune, and so triumphantly successful. Similarly, when Vespasian returned from his conquest of Judaea, struck his coins in celebration, and built his triumphal arch on the curve of the Circus Maximus, he also commissioned the Templum Pacis (Fig. I.31) near the Forum Augustum as a quiet preserve for intellectual and aesthetic pursuits in testimony to the beneficent fruits of peace, which his victory had won. This balanced association of triumph and its aftermath governed the programme of Trajan's Arch at Benevento (Fig. II.39): the side facing the south and east, away from Benevento, displayed in somewhat allegorical terms the Emperor's victories, while the side facing the city and Rome carried the message of his domestic policy, assured by those victories. Much the same programme was adopted in the design of the Constantinian Arch in Rome (Figs. II.42, 46a–b), if less sincerely, since it in fact celebrated victory in a civil war against Maxentius and not against a foreign enemy, the traditional prerequisite of the triumph. The west end and the south façade of the Arch present descriptively and allusively Constantine's campaign and the fatal defeat of Maxentius at the Battle of the Milvian Bridge, just outside Rome. The reliefs on the east end and within the central passageway indicate the real and metaphorical character of his entry into the City, while the north or inner façade displays to the Roman citizens the positive result of this victory in the coming of a new era, achieved under the divine inspiration (*instinctu divinitatis*) mentioned in the inscription.

One of the Constantinian reliefs on the north façade shows the Emperor addressing the Roman people from the Rostra in the Forum (Fig. II.46a). Behind him and behind the Rostra rise five columns belonging to the Decennial Monuments of the Tetrarchs (Fig. II.2), conceived within the tradition of the honorific, statue-bearing column. Their message was not the message of peace, but rather that a condition of peace and of the continuity of Empire was perennial victory in war. With this, the inevitability of triumph became a permanent fixture of the state and of its most public monuments.

Chapter III
Ornament and Decoration

ROMANS had a passion for ornament in all its forms, in all its possible applications. They cultivated an expensive taste in the decorative arts as a source of immediate pleasure and as a symbol of ostentatious wealth, thereby attaining both private and public gratification through the same means. Glittering combinations of costly materials, arranged in complicated patterns, seem to reveal an underlying vulgarity that even the pressure of elegant refinement could never wholly conceal, and opulence was its hallmark. Unfortunately, no history of Roman taste exists, nor any deeply critical examination of the media and motifs in the Roman decorative arts with the exception of Riegl's other-directed interpretation of Late Antique ornament. Yet the Romans' elaboration of *any* surface, not merely the development of façadism in architecture, and their preference for ornamental pattern-making would appear to be the most appropriate subjects for a structural analysis of Roman art at its basic levels of generation. The choices of form, the creation of ordered patterns, the continuous elaboration of favoured motifs, the definition of ornamental fields, all are topics worthy of study but neglected despite their importance to the history of Roman art. One should not forget that it is very likely that the Romans discovered the picture frame as a prime motif of decoration in itself, as an exclusive limit within a larger context, and as an inclusive device to establish an interior, pictorial field (Figs. III.1, 2). Above all, the Romans' attempt to animate the surface of objects and to enhance the dimensionality of the plane may indicate a primitive attitude about the nature of materials and their powers consistent with the relish that Roman art expresses for all images.

a. The Adaptation of the Greek Orders When Roman architects took the Greek orders, which had been developed primarily for their structural properties within a coherent system of architectural design, they destroyed that function by the imposition of other objectives. Of course, columns were still used to hold up architraves and pediments (Fig. I.7b). Bases, capitals, entablatures, and cornices survived as foci of architectural ornamentation, even if the forms and patterns became more complicated, the rhythms and combinations were modified toward greater abstraction, and the carving progressively deepened (Fig. I.32). Proportional schemes of different types, frequently in the Pythagorean ratio of $1:\sqrt{2}$ as in the Arch of Septimius Severus in Rome, continued to be employed in the organization of façades and elevations. Also, hellenistic architects had anticipated the Roman desire to embellish the orders with varied ornament, marked especially by the increased popularity of Corinthian and by the introduction of mosaic pavements and painted walls, while

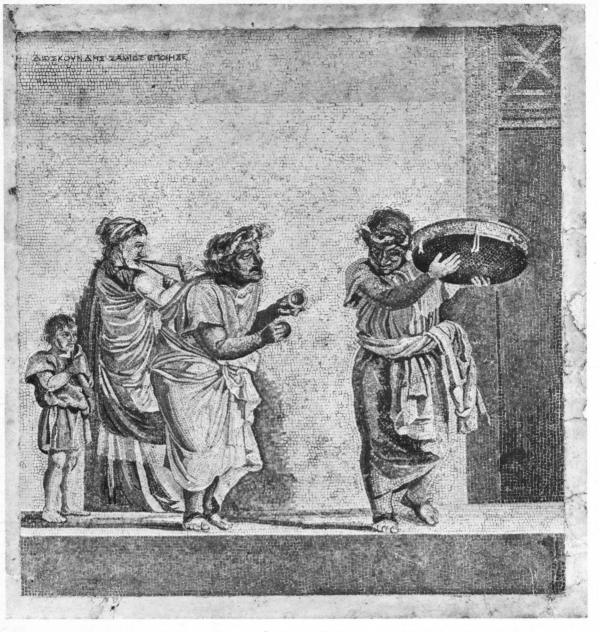

Fig. III.1 Mosaic by Dioscurides: scene from a comedy. Augustan period. Naples, Museo Nazionale

hellenistic urban architecture had similarly provided the motif of the extended colonnade as an elegant, effective model for the Roman architects of the city. But the Romans disassembled the orders into their constituent elements, which they treated individually as decoration (Fig. III.3). Their architects turned the column into a free form that could exist without any fundamental structural responsibility (Fig. I.61b) or as part of a diaphanous wall (Fig. I.30), or as a field for additional carving in spirals or other decorative patterns. Furthermore, architectural mouldings became a dramatic means of energizing, or corrupting, a wall surface through the multiplication of planes, shapes, and colouristic accents. Even more significantly,

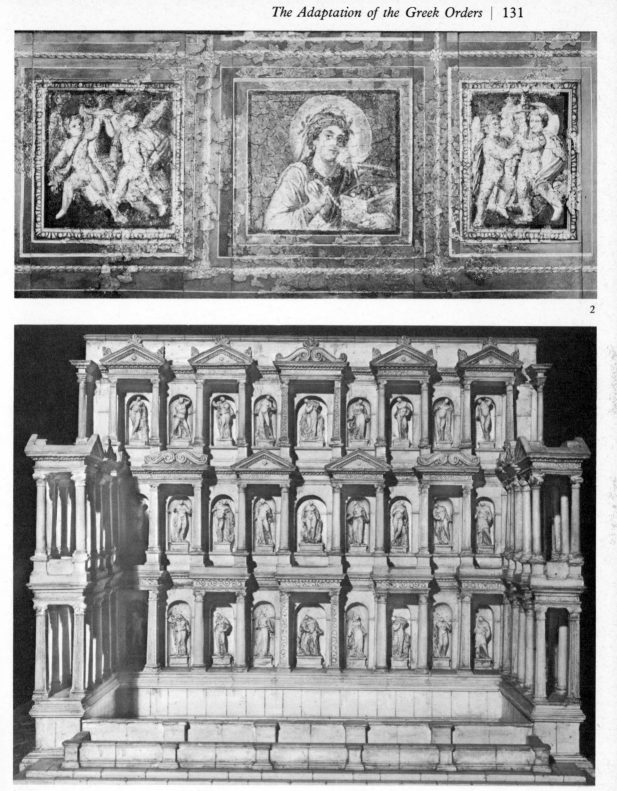

2

3

Fig. III.2 The Constantinian Palace, Trier: ceiling paintings with busts in coffers, possibly representing members of the Imperial household. Early IV century A.D.

Fig. III.3 The Nymphaeum at Miletus. Mid-II century A.D. Model. Rome, Museo della Civiltà Romana

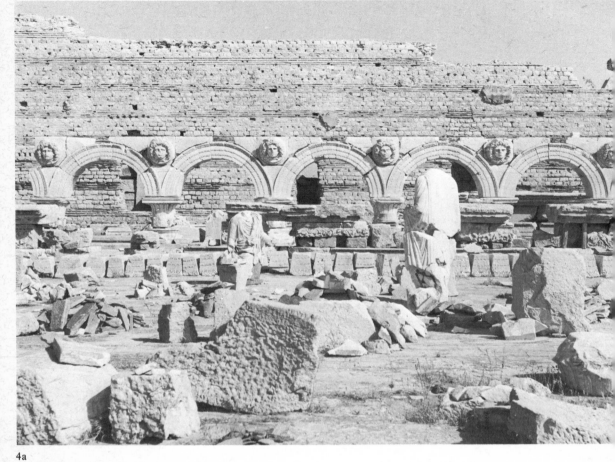

4a

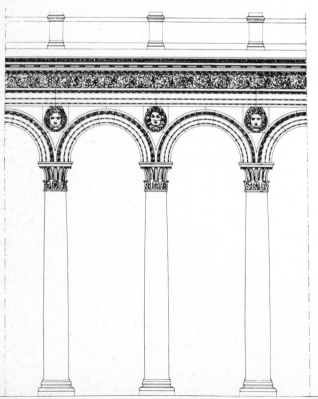

Fig. III.4a The Arcades of the
Severan Forum, Leptis Magna.
Early III century A.D.

Fig. III.4b Arcades of the Severan
Forum, Leptis Magna. Reconstruction
after Vergara Caffarelli and Caputo

4b

the Romans translated the borrowed, adapted architectural motifs into visual symbols of high culture and good taste, thereby replacing their original participation in the substantial process of building by a new manipulative role in the making of prestigious images.

The effect of taste-making in the formation of Roman architecture began to be felt in the late Republic and was perfected by the adoption of marble as a precious packaging material under Augustus. The Greek repertory was retained until the fourth century, if distorted by exaggeration as indicated by the development of the composite capital (Fig. IV.35), but the presence of these 'Greek' features was justified by non-structural considerations. Typical of this attitude was the widespread substitution of the engaged column for the column itself in order to articulate a surface (Fig. I.22) or to compose more definitely a rhythmic system of bays (Fig. I.43). Pilasters came into their own, not merely at corners or the ends of walls, but as the reflection of an exposed column, the flattened representation of a column in the round, now seen as a vertical strip of ornament, comparable to the well-established horizontal accents of cornices and entablatures. Column capitals without columns, broken pediments, discontinuous mouldings, arcuated lintels, and the progressive domination of pattern over plasticity are all indicative of the deformation of the Greek models under the pressure of a different sensibility.

Despite the liberating possibilities of Roman concrete, which freed the architect from the static necessities of masonry, not every change in the treatment of the Greek orders had such an atectonic effect. The Romans took the extended colonnade and converted it into a porticated screen or permeable wall, which they then applied as an intentionally imperfect division between the related components of large complexes in both exterior (Fig. I.31) and interior (Fig. I.4a) situations. The later transformation of these porticoes into arcades (Figs. III.4a–b; I.65) enriched the dialogue between horizontal and vertical accents, while it enhanced the very openness of the colonnade. A second major development was the creation of the screened wall, that is to say the load-bearing wall screened and ornamented by columns standing immediately in front, connected by projecting entablatures. The Flavian auditorium on the Palatine and the Domitianic Forum Transitorium (Fig. III.5) show this feature, possibly an architectural interpretation of the compression-expansion of planes previously suggested by the perspectival presentation of the peristyle portico in certain 'Second Style' wall-paintings (Fig. III.24; see pp. 152 ff.). Much Romano-hellenistic architecture of Asia Minor and Syria—at Ephesus, Miletus, Sardis, Aphrodisias, Baalbek, Palmyra (Fig. I.53)—adopted and perfected this type of doubled wall, which then passed on to the Severan Basilica at Leptis Magna (Fig. I.33) and to the late triumphal arches of Septimius and Constantine (Figs. I.10; II.42). If the adjacent colonnade encrusted the wall with plastic projections, another vision led to the creation of the disembodied wall, most fully realized in the *scenae frons* of the Roman theatres, nymphaea, and libraries (Figs. I.61b; III.3). Although the disembodied wall was, in a sense, anticipated by the transparencies of Hadrian's Piazza d'Oro at Tivoli (Fig. I.47), it also portended the dissolution of the load-bearing wall by windows in late Roman architecture (Figs. I.13, 14b).

5

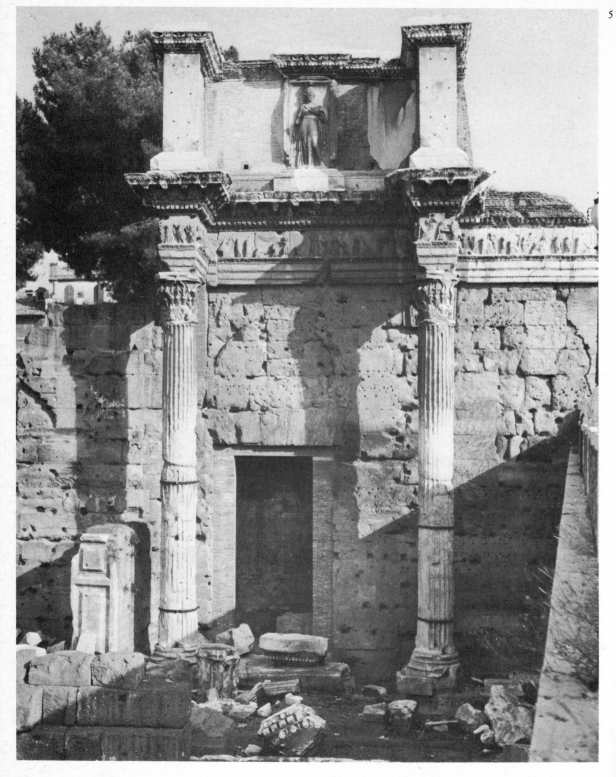

Fig. III.5 Forum Transitorium, Rome.
A.D. 95–97

Fig. III.6 An ambivalent floor mosaic from
Rome. Mid-II century A.D. Rome, Museo delle
Terme

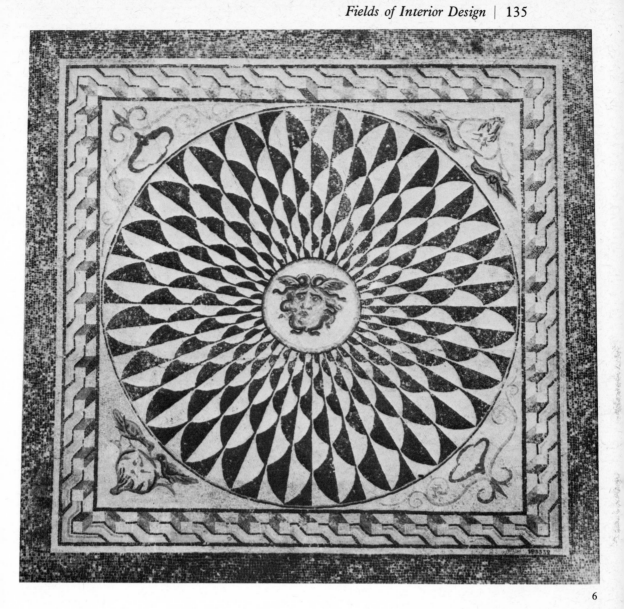

6

b. Fields of Interior Design: Floors, Walls, Ceilings No coherently decorated interior exists without an over-riding conception of the ensemble. Unfortunately the poor state of preservation and the relative indifference of most scholars to this problem have left the principles of Roman interior design in darkness. Rarely, indeed, has any attempt been made to show how the painted walls of a room go together (let alone with the floor), how the mosaics or opus sectile pavements of the floor may be composed not only in the ensemble but in sequence, and how the decoration of ceilings and vaults may have participated in the creation of a total effect, an interior charged with certain visual-psychological qualities and with carefully orchestrated meanings. The most significant essays in establishing the decoration of a Roman interior have taken the form of reconstruction drawings, often the product of an excellent intuition if lacking documentation, and applied to large

projects such as baths (Fig. I.8). Admittedly, it is very difficult to interpret the paintings or mosaics or stucco mouldings of a vault that exists only at the edges, although some insight into the original composition might be gained from an analysis of well-preserved tombs or catacombs, where at least the decorative schemes of walls and ceilings may survive intact.

A fascinating aspect of Roman interior decoration, still evident in many monuments, is the ambivalent treatment of the parameters of the chamber as active or acted-upon surfaces. This intentional ambiguity affects the choice of designs but, more importantly, the apparent stability of the decorated surface, transformed into an energized field. Accordingly, the floor-wall-ceiling could be considered either something palpable and firm, establishing precisely the tactile, sensible limitations of the local space, or an unfixed, indeterminate boundary, suggesting the flexible expansion of the chamber by coherent or irrational perspectives. To achieve this result, the decorator might convert the ceiling into the sky (Figs. I.12; III.32), the wall into an extended landscape (Fig. I.56), a billowing veil (Stabiae), or architectural prospect (Fig. I.57), and the floor into a disquieting, recessive illusion (Fig. III.6). These are all expressions of a delighted uncertainty about depth of field and a perverse pleasure in the game of perspective that makes Roman interior decoration so moving an experience, while it points again to the Romans' peculiar perception of an irresolute, active boundary between solid and void.

1. THE FLOOR Floors are durable covers, concealing the rough construction of the platform beneath, opposing the seepage of moisture, and resisting the wear of foot-traffic. These practical considerations were always important in Roman architecture and dictated the selection of hard materials, such as terra-cotta, brick, and stone, wherever possible, given the expense and natural weaknesses of wood. Flat squarish tiles were used as an underflooring or as a paving for commercial and commonplace public buildings, although small terra-cotta blocks, arranged in herring-bone patterns, enjoyed a brief popularity in late Republican domestic architecture as a convenient, attractive flooring. Thin slabs of limestone or marble, cut into rectangular shapes of varying dimensions and smoothly polished, formed the pavements of many stately rooms and corridors during the Empire, whenever cost was not in issue. However, the monotonous stone floor, composed of a single material and lacking any design but that offered by the orientation of the slabs, gave way to the liveliness of *opus sectile*, formed of many kinds, colours, and textures of stone set into complicated abstract and figured patterns.

The repertory of abstraction in the treatment of opus-sectile pavements showed a clear preference for polygonal shapes, especially in the intricate designs created out of small units, somewhat in the manner of textile patterns (Fig. III.7). Frequently, the result was extremely rich, opulent, and even jewel-like, anticipating the medieval polychromy of the Cosmati and responding to the visual feast offered by the all-encompassing mosaics of Late Antiquity (see pp. 142 ff.). Although these patterns have yet to be categorized and catalogued, it is clear that a very subtle manipulation of the figure/ground relationship constituted a basic principle of their composition. Certainly this concept governs the organization of several grand, late Roman floors,

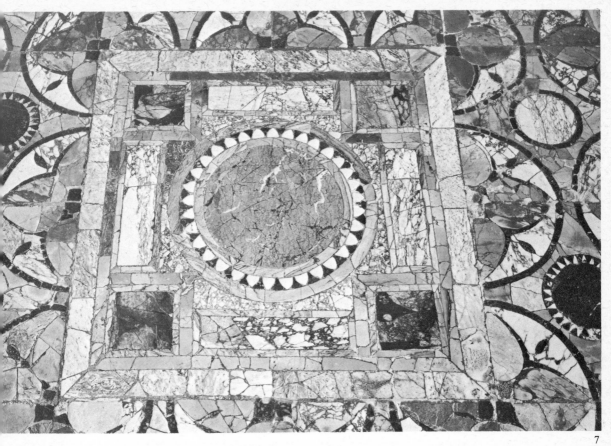

7

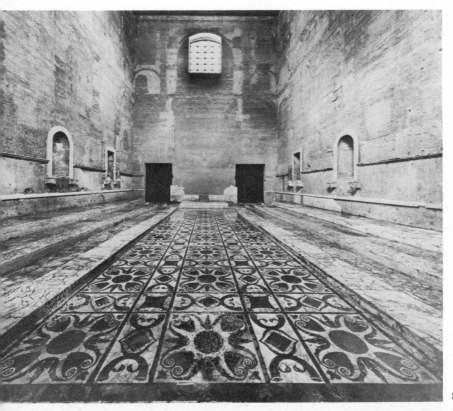

Fig. III.7 Opus sectile
pavement from the
House of Cupid and
Psyche, Ostia. Early
IV century A.D.

Fig. III.8 Opus sectile
floor in the Curia
Senatus on the Forum
Romanum. About
A.D. 300

8

including those of the Pantheon (Fig. I.7c) and of the Curia (Fig. III.8), where contrasts of colour and value establish a dialogue of movement among the constituent elements of the design. It should be noted that very similar patterns appeared among the painted or veneered decorations of the lower part of the wall in a large number of third- and fourth-century Roman chambers at Ostia, in Gaul, Germany, and Macedonia, and even in the third-century Synagogue at Dura Europos. This development again demonstrates the coherency of Roman interior decoration, while it suggests the progressive elimination of the visually differentiated zones of a room in favour of the splendid ensemble.

Opus-sectile floors were also composed in complicated, figured designs, resembling the intarsia of the cabinet-maker. If largely restricted to floral motifs in the first century, this type of decoration crept up the walls (Fig. I.23) and onto the ceilings of the Basilica of Junius Bassus, Rome, in the fourth century, but the practice was limited, probably because of the great expense of materials and labour. Besides, a comparable effect could be achieved at less cost and with the side benefit of insulation by the use of tapestries and rugs, produced by the workshops of the eastern Empire (Fig. III.9). These figured motifs in opus sectile—and those of the similarly treated contemporary windows from Kenchreai—seem to reflect pictorial compositions, translated into the permanence of cut stone. But there was another technique, less expensive and equally permanent, that could attain comparable results with much greater variety as it offered the further inducement of a lively, multifaceted surface: mosaic.

Mosaic is a surfacing technique invented by the Greeks and employing small pieces of stone (*tesserae*), relatively square in section, set close together in a waterproof grouting or mortar. Depending on the fineness of the mosaic, the tesserae range in size from small cubes, about 1 cm. on each edge, to stones with almost nine times the area and six or seven times as deep, in the latter case resembling great, flattened teeth; the composition of the mortar also varies, depending on use, local workshop practice, and available materials, but its adhesive properties were

remarkable, given the enormous number of surviving mosaics from all parts of the Empire. Any kind of durable, easily cloven stone might be used, and the mosaicist often extended his 'palette' by cutting tesserae from glass rods manufactured in bright, solid colours, or from glass blanks fused as a transparent medium around gold leaf. Patterns, motifs, subjects, methods of composition and arrangement, techniques of laying the tesserae, colour selection, and quality varied with the time and place of making, but perhaps the most important role in determining the appearance of a mosaic was played by the workshops. These offered expertise and a repertory to their clients, in a way comparable to the role of sculptors' studios in the sarcophagi trade, but depended more on the location of their commissions than on the source of materials. Mosaics can be grouped stylistically and iconographically by region: Antioch-Apamea in Syria; western Asia Minor; Alexandria-Cyrenaica; North Africa, comprising Tripolitania, Tunisia, Algeria, with an offshoot in Sicily; Rome and central Italy; southern Gaul and the Rhone Valley; the Rhineland, Switzerland, and the western Danube. However, these divisions have not yet been clearly established, and when artists travelled on commission, compositive schemes

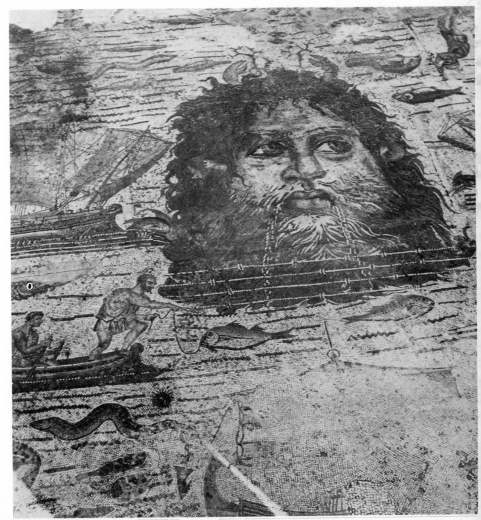

Fig. III.9 Coptic textile. IV or V century A.D. London, British Museum

Fig. III.10 Oceanus mosaic. Sousse, Tunisia. A.D. 125–150

10

and iconographic types passed with changes from one part of the Empire to another. The recently initiated corpus of Roman mosaics will eventually illustrate both the peculiar characteristics of mosaic workshops and the transmission of their designs.

Roman mosaics (*opera musiva*), applied as a decorative surface to floors, pools (Fig. III.10), and fountains, are derived from hellenistic models in technique, conception, and arrangement. The development of new motifs and compositions, the rapid proliferation of types and programmes, and the exigencies of stylistic change distinguish the Imperial works of art from their predecessors. Perhaps the most important distinction rests on the Romans' creative perception of the dual nature of mosaic as being either painting in stone, with individual tesserae functioning as spots of colour subservient to pictorial objectives (Fig. III.1), or an arrangement of coloured stones in which the presence of the lapidary and his technique are dominant (Figs. III.11, 16). The mosaicist-painter treated the surface as a transparent plane behind which forms receded in illusionistic retreat. The mosaicist-lapidary insisted on the substantiality of both surface and material, even going so far in late Roman wall and ceiling mosaics as to emphasize the nature of his medium as a coloured, reflecting surface by varying the pitch of the tessera face so that the mosaic was no longer smooth and passive. These are, of course, polarized attitudes, and most Roman second- and third-century mosaics show the composite effect of their antagonistic influence, e.g. the single or double line of white tesserae that reinforce the outer contour of the figures in black-and-white mosaics (Fig. III.12).

Apart from the central issues of style and iconography, Roman mosaics can be considered analytically from several points of view, beginning with the floor as a field for composition and design. The mosaicist tended to treat the floor as a semi-isolated shape, possessing both a defined edge and an uncertain centre, and dependent in some way on the position of the openings into the chamber. For these reasons he developed his conception of borders and panels as individual but related schemes of design. He also sought to orient his composition visually on the major entrance or on subordinate places of rest, if the space was very large, and tried to maintain the participation of his decorative concept within the over-all architectural frame of reference. Unfortunately, mosaics have often been presented as *disiecta membra*, stripped of their original character so that both context and concept were lost, but recent publications are attempting to remedy this defect.

The earliest Roman mosaics, or proto-mosaics, were laid in the late second to early first century B.C., before the full repertory of the hellenistic models had been assimilated. They were composed of irregular buff-coloured tesserae, set down without pattern but interrupted frequently by large, coarse fragments of blue, green, red, and yellow stone, and all contained inside a simple dark border; this type of mosaic (*lithostraton*) can be found in a number of late Republican houses, public buildings, and at the Sanctuary of Fortuna in Palestrina. Although rapidly abandoned because of the hellenization of taste in the mid-first century B.C., these early mosaics represent the Romans' conception of the floor as an opaque surface and as a continuous field. This appreciation of the field with its possibilities of lateral or horizontal extension seems never to have been lost despite the introduction of many

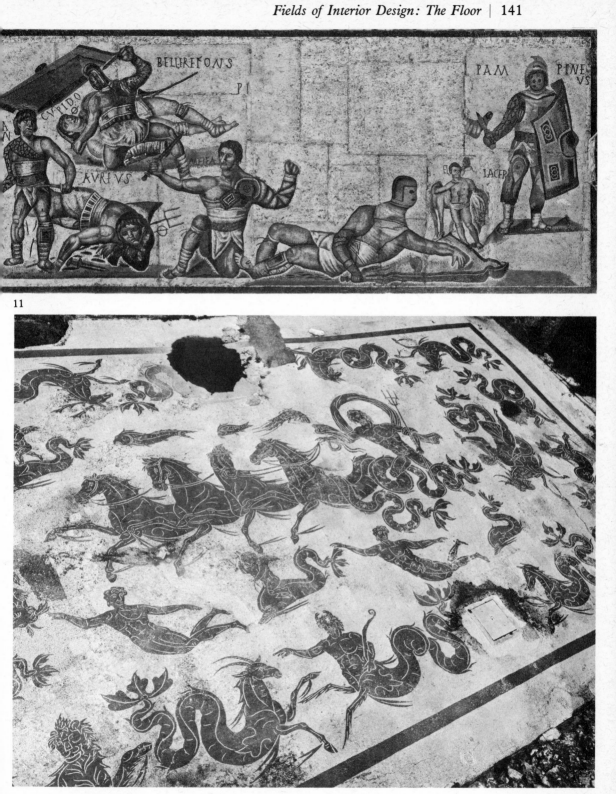

Fig. III.11 Gladiatorial mosaic. Mid-III century A.D. Rome, Galleria Borghese

Fig. III.12 Mosaic from the Baths of Neptune, Ostia. Mid-II century A.D.

new designs. Large second- and third-century black-and-white mosaics (Fig. III.12) take every advantage of the spreading field because the mosaicist has designed his black figures to convey an impression of lateral movement over the white ground, thus filling that ground with implied movement while avoiding clutter. By the early third century some of the abstractly patterned mosaics of the Baths of Caracalla in Rome (Fig. III.13) suggest the simultaneous existence of two fields on a single surface through the continuous alternation and substitution of the figure/ground relationship. This superb design, dependent on the repetition of a simple shape, varying in direction, colour, and value, charges the mosaic field with extraordinary energy and with an infinite capacity for lateral extension, but without monotony. Pattern, vibrating in controlled movements, here responds to the same conception of the dynamic surface that motivates the composition of opus sectile (Fig. I.7c) and of late Roman architecture (Figs. I.10; IV.35) and sculpture (Figs. VI.45, 46; see pp. 257 ff.).

Within the visual context of the field, Roman mosaics may also be profitably examined according to their division into borders and frames or panels (Fig. III.14). Mosaic borders have many functions, affecting the inclusion or exclusion of indi-viduated compositions and the establishment of a unitary scheme of decoration. In this sense the mosaic may be compared with the bordered carpet, and it is very likely that ancient mosaics and textiles were mutually influential in this respect. However, borders can also be interesting in themselves as patterned forms, seen either progressing along a predetermined path or appearing as banded rhythms in cross section. Many of the long patterns are well known, even frequently derived from Greek architectural and textile ornament: meander, key, or fret motifs, the twisted rope or guilloche, various geometric forms, floral devices, etc. No one pays any attention to the composition of these borders in section, where rhythm, interval, and ribboning effects play an essential role in bringing the border to the attention of the spectator as a *frame* which contributes to the spatial implications of the enclosed panel. From the surviving examples of Roman floor mosaics it is evident that great attention was paid to the discrepant potentials of these framing borders, because their composition is so subtle and varied despite the restricted convention-ality of the decorative repertory.

Mosaic panels have many different shapes, including the square, rectangle, hexagon, octagon, circle, and semi-circle or lunette. In several instances the panel was treated as a dependent subdivision of the field, determined by the border and participating intimately in the whole, but possessing its own distinctive designs. These panels may contain purely geometric schemes, complex optical illusions such as whorl patterns (Fig. III.6) and labyrinths, and black-and-white mosaics (Fig. III.12); they can also depend on the special conditions of emplacement under water (Fig. III.10). Greater independence from the ensemble characterizes the other type of mosaic panel, which consists of a vast repertory of framed pictures, initially taken from pictorial sources but later self-generating. These include isolated pictures of different kinds and subjects, collections of related scenes or episodes carefully separated by ornament (Fig. III.14) or by distance (Fig. III.16), enormous 'mosaic

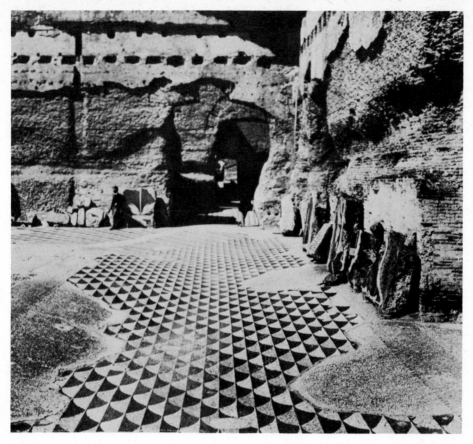

Fig. III.13 Scintillating floor mosaic in the Baths of Caracalla, Rome. About A.D. 215

paintings' (e.g. the Alexander Mosaic from the House of the Faun, Pompei, and the Circus Mosaic from the Villa at Piazza Armerina), and pictures with immediately dependent predellas (Fig. III.15). If contrasting and complementary panel shapes strongly affect the composition of the pictorial ensemble, orientation and sequence become essential factors in establishing the meaning of the individual panels, their relation to each other, and the character of the mosaic programme, especially in the well-endowed houses and villas of the rich, where they are most often found. Although mosaics do occur widely in Roman public buildings, most notably in the great baths, the complex programmes of figured mosaics seem to be more closely tied to the ideologies and tastes of private patrons, at least until the fourth century. Private commissions lead to iconographic schemes of individualized, even idiosyncratic meaning, difficult to interpret, and to capricious selection or cultivated posturing. Yet such elaborate programmes tend to confirm the close relationship between the figured mosaics of the later Empire and the earlier ensembles of wall-painting brought to light in the private residences of Campania (see pp. 154 ff.).

The range of subjects and themes represented on these figured mosaics is similarly comparable to the vast repertory of Roman painting, and like it shows the progressive attenuation of the Greek models and their replacement by new forms

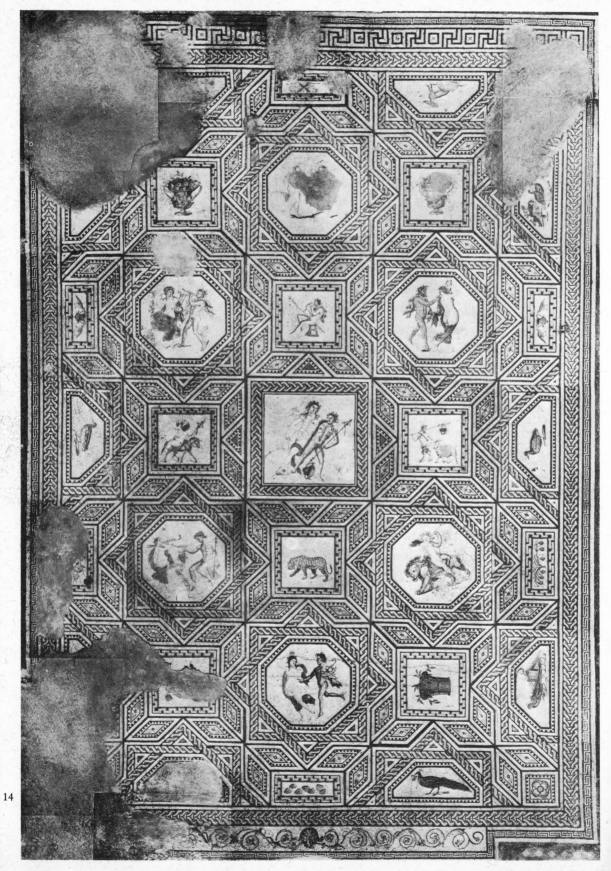

14

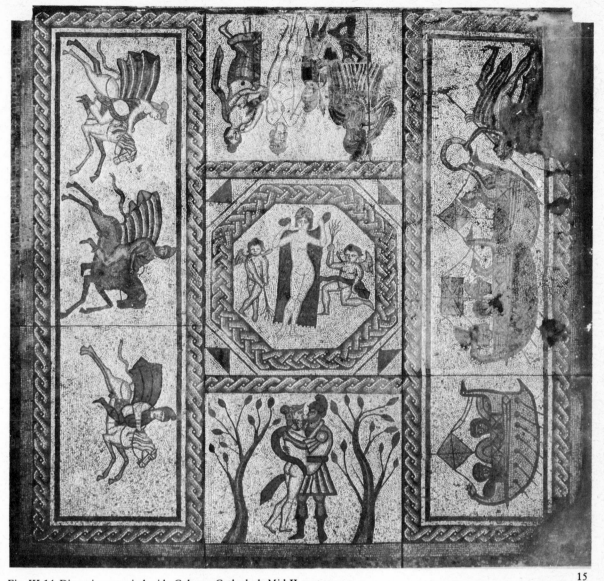

Fig. III.14 Dionysiac mosaic beside Cologne Cathedral. Mid-II century A.D.

Fig. III.15 Mosaic with Vergilian echoes, from Low Ham. IV century A.D. Taunton, Castle Museum

and methods of composition. The greatest changes probably concern the continual reduction of illusionistic space, the liberation of colour from the task of modelling, and the gradual enlargement of the tessera (Figs. III.1, 16), but the repertory of images survived for centuries with extraordinary persistence, indicative of the great strength of classical culture. The subjects include still-life and landscape (Fig. III.17), scenes taken from the popular theatre (Fig. III.1) and from the schools of philosophy and rhetoric, and the genre aspects of rural life on a great estate (Fig. III.18). The excitement of the chariot race in the circus was a favourite subject (e.g. the Circus mosaic from Piazza Armerina) and so was the bloody violence of the arena (Fig. III.11) and of the hunt. Historical episodes and topics also appear occasionally, either drawn from the Greek repertory (e.g. Alexander Mosaic, Naples), or from

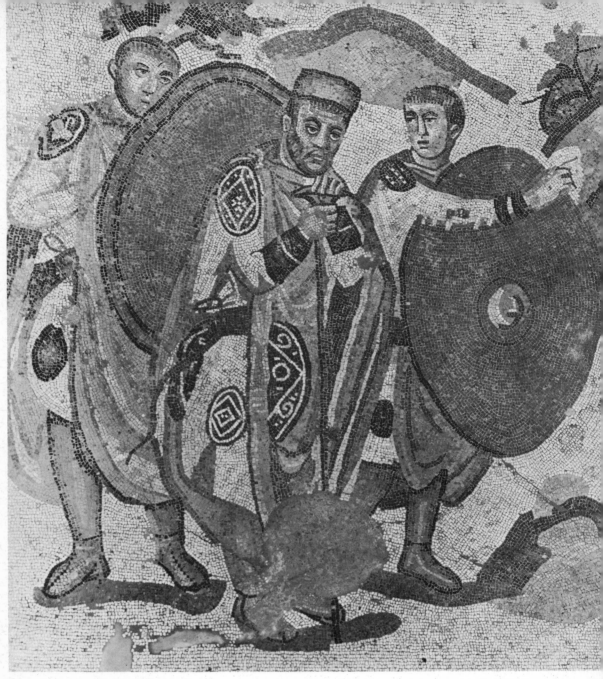

16

the incessant barbarian wars, or from ceremonial happenings, such as the Advent of the Master, Piazza Armerina (Fig. III.16).

These well-defined *topoi*, carefully formed out of the material of worldly experience, vied in popularity with the traditional subject matter of classical mythology. The legendary deeds of the Greek heroes enjoyed their usual patronage at all levels of sophistication, while the Greek and Roman deities dominated many panels either as individual presences (Fig. III.14), or in Olympian associations (Fig. III.15), or in the epiphanetic roles of Bacchus or Orpheus. Personifications of all kinds peopled the mosaics with natural spirits and anthropomorphic abstractions, sometimes appearing in the guise of Seasons as symbolic busts complete with attributes (Fig.

17

Fig. III.16 The Advent of the Master, mosaic from the Villa at Piazza Armerina, Sicily. Early IV century A.D.

Fig. III.17 Mosaic with landscape and wild animals, from Hadrian's Villa, Tivoli. A.D. 125–150

Fig. III.18 Mosaic with rural scenes. Mid or late III century A.D. Cherchel, Algeria

18

III.19) or in the composite forms of fantastic creatures of the sea (Figs. III.10, 12). Portraits of poets and philosophers, excessively familiar in Roman sculpture (see pp. 166 ff.), were relatively infrequent in mosaics, although the *topos* was a prestigious symbol of cultivation and their appearance would have been consistent with the use of genre types in the second- and third-century mosaics produced by North African workshops. However, the representation of literary, even Vergilian themes survived into the fourth century, perhaps most poignantly in the mosaic from Low Ham in Britain (Fig. III.15). Yet in the same province at about the same time the Christian Chi-Rho was competing with Neptune in the mosaic from Frampton near Dorchester, and the haloed figure of Christ himself (?) appeared in the pavement from the Roman villa at Hinton St Mary (Fig. III.20) not far away.

Some Roman mosaics are signed (Dioscurides of Samos), some repeat the name of the Greek artist from whom the model descended (Sosos of Pergamon), but the great majority are anonymous. Unknown artists created them, working with fellow artisans in roving studios, and receiving little honour for their effort, however fine. Still, the Roman mosaicists have left behind magnificent monuments to their skill as craftsmen, wild about colour and sensitive to the problems of two-dimensional design. Their works of art have a value beyond themselves in that they preserve the most extensive visual record of Roman pictorial motifs and techniques of composition, given the nearly total disappearance of that perishable medium, painting.

19

2. WALLS Roman mosaics and stone revetments crept up the walls after the retreat of painting in the second and third centuries A.D., but before that time painting had dominated the surface of the interior, plastered wall in every type of Roman architecture. Unfortunately the destruction of the Campanian sites by the eruption of Vesuvius in A.D. 79, which preserved the wall-paintings of Pompei, Herculaneum, Stabiae, and the neighbouring villas, has distorted the history of Roman painting by its very fortuitous selectivity. Wall-painting, tendentiously fixed to the requirements of interior decoration, is only a very special, if important part of the entire range of Roman painting, which once included independent panel pictures painted on gesso in a fresco technique or on wood with a wax medium (*encaustic*), drawings (Fig. III.21), and illustrated manuscripts. However, the great masters, occupied by wealthy patrons in the capital cities, did not work as house painters, even if an outstanding artist like Fabullus was employed by Nero in the decoration of the Domus Aurea (Figs. I.12, 63). Therefore, the Campanian paintings and those from second- and third-century buildings in Ostia rarely rise above the level of competent mediocrity, despite their considerable success as decorations. In this sense, the *pictores parietarii* (wall-painters) are directly comparable to the average mosaicist, but because of the accidents of preservation their works display neither the heights of achievement nor the stylistic variations of the Roman mosaics.

When A. Mau began to publish the paintings from Pompei in the late nineteenth

Fig. III.19 Mosaic with the four Seasons. II or III century A.D. Tripoli, Archaeological Museum

Fig. III.20 Christian mosaic from Hinton St Mary. IV century A.D. London, British Museum

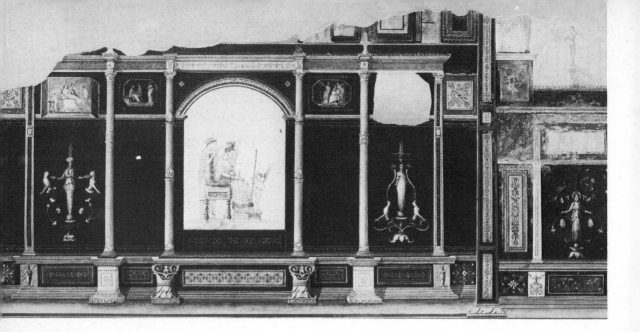

century, he was struck by a number of changes which seemed to correspond to distinct, chronologically successive styles of wall-painting. He classified them as the *First* (or encrusted) *Style* (late second to early first century B.C.), the *Second* (or architectural) *Style* (mid to late first century B.C.), the *Third* (or capricious) *Style* (Augustus to Claudius), and the *Fourth* (or composite) *Style* (Nero to A.D. 79). These somewhat arbitrary divisions have stuck, although they are no longer considered accurate guides to formal criticism nor are they clearly sequential, since Third Style overlaps Second and Fourth. They do, however, correspond loosely to three distinct intentions about the painted decorations of the room, which were both influential

Fig. III.21 Painted wall from a Roman house by the Farnesina. About 30 B.C. Reconstruction

Fig. III.22 The House of Sallust, Pompei: First-Style painting. Late II century B.C.

Fig. III.23 The House of the Griffons, Rome: early Second-Style painting. Early I century B.C.

22

and contradictory. The painter might seek either to manifest the architectural presence and functions of the wall as a solid, which he then articulated by real or painted mouldings (Fig. III.22), or to transform the wall into a transparent window to the outside, extending the room beyond its physical boundaries through illusion (Figs. I.56, 57; III.23, 24), or to acknowledge the wall as a surface and then proceed to ornament it as if with wallpaper (Fig. III.25). If the so-called First Style respected the wall as a solid, the Second moved toward illusionistic transparency, and the Third became superb wallpaper with a few tricks thrown in, but the Fourth Style seems to have combined all three discrepant attitudes in restless resolution (Figs. I.63; III.26).

The First Style was a creation of hellenistic interior decoration, well known at Delos and even earlier at Panticapeum. In typical Greek fashion this style emphasized the horizontal upper and lower edges of the wall by plaster or stucco mouldings and then ordered the vertical face by the semblances of masonry or stone veneer, rendered in painted plaster; the House of Sallust at Pompei preserves this

23

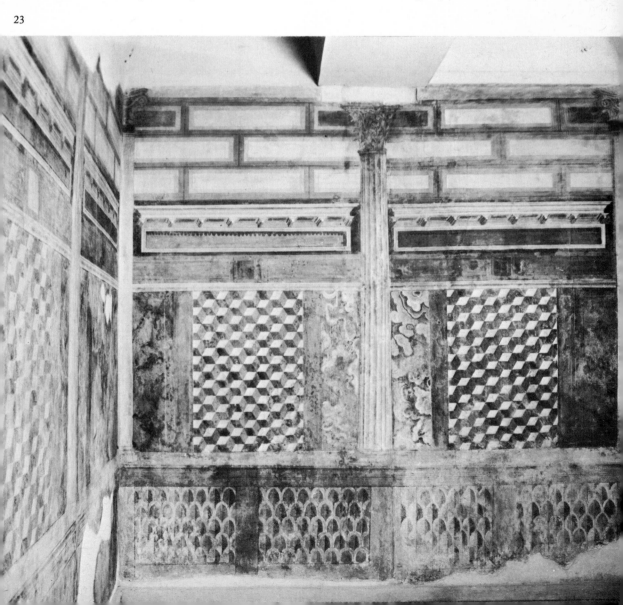

encrusted, masonry type of decoration (Fig. III.22). The Second Style may have been a Roman invention, appearing in its first tentative stages about 100 B.C. in the House of the Griffons on the Palatine (Fig. III.23), but rapidly developed into the exciting, liberating architectural prospects of the Villa at Boscoreale after mid-century (Fig. I.57). This translation of the prospect into a coherent rationalized perspective could not have taken place without the development of both a perspectival technique in contemporary Roman painting, probably drawn from the scenographic inventions of the Greek stage, and a desire to impose visual, and hence human, control on the exterior world. In its purest form the Second Style dispensed with the wall completely, opening the once opaque plane into extended architectural vistas (Fig. I.57) or into an open, inviting garden (Fig. I.56), as if the spectator had been transported to the outside beyond the confines of the chamber. The Third Style indulged in capricious whimsy, taking great delight in the pleasures of elegant, attenuated ornament, delicate forms and colours, and small-scaled motifs (Fig. III.25). This Style was also unconventional, even mannered, as the painters deliberately rejected the monumental constructions of the Second Style and toyed with partial perspectives and the unstable separation of planes, effected by the juxtaposition of solid areas of black, red, green, blue, and yellow, bounded by thin, vibrating bands. Although fundamentally surface decoration, these paintings were possibly the first to evince the visual implications of a conception of the wall as being there and not there simultaneously.

This recognition of the ambivalent intentions of decorative wall-painting seems to have become the basis of the Fourth Style with its restless architectural schemes, *trompe l'œil* illusions of pictures, objects, people, and vistas, and swift transitions between actual stucco mouldings and their painted continuation. Fourth Style decoration appears extravagantly in the Pompeian houses, such as those of the Vettii (Figs. I.14a; III.26), of Pinarius Cerialis, and of Loreius Tiburtinus after the earthquake of A.D. 62, and was probably developed and made fashionable by the painters working for Nero on the Domus Transitoria and the Domus Aurea (Figs. I.12, 63) in Rome. Never before, and never again, was Roman wall-painting charged with so much energy. A near-surfeit of images, effectively controlled by a sure touch and presented in three dimensions through great skill in colour modelling, anticipated in paint the barrage on the spectator's eye subsequently given forth by second- and third-century architecture (Fig. I.61) and late opus-sectile environments.

After the destruction of Pompei, the styles of Roman wall-painting are no longer numbered, and the history and development of painting are difficult to trace. Many of the earlier decorative motifs remained in the repertory for two hundred years, but the schemes, methods, and objectives of composition, and the constitution of the palette, underwent many changes, consistently moving in the direction of increased figural isolation and patterning at the expense of illusionistic modelling and spatiality. Broadly speaking, there seem to have been two distinct ways of treating the wall, both of them founded on traditional modes of composition. More prevalent is the continuation of a stabilized Third–Fourth Style repertory, consisting of fewer but larger elements, set on a pale or cream-coloured ground, and painted thinly in

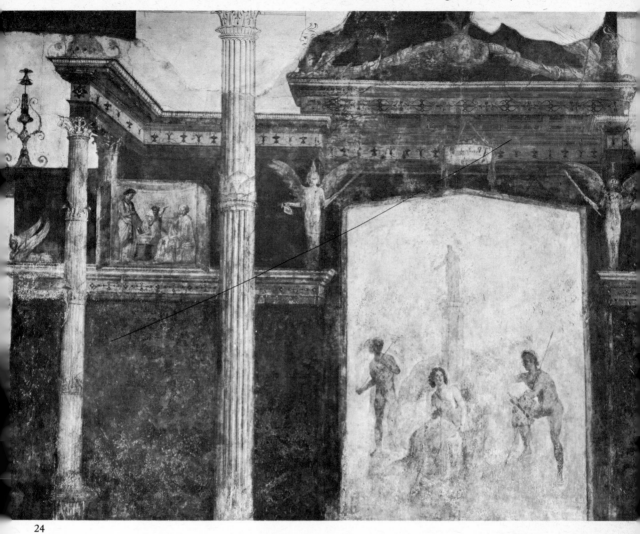

24

Fig. III.24 A House
of Livia on the
Palatine: Second-
Style painting.
Mid-I century B.C.

Fig. III.25 Casa del
Frutteto, Pompei:
Third-Style
painting. Early
I century A.D.

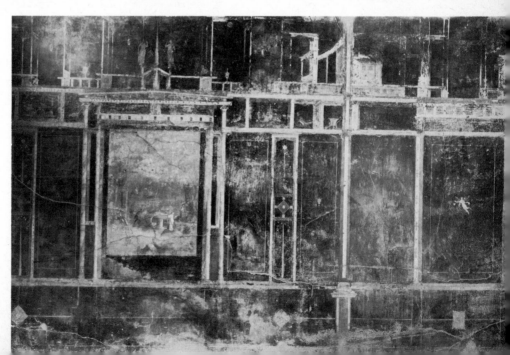

25

almost transparent shades on the plaster wall. These features characterize the paint-
ings from Hadrian's Villa at Tivoli as well as the cruder decorations of the House
of the Yellow Walls in Ostia, but enjoyed their greatest currency in tombs, such as
those of the Anicii, the Aurelii, and Valerii (cf. Fig. I.11) on the Via Latina outside
Rome. Perhaps the domination of this compositional type in tombs and especially
in catacombs may have been due to the use of a light ground and gay motifs, which
would enliven the dark tomb and convey some small suggestion of paradise. Or,
perhaps less poetically, these designs were simple to execute, adapted themselves
well to small areas, and required lesser skills.

The second approach to the wall in late Roman painting conceived it as a large
panel almost devoid of architectural significance but responding to the shape of the
room as a whole, to the source(s) of light, and to the visual entry of the spectator.
This conception had previously affected several of the greatest extant paintings of
the Second Style, in particular the monumental friezes from the Villa of the Mys-
teries, Pompei (Fig. I.55), the Villa of Fannius Sistor at Boscoreale (Fig. VI.17), and
the Odyssey Frieze, Vatican, from the House on the Esquiline in Rome. These
friezes, however, were held within an architectural scheme which provided a rela-
tively coherent spatial reference for the entire painting as well as for the individual
figures or scenes they contained, but that grasp weakened in the later centuries. In
a third-century painting from the house under SS. Giovanni e Paolo in Rome, Venus
is seen floating gently on a wall turned into the sea, anticipating the loosened figures
and unfixed scenes of the catacombs, but the whole composition seems to lack refer-
ence to any visible point outside of itself. Another third-century painting, found in

26

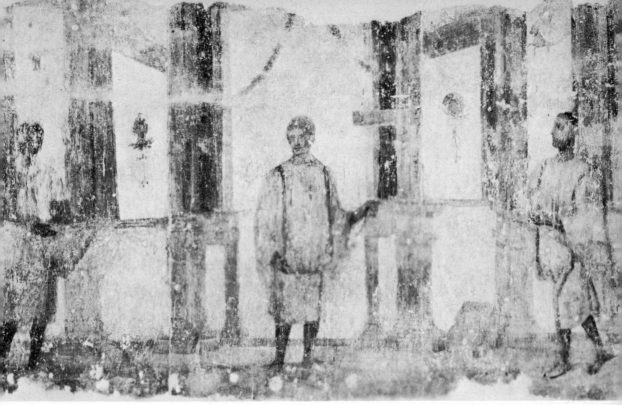

Fig. III.26 The House of the Vettii, Pompei: Fourth-Style painting. Mid-I century A.D.
Fig. III.27 The House of the Praecones, Via dei Cerchi, Rome: wall-painting. Early III century A.D.

a Roman house under the Via dei Cerchi in Rome and probably representing a pro-cession of dignitaries (Fig. III.27), appears to fold and unfold laterally like some oriental screen as it passes alongside the corridor from which the painting is set off by a small dado. This dado in other paintings of the same or a slightly later period is treated not so much as a device of spatial division but rather as a flat decoration of the lower edge of the wall, where no great effort would be expended, possibly in emulation of opus sectile. But the dado could also be used to effect a psychological and spiritual separation between the image and the viewer within a sacred environ-ment, such as that offered to the congregation of the mid-third century Synagogue at Dura Europos in Syria. In this context the painters have turned away from the problem of composing the wall as decoration to the more solemn task of presenta-tion, focusing the attention of the viewer-worshipper on the various epiphanies of his deity, much as other artists were commissioned to do for the sanctuaries of Mithras (Fig. III.28) and for the Christian catacombs. Ironically, perhaps, this trans-formation of the sacred wall into a force-field of divine power occurred at about the same time that elaborate painted wall decorations began to disappear. They were replaced by simple painted reproductions of contemporary geometric patterns in opus sectile, almost in the manner of the long-abandoned First Style but without its vivid coloration.

The paintings of the Dura Synagogue, of the various mystery cults, and of the catacombs also emphasize the great importance of the pictorial ensemble and of the individual panel or register as meaningful representation. The significance of

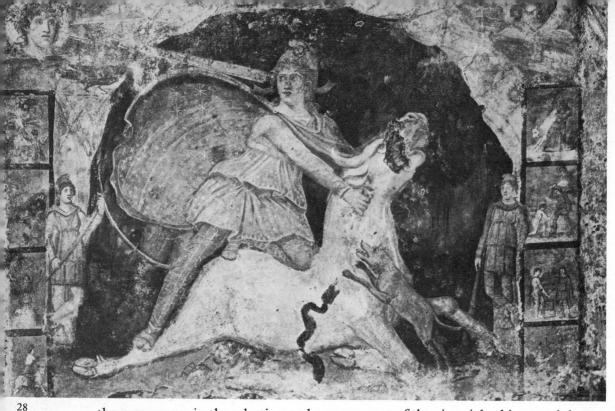

the programme in the selection and arrangement of the pictorial subjects and themes has long been recognized as a governing principle in the organization of both secular (Fig. I.14a) and religious paintings (Fig. I.55), even if the specific meaning may be difficult to discover. In addition, the thematic association of subjects had long been a rhetorical topic, easily translated under the aesthetic stimulus of the doctrine of 'ut pictura poesis' into the elaborate, if far-fetched relationships suggested by Philostratus' visit to a picture gallery, artfully presented in his *Imagines* about A.D. 200. Understandably, it is the individual picture panel that carries the burden of significance as the primary field of images, probably because of the original development of the independent painted panel in the hands of the great masters, many of them Greek artists of the fifth to third centuries B.C.

The figured panels in Roman wall-painting offer two distinct levels of representation: they refer to their described subject matter, be it mythological or religious, historical or fantastic, anecdotal or descriptive, and they refer to themselves as pictures, based on other pictures. Indeed, many of these 'pictures', e.g. those from the Farnesina (Fig. III.21) and from the House of Livia on the Palatine (Fig. III.24), are clearly derived from different sources, media, and periods, but frequently they are also to be distinguished stylistically from the decorative context in which they exist. Several Pompeian houses have preserved panels with lead borders, indicating that the panels were removable and could be exchanged for others of a similar dimension whenever the owner of the house so desired. This invisible collection of prestigious or significant pictures, drawn from a large pool of standard-size favourites, proves the existence of an active trade in reproductions of the great masters, from which it has been possible, even tempting, to reconstruct the Greek originals. However, a comparison of two paintings representing the same subject, 'Theseus Rescuing the

Fig. III.28 The Mithraeum, Marino: wall-painting. Late II century A.D.

Fig. III.29a Heroic Theseus, slayer of the Minotaur: painting from Herculaneum. Mid-I century B.C. Naples, Museo Nazionale

Fig. III.29b Heroic Theseus, slayer of the Minotaur: painting from Pompei. Early I century A.D. Naples, Museo Nazionale

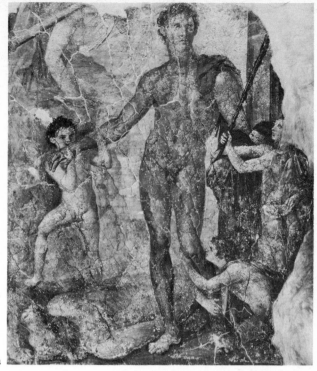

29a

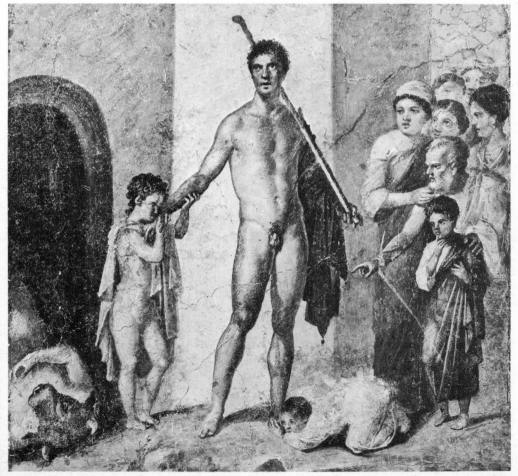

29b

Athenian Children from the Minotaur', one from Pompei (Fig. III.29b) and the other from Herculaneum (Fig. III.29a), reveals significant changes, even if both indisputably go back to a common model. Certainly, the identification of such models is fundamental to the establishment of the repertory available to Roman painters and their patrons. Yet the act of selection and the deformation of the models probably reflect even more closely the pictorial vision of the painter and his client, and their taste as Romans.

The repertory of subjects is enormous and has occupied most historians of Roman painting, as their publications demonstrate. No brief catalogue can do justice to the marvellous variety, but one should notice the differences in the shape, size, and orientation of the panels, since they develop different degrees of intimacy with the beholder as they assume roles of greater or lesser visual importance. Vertical rectangles apparently were preferred for the larger pictures, horizontal rectangles for the smaller, but squares, circles, and even long, narrow friezes were also used. Similarly, differences in scale between large figures in large spaces, small figures in large spaces, and small figures in small spaces were manipulated by the artists to create distinct moods, not always appropriate to the ostensible subject of the picture but rather deliberately chosen for their suggestive effect on the spectator. These hidden subjects of Roman painting, so fully sharing in that peculiar psychic aggression that characterizes so much of Roman art, must be distinguished from the conventional repertory of well-categorized themes that fill these pictures with handsome images.

Panels may contain vast landscapes (Odyssey frieze, Vatican), 'realistic' architectural visions (Figs. I.46, 57), evocative, magical groves, and delicate, monochromatic dreams in the manner of a Sung painting. They can also display a repertory of mythological and legendary episodes, more or less literary in origin, usually divided into large, vertical panels (Fig. I.14a), but occasionally presented either in long friezes, such as those from the Tomb of the Statilii in Rome and from the House of the Cryptoporticus, Pompei, or in numerous small panels (Fig. I.12). Whimsical fancies with gnomes, children, and Cupids were very popular, as were apotropaic images, portraits, still-lifes, and even advertisements of products and services for sale, from foodstuffs to prostitutes.

Some Roman artists were capable of producing fine work, whether drawn from Greek models as the picture of 'Hercules and Telephos in Arcadia' from Herculaneum or in spontaneous Pompeian response to the scintillating appearance of coloured light (Fig. III.30). But Roman wall-painting is principally the achievement of artisans employed in the pleasing decoration of surfaces. In that capacity, their work must always be seen not only in the context of the entire local programme of wall-painting, but also in relation to the ceilings above, themselves usually painted and stuccoed.

3. CEILINGS AND VAULTS Ceilings, whether flat or vaulted, are most vulnerable, and when they collapse, their decorations are destroyed. Given the paucity of standing buildings, it has been very difficult to reconstruct either the vocabulary of ceiling ornament or the systems of its application, although attempts have been

Fig. III.30 Male head: detail of a Fourth-Style painting from the Temple of Isis, Pompei. Mid-I century A.D. Naples, Museo Nazionale

made to do so in archaeologically secure situations. Evidently, the profile and section of a room-covering greatly influenced the decorator in his choice of appropriate designs, as did the exigencies of constructing large spans, but whatever the shape and physical character of the ceiling, two problems seem always to have been present in his mind: the expanse as a field with or without a developed centre, and the hinge-like edge where ceiling meets wall. These considerations recall the design responsibilities of the floor-mosaicist and there are many reflective correspondences between the compositions of floors and ceilings in Roman interior decoration, since

they are both dependent on the same basic plan. However, one does not walk on but beneath ceilings. This great difference in function and position led the plasterers, painters, and mosaicists who adorned these flat ceilings and curving vaults to acknowledge the psychological importance of overhead release in their designs. Lightness, aided by the high placement of windows in large rooms, and the reality or illusion of surfaces curving away from the spectator contributed to this effect, even if Roman designers never reached the heights of an Andrea Pozzo. Within the parameters of this fundamental objective, the definition of the ceiling edge by bands or mouldings, the choice of materials, and the decoration of both square or rectangular flat ceilings and every type of curving or segmented vault played their parts.

In Roman ceiling decoration the scheme is the thing, not the material. To a very large extent the artists used the available materials interchangeably, but without neglecting the peculiar visual properties of flat paint, projecting stucco, gleaming mosaic, and even wood, often applied in combination. Perhaps the simplest motif, developed from wooden forms, was the coffer, which allowed the artist to impose on the ceiling an uncomplicated, strong, all-over pattern, subject to controlled variation within the coffered frame, and stressing the grid-like network of the borders as a structural paraphrase. Coffers were often used for flat ceilings, especially in flat-roofed basilicas, sometimes in combination with brightly painted terra-cotta plaques, as in the Synagogue at Dura Europos, or with large painted panels, as at Trier (Fig. III.2). Coffering traditionally bridged the decorative gap between column

Fig. III.31 Pythagorean underground Basilica, Rome. Late I century B.C.

Fig. III.32 Ceiling in the House of the Painted Vault, Ostia. A.D. 150–200

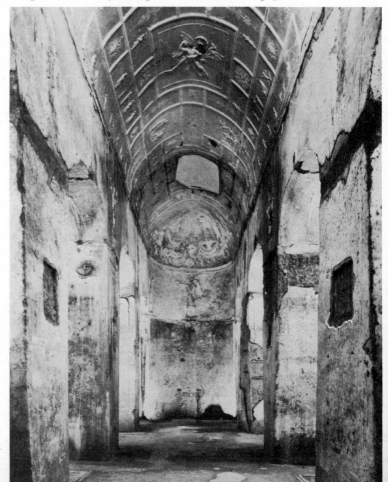

31

and wall, if not always with the confusing exuberance of Baalbek, where the frames were somewhat obscured by carved ornament; similarly, annular and barrel vaults were frequently decorated by coffers, their openings filled with floral motifs in eruption as on the vaulted passages of Roman triumphal arches. In all these examples the size of the coffers essentially remained constant, but in two instances changes in dimension and/or profile occurred in conformity with the projection of the vault to which they were attached: the diamond-shaped coffers on the apse of the Temple of Venus and Roma, Rome, and the proportionally diminishing coffers of the Pantheon (Fig. I.7c). The latter coffers, formed in stucco, have no static function whatsoever, but instead provide an illusion of structure, comforting within the vast space. They also articulate the great domical vault through an almost cartographical system of co-ordinates, and in their recessions respond to the play between square and circle in the floor below (fig. I.7c, d).

Coffering as a system of ornament must be distinguished from the application of stucco and plaster to flat or curving ceilings, modelled by hand or pressed by patterned moulds into three-dimensional designs without structural pretence. The technique may have developed as an extension of the need to protect damp interiors from the effects of moisture, but the repertory of framing devices, continuous patterns, and decorative motifs seems to depend on pictorial sources, especially in miniature. Fine stucco decorations have survived fragmentarily in some Campanian

32

and Ostian houses, as well as in the Farnesina, Rome, in the Garden House of Livia at Prima Porta, and in the cryptoporticus or underground corridors of many Roman villas. Even the vaulted entrances of the Colosseum were covered in this way, as recorded by Renaissance drawings, but perhaps the best preserved ensemble is that which still covers the vaults of the so-called Pythagorean Basilica near the Porta Maggiore, Rome (Fig. III.31), dated to the late first century B.C. The superb vault stuccoes of the later Tombs on the Via Latina (Fig. I.11) reveal how precisely subtle stucco ornament could be, posing artful contrasts between delicate figure and clear ground which maintain a continuous pattern without losing the integrity of the individual forms. However, these schemes were not employed solely by the plasterers but relate very closely to the development of all-over roundel patterns, equally popular in decorative painting, mosaics, and textiles as a method of creating a coherent ornament without beginning or end.

Many of these stuccoes were painted or were closely associated with paintings, if not always so successfully integrated as in the Domus Aurea (Fig. I.12), and many ceilings were painted with designs drawn from a single repertory. This free interchange between painting and stucco is equally evident in the composition of the Insula of the Painted Vaults at Ostia (Fig. III.32), where the photograph conceals the nature of the decorative materials but not the open effect of the design. Furthermore, this Ostian room also shows a newly sophisticated interaction between ceiling and wall, now closely joined without a clear, horizontal division, seemingly expressing the artist's desire to create a single interior subject to the same pervasive system of design. Such a unitary approach is also implied by the paintings of vaults with large, unframed pictures, as in the early third-century Hunting Baths at Leptis Magna, which drew attention upwards to the rising, curving side of the wall. But the second and third centuries also saw the spread of mosaics, first upward onto the wall and then into the vault, as attested by a number of late Roman baths, apparently in response to a similar impulse toward comprehensive unity. This decorative concept clearly emerges from the late Roman conversion of architecture into unified shells whose inner surfaces were to be as richly decorated as possible. The resultant effect could be sheer splendour.

c. Sumptuary Arts Although the virtuous Romans of the Republic legislated firmly against conspicuous and costly personal and domestic ornamentation, they loved it so much that the laws were ineffective. For the rich nothing was impossible and they lived in a manner comparable to the Prince Regent in Nash's Pavilion at Brighton. They wore garments more and more heavily embroidered in rich colours (Figs. III.16, 9), and fitted with elaborate jewellery, consisting of large gems set in gold mounts, and great gold pins (Fig. III.33). They sat on inlaid furniture made of costly materials including ivory and metal (Fig. III.34), in rooms illuminated by gilded bronze lamps and scented by burning incense; their tables were laden with silver and gold dishes (Figs. II.36; III.36); elegant flagons and vessels of glass added glistening brightness; and their environment was further enriched by song birds in gilded cages, scented fountains, and musical choirs. If not everyone was or could

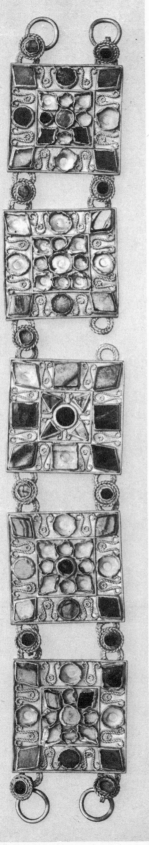

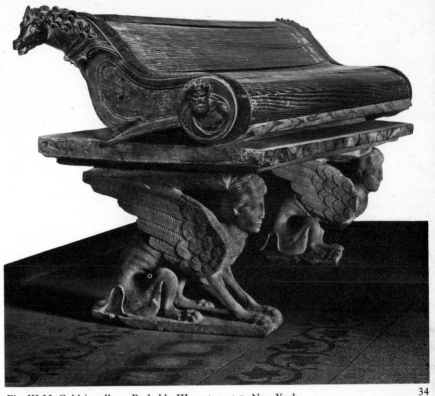

34

Fig. III.33 Gold jewellery. Probably III century A.D. New York, Metropolitan Museum of Art
Fig. III.34 A garden chair from Pompei. I century A.D. Naples, Museo Nazionale
Fig. III.35 Arettine ware from the workshop of Marcus Perennius. About 30 B.C. Arezzo, Museo Archeologico

33 35

aspire to be Nero at splendid ease in the Domus Aurea, surrounded by an opulent world of sensual delight (Suetonius, *Life of Nero* 31), he made every effort to emulate the Emperor as much as possible. Bronze pins might be substituted for gold, simple pottery (Fig. III.35) for silver dishes and bowls, coarse garments for elegant stuffs, and imitations of all kinds kept the industrial workshops busy. Indeed, the pursuit of visual stimulation and the pleasure of possession seem to have been common to all levels of society.

Wealthy Romans were habitual collectors, buying pictures, drawings, statues, and statuettes for display in their houses (Fig. III.21; Fig. A), in the porticoes of their peristyles, and in their gardens. These precious works, often Greek originals or close replicas, were considered consciously as objects of art, the natural expression of a cultivated man of taste who enjoyed the aesthetic pleasure they could give him. Yet these objects also served as the *mark* of a cultivated man, and in this capacity not only were they subject to the same motive of ostentation that ruled so much of his life, but they must also be understood in the context of Roman decoration, since they formed part of the visual, ornamental ambience of the owner's existence. Fortunately this motive, however it may be judged, preserved many Greek master-pieces for a later time, and so justified to the philhellenes the vagaries of Roman taste and its passion for significant display. But Roman taste has its own rationale.

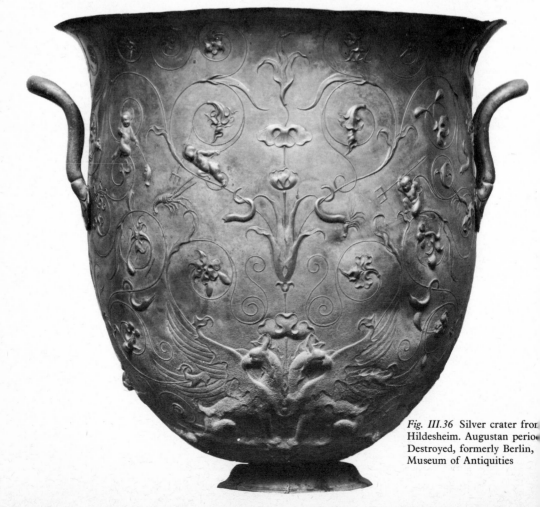

Fig. III.36 Silver crater from Hildesheim. Augustan period. Destroyed, formerly Berlin, Museum of Antiquities

Chapter IV
Roman Realism:
Curiosity about Peoples, Places, Things, and Events

FOR the Romans, facts were stubborn attractions. They constituted both the perceptible data on which men organized their experience of the world and the prime subject matter represented in works of art, created to reflect that world and to overcome its transiency. Whether the product of a primitive mentality which gives power to things, or of a semi-scientific, even encyclopedic curiosity about *how* and *what* things are, the Roman mind seems to have expressed itself most completely in the meticulous description of the visual and temporal facts of human existence. The emphasis lay on a concerted effort to capture the surface of reality and not on the analytical investigation of natural, physical phenomena and their causes. For this reason, the Elder Pliny's multi-volumed *Natural History* with its materialistic categories is much more representative of Roman scientific interest than the phenomenological concerns and speculations developed by late Hellenic Stoicism and Neo-Platonism. Pliny took such intellectual and spiritual comfort in what was explicit, as if the essense of experience could be captured by a careful, reductive description of its external manifestations.

The descriptive intent is wholly consistent with the Romans' marked predilection for the expression of outwardness in all artistic media and stimulated the peculiar pursuit of appearance, manifestation, and display ingrained in Roman art. This attitude led directly to an obvious appreciation, even relishing, of the immediate visual experience, often without a beautifying gloss, although neither the selection of subjects nor their representation was innocent. Perhaps it was the intensity of this actualizing sensibility that made Romans of the late Empire so vulnerable, when the achievements of men and their sensual experience of the world were suddenly devalued by that destructive tendency to concentrate all positive energy on the supramundane, spiritual realm of the soul (see pp. 186ff., 253ff.). Although this development signals the ultimate admission of transiency as a fact of existence and the relative unimportance of sensible facts, Roman artists had long before created their formal response to the challenging possibilities of a concrete reality, a response which they brought to superb fruition in two of the most characteristic motifs of Roman art: portraiture and anecdotal history.

Both portraiture and history-painting or historical reliefs contained the complementary ingredients of representative description and didactic clarity, the accuracy of one reinforcing the effectiveness of the other. Ease of recognition was always the key to the Romans' attitude about explicit representation, conditioned familiarity its basis, and quickness of comprehension its measure. Accordingly, a theatrical or

rhetorical impulse shaped these motifs because the artist sought to impose a pre-determined response on the viewer, as if he were the member of a general audience whose feelings might be stimulated. In this circumstance, such works of art did not and could not stand alone, and being intended for an appreciative reception, they became incomplete without it. Portraits were consciously made for others beside the portraitist and his subject, while the story-telling artist presented well-coloured historical episodes to a public tendentiously. Because role-playing and careful staging so deeply affected the presentation of portraits and of historical events in Roman art, it is evident that, beneath the mask of ostensibly realistic description, self-advertisement and the exercise of influence were the dominant motives. Unfortunately, the Roman public has disappeared, and only the frequency of the surviving images attests to the dramatic success of these monuments, which preserve the appearance of long-dead men and women and the colour of their accomplishments.

a. Portraiture Roman portraits are reminiscent of political speeches of introduction in that they always seem to present 'the person who . . .', thereby both establishing the identity of the individual portrayed and placing them in a differentiating context. If, as some scholars have alleged, Roman portraits have their origin in the old Republican practice of making posthumous or fictional portraits of distinguished ancestors to parade on public occasions (see Preface) or to keep in a sacred place among the household treasures and gods of the great families, then these joint motives of preservation and celebration were present from the very beginning. Subsequent Greek influence in the making of elaborate marble or painted portraits, and the absorption of well-established portrait types, merely extended the range of formal possibilities without essentially changing the explicative function of these portraits nor their concern with the manifestation of the individual, wrapped, as it were, in whatever pomp and circumstance he could muster.

An early first-century A.D. statue in Rome epitomizes very well these rhetorical, self-declamatory portraits (Fig. IV.1): a dignified Roman, dressed in a voluminous toga, and holding two busts in his hands. The imagery is straightforward but not simple, because the toga indicates that he was a Roman citizen, the marble life-size statue suggests that he had money and prestige, and the busts—portraits within a portrait—represent his ancestors, not of the same generation, proving that he had a distinguished lineage and implying that he has continued the honourable family tradition, so that he might be similarly treated by his progeny. Although the head on the statue is ancient, it does not belong. Nevertheless, the present reconstruction is iconographically sound, since the specific identity of the subject, established by the particularized features of the original head, has been conceived as a symbolic addendum without regard to the integrity of the body. It would seem, therefore, that the sculptor had created the head as the principal visual clue for purposes of identification, set into a well-orchestrated environment similar in conception, if not in intent, to the scenic flats with cut-outs for faces, popular among resort photographers early in the twentieth century. Indeed, the many headless togate statues that survive from antiquity are analogous to stage-sets without actors, even more so

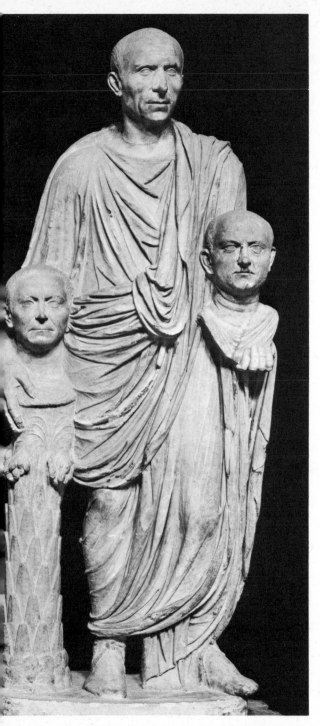

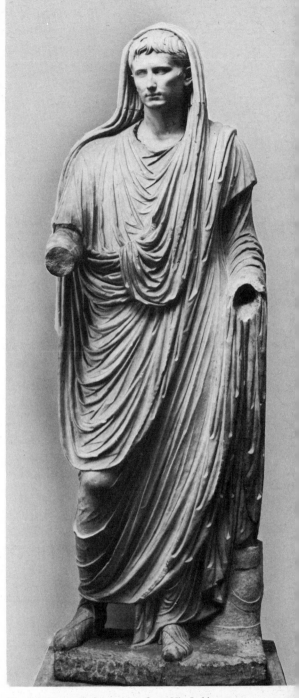

Fig. IV.1 Statue of a Roman with busts of two ancestors.
(Head is antique, but not original and restored.)
Rome, Palazzo dei Conservatori

Fig. IV.2 Statue of Augustus from Via Labicana.
After 27 B.C. Rome, Museo delle Terme

when the sunken hole between the shoulders was prepared by a sculptor's workshop, in advance, to receive a head (and an identity) carved and inserted by the master portraitist.

If the 'who' is vital to all portraiture, the identification of the 'what' spawned a battery of status-oriented types, appreciated by the Romans and fascinating to social historians. These types, corresponding to familiar roles in Roman society, are generally equivalent to class and occupational designations definitively expressed and indicated by symbolic attributes including dress, by fashions and methods of display, and even by stylistic distinctions (see pp. 200 ff.). They include the upper-class patrician (Fig. IV.2), the propertied knight or *eques* with his iron finger-ring, and the general category, Roman citizen (Fig. II.9). The military commander (Figs. II.31, 33) and the soldier-ranker appear within this group, as do the teacher, the merchant-businessman, the artisan, the gladiator, the charioteer, and many other working types. Roman artists also employed a specific vocabulary of dress to cast the Greek, often clothed in his himation or pallium, the cultivated, friendly foreigner with his peculiar costume, and the hostile barbarian (Figs. IV.36c, 37a). As usual, the provincial manifested himself by provincialisms rather than by special symbolic devices (see pp. 215 ff.).

Sometimes, the types or models were coloured by value judgements, derived in part from the hierarchical system of spiritual qualities established by the Greeks and subsequently embodied in the Roman concept, *nobilitas*. However, nobility of soul was often attenuated in transition, becoming just another level of assumed

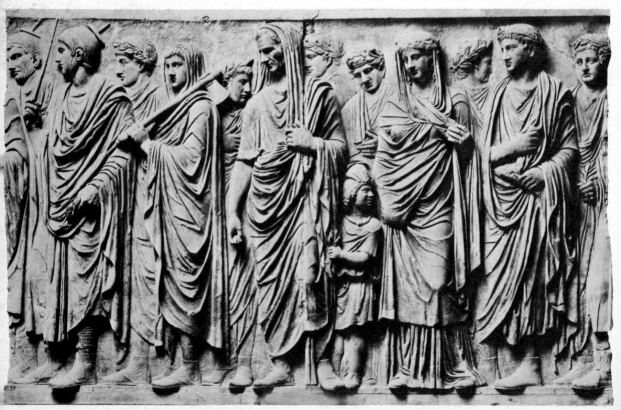

3

meaning in a grandiose performance. These prestigious representations, reeking of honour and often more pompous than virtuous, express the imagery of leadership in the traditional forms of the statesman (Figs. IV.3, 4), and of the commander as an equestrian (Fig. II.33) or as a cuirassed general (Fig. II.32). The philosopher type, well known from the abundant replicas of Greek Philosophers and intellectuals displayed by every cultivated Roman (Fig. IV.5), appeared nobly bearded and wrapped in Greek garments to signify contemporary thinkers, literary figures, savants, and highly cultured men, such as Herodes Atticus, the friend of Hadrian, and also for philosophical Emperors like Hadrian, who reintroduced the beard into Roman portraiture. This same type, seated or standing, similarly spiritualized the portraits of the deceased on philosopher sarcophagi (Fig. II.29). However, perhaps the most difficult Greek role for the Romans to play as a vehicle for significant portraiture was that of the nude male hero, sanctified by Greek classicism. The

Fig. IV.3 Procession of the Imperial Family, on the Ara Pacis Augustae, Rome. 13–9 B.C.

Fig. IV.4 Hadrian adopting his Successors: detail from great Antonine relief from Ephesus. Mid-II century A.D. Vienna, Kunsthistorisches Museum

Fig. IV.5 Statue of Sophocles, from Terracina. Augustan copy of IV century B.C. Greek original. Vatican, Museo Gregoriano Profano

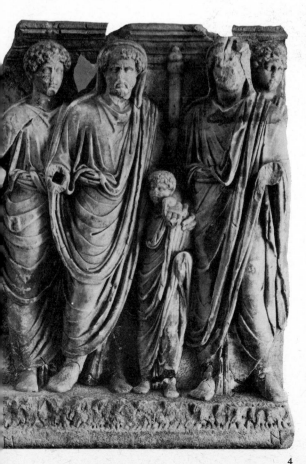

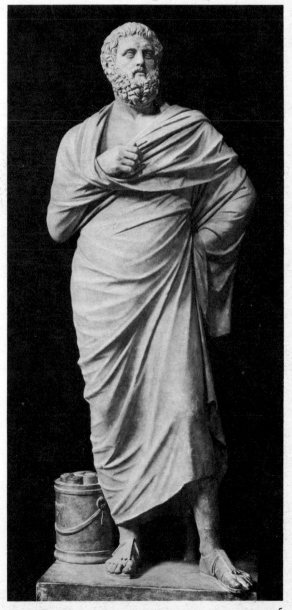

4

5

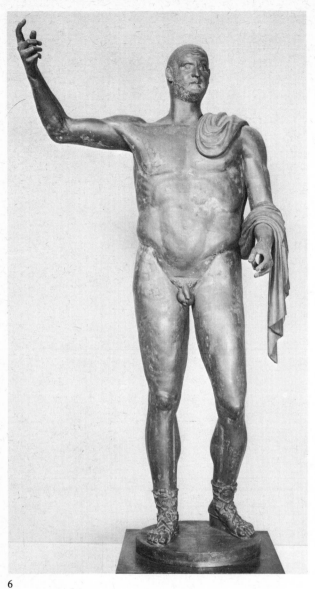

6

Fig. IV.6 Bronze statue of Trebonianus Gallus. Mid-III century A.D. New York, Metropolitan Museum of Art

Fig. IV.7a Bronze statue of Aule Metelle, 'The Orator'. About 80 B.C. Florence, Museo Archeologico

Fig. IV.7b Detail from IV.7a

discomfort caused by this adopted model is clearly registered by the naked figures of Republican generals (Fig. II.31) and of the Emperor Septimius Severus (Bruxelles and Nicosia), even by the philhellenic Hadrian at Pergamon. For the barbarous soldier-emperor, Trebonianus Gallus (Fig. IV.6), the hero transformed himself into the strong man, an overwhelming image of brute force.

But the hero as a conceptualized type, full of virtue, was also taken up by Augustan artists to express in metaphorical terms the notion of anticipated achievement, whether or not attained; they employed it in the representation of the *principes iuventutis*, leaders of the noble youths of Rome, which they adopted for the Julio-Claudian princes, and thus set the pattern for the Imperial heir-apparent. This usage emphasized the manifestation of nobility through accomplishment, an emphasis fully comprehended within the concept of *virtus* (see pp. 87 ff.) and

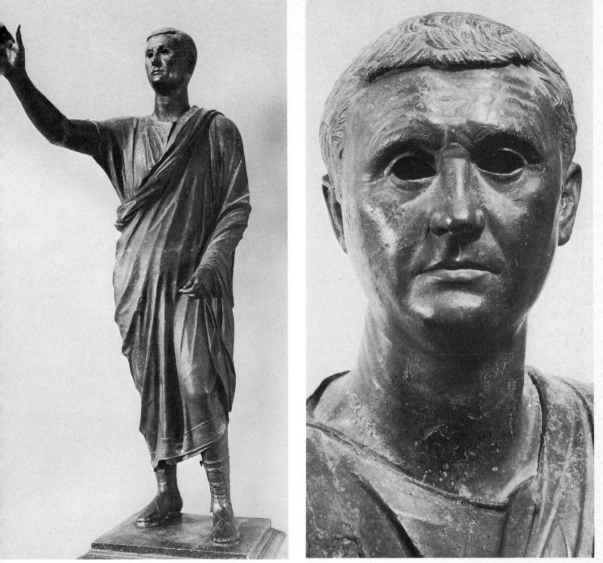

7a

7b

arising from the traditional Republican ethos of work, responsibilities accepted and discharged, sober seriousness (*gravitas*), and dignity (*dignitas*). That ethos produced its own demonstrative portrait types, including the magistrate (Figs. IV.7a, 8), the veiled priest (Fig. IV.2), the togate citizen (Fig. II.9), the paterfamilias (Figs. IV.4, 9, 10), the pair of husband and wife (Fig. II.4b), the good woman, hand to chin in the *pudicitia* (modesty) gesture (Fig. IV.11), and the dutiful soldier. Lightness, joy, grace, and beauty had no place in this somber repertory of life's burdens, categorized by profession, sex, marital status, and civic obligation.

The old gods were certainly less earthbound and much more grandiose, as the Romans and their artists quickly realized. The lineaments of the gods, their attributes and powers might be readily assimilated as sensibly potent types into the symbolic portraiture of the Imperial family or into the iconography of the hopeful

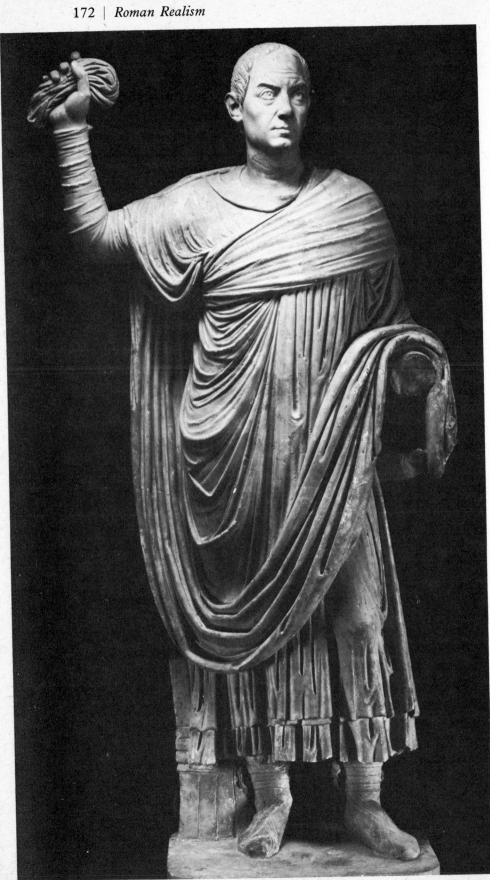

Fig. IV.8 Statue of IV century consul holding a mappa (starting flag). Rome, Palazzo dei Conservatori

Fig. IV.9 The grave stele of Lucius Vibius. Mid-I century B.C. Vatican, Museo Gregoriano Profano

Fig. IV.10 Portrait of Septimius Severus with his wife Julia Domna and son Caracalla (the other son, Geta, removed). About A.D. 205. Berlin, Staatliche Museen

Fig. IV.11 Bronze statue of Livia, from Cartoceto. Early I century A.D. Ancona, Museo

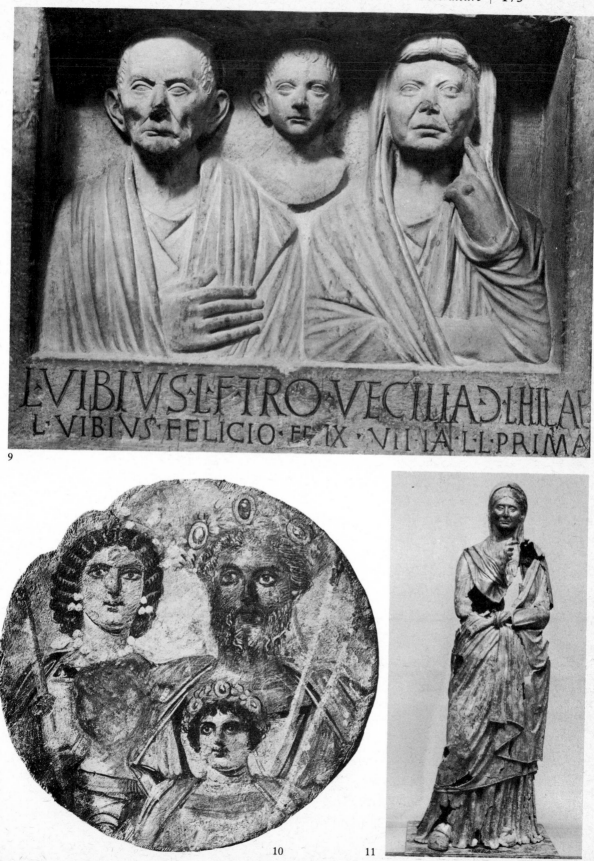

9

10

11

dead, who wished to secure the protection of a divine saviour. Accommodation, assimilation, and identification are the stages of progressive association between man and the gods, continually exploited in the representation of special persons at moments of the greatest importance, or as an informative condition of their being. Jupiter, Mars, Juno, Venus, Ceres as Abundantia, and Hercules were the divinities favoured for this purpose of exaltation. In this situation, one might think of them as transvestites whose outer appearance, mode of behaviour, typical poses, and costume might be assumed by the actor who thereby became what he had not been before. The role, however, could be pushed to great heights of overstatement. Possibly, the assimilation of Augustus to Jupiter on the Gemma Augustea (Fig. II.35) can be accepted as a meaningful expression of the Emperor's great *auctoritas*, and the incorporation of Antonia into Juno (Fig. IV.12) may be understood as a proper image of her august status. But the transfiguration of bandy-legged, middle-aged Claudius into Jupiter (Fig. IV.13) can only be seen as an elaborate put-on, legitimized by the fact that he was Emperor and hence like Jupiter all-powerful. Only because his position and the imagery developed for the role coincided, was it possible to create such a portrait and cast old Claudius in it, knowing that the mechanisms for public acceptance existed, and Claudius-Jupiter would not appear incongruous.

If Jupiter and Juno pre-empted the leading roles, Roman artists gave to other gods a number of supporting parts in the repertory of portraiture that suggested fertility, abundance, and love. Thus the Empresses Sabina (Fig. IV.14) and Faustina appeared in the guise of goddesses of plenty at Ostia and austere Julia Domna appeared as Ceres (at Ostia) and assumed the garb and the attributes of abundant providence in a superb early third-century silver medallion (Fig. IV.15). Her husband, Septimius Severus, for much the same reason sported the four symbolic bangs of Serapis on his forehead (Fig. IV.16), establishing firmly the symbolic relationship between himself as Serapis and the continuing prosperity of the Roman Empire under his rule. Although these images partake heavily of the well-established iconography of Imperial power (see pp. 204 ff.), they are unmistakably portrait types with a message. Representations of Venus and Mars, often in company, were considered valid metaphors for loving partners in marriage and might be used in heroic situations for the portraits of Commodus and his wife Crispina (??) (Fig. IV.17) or in humbler circumstances to express the affectionate conceits of husband and wife as in a second-century grave relief in the Villa Medici, Rome. Venus' association with the morning star, with love, and the springtime renewal of life brought hope to the tomb.

Hercules and Herculean imagery also played an increasingly important part in Roman portraiture as the perfected type of semi-divine hero who prevailed over great obstacles and achieved immortality. The famous Commodus-Hercules bust in the Conservatori (Fig. IV.18) is conceived in this manner, intermingling completely the persona of the hero with that of the muscular Emperor, closed within the lion's skin and displaying Hercules' club of power and the apples of the Hesperides, symbolic of apotheosis. The portrait is appropriate to its subject, not only because Commodus thought of himself as Hercules and contended for glory in the amphitheatre, but also because Hercules brought grace to mankind, as indicated by the

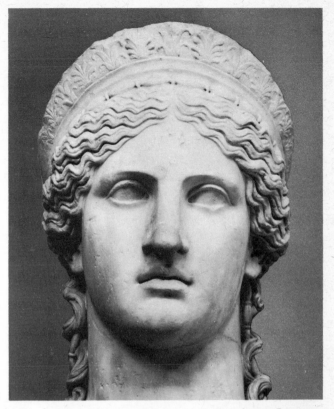

12

Fig. IV.12 Juno Ludovisi, identified as Antonia Augusta. About A.D. 41. Rome, Museo delle Terme

Fig. IV.13 Claudius as Jupiter. About A.D. 50. Vatican, Museo Gregoriano Profano

Fig. IV.14 Sabina. About A.D. 130. Ostia, Museo

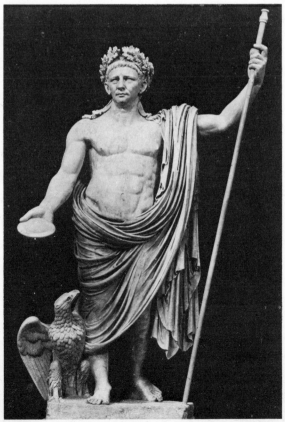

13

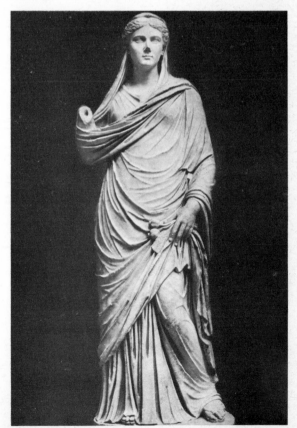

14

Victories and cornucopiae supporting this striking bust. Yet Hercules could save, and in that capacity he became available for sepulchral portraits, even for poor North African farmers (Fig. II.12) who sought protection by donning his attributes but without hope of fusion. By extension, the forceful muscularity of Hercules similarly permeated the heroic imagery of Trebonianus Gallus (Fig. IV.6) as a physical presence and as a residually familiar type, while by the end of the third century the Tetrarch Maximianus took the name Herculius and showed himself on his coins with the lion's skin headdress. Perhaps the acme of this progressive approximation between man and deity occurred in the explicit comity presented in medallions of Constantine, where Sol/Helios took on the features of Constantine, reversing the direction of the typological equation set up long before.

Constantine in this medallion appears very young. Iconographically, his youth was indicative of an heroic nature (see pp. 168ff.) and symbolized the advent of a new era, much in the way Christ the Good Shepherd was portrayed young and radiant. But Romans appreciated the iconography of the heir-apparent, even in its most metaphorical extension, without losing sight of age and of ageing. The appearance of age had been recognized, indeed strongly appreciated, during the Republic and

Fig. IV.15 Julia Domna personifying Abundance. Silver medallion, A.D. 196–211, Mint of Rome

Fig. IV.16 Septimius Severus with Serapis locks. About A.D. 200. Boston, Museum of Fine Arts

Fig. IV.17 Commodus and Crispina or Marcus Aurelius and Faustina II as Mars and Venus. A.D. 150–175. Rome, Museo delle Terme

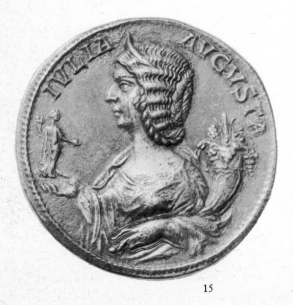

15

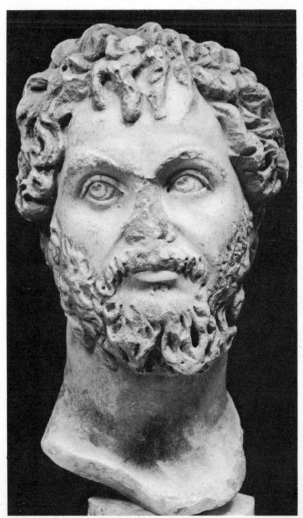

16

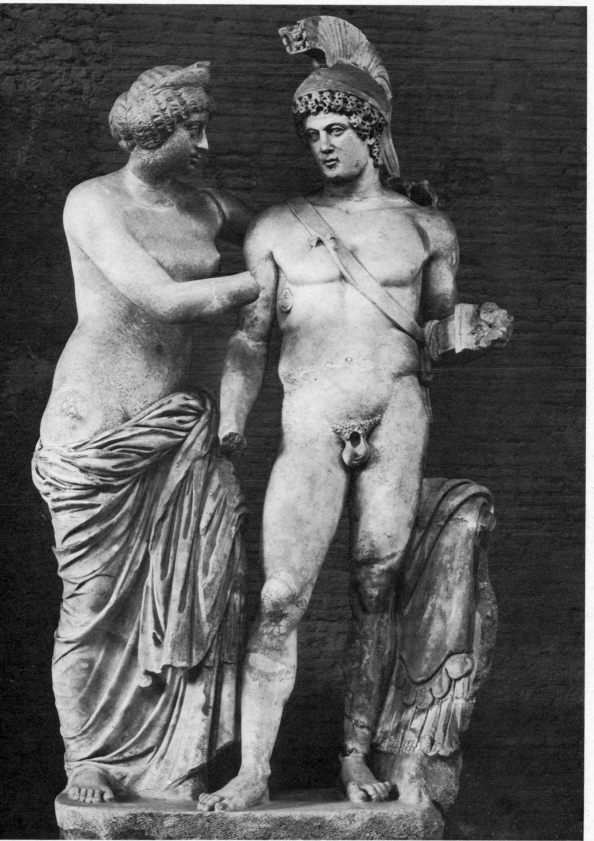

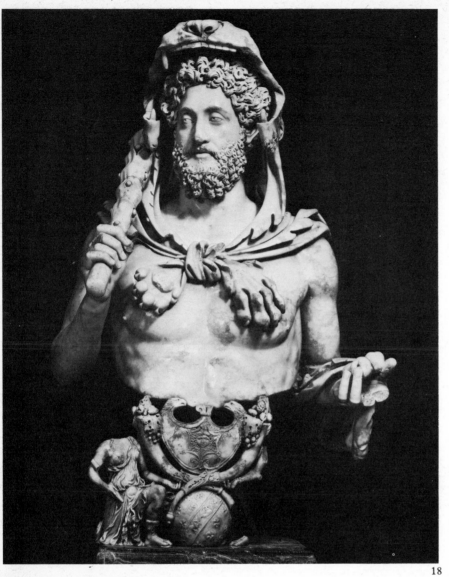

18

Fig. IV.18 Commodus as
Hercules. Marble. About
A.D. 192. Rome, Museo
Capitolino, Palazzo dei
Conservatori

Fig. IV.19 A Flavian
court beauty. Marble.
A.D. 80–90. Rome, Museo
Capitolino

again under Trajan (Fig. IV.24; see pp. 180 ff.), although image-makers under orders
might attempt to deny it as they did in the numinous portraits of the seemingly
ever-youthful Augustus (Fig. II.32). However, a child of promise like the young
Nero might be shown growing up, a process cut short by assassination. Possibly
because Roman artists had assimilated so completely the descriptive portraiture of
the late hellenistic period, they were able to capture the physical manifestations of
ageing, when they were given both the natural opportunity and the permission to
do so. The classic example in Roman portraiture of a biographical series of portraits
is that created to represent Marcus Aurelius in his noble passage from handsome
young prince (Fig. IV.20) to young manhood (Fig. IV.4), then to bearded, responsible
maturity (Fig. IV.21), and ultimately to wearied, anxious old age (Fig. IV.22). Two
generations of artists portrayed this arduous hegira of the handsome youth—the
model of the heir-apparent for the next century—to troubled, reflective old

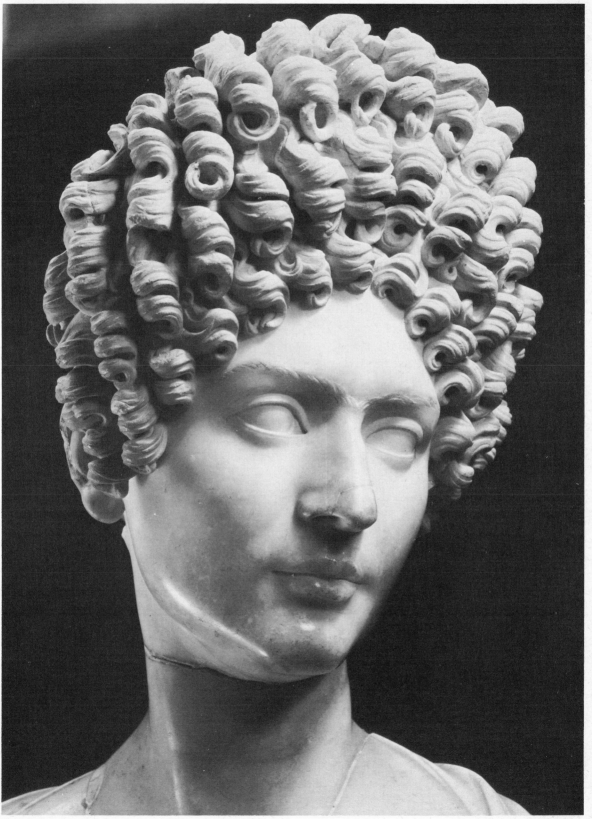

age, revealing not only the physical changes in appearance but also penetrating acutely into the mind and personality of this sensitive, noble, and suffering man, who was Emperor. This Aurelian portraiture of 'the prince' had immediate echoes in the superbly arrogant portraits of the young Commodus, his son (Fig. IV.23), but nothing in the imagery of the father stands as precedent for the subsequent tangled conflation of Commodus-Hercules (Fig. IV.18), executed shortly before he was murdered. Similarly, his mother, Faustina II, wife to Marcus Aurelius, moved openly from young beauty to softened, matronly petulance, evident in both numismatic and sculptured portraits. The tradition of 'the beauty' goes back at least to Flavian times in vivid portraits of belles of the court (Fig. IV.19) and of attractive young women (Fig. II.13a), while the more prosaic but no less sensitive representation of the older woman was first formulated in the Republic (Fig. IV.9), re-emerging in the Republican revival under Trajan in the portraits of his wife, Plotina (Fig. IV.24).

But the appearance of advanced age had a significance beyond descriptive portraiture in that its representation was interpreted positively as an honourable image of a dignified life of achievement. In Roman portraits, age and youth became formal types with an important temporal dimension, expressing either an effective life seen retrospectively or the expectation of such a life projected in anticipation. The so-called Catonic images of the Republic with their grim, lined, even disfigured faces (Figs. IV.27, 9) seem to describe with chilling realism the appearances of the old. But in the Republic 'the old' must be translated into 'the elder', and it was he, in the honoured fullness of his days, that represented the idealized image of the dignified, successful Roman. Realism was therefore a screen for the display of a virtuous model, and its displacement under Augustus by clarified images of perennial

20 21

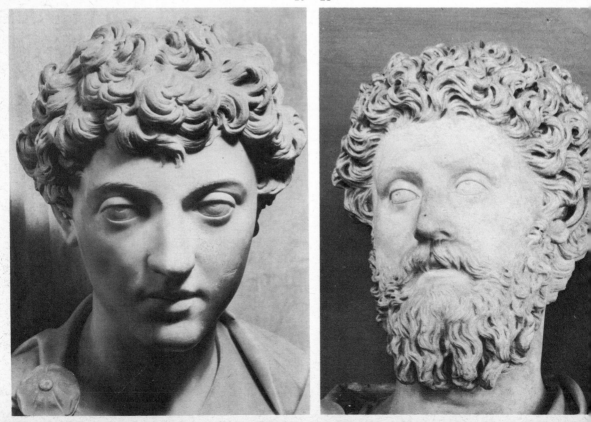

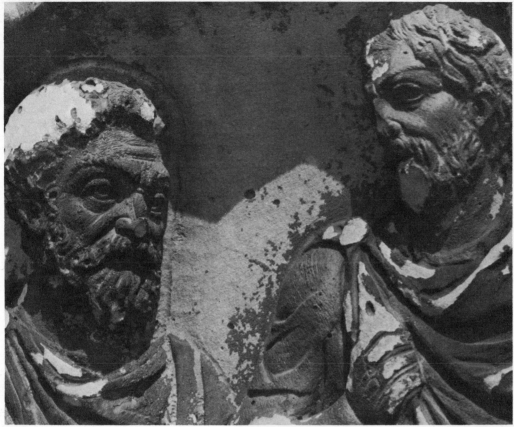

22

Fig. IV.20 Young Marcus Aurelius. Marble.
A.D. 145–150. Rome, Museo Capitolino

Fig. IV.21 Middle-aged Marcus Aurelius.
Marble. About A.D. 170. Rome, Museo
Capitolino

Fig. IV.22 Aged Marcus Aurelius. Detail
from his Column, Rome. After A.D. 180

Fig. IV.23 Young Commodus. Marble.
A.D. 170–175. Rome, Museo Capitolino

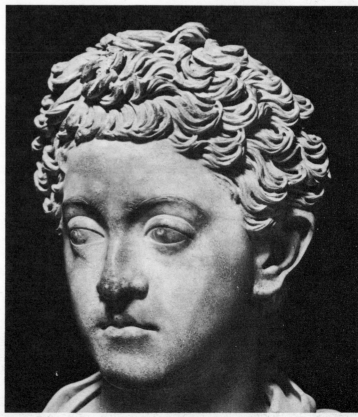

23

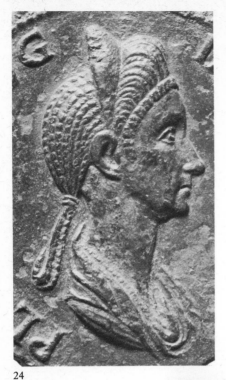

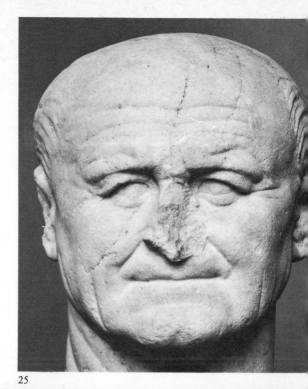

24

25

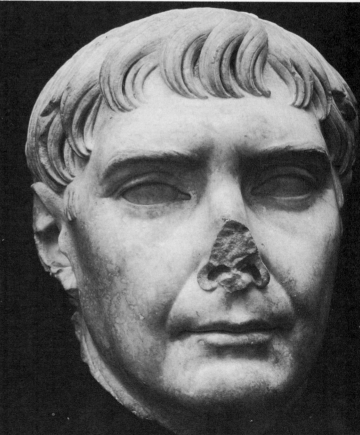

26

Fig. IV.24 Plotina, on a sestertius, A.D. 112–117, mint of Rome

Fig. IV.25 Vespasian. Marble. About A.D. 75. Copenhagen, Ny Carlsberg Glyptotek

Fig. IV.26 Colossal waxed head of Trajan. Marble. About A.D. 120. Ostia, Museo

Fig. IV.27 'Old Republican' portrait, Catonic type. Marble. 75–50 B.C. Vatican, Museo Gregoriano Profano

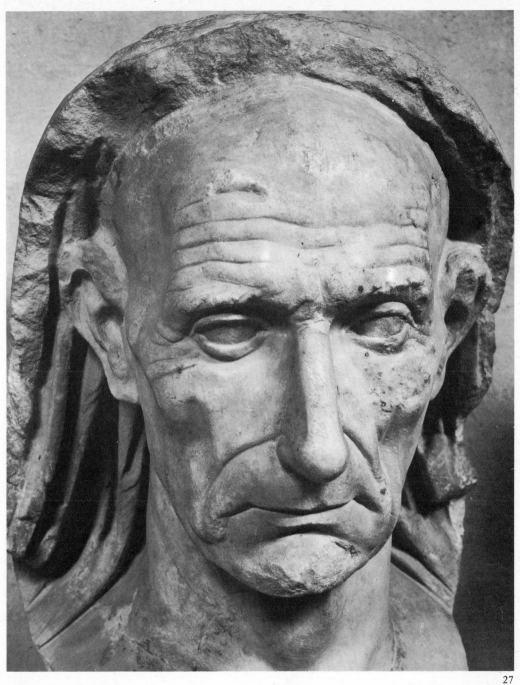

27

youth (Fig. II.32) does not simply indicate an abandonment of realism under the pressure of an heroicizing classicism (see pp. 204 ff.) but rather the substitution of an auspicious image for a conspicuously historical representation. These are facial types that tell tales, and in them Roman portraiture reached a very high level of sophistication, blending identification with inspirational value judgements.

▬ Although youth and old age are the twin poles of this system, middle age as a time of accomplishment and continued vigour intruded as a favourite image into

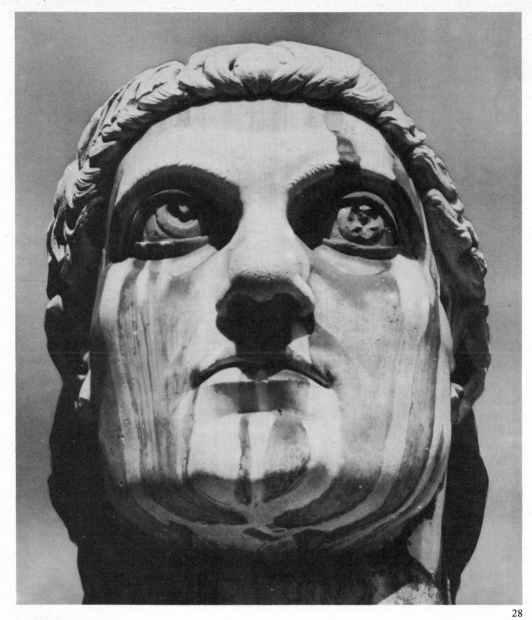

28

Fig. IV.28 Colossal head of Constantine. Marble. About A.D. 315. Rome, Palazzo dei Conservatori

Fig. IV.29 Caracalla as the infant Hercules strangling serpents. About A.D. 195. Rome, Museo Capitolino

Roman portraiture from the Flavians (Fig. IV.25) throughout the second century (Fig. IV.21). However, there gradually appeared an iconography of agelessness, first intimated in the Augustus of Prima Porta (Fig. II.32), then more boldly stated in the late waxen portrait of Trajan (Fig. IV.26) from Ostia, and finally perfected in the colossal, impervious image of Constantine (Fig. IV.28). This last is a portrait of eternal majesty, framed within a Trajanic tradition and still loosely tied to the requirements of identification, but the image is now freed of the shackles of time.

'We do not say that the statues of the emperors are mere wood and stone and bronze, nor that they are the emperors themselves, but that they are images of the emperors. He therefore who loves the emperor delights to see the emperor's statues. ... It follows that he who loves the gods delights to gaze on the images of the gods and their likenesses, and he feels reverence and shudders in awe of the gods, who look at him from the unseen world.'

Julian, *Letter to Theodoros*, Loeb Lib. ed. II.309 (transl. W. C. Wright)

When little Caracalla grasped the serpent in his hands with Herculean strength (Fig. IV.29), no one could have foreseen the tormented ferocity that became his habitual manner in maturity (Fig. IV.30). Yet the exploration of the psychic condition of the subject had always been an aspect of the portraitist's art, even if that condition was concealed under many layers of subterfuge by the Romans. In the fourth century B.C. Aristotle and his pupil Theophrastus had developed the concept of physiognomics, which attempted to demonstrate the close connection between the

appearance of a person and his spiritual or psychological character. This doctrine, imprecise and impaired by snobbism, survived as a leitmotif in hellenistic portraiture, taking on the colour of realism because it offered a particular characterization of the subject by the artist with such intensity that a specific empathetic response on the part of the viewer seemed possible. The Roman biographical tradition, well represented by Suetonius, is full of these characterizations based on personal appearance, but a formal iconography of humours has been very difficult to establish in the surviving Roman portraits, though an attempt has been made to do so in certain portraits of Caesar. Nevertheless, it is evident that the mature Caracalla has something very troubling on his mind (Fig. IV.30), that not only age but also anxiety twists the features of Marcus Aurelius on his last campaign (Fig. IV.22), while Agrippa and Vespasian (Fig. IV.25) are not just represented as middle-aged strong men, but exude a feeling of inner confidence and security. This later distortion of the visage seems, however, to coincide with the so-called spiritual crisis of the late second century (see pp. 253 ff.), as if in some individuals the sudden awareness of the perils of life and the uncertain, frightening pressure of a rapidly changing society had torn away the masks of conventional portraiture.

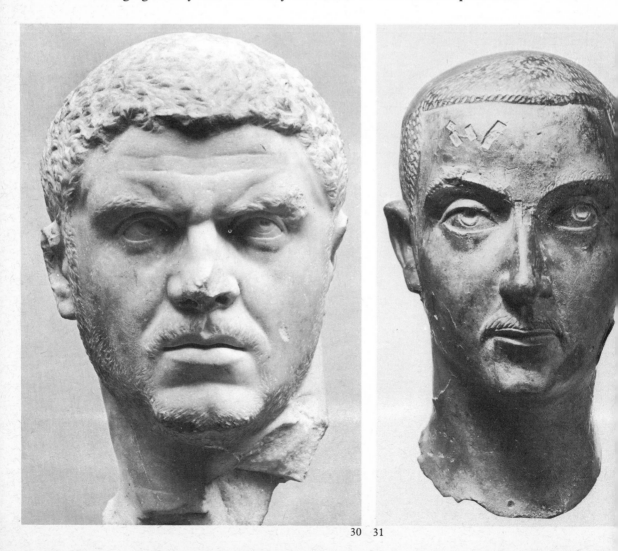

30 31

Indeed, the *superbia* (pride) of the young Commodus (Fig. IV.23) may be an expression of the artist's new comprehension of the psychic nature of his subject and a proof of his willingness to expose that characteristic to view. In the same way, the extraordinary hardness of many third-century portraits, such as those of Gordian III (Fig. IV.31), Severus Alexander, Philip the Arab (Fig. IV.32), and even the Tetrarchs (Fig. IV.33), may reflect a stubborn denial of stress, just as disturbing and just as intense as that so fully revealed in contemporary images of the sentient, haggard philosophers (Fig. IV.34). Possibly this very fact of psychic disturbance and profound malaise, openly acknowledged or ruthlessly concealed beneath a frozen, grim mask, makes the portraits of Constantine so compelling a rejection of the sensible world, and something other than the representation of a mortal human being (Fig. IV.28).

b. Historicism Romans were infatuated with the evidence of past actions, favourably presented and treated with a reverence for factual detail, as if accuracy of reporting were equated with reliability and truth. The temporal act was no longer isolated in the past, but it became significant in proof of achievement, thereby legitimizing a present condition of fame and virtuous repute. For this reason, the

Fig. IV.30 Caracalla frowning. Marble. A.D. 215–217. New York, Metropolitan Museum of Art

Fig. IV.31 Bronze head of Gordian III. About A.D. 240. Bonn, Landesmuseum

Fig. IV.32 Philip I. Marble. A.D. 244–249. Vatican, Museo Gregoriano Profano

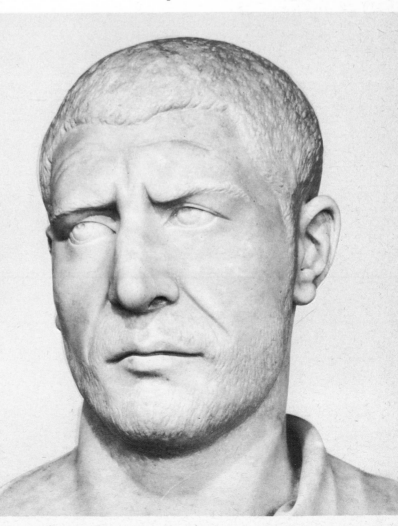

damnatio memoriae, which obliterated the past, was so devastating to any Roman with pretensions. This historical attitude also manifested itself in an excessive self-consciousness about one's role in the deliberate making of history, evident not only in the compilation of records and the shaping of commemorative monuments, but also in the construction of the present in order to make the most favourable impression on the future. The relationship between 'what I do now' and 'what will they think of me then?' seems often to have been uppermost in the minds of prominent Romans, in no man more so than in Augustus, who manipulated all of Roman history in the composition of his monuments (Fig. I.1; see pp. 238 ff.) in order to justify his *fama.*

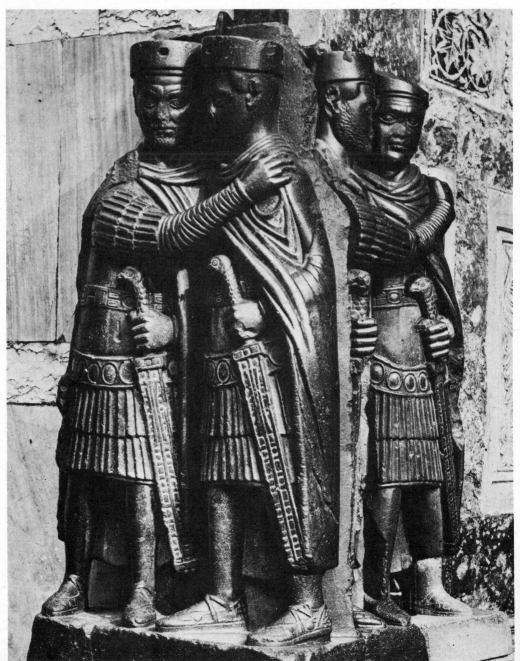

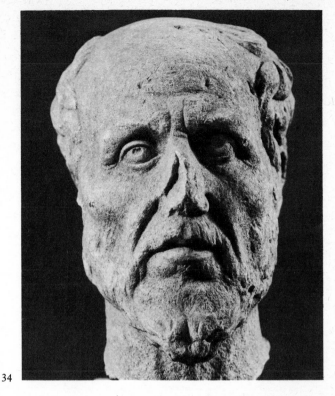

Fig. IV.33 The Tetrarchs ('I Mori').
Porphyry. Early IV century A.D.
Venice, S. Marco

Fig. IV.34 Plotinus. Marble.
About A.D. 270. Ostia, Museo

34

In the manner of the Roman annalists, the bare past might be captured visually in the form of a documentary imagery that recorded sufficient information about people, places, and events, to make them coherent and identifiable. Thus, portraits are also historical documents, preserving a transient appearance in permanent, recognizable form through the application of conventionalized mechanisms of presentation. Other Roman artists, especially those working in the open media of painting and relief sculpture, similarly faced the task of bringing order and intelligibility to the random factual material, circumscribing the temporal and spatial position of any event. For this purpose they developed a number of descriptive techniques leading to anecdotal scenic construction in order to rationalize historical representation and the locus of actions.

The relief describing the making and selling of bread that adorns the Tomb of Eurysaces (Fig. II.4a) has all the characteristics of historical representation, even if the history is both private and typical rather than specific; the operation is presented sequentially with changes in space corresponding to the passage of time, and the costumes and tools of the workers as well as the ovens, trays, and other paraphernalia are all precisely delineated. Correct depiction and a careful arrangement of characteristic bits, strung out along the relief, together participate in constructing a limited, even genre-like episode, convincing in its actors and setting, and possessing its own time. Pompeian genre pictures with slender story-lines and some mythological sarcophagi follow this simple linear scheme, which is very effective whenever a familiar episode can be broken down into a series of consecutive, well-connected events with a minimum of setting. Historical continuity arises from the

controlled directional response of the observer, although that might be heightened by repeating a protagonistic figure at different stages of the episode. There is little difference between these compositions and extended narrative friezes, such as that of the Basilica Aemilia in Rome, except that the Republican artist has provided a rudimentary topographical background in which an action takes place, and the reference is neither typical nor mythological, but purports to represent a tale of early Roman history. Nevertheless, the nature of the event may be of less significance than the manner of its presentation, once it is understood that to the Romans the very rendering of an event in coherent visual terms was an artistic problem bound up with the intellectual perception of time.

Roman artists, however, recognized that the experience of past time through a visual medium may be contaminated by the intrusion of the observer's sense of the present, much in the way a reader enters into a nineteenth-century novel. In the Processional Reliefs of the Ara Pacis (Fig. IV.3), and even more so in the panel reliefs on the Arch of Titus (Fig. II.1a, b), despite the explicit reference in both instances to a specific historical event in the past—the dedication of the Altar of Peace by Augustus and the Judaean Triumph of Titus—the observer cannot help but respond directly to the large figures apparently moving in front of him. When he does so, he converts this historical representation into an impressive contemporary event.

However, that there were ways to prevent or limit this emphatic response was recognized by the Flavian sculptor when he inserted a prominent topographical reference, an arch, into his relief (Fig. II.1b) and thus converted *here and now* into *there and then*. Topographical references of great exactness, going back to hellenistic models, are familiar features of Roman painting (Figs. I.57, 46) and reliefs of all kinds (Figs. I.64; VI.41). As such, they represent a three-dimensional realization of a place, comparable to the way Roman draftsmen were able to reconstruct locations in their maps, town plans, and campaign records (cf. Trajan's Column, Figs. IV.36; II.44). These specific, well-documented topographical elements individuated the locus of action, while a variety of perspectival devices, whether linear (Fig. III.24), en-face (Fig. IV.37c), or oblique (Fig. IV.35), helped to establish the space in which action occurred. However, in handling perspective the artist had to be careful to limit the visual entry of the spectator, if he wanted to maintain the exclusiveness of his narrative composition (e.g. Fig. I.55).

When place and space were defined coextensively, it was possible to create a plausible environment for single actions in the form of *tableaux vivants*. But to develop the sequence of action, the internal time scheme of narrative, Roman artists resorted to two techniques of presentation, one theatrical and the other cinematographic. In the famous painting representing the riot at the Pompeian arena (Fig. I.62), an observant artist has shown the Pompeians and the Nocerans fighting in and around the amphitheatre, most accurately portrayed within a stage-like space, seen in oblique perspective from above. Through these compositional means he has created a *scene* which succeeds admirably in relating an historical episode, but the viewer is somewhat uncertain whether the painter intended to represent the course of the riot which began in the arena and spread outside or

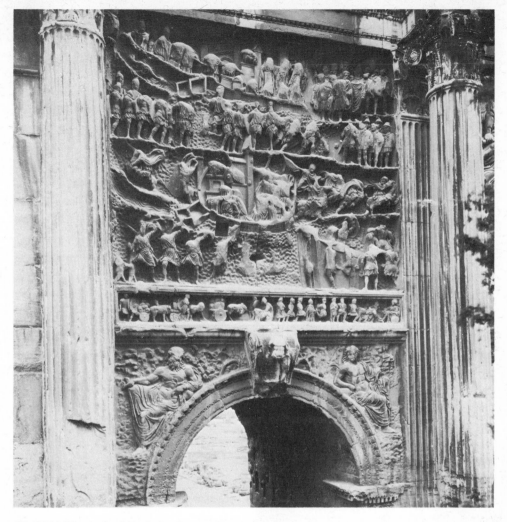

Fig. IV.35 The Arch of Septimius Severus, Forum Romanum: panel IV. A.D. 203

wished to sum up the entire event in a comprehensive panorama at once. Both conceptions are historical, but the latter lacks an inner temporal dimension. If, however, the course of the riot is the subject of the painting and, therefore, the representation contains more than one moment of time, sequentially and not simultaneously described, then the artist has used the setting as a stage, moving his actors about much as the rioters themselves would have done during the riot. The absence of a recognizable protagonist(s) who might reappear frequently within a single stage space, and thereby indicate by his own person the sequence and direction of the action, obscures the intent and the temporal structure of the Pompeian painting. Conversely his appearance in different positions, and hence at different times, in the large panel of the Tabula Iliaca Capitolina articulates the narrative of the Fall of Troy. In this clay tablet, probably made as an illustrated guide to Homeric literature for Roman schoolboys, the square panel describes the sack of the city by the Greeks, composed as a setting for the escape of Aeneas, Rome's founder, who appears leaving the city and also (*then*) boarding ship to continue his flight.

Around the large panel in the Iliac Tablet are several narrow registers presenting various subjects taken from the Trojan cycle. The long friezes follow the linear scheme adopted by the relief on the Baker's Monument (Fig. II.4a), but the smaller registers depict individual scenes with the narrative connection between them established by harmonized surface and ocular movements, specifically directed from one discrete register to another. Accordingly, visual passage is directly equivalent to a progression in time, with each register appearing successively as a new frame of action, subsequent to the previous one. This compositive system is analogous to cinematographic presentation, where each frame has its own ambivalent moment, after/before, and in that ambivalence inner temporal continuity can mirror artistically the chronology of historical events. The culmination of this effort in Roman art is usually taken to be the helical relief of the Column of Trajan (Figs. II.43, 44; IV.36).

The Trajanic relief supposedly presents the Emperor's triumphant campaign against the Dacians in a monumentalized form of visual history. The great master responsible for this superb conception offered to the Romans a visually coherent narrative, broken down into more than one hundred scenes, strung out along the relief as it wound up the Column and played by more than one thousand actors. The whole repertory of Roman scenic construction was employed in the composition, in establishing scenic divisions, and in providing the colour of historical accuracy by means of the most specific depictions of costume, weapons, tools and machines, flora, topography, architecture, and even individuating portraiture (Fig. IV.36a–c). Of course no historical presentation can recapitulate everything that happens, no matter what the medium, and therefore the historian's task, and that of the Trajanic master, was to present meaningful selections of the most important events, composed as such in order to become intelligible. The Trajanic artist did so, relying in part on a repertory of ceremonial scenes previously developed in Roman Imperial iconography (see pp. 238 ff.) and partly by inventing new motifs to show Trajan, the Romans, and the barbarians, in all the salient and typical actions of the wars. For this reason scenes of marching men, battle, camp building, siege, departure, arrival, Imperial speeches and sacrifices, and barbarian submission reappear frequently, structuring the narrative in recognizable periods. However, if such an arrangement gave coherency to the narrative, it also limited the randomness of real events by imposing a calculated structure on time and accident, dominated by the underlying purpose of the Column: the exaltation of Trajan, who appears as the dominating figure throughout. Without doubt, Trajan is the hero of the narrative presented by the artist, but the question remains, how is that narrative perceived by the spectator. When the reliefs are seen in situ (Figs. II.44; I.31), it is very difficult to follow the helical course around the column, so that ocular movement no longer coincides with the passage of the relief surface. Furthermore, although the Roman citizen might have known what the reliefs depicted because 'official' accounts were available to him in other forms, it would have been impossible for him to comprehend the subjects of the scenes in the upper part because he could not see them clearly enough from the ground. Therefore the narrative of

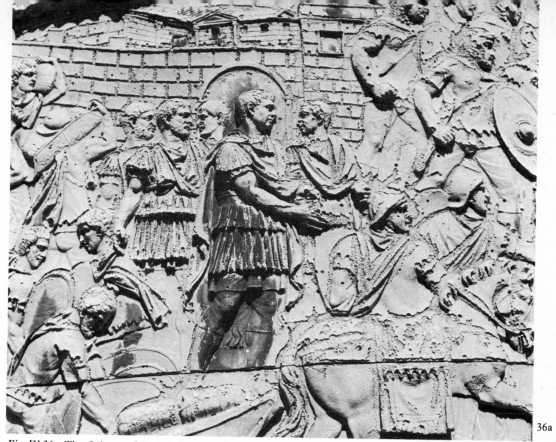

36a

Fig. IV.36a The Column of Trajan, Rome. About A.D. 110. The Emperor

Fig. IV.36b The Column of Trajan, Rome. *Adlocutio*

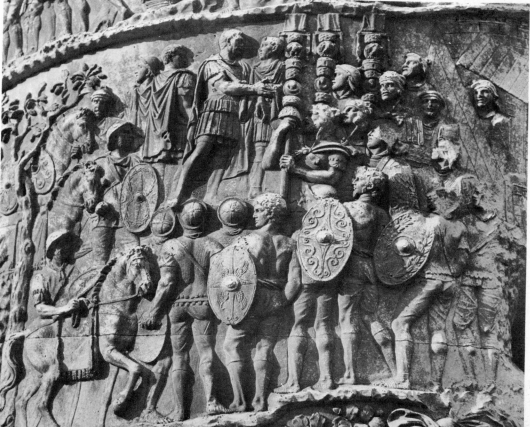

36b

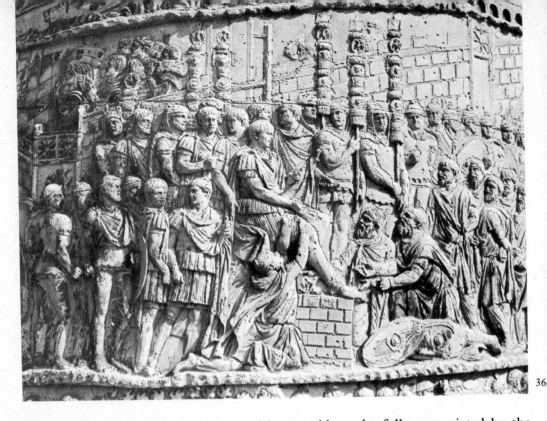

Trajan's Column, apparent in composition, could not be fully appreciated by the viewer, and in that sense the monument failed as visual history.

But if the Column of Trajan were taken not as a record but rather as a manifesto of Imperial victory (Fig. I.66), to be grasped all at once wherever the viewer stood, then the ensemble was no longer primarily historical but, instead, had become a proof, comparable to the tendentious accumulation of evidence in the annalistic tradition. This disconnection between historical time and the spectator's time became irrelevant when the derivative Column of Marcus Aurelius was erected under Commodus to celebrate their German victory (Figs. II.45; IV.37a–c). The unknown Antonine master perfected the selection process begun under Trajan; he reduced the total number of scenes and figures, increased the height and depth of the relief for greater visibility, and eliminated many of the narrative connections while developing even more strongly the ceremonial scenes dominated by the Emperor, often represented frontally (Fig. IV.37c). At the expense of narrative continuity, the symbolic message of the Column as a declaration of power and triumph was ever more apparent. Indeed, the viewer was encouraged to ignore the temporal character of the continuous helical relief and look outside it because of the insistent vertical line-up of so many of the major ceremonial scenes, one *above* the other and hence out of time.

Ironically, when the Roman artists had fully mastered the techniques of narrative presentation in the visual arts, the concept of time, and therefore of history, underwent a great change. The reliefs of the Aurelian Column make a strident statement of inevitable victory, summed up synoptically by the lost relief at its base, which showed the barbarians submitting to the Emperor. But inevitability is a challenge

to the classical view of history, a denial not to the meaning of narrative but to the significance of the human actor. The effect of this drastic change may be perceived in the religious paintings of the ancient Jews and Christians. In them historical representation in the visual arts has been converted into a manifestation of the Divine will and presence, using the techniques of late Roman tendentious narrative to render the Biblical accounts into visible form, and readily accessible to the eyes of the worshipper. However, the purpose of such narrative paintings is not primarily to tell a story, even if the story is well told—e.g. the Infancy of Moses at Dura, the Adventure of Jonah in the Catacombs—but to provide a metaphor, that what happened then (i.e. salvation) might happen again. Then the isolation of the past, as the past, was over, and facts of history were but pale externals of reality.

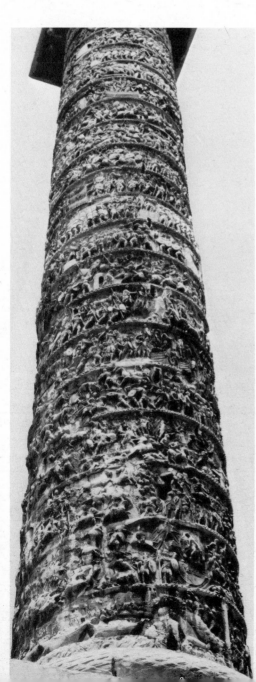

37a

Fig. IV.36c The Column of Trajan, Rome: The Emperor accepting Surrender

Fig. IV.37 The Column of Marcus Aurelius, Rome. About A.D. 180–182

Fig. IV.37a The Column of Marcus Aurelius, Rome: Defeat

37

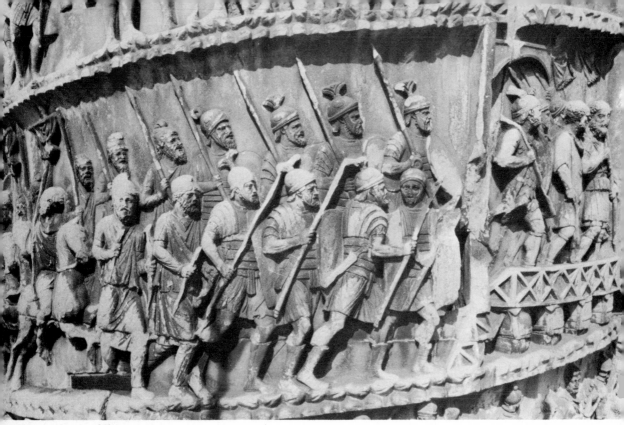

37b

Fig. IV.37b The Column of Marcus Aurelius, Rome: On the march

Fig. IV.37c The Column of Marcus Aurelius, Rome: Council

37c

Chapter V
Non-Periodic Styles and Roman Eclecticism

ALMOST concealed among the splendid ancient treasures of the Louvre there can be found a well-preserved, but modest Roman relief that seems to represent a specific scene of considerable historical interest, identified as the taking of the census at Rome (Fig. v.1a). This long, narrow frieze, carved without subtlety in high relief, consists of a number of stocky, carefully dressed figures, set paratactically against a clear ground, and with sufficient props to make the event intelligible to the viewer. Without question, this relief fits into a group of politico–historical works developed in the later Republican period to illustrate important public ceremonies for the benefit of the state and the leading families; the presentation is baldly prosaic, slightly awkward in disposition, and lacks stylistic refinement although effectively direct. Fittingly installed in the neo-classical halls of the Munich Glyptothek is another large Roman relief, handsomely carved in a flowing, linear style that captures the beautiful, changing forms of figures drawn from the Greek repertory of mythical sea creatures (Fig. v.1b). The motif, recognizable as a sea-thiasos, bears all the hallmarks of Greek inspiration, not only in its imagery but also in its elegant, sophisticated composition, which transforms the relief ground into the sea and unites all figures in sinuous movement. Unfortunately for those who like their stylistic distinctions wrapped in neat chronological or geographical packages, both reliefs have come from the same monument, the so-called Altar of Domitius Ahenobarbus in Rome, and were executed at the same time, in the late second or early first century B.C. Apparently the Altar celebrates both a naval victory won by a member of the family and the taking of the census under the direction of the censor, the most dignified office in the state, held by a family chief, possibly but not certainly the same person. However, this single commemorative commission expresses itself simultaneously in two totally different modes, using Greek images presented in a discernibly Greek style to offer a marine subject as an indirect symbolic allusion to the victory at sea, while turning to an indigenous tradition of forms and images (Fig. v.2) to describe a Roman event directly in specific, even anecdotal terms. The coexistence of two such distinct languages of form raises the qualifying spectre of incoherency within the artistic conception of the monument, as if the Romans were insensible to the difference, unless such careful separation of parts is meaningful both historically and iconographically in the Altar of Domitius Ahenobarbus and in the evolution of Roman art. When this seeming incoherency follows a repeated pattern of occurrence, then it must be considered a condition of Roman art despite the antithesis of the two styles.

The early Romans apparently did not prize the fine arts very highly until they

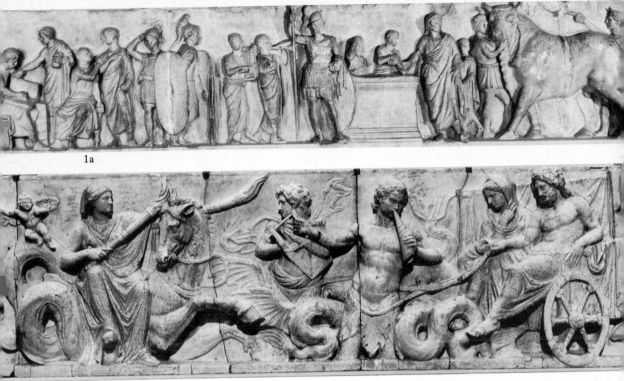

1a

1b

were taught to do so by others. Perhaps this peculiar circumstance explains their self-conscious approach, the frequent uncertainties of their later expressions of taste, and the striking, polythematic development of artistic languages in Roman art from the Republic to the late Empire. Neighbouring Italians, Etruscans, and the Greeks of Campania and Magna Graecia provided instruction in the arts to the hard-working Romans of the Republic, who lacked experience in making aesthetic judgements and therefore showed little discrimination, but hungrily gobbled up models, ideas, original works of art, and foreign artists, much in the way they gobbled up the territory of Italy, systematically but without system. The Romans themselves often admitted that, although they had taken possession of the body of Greece in the second century B.C., the Greeks in turn had captured their minds and imaginations. If the former was true, the latter was a slight exaggeration, acknowledging, however, the enormous direct impact of Greek culture, which covered Roman pragmatic bluntness with an Hellenic veneer of codified idealism. But Greek culture had been created by and for Greeks, not as a deliberately creative act but as the natural expression of a fully integrated civilization. For the Romans, Greek culture always remained a recreative importation, an increasingly familiar but still foreign element, assimilated with discrepant eclecticism into another civilization, differently conceived, diversely oriented, and with its own heterogeneous history and social structure.

The artistic horizon of the Republican taste-makers was confused, often discordantly so, by the wealth of images and styles available to them after the Punic and Macedonian Wars, the inheritance of hellenistic Pergamon in 133 B.C., and the

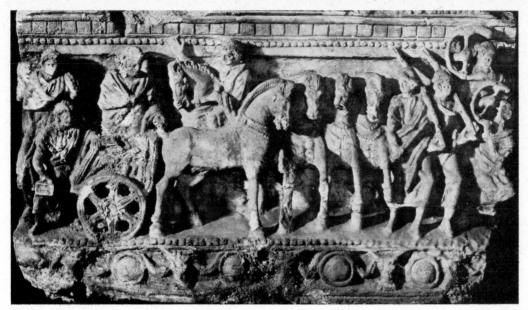

Fig. V.1a Relief with Census and Sacrifice. From the Altar of Domitius Ahenobarbus.
Late II or early I century B.C. Paris, Louvre
Fig. V.1b Relief with marine deities. From the Altar of Domitius Ahenobarbus. Late II or early I century B.C.
Munich, Glyptothek
Fig. V.2 Etruscan cinerary urn with relief of magistrate in procession. II century B.C. Volterra,
Museo Guarnacci

conquest of the eastern Mediterranean in the first century B.C. While rapid conquest
provided Romans with the means, the incentive, and the opportunity to become
collectors and patrons, the very abundance of choice and their own intellectual
unpreparedness led them to rely on contemporary Greek artists and critics in the
public exercise of taste that would be both discriminating and correct. Unfortunately,
these same authorities were themselves redundant, having become dependent on the
heroicized classical tradition, sanctified by the hellenistic savants in the Libraries of
Alexandria and Pergamon and in the Schools of Athens. Their own art was but a
pale, if refined pastiche of fifth- and fourth-century B.C. Greek work (Fig. v.3),
enervated by propriety and sentimentalized by nostalgia. Little wonder that an
eclectic Greek sculptor, like Pasiteles in the mid-first century B.C., could have great
success as a creative but correct artist, employed by acquisitive, newly sophisticated
Romans, for whom he wrote a guidebook to the great masterpieces in five volumes.

With such guides, who had lost their creativity, leading Romans, who had not yet
found their own way, the integration of Roman art was delayed by an extensive
period of hybridization. During this time the constituent elements of the Roman
artistic heritage—Italo–Etruscan, hellenistic Greek, and codified Hellenism—con-
stantly manifested themselves in various states of contaminated development. In
addition, class distinctions, directly proportional to the degree of hellenization, and
a developing sympathy between the newly acculturated western provincials and the
Roman middle class helped to perpetuate a number of dialectal variants in the
developing formal language of Roman art. Some scholars would call these variations
patrician and plebeian styles, perhaps giving the socio-economic distinctions too

much weight, but all would agree that they are not periodic manifestations but rather aspects of a continuous process of amalgamation with changing intensities of emphasis, all developing around a central core that is totally un-Greek. Greek art revealed a passion for the natural world in its entirety, a marked appreciation of the organic cohesion of all forms of life in life, a positive evaluation of the human spirit, and the independence of the work of art from the viewer. Roman art, on the other hand, delighted in exploring the disconnected fragments of life and of lives, found its imagery of the world in a political and not in a natural system, and sought to express the symbolic, even magic power in images and signs, brought ever closer to the viewer in an effort to control his response. Although one was liberating and the other restrictive, still Greek and Roman art were associated by historical succession and by a common humanism, which was prized by an educated élite.

The perennial Roman weakness for conspicuous display also contributed to the favour shown to Greek art by the upper classes because of the suggestible connection between hallowed Hellenism and that which was considered admirable, even noble, by rhetoricians and critics. Greek models, specifically and intentionally endowed with ethical values, determined by the calculating and tendentious projections of cultivated, hellenized Romans, were adapted to the expression of an authoritative, 'official', even self-righteous imagery (Fig. II.32), held to possess a higher worth than the familiar, blunt crudities of the old Republican types (Fig. II.4b). The Greek mode, identifiable through the flagrant use of conventionalized types, forms, and styles, appeared eminently suitable to artists who had the immediate task of creating works of art for collectors (Figs. V.4; IV.5; Fig. A) or of developing an iconography anticipated in hellenistic art but turned to new Imperial objectives (Fig. I.1). However, a nominal Greek style also functioned as a veneer at two different levels of signification: either as an appropriate vehicle for the representation of physical beauty and grace (Fig. V.6) or as a sign of purified nobility (Figs. II.32, 35). Whatever the application, the continual reference to Greek models progressively familiarized the Romans with the appearance of Greek works of art and stimulated a profound enrichment of the Roman monuments (Figs. V.5; II.39; V.7). Yet periodic changes in Roman taste, unfortunately poorly known, affected the preferential selection of these Greek models (Fig. V.6), and thus both conditioned their reception and their influence. Parenthetically, it should be noted that the vagaries of Roman taste directly governed the survival of the numerous Greek masterpieces preserved and known only in Roman replicas.

a. Reproductions of Greek Models Artists and workshops specializing in reproductions for the art market evoked their Greek models in very different ways, depending on whether replication or reference was the primary motive. The intention to make the classical reference recognizable was always present, although exactness was not required, even if, as in portraiture, it might be prized in certain circumstances. Given the great prestige of the Greek masterpieces and their relative scarcity and immobility, many wealthy Romans formed collections of copies, often

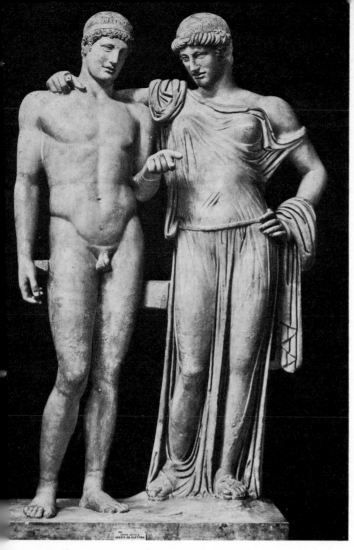

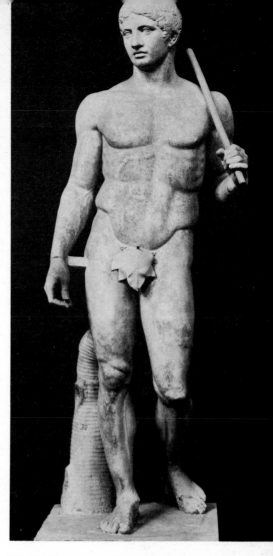

Fig. V.3 Orestes and Electra. Marble. From Pozzuoli. Late I century B.C. Naples, Museo Nazionale

Fig. V.4 Doryphorus. Augustan copy of the original by Polykleitus. Naples, Museo Nazionale

tied together by idiosyncratic thematic arrangements, as in the Villa dei Papiri at Herculaneum and in the late Roman Villa at Weschbillig in Germany. Such copies were rarely executed in the same material or scale or pattern as the original, because of the vagaries of taste, talent, and circumstance of use, although the variations tend to behave in predictable ways. Portrait statues of Greek statesmen and intellectuals were very popular, not however in their original form but cut down into busts or herms in derogation of their holistic conception; their new form served as a substitute model for contemporary Roman portraits. Heroicized statues of athletes, once created as life-size figures, especially in bronze, like the Polykleitan Doryphorus, were translated into marble with disfiguring struts and bases (Fig. v.4), while colossal statues, such as Lysippos' Hercules, might be grossly deformed in reduction and, thus, converted into an *objet d'art*. Prudent and lovely statues of the nude Aphrodite, highly esteemed as works of art and as a poetic topos, were frequently replicated but coloured somewhat by a prurient awareness of the spectator and his thoughts.

These reductions, mirror reversals, changes of medium, truncations, mistakes, deliberate alterations, when combined with the shortcomings of the artist concerned, tend to obscure the original. This greatly distresses those philhellenic scholars who seek only to establish the genuine appearance of the original, sometimes losing sight of both the quality of the replica and the effect of replication as a transformational, adaptive process. Occasionally, useful attempts have been made to date replicas by close examination of the techniques of making, the periodic fashions in props and bases, and the patterns of iconographic and formal change, and thereby evidence has slowly accumulated for the relative popularity of types as an index of taste.

Masterpieces of Greek panel painting were similarly reproduced in Roman wall-paintings (Figs. III.21; I.14a; Hercules and Telephos in Arcadia, from the Basilica, Herculaneum). Others have been translated into mosaic (e.g. the Alexander Mosaic) with the resultant distortions of medium, visual effect, and angle of sight. In addition, some paintings may have been converted into relief sculpture, such as those belonging to the so-called Spada group of the mid-second century A.D. (Fig. V.10) which were probably hung on the wall of a peristyle like permanent panel pictures. Furthermore, if the typological patterns of Roman mythological sarcophagi (Figs. II.22, 23) have any pictorial basis, and that is likely if remote, then Greek paintings would have served as ultimate sources. In the minor arts, especially in court silver, cameos and gems, the connections and continuities were particularly intimate, not only because the workshops seem to have survived from the hellenistic period into

Fig. V.5 The Procession of Domitian. Cancelleria relief. About A.D. 95. Vatican, Museo Gregoriano Profano

Fig. V.6 Antinous Braschi. Marble. About A.D. 130. Vatican, Museo Gregoriano Profano

5

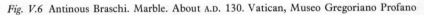

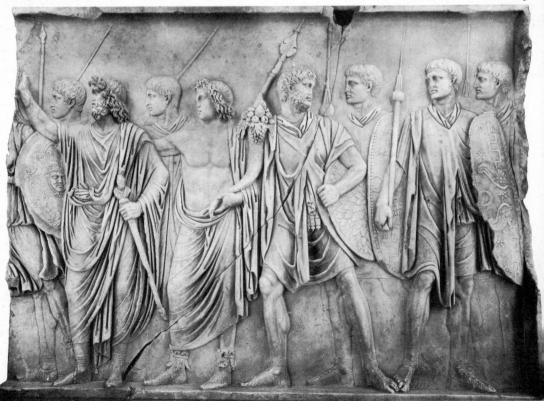

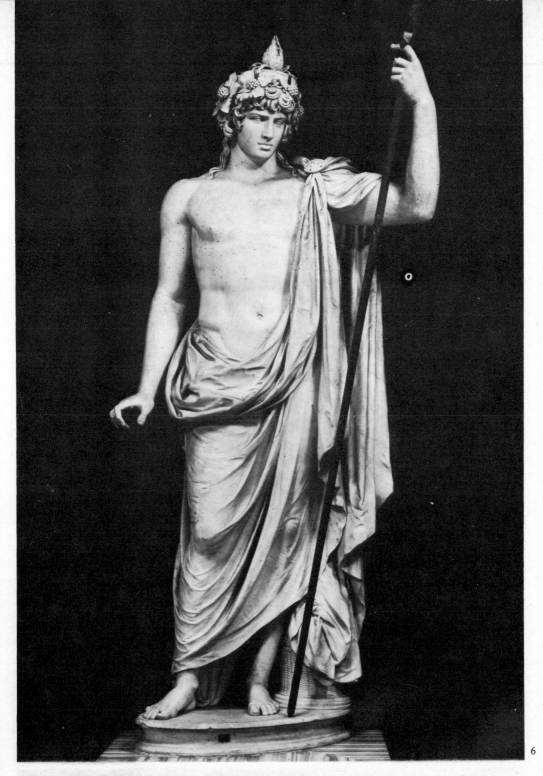

6

the Empire, but also because these craft traditions seem to have had greater, persistent autonomy. And those traditions had a Greek foundation. The rubric 'Greco-Roman', often applied to these precious works, conceals the lack of a sufficiently precise technique of analysis for the establishment of secure dates and attributions, while it does admit of the contiguity of late Greek and Roman styles.

b. Equivalencies and the Iconographical Assimilation of Models Throughout the history of Roman art there was an attempt to blend the personae of the Greek and Roman gods in analogous, syncretistic pairs, even if their identities were never entirely commingled: Zeus/Jupiter, Hera/Juno, Hades/Pluto, Poseidon/Neptune, Ares/Mars, Hephaistos/Vulcan, Hermes/Mercury, Aphrodite/Venus, Artemis/Diana, Demeter/Ceres, Dionysus-Bacchus/Liber Pater, Herakles/Hercules, etc., but only one Apollo. To a very great extent, however, the imagery of these paired deities was consistent and, accordingly, Roman artists drew heavily on the very rich repertory of images, types, and themes previously developed in Greek art for the representation of the great gods and their exploits. Such forms remained prime vehicles of Hellenic style as long as they were used. Of course, differences in cult, especially marked in the observations of the Roman state religion and in funerary practices, and different intruders into late Roman religion, such as Mithras (Fig. III.28), had their effect, but the strong similarities predicated the rapid adoption of the Greek repertory with little distortion.

Some distortions did occur wherever political or domestic considerations inter-

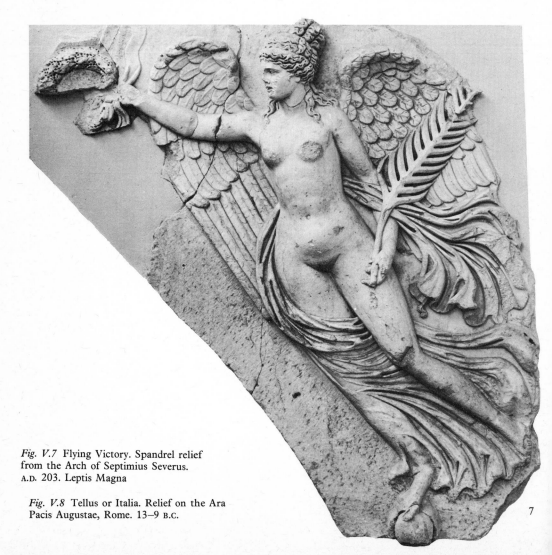

Fig. V.7 Flying Victory. Spandrel relief from the Arch of Septimius Severus. A.D. 203. Leptis Magna

Fig. V.8 Tellus or Italia. Relief on the Ara Pacis Augustae, Rome. 13–9 B.C.

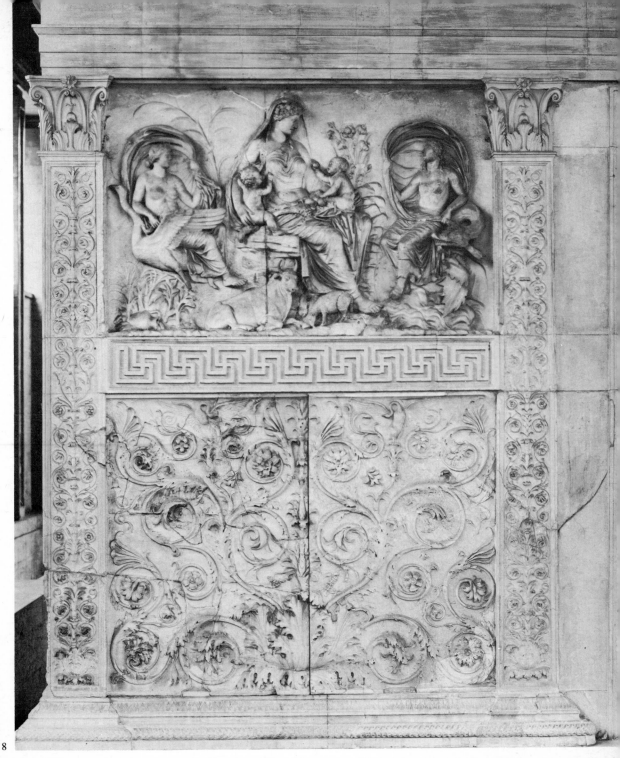

vened. Juno played a greater role than Hera because of her close association with
Hercules in the West, her availability to the Imperial House as a metaphor signify-
ing the Augusta (Fig. IV.12), and the domestication of her function as the protector
of the marriage bond in the guise of Juno Pronuba. Mercury became closely tied
to the market place and to the circus and was less well rounded than Hermes, but
like him served as the conveyor of dead souls (psychopomp). Minerva assumed the

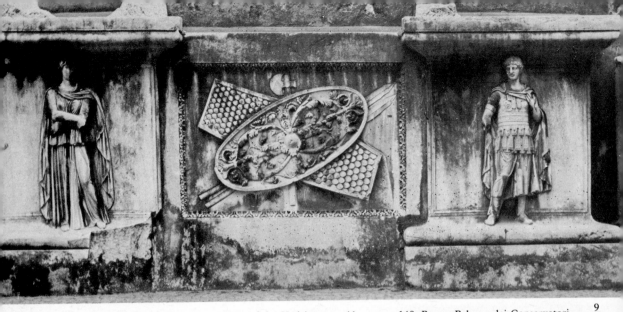

Fig. V.9 Reliefs from the podium of the Hadrianeum. About A.D. 140. Rome, Palazzo dei Conservatori

Fig. V.10 Perseus and Andromeda. Relief. Mid-II century A.D. Rome, Capitoline Museum

Fig. V.11 The Tower of the Winds, Athens. 50–40 B.C.

war-like aspects of Athena and her mature imagery, although her intellectual powers were particularly celebrated by Domitian and Hadrian. Ceres took Demeter's part without her Eleusinian cult, even if her functions tended to merge with the abstract personifications of abundance, joyful providence, and fertility (see pp. 238 ff.). Venus, however, never lost her power over love, yet became deeply involved in the dynastic politics of the late Republic and early Empire because of her patronage of the Trojan hero, Aeneas, her liaisons with Mars, and her subsequent position as tutelary deity of a number of Roman leaders, such as Caesar (Temple of Venus Genetrix, Forum of Caesar, Fig. I.31). Mars, too, played an enlarged role among the Romans as the war god of the spring campaigns, as the bearer of trophies on the keystone of the central bay of the Arch of Septimius Severus, Rome, and as Mars Ultor, the hoary avenger in the service of Augustus (Temple of Mars Ultor, Forum Augusti, Fig. I.30). In addition, there were many programmatic distinctions in the evolution of the Roman Hercules, not only as a companion of the Emperor (Fig. IV.18) and saviour of the faithful (Fig. II.12), but as the patron of gladiators. Apart from the historical differences in cult, these Roman gods seem to have been more artificially conceived than their Greek counterparts, as if myth had been replaced by a tendentious pragmatism motivated by political or eschatological ambition.

Romans found abstractions and the personification of those abstractions in human form deeply satisfying. Certainly, an avid taste for the personification of abstract ideas had been developed among the hellenistic intellectuals to represent their recondite learning and the elaborate postures of the hellenistic kings. Yet the extraordinary proliferation of such abstractions, well documented in the reverse motifs and legends of Roman coins, bears witness to the Roman tendency to fragment ex-

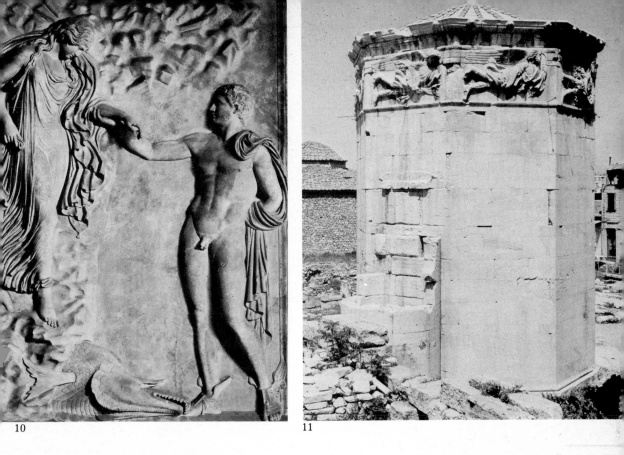

10

11

perience and then reconstitute it symbolically, but in parts. There were many paired, successive combinations in the Roman vocabulary of personified forms, so that the Greek Tyche easily became the Roman Fortuna, Oikoumene was directly translated into Orbis Terrarum on the coins of Hadrian, Aurelian, and Probus, and winged Nike into Victoria (Figs. I.10; II.39, 42), but the female Greek Horae turned into the young male Seasons of Roman art (Fig. II.25). Although the graphic, self-explanatory image of the captive barbarian long survived (Fig. II.35), the figure of the personified province also appeared (Fig. v.9), usually in the female form antici-pated in Greek regional personifications (e.g. Arcadia in the painting of Hercules and Telephos from the Basilica, Herculaneum), but rendered emblematically. Similarly, personifications of the fertile land (Fig. v.8) come directly out of the hellenistic repertory, as do the river gods (Fig. IV.35), while Father Tiber is but a western version of the Nile. Still, the forces of nature, such as the winds, although represented in the Greek fashion on the Tower of the Winds in Athens (Fig. v.11), which was set up by the Romans in the first century B.C., have nothing in common with the fiercely elemental, terrifying energy of the Rain-Storm God, who came to the rescue of the Roman army in a moment of great danger and thus appears in the reliefs of the Aurelian Column (Fig. v.12).

Despite the use of the Greek emblematic types which represent a city in the form of an enthroned or seated female with a mural crown, the personification of Roma herself and of her closely related sister-abstraction, Virtus (Figs. II.10; v.13), seem to be Roman inventions, possibly inspired by the majesty of Hera and the martial

sternness of Athena, freshly combined. Some of these conflated types have great imaginative power, resolving complex, political conceptions into deceptively simple human forms: such are the personifications, probably originally Augustan, of the Genius Populi Romani in the person of a golden youth shaped in an heroic Greek mould and of the dignified Genius Senatus, taken from the bearded figures representing the Greek demos in the fourth century B.C. (Figs. II.1a; V.5). In addition, many other Roman personifications, including Abundantia (cf. Fig. IV.15), Providentia, Salus, and Iustitia have no exact figural source in the Greek repertory, despite strong echoes, while several others, like Pax and Concordia, were rendered as pure abstractions in monumental but not human form by the Altar of Augustan Peace (Fig. I.1), by the Temple of Concord above the Forum Romanum, or by the well-framed motif of the *Concordia Augustorum*, marked by a handshake between dynasts (Fig. V.15). This tendency to remote abstraction and, further, to allegorical composition, so completely realized in the felicitous, programmatic imagery of the Trajanic Arch at Benevento, became extremely prevalent in Roman art, where the passion for metaphorical presentation eventually contributed (or responded) to the gradual erosion of sensually perceived reality (Figs. V.14; II.46).

Between the borrowing of Greek forms and their full assimilation there was an intermediary stage, in which both ingredients maintained their recognizability while participating in a new identity. Such a conflated work, created to serve the traditional Roman purpose of advertisement, is the statue of Augustus from Prima Porta (Fig. II.32), garbed in the emblematic costume of a general with his carefully decorated cuirass and elaborate props, including a reference to Venus, his divine ancestor. But the stance, the proportion of the figure, and the conception of the dignified, moral youth, are all dependent on a well-known model, the Polykleitan Doryphorus (Fig. V.4), considered in the Hellenic tradition as the very acme of physical and artistic perfection. Naturally, under the circumstances the Doryphorus has become the beautiful hero, a role which Augustus has assumed to represent his ethical character as the maker of a great new age. Hadrian's open pursuit of similar goals continued this pattern with a slightly different emphasis, as he exposed either himself (Pergamon) or his beloved Antinous (Fig. V.6) in the soft, sensitive imagery of the fourth century B.C. Although his successors, the high-minded Antoninus Pius and Marcus Aurelius, rejected this reference, they took equal refuge in the Greek philosopher type to confirm that sense of restrained dignity held proper to themselves and conventionally familiar. Not all Roman artists were drawn to the moral gloss of ancient Greek models, even if they found a number of Greek masterworks extremely useful as prototypes for the specific treatment of contemporary subjects. Thus some well-trained artist was able to portray the perturbed Caracalla (Fig. IV.30) on the model of 'the startled Diomedes', thereby equivocating between a penetrating, if potentially offensive and dangerous representation of the Emperor and a flattering reference to the alert prince of the heroic age. Similarly, when Commodus became herculean (Fig. IV.18), he could also become Hercules in a statue now in the Palazzo Pitti, Florence, conventionally presented within the Lysippan tradition of the Greek hero but given Commodus' features. In a sense, this last wilful, deliberate conflation

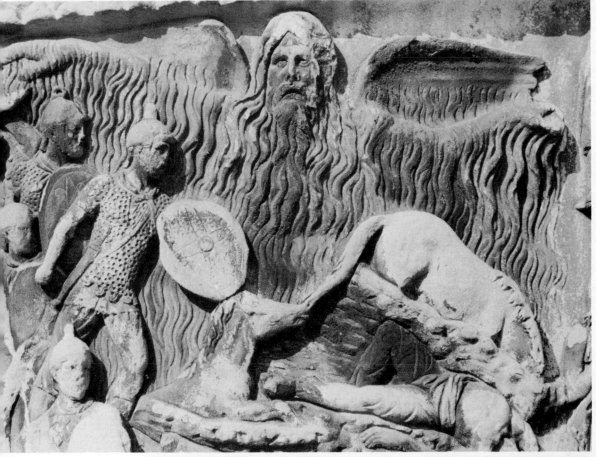

12

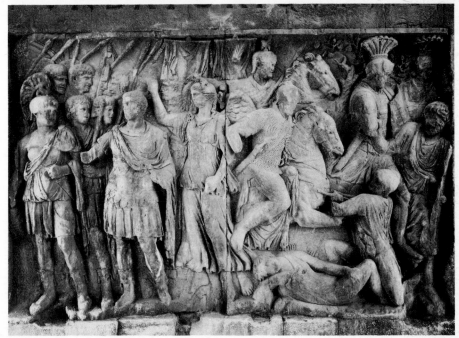

Fig. V.12 The Rain-Storm God. Detail from the Column of Marcus Aurelius, Rome. A.D. 180–192

Fig. V.13 Trajan entering Rome. Passageway relief on the Arch of Constantine, Rome. About A.D. 110

13

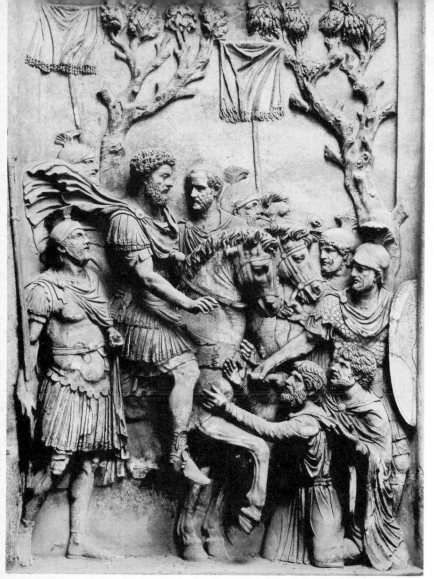

Fig. V.14 The Triumphal
Advent of Marcus Aurelius.
Panel from a lost triumphal
arch. About A.D. 175. Rome,
Palazzo dei Conservatori

Fig. V.15 'Concordia'. Relief on
the Arch of Septimius Severus,
Leptis Magna. A.D. 203

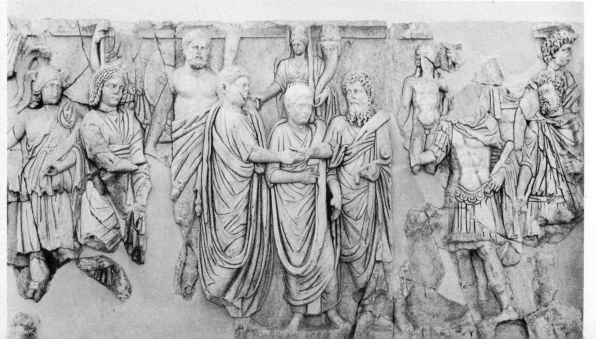

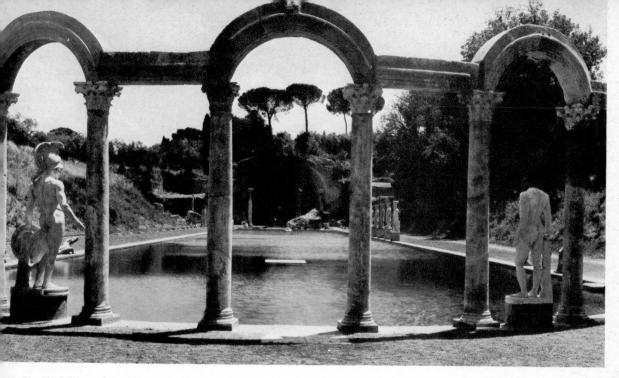

Fig. V.16 View of the 'Canopus', Hadrian's Villa, Tivoli. About A.D. 130

seemingly offers a familiar, hallowed image drawn from the Hellenic tradition for the benefit of the man of educated taste, and then quickly changes that image before the eyes of the spectator, bringing the great tradition into the present for its immediate effect. Augustus did much the same when he echoed the monuments of the Athenian Acropolis in the decorations of his Forum, and so did Hadrian, surrounded by reproductions of Greek masterpieces in his villa at Tivoli. These statues, arranged around the Canopus pool (Fig. V.16), as if their reflections in the water could augment their power as evocative images, formed part of the Emperor's art collection not just for their own intrinsic value, but also to colour their present environment with the mark of an exquisite sensibility.

c. Internal Revivals: 'Renovationes' Roman eclecticism also turned inward, drawn by a patriotic, if purposeful reverence for the indigenous past, shaped into prestigious periods largely by non-aesthetic factors (Frontispiece, p. 9). The selective mechanisms appear to function in tendentious ways directly comparable to the revival and re-use of Greek models in Roman art, but without the constraints imposed externally by a canonical, classicizing system of values. Instead, Roman artists and their Imperial patrons formulated their own critical judgements, based principally on programmatic considerations and combining the iconographic and stylistic features of a favoured period into a recognizable visual reference, or sign. Since the very act of doing so indicates both a high degree of innovative talent and the ability to conceptualize historically the artistic character of a periodic style, Romans of the Empire may not have been such aesthetic innocents after all.

It all began with Augustus, that catholic collector of past traditions who imposed a neo-classical, moralizing gloss on Roman art (Figs. I.1; IV.3; V.8; see pp. 238 ff.). But

the first Emperor was more than a glossator, for he and the legion of artists working on Imperial commissions during the fifty years of his rule created the imagery of Empire in all its dimensions, an artistic legacy passed on to all his successors. Julio-Claudian Emperors made constant reference to Augustus as founder of the dynasty and to Augustan works of art, either by posthumous replication of his portraits and monuments (Fig. II.32), or by an iconographic invocation of his authority (Grand Camée de France, Paris), or even by subtly continuing to create new works in the old tradition, if a Claudian date for the Gemma Augustea (Fig. II.35) is correct. Claudius himself was probably partly motivated to undertake the invasion of Britain in order to complete a dynastic enterprise left unfinished by Julius Caesar ninety years before. Naturally, Claudius' Britannic Arch, preserved on coins, follows very closely the design of the preceding triumphal arches of Augustus. In much the same vein, Nero sent armies into Parthia, less for positive reasons of foreign policy than to remind the Romans of the great Parthian victory of Augustus; he, too, began a Parthian Arch to celebrate this anticipated triumph in emulation of Augustus' Parthian Arch in the Forum, and even made repairs on the Ara Pacis Augustae, which he commemorated in a handsome coin issue. With the Julio-Claudians, therefore, Roman art already had begun to move forward looking backward.

Nero, however, was considered excessively extravagant even by Roman standards and, worse, had flaunted his adoption of Greek and oriental customs to the great distress of the xenophobic elements among the upper classes. Senatorial reaction was very strong, leading to a political solution, murder and the destruction of his monuments, and to the revival of late Republican sobriety in the portraits and styles of his successors, Galba and Vespasian (Fig. IV.25). The ostensible reference to the objective portraiture of the Republic, which prized the mature man of accomplishments realistically depicted, signalled the return of old-time, traditional values, advertised by the new masters of the state. If the content of this revival was distorted by political considerations, the style of representation showed not only the effect of Neronian developments (Fig. VI.29a, b), but also a preference for the robust plasticity of hellenistic art, which was already appreciated in the late Republic by some of the great captains (Fig. V.17). When Nerva and Trajan succeeded the second Nero, Domitian (Fig. VI.31), at the end of the first century, they too deliberately returned to the images *and* forms of sober Republicanism (Figs. IV.24, 36a) in order to demonstrate their moral reaction to the philhellenic and authoritarian excesses of Domitian. This ideological invocation of old Roman *dignitas et gravitas* survived very evidently in the private portraits of the second and third centuries (Fig. V.18), possibly tied as a responsive, proclamatory image to the private portraits of the middle classes within the Empire. For Trajan, however, the Republican *dignitas* was soon overlaid by Imperial *maiestas* (Fig. IV.26), and it was this imagery of the optimal Emperor, virtuous and victorious, that Constantine (Fig. IV.28) reassumed two hundred years later. With him this lingering series of Republican echoes terminated in an imagery of absolutism, contrary to its originating principle.

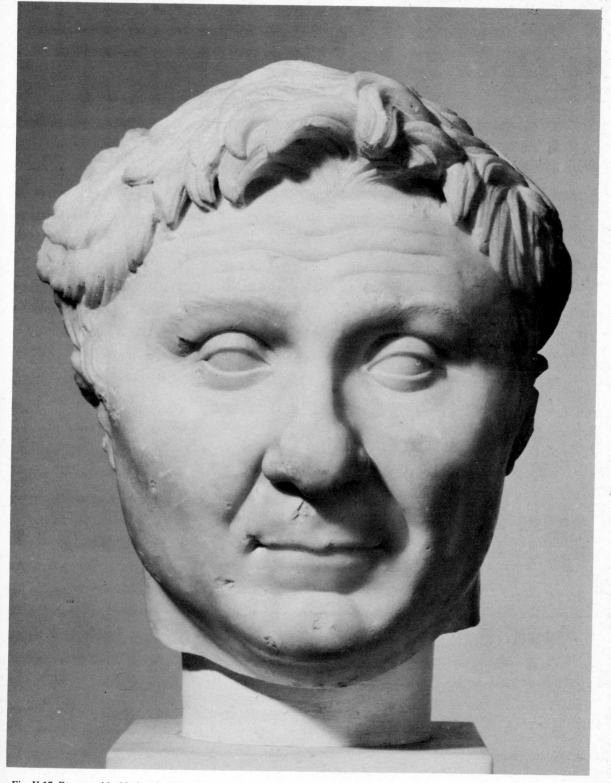

Fig. V.17 Pompey. Marble head. About 50 B.C. Copenhagen, Ny Carlsberg Glyptotek

Trajanic artists also looked elsewhere for revivalist inspiration, given the sensible grandeur of the age, the real achievements of the Emperor at home and abroad, and the comfortable feeling of stable security his rule had engendered in the Roman citizenry. No other model than Augustus would suffice. Therefore the Forum of Trajan came into being as a deliberate, if more impressive version of the Augustan Forum (Figs. I.30, 31), and the Trajanic Arch at Benevento (Fig. II.39) combined in its allegorical programme of war and peace the purposes of both the Parthian Arch (Fig. II.40) and the Ara Pacis (Fig. I.1) of Augustus. In the Trajanic context, the retrospective takes an iconographic rather than stylistic form, but Augustan classicism as a moralizing convention had a stylistic revival under Domitian (Fig. V.5) and then, again, in the neo-Hellenic expressions of Hadrianic taste (Figs. V.6, 9). But Hadrian rejected the impure eclecticism of Augustus in favour of a more correct aesthetic and archaeological evocation of the Hellenic past (Fig. V.16), as if by stressing accuracy of reproduction he might draw greater strength from ancient Greece.

Flavian art (Figs. IV.25; II.1a, b; V.5) in its own right and as a transmuted hellenistic revival provided another basis for new interpretations of past styles under the

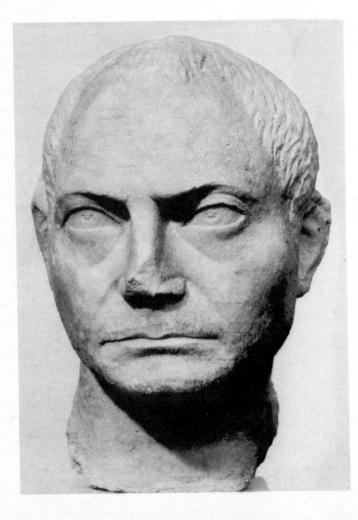

Fig. V.18 Portrait of a Man. Marble. Mid-III century. Aquileia, Museo Archeologico

Antonines in the mid-second century A.D. (Figs. V.9; IV.4). In turn, the Antonine artists passed on this legacy to the Severan dynasty (Fig. V.15), eager to associate itself visually and iconographically with Marcus Aurelius and Commodus as their legitimate successors. Furthermore, this tendentious association was strongly reinforced by Septimius' reoccupation and extension of the Flavian Domus Augustana on the Palatine. The Antonine style was again revived in the third century among sculptors' workshops employed in the production of elegant sarcophagi (Fig. V.19) and shaped the Hellenism of Gallienus at mid-century, itself stimulated by the contemporary emergence of Neo-Platonic philosophy (Figs. II.29; IV.34). On the other hand, the Severan rejection of Antonine conventions, equally evident in the Roman Arch of Septimius Severus (Fig. IV.35), set the pattern for the entire third century with its stocky, anonymous figures deprived of any corporeal grace, that lasted until the Tetrarchy (Figs. IV.33; II.2).

The confusing art scene of the second and third centuries clearly demonstrates the non-periodic character of stylistic recall in Roman art. These multiple strands of eclectic choices and transmuted revivals were not time-bound by any unique exercise of taste but rather were assumed and reassumed deliberately and most provocatively for a variety of historical, iconographical, and psychological motives, whose own history, perhaps more than a history of style, properly represents the later evolution of the arts in the Roman Empire. But even these eclectic, historical revivals comprised only one of the deep currents of artistic expression visible and effective during this period of continuous development.

d. State Art, Patrician Art, Plebeian Art, Provincial Art Roman state art comprises those formal public commissions in all media executed in favour of the state or its leadership and characterized by conspicuity, propagandistic messages, and an official, elevated style (e.g. Figs. I.1; II.32, 35; IV.3; V.5; etc.). Elaborate and comprehensive programmes of architecture, public works, coinage, and sculpture, lavishly financed and prominently displayed, were promulgated in order to reveal the exalting condition of great power and all its appurtenances. Architecture, by virtue of its bulking presence and overt costliness, rose as an especially effective declaratory symbol of the state and of its rulers throughout the Empire. These very factors, when taken in combination with the typological development of Roman architecture (see pp. 79 ff.), tended to develop a recognizably impressive manner wherever public buildings were erected, and that manner was the hallmark of the state commission, irrespective of the stylistic development of Roman architecture over the centuries.

The state also controlled the coinage and thoroughly exploited both the obverse (Fig. VI.14) and reverse (Fig. IV.15) of coins and medallions for the widest possible publication of the most elaborate, self-serving, and official messages to the Roman people. Even Antoninus Pius, that modest Emperor, struck more than one thousand separate coin issues during his reign, their purpose, advertisement, and their style determined by the Imperial mint and the artists of the court. However, sculpture and painting enjoyed no such monopoly, unless directly attached to some monument

impressive in itself or forming a significant part of some official and important place, as did the Imperial portrait in the law court by which men swore the truth of their testimony. In these media, official Roman art, distinguished frequently by its special subject matter, became easily equated with the art of the upper classes, since they provided the leadership at least until the mid-third century. Because that group was so deeply penetrated by Hellenism in all its forms, and because they prized the moral qualities of the Greek tradition, official Roman art, the figured arts as an instrument of state policy, revealed a deep layer of Hellenic influence in almost all of its works from Augustus' time, and even before.

This official manner is present as early as the Altar of Domitius Ahenobarbus (Fig. v.1) but in association with a totally different formal language, taken from the old Roman tradition, clearly considered to be equally 'official'. Nevertheless, this dichotomy in Roman official art was largely concealed for three hundred years, until it began to re-emerge in the compounded Arch of Septimius Severus in Rome (Fig. I.10), where both an Antonine-Hellenic strain, visible in the pedestals, spandrels, and keystones, and an anecdotal, stumpy, graphic style, evident in the great panels (Fig. IV.35), made their simultaneous appearance. A century later, that seeming pastiche born of stylistic uncertainty had become a true pastiche in the composition of the Arch of Constantine (Fig. II.42) from pieces of Trajanic, Hadrianic, and Aurelian monuments, combined freshly with Constantinian friezes and other reliefs (Figs. II.46a–b). The older monuments still carry the mark of the official, hellenized style, which they bring with them into the fourth century, but the Constantinian works represent a continuation of the stumpy forms of the Severan age, rendered even more abstractly and without any trace of a Hellenic gloss. Although this Late

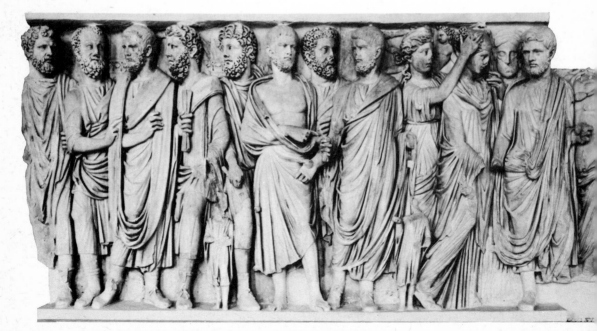

Fig. V.19 Philosopher sarcophagus. A.D. 260–270. Naples, Museo Nazionale

Antique substitution of formal language is a fundamental problem in the evolutionary history of Roman art (see pp. 262 ff.), the continued existence of this unnaturalistic manner—called by some scholars 'plebeian'—is further proof of the complex, hybrid character of that art from its very inception.

This plebeian art, if followed from its Republican origins through its early Imperial, Trajanic, Severan, third-century, and Constantinian phases, may, indeed, be partly tied to the weakly hellenized 'Roman' traditions, favoured by the less profoundly hellenized middle class at Rome. Yet within the parameters of this unclassical manner there are vast differences between the stark objectivity of its early manifestations (Fig. IV.9), the frontal hieraticism of the Severan Arch of the Silversmiths (Fig. V.20), a classic example of a middle-class commission, and the reductive cubism of the early fourth century (Fig. II.46a–b). Such inconsistencies seem to deny the existence of any conscious, middle-class or plebeian style as such, while they affirm the destructive effect of Roman contextual functionalism on the naturalistic and borrowed Greek tradition. By contextual functionalism is meant the total of those explicit, pragmatic, symbolic, and ideological objectives that constantly turned works of art into forces, powers, and speaking things (Fig. II.32), instruments for the transmission of intrusive messages (see pp. 85 ff., 166 ff.). Hellenism was a bulwark against it only so long as and wherever the Greek tradition remained strong.

That tradition was particularly weak in the western and northern provinces, far from Greece, and along the eastern periphery of the Empire, where strong local cultures contended with Greco-Roman civilization. The art of the provinces reflects either official models (Figs. V.21, 22), sent out or formulated by Rome, or the expressions of middle-class taste, which was especially congenial to the provincial ruling classes (Fig. II.7). Regional differences are marked because of the existence of local cultural patterns which affected the reception and the absorption of Roman or Romanized models, while the development of provincial schools of distinguished quality (Figs. V.23; III.18) often led to the importance of local artistic centres, such as Lugdunum (Lyons), overtaking that of far distant Rome. And yet there is an underlying primitive strain that brings the Bonn Matronae (Fig. V.23) and the Capua Matres (Fig. V.24) together despite the separation of several centuries.

However, Imperial art in the second to fourth centuries did encompass a stylistic koiné, comparable to the political organization of the different peoples of the Empire under the *Pax Romana*: a loose framework in which diversity was possible. The artistic framework consists essentially of the formal solutions and typological models developed during the first century A.D. as the point of reference and departure. For this reason it is possible to relate Roman grave stelae found in England (Fig. II.16), along the Rhine, in Pannonia, in Asia Minor, and even in Italy (Fig. II.17), with one another, joined in a common type, created for similar reasons, and for people who would not have been strangers to one another. In like fashion, the formal characteristics of the third-century wall-paintings from the Synagogue at Dura Europos and the fourth-century mosaic from Low Ham (Fig. III.15) may be analysed within the terms and conventions of Roman provincial art, even if the programmes and subjects of these works are very different and they were created

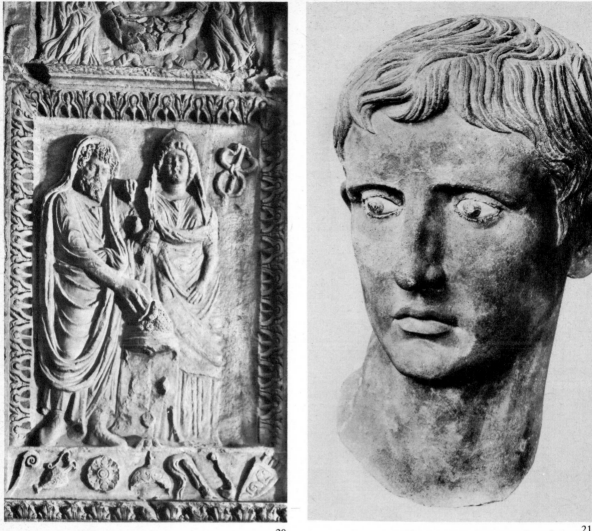

20

21

Fig. V.20 Septimius Severus and Julia Domna sacrificing. Relief panel on the Arch of the Silversmiths, Rome. A.D. 203–205

Fig. V.21 Augustus. Bronze head from Meroë. Late I century B.C. London, British Museum

Fig. V.22 Lucius Verus. Silver bust from Marengo. A.D. 161–169. Turin, Museo di Antichità

at different times in places far apart. The Roman Empire absorbed and transformed, but identities were not lost. So it would seem from the tombstone of Regina, a freedwoman of the Catuvellaunian tribe of Britain; it was put up in her honour, probably at South Shields near the eastern end of Hadrian's Wall, by her husband Barates of Palmyra some time in the latter part of the second century A.D. (Fig. II.16). The inscriptions are in Latin and Palmyrene, and Regina, dressed in local costume and nimbate in the eastern fashion, is presented with her jewels and her work-basket under an arcuated lintel. She is as she was, esteemed in life as in death by her husband. Her tombstone is as it was, a compendium of the multiple themes and forms of Roman Imperial art successfully brought together.

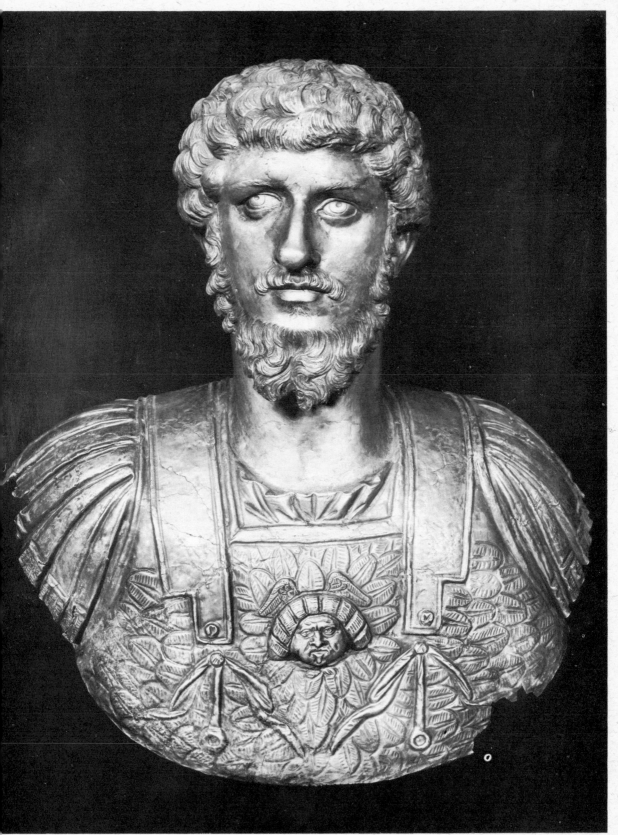

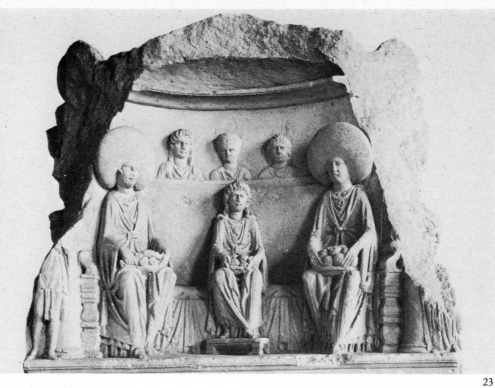

23

Fig. V.23 'Matronae'. Votive relief.
A.D. 164. Bonn, Landesmuseum

Fig. V.24 One of the 'Matres'.
III century B.C. Capua, Museo
Campano

24

Part II
Into the History of Art

Chapter VI
Periodic Styles in the Figured Arts

THUCYDIDES was the first historian to conceive of history as being divisible into periods, possessing both a beginning and end, with some distinctive form or character that gave to a certain passage of years a discernible quality of its own. Although Greek and Roman historians followed his example in their writings, they often defined the periods investigated by them from where their admired predecessor left off until that time, in their own time, when their interests declined or it was unsafe to continue. These dangers do not readily confront the historian of Roman art, but lack of method and a failure of objectivity frequently have complicated his task.

The history of Roman art has been neatly divided into periods, principally however by historical factors dependent on the articulation of time according to the sequence of political events, as if, for example, the transition from the kingdom to the Republic in the sixth century B.C. were clearly significant in the development of art at Rome. The change from the late Republic to the Augustan principate has also been seized upon as a magic moment, and then the several dynasties have been taken to establish categories of stylistic change in a manner that would please the positive mentality of the eighteenth century, and even Gibbon. The third century A.D. after the Severan dynasty is still largely ignored, in part because Rome lacked political stability and there is no easy tag to assign to it. Justifying this point of view is an unrecognized assumption that Roman art—except under Augustus and Hadrian—depended primarily on the taste of the Emperor in power. However, political realities only occasionally correspond to changes in style, changes of such an order of magnitude that it is correct to consider them sufficiently interruptive of preceding patterns

of composition and imagery for the creation of a totally different manner of expression.

For historiographical reasons, therefore, it is difficult to accept the conventional term 'Republican art' as a meaningful designation of a periodic style. The period so defined lasted five hundred years, and there is no fundamental difference between the late kingdom and the early Republic, despite a slow evolution, until about 300 B.C., when Rome began to emerge onto the world's stage and absorb the world's goods and ideas. Similarly, Roman art under Claudius and Nero seems much closer in form to Flavian works than to the Augustan monuments, although these two Emperors were bound to the dynastic iconography of the Julio-Claudians, promulgated by Augustus. Again, despite Gibbon's encomium of the Roman Empire in the second century A.D. as a time of harmonious felicity, something very drastic, even disorienting, befell Roman art during the third quarter of the century and not only broke the patterns and formative assumptions of the past, but also initiated a new artistic vision, which lasted until the fourth century. It would seem, then, that the history of Roman art has been badly served by periodic divisions based on critical observations directed to phenomena outside of its own frame of reference and often in contradiction to the rhythms of its chronological development. That is not to say that Roman art developed in a vacuum, but rather that the connections between periodic style and historical episode need to be more precisely established and mutually justified. In addition, one must recognize that the attempts to establish periodic styles have been inevitably contaminated by the continuous regeneration of those non-periodic currents (see pp. 197 ff.), peculiarly characteristic of Roman art, which deny that completeness of the past believed necessary to any normal conception of a finite, comprehensive style.

The historian of Roman art usually makes a practical choice and reverts to a simple chronological scheme, basing his formal analysis on the development of official, high art, because he is attracted by its evident quality and because it is usually well documented. Although the distortions of the key-monument approach are recognized, such an entrance into the history of Roman art has been justified by the great abundance of official monuments readily datable by inscriptions or by other bits of hard information, e.g. portraits whose identity can be established through the coinage. Furthermore, the active interest of the aristocracy and of the Imperial court in the creation and publication of works of art confirms the functional intent of the monuments as self-evident models, a standard for imitation at all levels of subsequent artistic production. This factor apparently strengthened the desire to employ distinguished artists for great commissions or for the execution of primary models, intended for later reproduction, because such talents could maximize the impressive effectiveness of these works in addition to whatever aesthetic contribution they might make. Unfortunately, although the names of a great number of artists are mentioned in ancient texts or inscribed as signatures on individual works, for the most part they have no history, no known career or body of work, and their significance is unknown. For every Fabullus painting Nero's Golden House (Figs. I.12, 63) and for every Apollodorus working architectural wonders for Trajan

(Figs. I.16, 31), the majority of great monuments have no known author, despite the intrinsic evidence of a considerable talent at work.

Some interesting attempts have been made to define artists by descriptive titles, such as a 'Master of the Trajanic Commissions', responsible for the Trajanic frieze in the Arch of Constantine (Fig. V.13), or a 'Caracalla Master' thought to be the creator of the portraits of Caracalla (Figs. IV.29, 30) and his mother, Julia Domna. Others have used the precise term, school, as in the 'School of Pasiteles', to refer to a loose body of sculptures (Fig. V.3), seemingly gathered around an eclectic Greek artist of the first century B.C. (see p. 199), none of whose works probably survives. The 'School of Aphrodisias' has also been conceived to evoke the style of an ambulatory sculptors' workshop originating in the old hellenistic town of Aphrodisias in Asia Minor because of its excellent marble quarry and later employed on the Severan monuments at Leptis Magna (Figs. V.15; III.4; VI.42). Perhaps 'workshop' would be more appropriate here in the absence of a dominating artistic presence, particularly when the so-called Aphrodisian style may be very closely related to the work of other hellenistic centres in western Asia Minor in the second and third centuries. Some useful efforts are now being made to discuss the role of workshops in the widespread commercial production of mosaics and sarcophagi or in the skilful execution of architectural ornament by masons moving from one great commission to another: from the Arch of Titus (Fig. II.1) to the Trajanic Arch at Benevento (Fig. II.39), from the Maxentian buildings in Rome (Fig. I.20a) to the Arch of Constantine (Figs. II.42, 46). Clearly, large-scale commissions, such as the Claudian programme of dynastic statuary in Velleia or Leptis, or triumphal arches (Fig. I.10), or the great Columns (Figs. II.43, 45), or vast mosaics, required not only the presence of workshops but also the direction given such workshops by a master designer.

Unfortunately for the history of Roman art, such terms as 'school' or 'workshop' have little validity in the absence of more detailed investigation; the critical situation is comparable to the study of Italian Renaissance painting before Berenson and without either Vasari or archives. Even where signatures exist, the signers are usually otherwise unknown or present additional problems, as does Glykon, who signed the Farnese Hercules as sculptor, probably early in the third century. He is, however, the adapter of a famous Lysippan statue and hence not original even if a virtuoso, while the equally skilful and certainly original bust of Commodus-Hercules (Fig. IV.18) is unsigned. Conversely, the superb group of statues, or fragments of statues, recently discovered in the Grotto of Tiberius at Sperlonga is attributed by an inscription to three famous Rhodian artists of the hellenistic period, but the date of making does not seem to correspond, reflecting perhaps a practice, familiar from Chinese painting, of affixing the signatures of great artists to later works for their prestige value. Perhaps this accounts for the wide prevalence of Greek names among the surviving records of artists, although there is little doubt that Greek-named artists and architects worked for Romans. But then it is difficult to say how Hellenic was Apollodorus, bearing a Greek name, coming from Damascus in Syria, and working at Rome, in Roman materials, for that most Roman patron, Trajan.

a. Developments in the Etrusco-Italic Koiné, Sixth to First Century B.C.
The late-sixth-century B.C. statue of Apollo (Fig. VI.1) from his temple at Veio, about
fifteen miles north of Rome, thoroughly demonstrates the imposition of an Etruscan
sensibility on a Greek model derived from Ionic sculpture of the archaic period.
This figure of the god, originally placed on the ridge-pole of the Temple and thus
silhouetted against the sky, appeared to the viewer below as a powerful force
moving forward, the lurching awkwardness of his gait enhancing the impression of
movement from afar. However, that very awkwardness, evident in the scissors-like
treatment of the legs and in the windmilling arms, is totally unlike the closed,
organic forms of contemporary Greek sculpture with its underlying geometric
structure, while the nervous linear patterns of the drapery, the tightly drawn
muscles and tendons of the legs, and the compressed decoration of the ornamental
support exaggerate the visual importance of the activated surface. In addition, the
statue has not been carved from a solid block of stone but is a hollow terra-cotta
sculpture, and the differences between solid and void, between an inner density and
an outer skin, establish the basic formal contrast between Greek and Etruscan art.
This interest in the outer limits of form, manifested by a complicated profile which
is enriched by a restless, provocative surface, expresses the direction of the Etruscan
sensibility, possibly stimulated by the modelling techniques required by terra-cotta.
However, the same effects may be observed in a late sixth-century B.C. bronze
sculpture such as the famous Lupa Romana, possibly executed as a totemic image
for the Romans by the Etruscan sculptor Vulca, who had been brought to Rome by
the commission for the sculptures of the archaic Temple of Jupiter on the Capitol.

Because of political and commercial troubles, Etruscan artists took very little
from Greece in the fifth century B.C. and, therefore, did not begin that process of
the disruptive absorption of Greek art until they again became borrowers of Greek
motifs and compositions in the fourth century B.C. The bronze statue of the Mars
from Todi in the Vatican is a handsome product of this new wave, but the Etruscan
touch is evident in the over-large head, the gesticulating arms, and the inorganic
compression of the torso beneath the tight cuirass. Despite an increasingly realistic,
even descriptive style in later Etruscan art, these features survive until the early
first century B.C., as exemplified by an Etrusco-Roman portrait statue in bronze of
Aule Metele, 'The Orator' (Fig. IV.7a, b). The term 'appendage aesthetic' has been
coined to characterize this Etruscan tendency to break up the organic coherency of
the body by emphasizing the signal possibilities of arm and hand gestures, the sym-
bolic, covering role of costume, and the disproportionately prominent head.

Terminal and surface exaggerations continued to increase, expressed in roughened
textures, excited contours, and convoluted postures, partially inspired by a similar,
more moderate development in hellenistic art. The late fourth-century B.C. bronze
chest, known as the Ficoroni Cista (Fig. VI.2), made in Palestrina for an Etruscan (?)
patron and signed by Novius Plautius of Rome, shows the initial stage of this shift-
ing of the Greek drawing style toward busy patterns and quickly moving lines, while
the plastic ornament in relief or three dimensions maintains the tradition of awk-
wardness, as if physical power varied inversely with grace. By the third and second

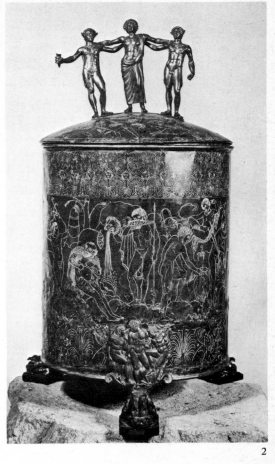

2

Fig. VI.2 So-called Ficoroni cista, from Palestrina. Late IV or early III century B.C. Rome, Museo di Villa Giulia

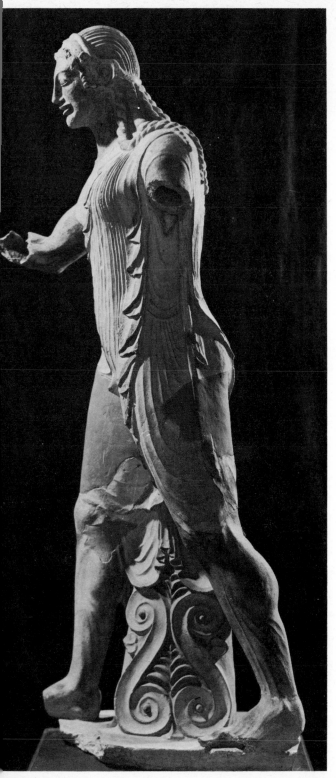

Fig. VI.1 Apollo. Terracotta statue from his temple in Veio. About 500 B.C. Rome, Museo di Villa Giulia

1

centuries B.C. awkwardness has been fully converted into melodramatic expression and a stirring plasticity, visible in a number of terra-cotta architectural sculptures from Etruscan temples at Pyrgi, Falerii Veteres, and Cività Alba (Fig. VI.3), and also in second century B.C. tomb-painting as in the Tomba del Tifone at Tarquinia. In these works, whatever the medium, rich, plastic modelling, quick or even sudden movements, and surface violence provide an exciting, restless image of peculiar intensity and instability.

Etruscan sepulchral art from the seventh to the second century B.C. has preserved a rich repertory of motifs, presented in fine wall-paintings and in decorated sarcophagi and cinerary urns that may reflect the lost monuments of Etruscan interior decoration. These motifs divide into three distinct programmes, characterized by subjects drawn from Greek mythology (Fig. VI.4), ceremonial scenes of different kinds (Figs. VI.5; V.2), and personalized representations of individuals or events (Figs. VI.6, 7). Although there are many variations in the handling of these themes, corresponding to the differences among major centres of Etruscan art—Cerveteri, Tarquinia, Chiusi, Perugia, Volterra, etc.—sculptors and painters both manifest an intensified interest in specific anecdotal detail, progressively restricting the generalizing power of images while enhancing their specific narrative or rhetorical content. The Greek myths which decorate so many Etruscan urns, anticipating by centuries the Roman practice (see pp. 103 ff.), by the third and second centuries B.C. assume more and more the character of stage-like sets, with props carefully depicted in the most accurate way, drawn however not from the Greek model but rather from the contemporary scene (Fig. VI.4). Similarly, the representation of the recumbent figures of the deceased on the lids of sarcophagi and cinerary urns moves toward increased specificity, either in the description of physical type in fat-bellied lid figures from Tarquinia or Tuscania, urns from Chiusi or Volterra reaching toward portraiture (Fig. VI.7), or in the rhetorical presentation of the trappings of conspicuous wealth

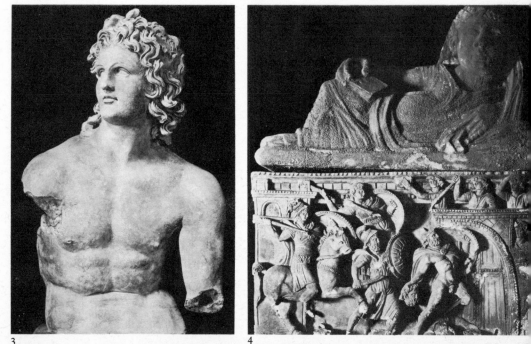

3 4

5

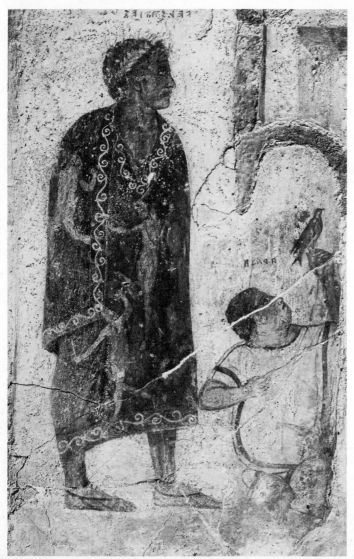

6

Fig. VI.3 Terracotta sculpture from Falerii Veteres. Late III century. Rome, Museo di Villa Giulia

Fig. VI.4 Etruscan cinerary urn with The Seven against Thebes. III–II century B.C. Volterra, Museo Guarnacci

Fig. VI.5 Wall-paintings in the 'Tomba del Barone', Tarquinia. About 500 B.C.

Fig. VI.6 Vel Satie. Painting from the 'François Tomb' in Vulci. Late III century B.C. Rome, Villa Albani

in images dressed up to impress. In these monuments many of those tendencies toward explicitness and ostentation that characterize so much of Roman art are already present.

The third-century B.C. Etruscan paintings from the François Tomb at Vulci combine these qualities in an impressive monument that is both violently explicit and ostentatiously descriptive. The artist has depicted scenes of cruel violence in an almost dispassionate manner but with realistic detail, setting his fully modelled figures against a light ground with very little attempt to create a spatial environment. This type of non-spatial composition also characterizes the flatter, more schematic and linear tomb-paintings of the fourth to third century B.C., now coming to light from Ruvo in Apulia and from Paestum, original Greek settlements subsequently taken over by Italians. A similar use of neutral space may be found in the famous fresco from a Republican tomb on the Esquiline in Rome, which probably, but not certainly, refers to a triumph won by the consul Q. Fabius Maximus Rullianus in the late fourth century B.C. and is very likely based on paintings of the Roman victories in the Samnite wars executed by Fabius Pictor shortly before 300 B.C. The Roman painting, however, is crude in its composition, but the arrangement in narrative registers recalls the technique of the Tabula Iliaca for the telling of a story and also the design of some of the mythological urns from Volterra in the architectural setting. Furthermore, from the inscriptions, the specific scenic construction, and the careful details of architecture and costume, it is clear that the painter has represented a specific historical episode, the oldest surviving example of history painting in Roman art (see pp. 187 ff.). The Esquiline painting also displays hieratic distinctions in scale, separating the principals from the mass of soldiers by the simple device of discrepant size, developed in Greek votive monuments and subsequently persistent in Roman art for centuries (Figs. V.1a, b; IV.3; II.46).

The François Tomb paintings also contain a precisely descriptive portrait of Vel Satie (Fig. VI.6), dressed in the embroidered *toga picta* of the high-ranking magistrate. All salient characteristics of Roman official portraiture (see pp. 166 ff.), including the identifying features of the man and the attributory costume, are in evidence, and, one must assume, for the very same reasons that these elements became so formulaic in later Roman art. Within the rhetorical context of his image, the *toga picta* relates to the representation of status in Etruscan monuments, accomplished either by symbolic items of dress or by qualitative and quantitative proofs of wealth, or by the telling description of pompous processions (Fig. V.2), which would be appropriate only for a very important person. At the same time, the intent to portray, which presents the viewer with the features of Vel Satie, still more typically than uniquely represented in the third century B.C. becomes increasingly specific and individually detailed in second-century B.C. tomb-paintings (e.g. the funeral banquet of the Velcha family, Tomba dell' Orco, Tarquinia) and cinerary urns, and in terra-cotta heads of the late second and early first centuries B.C. Much of this development is summed up in the early first-century bronze statue of Aule Metele, now in Florence (Fig. IV.7a, b). This is the life-size portrait of a man individually portrayed in his own likeness, garbed in the toga and high shoes of the magistrate, and

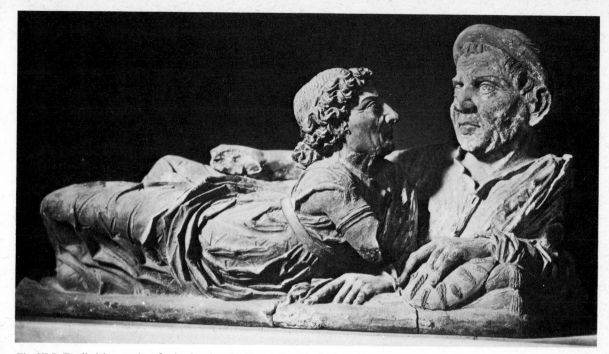

Fig. VI.7 'Realistic' portraits of a husband and wife, on the lid of a Late Etruscan cinerary urn. Late II century B.C. Volterra, Museo Guarnacci

placed on a pedestal in the public square, addressing his fellow citizens in the perpetual reaffirmation of his authority and distinction. If he is a worthy predecessor of the Prima Porta Augustus (Fig. II.32), his statue is no more a declaratory symbol of himself than the elaborately sculptured Porta Marzia, Perugia (Fig. II.37), is of the Etruscan city within. And this type of proclamatory public gate anticipates the rhetorical billboards that became Roman triumphal arches.

Italic art, poorly understood as it is, encompasses a vast assortment of works, produced usually at a low level of quality by a number of tribes living in central Italy and along the Appenine chain. The best known of these tribes—the Sabines, Samnites, Volscians, Aruntii, Faliscans, Lucanians, and Marsi—before the Roman conquest seem to have developed their own artistic languages, partly influenced by the Greek colonies of Magna Graecia and by the Etruscans of Campania, centred around Capua. In the fourth to third century many of these tribes came down from the hills and captured the Greek cities of the coastal plain, such as Paestum and Pompei, quickly adapting Greek forms to their own use and taste. So the Lucanian tomb paintings, now constantly being discovered around Paestum, reflect with greater or lesser reliability the styles and motifs of contemporary Greek art, although comparisons are difficult in the absence of Greek monumental painting. The Samnites occupied Campania and Pompei with it, becoming gradually more hellenized, building and decorating houses in a distinctly hellenistic-Campanian style. They also carved the local volcanic stone in a vigorous, direct manner, well represented by some handsome historiated capitals, now in the Pompei museum (Fig. VI.8). Yet despite the hellenistic source of the historiated or figured capital, these carvings have an almost primitive forcefulness, conveyed by the sharp contrasts

between simple shapes, rough textures, and abrupt changes of plane, that is very un-Greek in its suddenness. Furthermore, the semi-destruction of the dense shape of the capital as an architectural member contradicts the purpose of Greek design to make ornament ancillary to structure, not the reverse.

However, such Samnite carvings interrupt and arrest the passage of the eye, they draw attention to themselves as forms emerging out of darkness, and they have great visual impact. If they anticipate some of the textured patterning of later Roman architectural ornament, their direct strength seems to derive from an Italic predilection for emphatic, even grotesque images that hold the viewer in an inflexible grasp. Hieratic frontality, insistent projection, and a concentration of effects coupled with a near-rejection of finesse characterize the sixth-century B.C. Warrior

Fig. VI.8 Samnite capital. III century B.C. Pompei, Museo

Fig. VI.9 Warrior, from Capestrano. Late VI century B.C. Chieti, Museo Archeologico

8

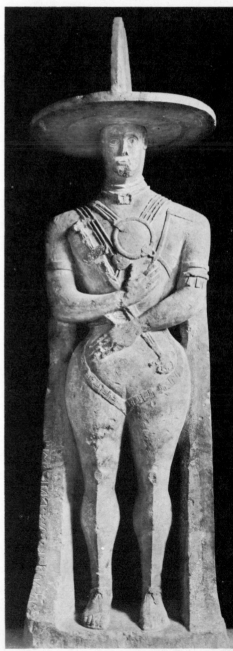

9

from Capestrano (Fig. VI.9), a funerary monument far removed from the archaic Greek kouros that inspired its creation. Much the same kind of iconic reduction dramatizes the dense, even blocky shapes of the Capua Matres (Fig. V.24), offered as votives in the third century B.C., symbolizing the 'I and thou' relationship between the dedicant and her god. This mode of primitive simplification also affects many of the Campanian votive terra-cottas of the fourth to second century B.C. which seem almost to achieve a perfect state of the appendage aesthetic, turning the human torso into an object to be fitted with limbs and a head.

Some very great third-century B.C. artist, heir to both the Etruscan and Italic traditions and knowledgeable about Greek portraiture, created the bronze masterpiece that now bears the name, the Capitoline Brutus (Fig. VI.10). There is no evidence that this is *the* Brutus, patriot and puritan in the formative years of the Roman Republic at the end of the sixth century B.C., nor that the head is a portrait of any Roman at all. And yet this shaggy, grim-visaged, tight-lipped, sharp-featured, austere man, intuitively felt as a very redoubtable individual, has come to represent,

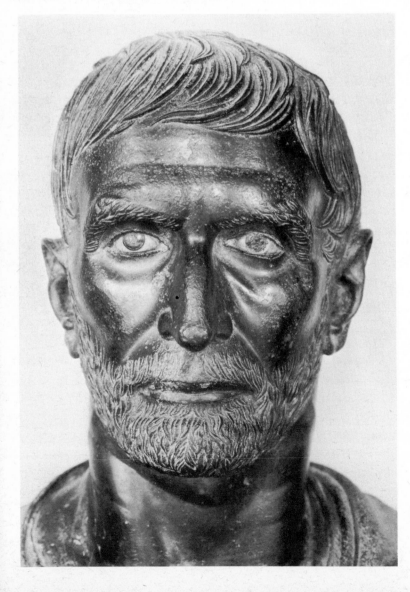

Fig. VI.10 Capitoline Brutus. Bronze. Probably III century B.C. Rome, Museo Capitolino

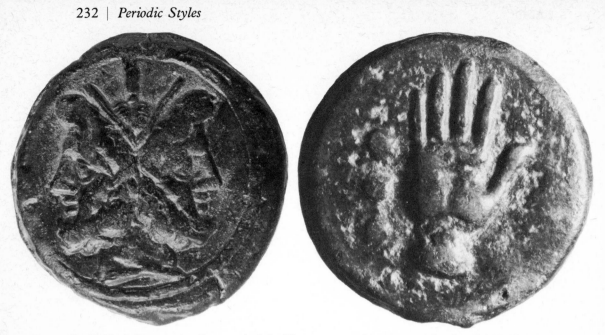

Fig. VI.11a–b Roman coins (Aes grave) of the III century B.C.: Janus; *manus*. London, British Museum

even typify, the highly moral 'Old Roman' of the great days of the Republic. At first sight the head is intensely direct, the powerful face stripped of all superfluous flesh as the bony skull comes very close to the surface, but then it becomes increasingly evident that the sculptor has subjected plasticity to the abstract demands of a simplified shape, which he covered with a dynamic, restless surface, agitated by lines and by tensions. In doing so, he left the Greek canon of physical beauty far behind, and in its place he has thrust an image of intense force into the consciousness of the beholder, who is thus compelled to recognize its power and authority. When the Romans began to coin money in the third century B.C. (Fig. VI.11), they too recognized the effectiveness of this imagery.

b. The Roman Republic, Third to First Century B.C. The varied forms and modes adopted by artists during the last two centuries of the Republic seem analogous to the products of an experimental farm where hybrids are developed without either protective isolation or a knowledge of genetics (see pp. 197 ff.). Artists of different training and tradition were employed by Roman patrons, largely without any critical background, who gradually acquired an Hellenic standard of taste, which was foreign to their culture but eventually coloured all that they would desire. For this reason, Republican art may be considered to have characteristics but no definitive character, since a full amalgamation of the discordant elements of which it is composed never took place. The history of the art of this period, then, should concern itself with the definition of these characteristics, all effected by the progressive introduction of Greek forms, and in sculpture by the adoption of marble. And portraiture was the most readily accessible medium of change.

Republican art was excessively political, especially after the middle of the

second century B.C., when all power gathered in the hands of a few ruling families that contended for rank in the state. These families and their noble friends, and enemies, expressed their glories, dignities, and distinguished ancestors in portraits and historical reliefs, encouraged to do so in a legitimate use of art even by those patriotic traditionalists, like Cato, who objected both to effeminate Hellenism and to the indulgence in art for its own sake. Except for sepulchral monuments, private portraiture was legally restricted to the noble families in possession of the *ius imaginum*, the right to make the realistic death masks of their distinguished members which would be placed in special cupboards in the *domus* and then taken out and paraded in public on great occasions. Over the years, some of these wax masks (which do not survive) were replaced by stone portraits, probably similar to the sepulchral images already in existence in the second century B.C. Once this occurred, the conventions of portraiture, previously articulated by Etrusco–Italic and Greek artists, began to affect the appearance and style of these works and the Roman art of the public portrait was launched.

The astringent Catonic type of leathery-faced, middle-aged 'Old Roman' (Fig. IV.27) seems, therefore, to represent the immediate translation of the death mask into a sculptured portrait. The grim character of these masks is known from the apparent reproduction of ancestor portraits on coins struck for political reasons by descendants of the great families in the late second and early first centuries B.C., while the retention of this imagery in contemporary portraits had a symbolic value as an immediate reminder of the past tradition and its heroes. Late Etruscan realistic portraits (Fig. VI.7) and those of a mixed Etrusco–Roman context (Fig. IV.7b) deeply influenced the Republican portraits in terra-cotta, bronze, and stone, while sepulchral monuments of the middle class (Figs. IV.9; II.4b) continued to maintain this explicit tradition down into the first century B.C. Interestingly enough, a number of the so-called classic examples of Republican realistic portraiture both in the Museo Torlonia and in the Capitoline Museum are in fact late Julio-Claudian or Flavian replicas. Their re-appearance suggests the renewed attractiveness of this imagery more than a century later and the continuous existence of such portraits in honoured, admired security.

A further reason for the later replication of these portraits may have been political, the same motive that led the moneyers of 44–42 B.C. to represent Julius Caesar (Fig. VI.12) in the lineaments of the Republican artistic tradition, when it was already on the decline, probably to cover his destruction of the Republican structure of government and society. Indeed, possibly the last vestige of this antiquated but symbolic tradition may be found in the gilded bronze statue of Livia from Cartoceto, near Ancona (Fig. IV.11). The statue was probably cast early in the first century A.D., perhaps by a local workshop, but represents this indomitable first lady of Rome with all the frank modesty of a worthy Roman wife of the middle class (Fig. II.4b). However, the plastic treatment of Livia's drapery demonstrates the erosion of the tight, linear forms of Republican sculpture before the Greek insistence on the creation of form, including drapery, in three dimensions. Indeed, in the latter part of the first century B.C. the Catonic portrait type was itself giving way to ample, clearly shaped, and less wary images of men and women. The forms remain dry and matter-

of-fact (cf. Fig. IV.1), even in the portraiture of the young (Fig. VI.13), but they are simplified and rejuvenated (Fig. II.17) in the direction of a new model, proposed by the artists of Augustus (see pp. 238 ff.).

Stimulated in part by the cultivated, hellenizing circle of the Scipios and in part by the Roman conquest of the eastern Mediterranean, an expressionistic current of hellenistic style slowly grew to importance. Certain replicas of Greek intellectuals such as the Pseudo-Seneca may have been the prime conveyers of this style, possibly because of their superficial resemblance to the shaggy fathers of the Republic. Nevertheless, a Greek artist adopted this manner of representation to portray the Roman commander, Flamininus, 'liberator' of Greece in 196 B.C. and the first Roman to appear on coins in his own lifetime. However, this style as a style had little direct success, although the numismatic portraits of Mark Antony struck in the eastern mints in the 30s may reflect the same tradition; it should be noted that Antony's western coinage and portraits seem, like those of Caesar, to make a deliberate reference to the *imagines maiorum* of the Republic. Yet this hellenistic intrusion led eventually either to the more frequent adoption of Greek heroic types for celebrational portraiture after 100 B.C. (Fig. II.31) or to the employment of Greek artists to render into solid, plastic form the portraits of the great captains in the mid-first century (Fig. V.17). From this point of development the portraitists of Augustus (Fig. VI.14) looked further back in time to the Greece of the fifth to fourth century B.C., but moved forward to the creation of a new mode.

Roman historical reliefs provide the other great series of Republican monuments, and it is significant that the late second-century Altar of Domitius Ahenobarbus (see pp. 197 ff.) should contain both the 'Old Roman' and 'Hellenic' traditions within its parts (Fig. V.1a, b). The Marine Thiasos follows the model of contemporary hellenistic art, thereby anticipating a similar reference in the first century B.C. when hellenistic art began to indulge in its own revivals. Thus, cultivated Romans imported neo-Hellenic sculptures directly from Greece, as indicated by the shipwreck at Mahdia

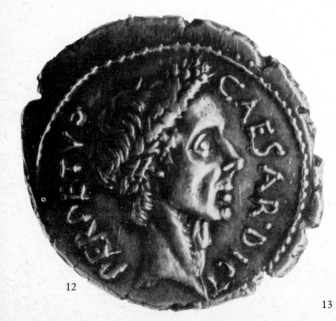

12

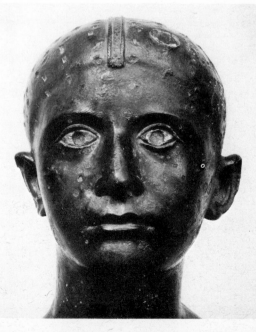

13

Fig. VI.12 Denarius of Caesar, 44 B.C. Obverse: portrait of the Dictator with long neck. London, British Museum

Fig. VI.13 Young girl. Bronze. Late I century B.C. Parma, Museo Nazionale

Fig. VI.14 Gold coin (aureus) of Octavian as *filius Caesaris*. Eastern mint before 27 B.C. London, British Museum

Fig. VI.15 Relief probably from a triumphal monument of Sulla. About 80 B.C. Rome, Palazzo dei Conservatori

Fig. VI.16 Decorative frieze from the Temple of Apollo Sosianus, Rome. 33 B.C.

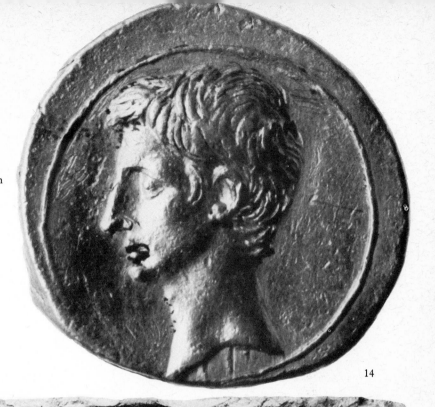

14

15

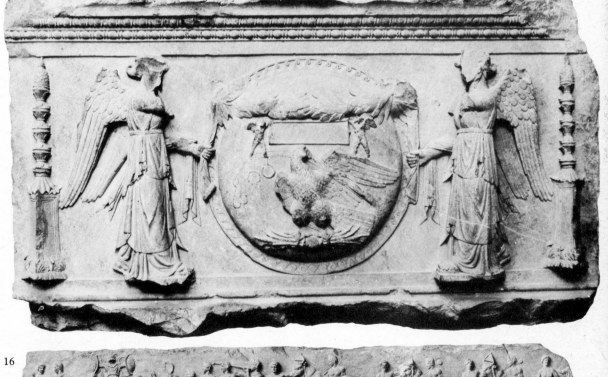

16

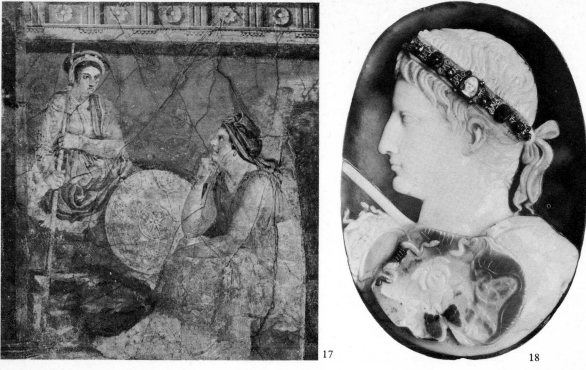

17

18

on the Tunisian coast, collected neo-Attic reliefs, employed eclectic Greek artists like Pasiteles and his followers (Fig. v.3), commissioned neo-classical objects of great elegance such as the Borghese Vase in the Louvre, and by the end of the century ordered good copies of Greek masterpieces of the classical period (Fig. v.4). For most of this time, however, the Greek glut had little impact on the development of historical or ceremonial reliefs, dependent, like the Census relief of the Altar, on the prosaic, non-spatial, and explicative composition previously created in Roman historical painting. However, the marked parataxis of the Census relief seems to be a novelty, perhaps introduced to fix more clearly and recognizably the specifically described constituent elements and figures of the different ceremonies, each one of which is prized. Something of this magic fixation, sharpened by a dry, precise technique of carving, characterizes the reliefs recently discovered in the excavations of S. Omobono in Rome and which probably come from a triumphal monument of Sulla made in the 80s (Fig. vi.15). Here the repertory is explicitly symbolic, but the sculptor has exerted every effort to clarify and isolate his sign language for the greatest possible visibility, given the fact that originally this frieze would have appeared high up on a building; this tendency will long survive in Roman art for similar projects (cf. Fig. v.9). Lastly, the stocky proportions of the human agents in the Census relief, visible but uncouth, established a norm for the declarative relief that was followed in the late first-century frieze on the Baker's Monument (Fig. II.4a) and in the historical reliefs on the Augustan Arch at Susa in northern Italy, erected early in his reign to celebrate the pacification of the Cottian Alps. Although this same figural tradition survives in the ceremonial marble frieze from the Temple of Apollo Sosianus (Fig. vi.16), completed at Rome in the mid-first century, Greek

19

Fig. VI.17 Wall-painting from the Villa at Boscoreale. 50–40 B.C. Naples, Museo Nazionale

Fig. VI.18 Augustus. So-called 'Blacas' sardonyx cameo. Early I century A.D. London, British Museum

Fig. VI.19 The Portland Vase. Late I century B.C. London, British Museum

art has touched this relief and given the figures a new lightness and corporeal grace.

That sense of grace and elegance, the outcome of a purified Hellenism, rose in critical estimation after the death of Caesar. Its effect was strongest in the decorative arts (Fig. III.36), in stucco ornament (Fig. III.31), and in wall-painting (Fig. III.21), but reached fulfilment in Augustan art (see pp. 238 ff.). However, an hellenistic revival also took place in this same period, beginning with the narrative frieze on the Basilica Aemilia in Rome, which represents episodes from the Roman past, placed firmly in a landscape setting, but now composed of active, fully modelled, muscular figures, strongly realized in space. In this relief the influence, direct or indirect, of dramatic Pergamene models has been felt by the artist, almost a century after Pergamon itself was given to the Roman state by its last king. The slightly later reliefs of the Julian Monument at St Rémy de Provence (Fig. II.7) clearly demonstrate the effect of this active, spatially sophisticated style with its strong pictorial overtones, a style apparently popular in hellenized-romanized southern

Gaul, as it colours the Augustan Arch at Carpentras and the early first-century A.D. Arch of Tiberius at Orange (Fig. II.41). Most important for the subsequent development of Roman art, these waves of Hellenic styles and models reinforced each other, gradually liberating the Roman artists from the constriction of the traditional methods of composition in the prestigious public monuments. Accordingly, the grand, solid figures of the Boscoreale paintings (Fig. VI.17) anticipate at mid-century the subsequent expansiveness of Augustan imagery, while the great frieze from the contemporary Villa of the Mysteries (Fig. I.55) prepared the way for the processional friezes of the Ara Pacis Augustae (Fig. IV.3). These private precedents perhaps express the illuminated taste of the great patrons at the end of the Republic before they were willing to expose their new cultivation to the Roman public in great state monuments.

c. From Augustus to the Julio-Claudians Augustus brought peace to a society wearied by continuous civil war, order to an ancient civilization disrupted by political ineptitude, and the gloss of classical culture to the entire Roman world. This revolution carried with it an aura of dispassionate correctness, so that the Pax Augusta became the normal pattern of life, and state monuments such as the Ara Pacis (Figs. I.1; IV.3; V.8; VI.20) and the Forum Augustum (Figs. I.30, 31) its most complete artistic expression. An imagery of pompous statism (Fig. IV.3), political propaganda (Fig. II.32), elaborate literary allusion (Fig. V.8), and an academic sensibility bent on self-justification (Fig. II.40) all played central roles in the conscious making of Augustan art. And consciously did the Augustan artists pursue the joined themes of victory, peace, and piety, as defined in Virgil's *Aeneid* and his millenarian *Fourth Eclogue*. In a sense, Augustan art is an artificial, eclectic style, highly syncretistic in its approach to Greco–Roman traditions, and invariably out to prove

Fig. VI.20 The Aeneas panel on the Ara Pacis Augustae, Rome. 13–9 B.C.

the virtue of Augustus and the reality of his governance of the world, so fully set out in the *Res Gestae*. But Augustan art has other characteristics that give it a unique position in classical antiquity: Augustus used the techniques of propaganda to turn fiction into history as an instrument of political persuasion, either by making more of less, as he did by converting the return of the Parthian standards into a great triumph, or by never seeming to grow old (Figs. II.40, 32), by which he retained a messianic power. He also deliberately created an image of great refinement, flavoured by Greek forms, as a medium of acculturation and propriety, taken as a just symbol of an harmonious, moral society (Figs. IV.2; VI.18). And he imposed the cultivated, metropolitan court style upon the unsophisticated mass audience of northern and western Europe as an instrument of romanization and unity (Fig. I.22). The programme was as successful as it was sanctimonious, and took firm hold in the fifty years of his rule.

The Ara Pacis Augustae, the Altar of Augustan Peace, located on the edge of the Campus Martius, the Field of War, in Rome, was completed in 9 B.C. It is the classic example of Augustan syncretistic classicism, analogous to the earlier Altar of Domitius Ahenobarbus (see pp. 197 ff.) but at a much higher level of synthesis and abstraction. An Arcadian quality of peaceful, quiet reverie (Figs. IV.3; V.8; VI.20) permeates the whole conception of this monument, devoted to the exaltation of peace within a harmonized society under Augustus' direction, and recalls the similar, if somewhat more Olympian mood of grace on the Portland Vase (Fig. VI.19), on the Gemma Augustea (Fig. II.35), and within the persona of the Augustus from Prima Porta (Fig. II.32). Inasmuch as Augustan artists reinforce their messages by repetition in the Roman manner but with a new delicate grace, the exterior of the marble precinct is covered in its lower part by a zone of exquisite floral ornament, a visible reminder of the pastoral environment and a pleasing symbol of the felicitous bounty of nature, assured by the Augustan peace. If virtuosity became an Augustan hallmark, these floral motifs also entered the repertory as decorative forms and as positive symbols, appearing in elegant silver vessels of the period (Fig. III.36), in the graceful wall-paintings that decorated Livia's villa at Prima Porta (Fig. I.56), and on the piers of the Arch of the Sergei at Pola in Istria. The hellenistic source of this pastoral imagery is reconfirmed by the great relief panel identified as Tellus or Italia (Fig. V.8), an allegorical personification of the fertile land, perhaps ultimately derived from Alexandrian models brought to Rome in small, precious objects made at the Ptolemaic court, similar to the Tazza Farnese in Naples. Still, despite the foreign source, both the imagery and the rich but precious style of the Tellus/Italia panel were quickly absorbed into early Imperial sculpture and the decorative arts (Fig. III.35). Not everything in the Ara Pacis is dependent on immediate Greek sources; the paratactically composed frieze which decorates the altar proper within the precinct closely follows the model developed a generation before in the ceremonial relief from the Temple of Apollo Sosianus (Fig. VI.16).

The well-preserved Aeneas panel (Fig. VI.20) of the Ara Pacis, representing pious Aeneas in the act of sacrificing to the gods within a sacred landscape, draws upon the central legends of the Roman past and its moral traditions, given new meaning

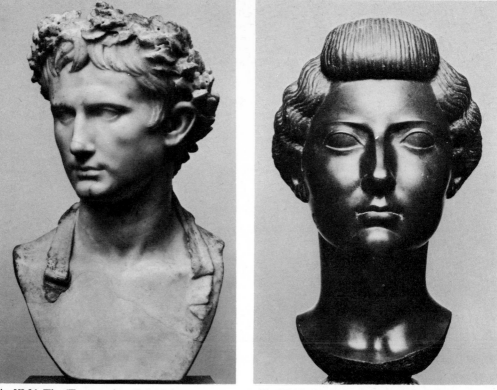

Fig. VI.21 The 'Transcendental' Augustus. Marble bust. 20 B.C. Munich, Glyptothek

Fig. VI.22 Octavia. Basalt head. 40–30 B.C. Paris, Louvre

by Virgil and Augustus. Aeneas, draped and veiled, has taken the form of the Greek philosopher type developed in the fourth century B.C.; this type remains in Roman art, reaching a renewed vigour in the period of Antoninus Pius, who deliberately revived some of the more solemn Augustan forms. Moreover, both the composition of the relief panel and the idea of the sacred landscape have their origins in late Republican adaptations of Greek models, as demonstrated by a number of decorative Roman reliefs with a strong hellenistic flavour and in the landscape conventions of certain Second Style wall-paintings. Whatever the figurative source, this reference to the past, to the origins of Rome and the Julian line, of which Augustus is heir, complements another badly damaged panel from the precinct of the Ara Pacis which represents the Lupercal and, by implication, the past of the Roman people, traced through Romulus and Remus. This insertion of a balanced historical relationship is an important feature of the historiographical tendencies of Augustan art and of the fictive programme of the Altar, which manipulates the past in order to provide the true reason for celebrating, and to prove the legitimacy of, the present political situation. In the Augustan constitution, the state was conceived as a dyarchy, consisting of Augustus and the Imperial family on one side and the Roman people on the other; Augustus, of course, became the leader and the first among equals in the Senate, a condition of Orwellian subtlety. Thus the Roman state was allegorically portrayed in the two great processional reliefs placed on the parallel long sides of the precinct, the Imperial family on the south led by Augustus and Livia (cf. Fig. IV.3),

the Roman people on the north, both moving west toward the opening and the altar of Pax within, as they might have done on the day of dedication itself.

The processional reliefs of the Ara Pacis are intentionally the Roman equivalent of the Parthenon frieze, conceived in a similar manner as the portrait of a nation and hallowed by a solemn but joyous occasion. However, the Augustan rhythms are slower, the figures more consciously elegant, and though carved in deeper relief, they appear less physically present. Men, women, and children, carefully arranged in family groups defined by gesture, glance, and the linear accents of swinging drapery, pass before the eyes of the spectator, who sees them from below as cool forms moving above him against a painted (blue?) background. The effect is strangely shadowy and impersonal, possibly because so much is concealed behind the full draperies, as in the statue of Augustus from the Via Labicana (Fig. IV.2). The sculptor, however, has made every attempt to indicate families and the identities of the individual members of the Imperial entourage by specific portraits, even if the portraits cannot all be recognized at present. Augustus, however, is readily visible at the damaged head of the procession and Agrippa, his chief minister and son-in-law, in the middle, because their features are precisely delineated and familiar, they stand where they would be expected to stand, and as the most important individuals present they are slightly but noticeably taller than everyone else.

The artistic interpretation of the political concept *primus inter pares*, first among equals, when applied to this representation of Augustus and Agrippa, immediately exposes the signal techniques used to achieve the hieratic projection proper to their status. But the idea of parity itself seems to be a powerful factor in Augustan art, complicating the identification of secondary personages, all of whom seem covered by the levelling gloss of Augustan classicism. Young men and women are handsome, upright, and bland, age is abolished (Fig. VI.21), and the individuating peculiarities of physiognomy are much reduced (Fig. II.17). If the underlying force was a resurgent classicism, based on high classical models (Fig. II.32) and a predilection for abstract, clarified shapes (Fig. VI.22), the consistency of this imagery and its broad imposition suggest a deliberate attempt on the part of the Augustan image-makers to recreate a classical age in the heroic Greek mould. They had two generations to achieve this purpose and obtained partial success in restating the principles of composition in the official monuments, but in the end the effort failed.

The Louvre Suovetaurilia relief, probably executed under Caligula, shows the pervasive influence of the Ara Pacis, but also the progressive deviation from that model in the direction of greater plasticity, richer modelling, and a more immediate sense of the presence of human actors, however solemn and ceremonial their comportment. The fine Claudian relief in the Villa Medici, Rome, known as the Ara Pietatis, is unequivocally based on the style and programme of the Ara Pacis, but this symbolic revival does not preserve the visual character of the model. Instead, the sculptor has broken the figural groups into smaller, more irregular units, no longer dependent on linear rhythms for their organization, while he presents the participants in the ceremony as individuals, placed in a variety of curving, turning

positions. The relief is also very deep, and the figures are not set against a background but rather in a space ample for their movement and coloured by the continual changes of plane and the presence of dark, cast shadows. Most striking is the rejection of the generalized soft lighting of the Augustan relief and the transition from that uniform blandness of the Augustan gloss in the direction of particularized details of feature, and more poignant, even personalized facial expressions. The last of this group of derivative state monuments is known as the Ravenna Relief (Fig. VI.23), almost certainly part of a Claudian ceremonial commission in honour of the great departed members of the Imperial family, dominated in the composition as in fact by the regal figures of Livia and Augustus at the right. The sculptor did not, however, conceive of this monument as a true relief but rather as a series of seemingly free-standing sculptures barely attached to the stone wall behind, and possibly the relief replicates in a reduced medium some great dynastic programme of portrait sculptures, similar to those commissioned by Claudius at Velleia, Leptis Magna, and elsewhere. Still, the Ravenna Relief, despite its Augustan echoes, recalls older, pre-Augustan traditions of figural isolation (Fig. V.1a), once again coming into view.

During the reign of Claudius, a group of street magistrates commissioned what must be termed a semi-official monument, known as the Vicomagistri Relief from the Cancelleria in Rome (Fig. VI.24). It represents a procession of street supervisors or priests, carefully dressed in the costumes of their office and civic station, bearing the lares and penates in their charge probably to the compital altar in their neighbourhood. The figures are stockily proportioned, bluntly carved in very high relief, and placed ambivalently against the neutral ground, as if the sculptor could not decide whether to describe the procession as moving laterally along the frieze or to show off these self-important fellows directly to their friends and relatives. In every

Fig. VI.23 Dynastic portrait of the Julio-Claudians. Relief. Probably A.D. 37–41. Ravenna, Museo Nazionale

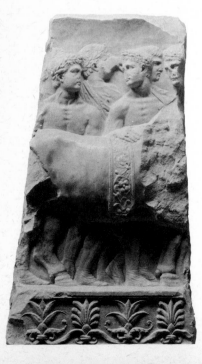

Fig. VI.24 Relief of the Vicomagistri (street wardens). A.D. 41–50. Vatican, Museo Gregoriano Profano

sense the Vicomagistri Relief is both descriptive and historical within the convention for such monuments, but the style of presentation and the composition must be distinguished from the contemporary Ara Pietatis by its much closer affinity to the old-fashioned, less deeply hellenized forms of the late Republic. Some scholars have seen in this monument an example of middle-class or plebeian resistance to the official style, even if clearly affected by developments in the high art of the court. Certainly traces of this resistance do appear in private sculpture of the late Augustan period, such as a sepulchral altar in the Terme Museum (Fig. VI.25), in diehard, 'Old Roman' families (Fig. IV.1), or in what might be a central Italian dynastic monument in honour of Augustus, Livia, and the young Caesars, partially preserved in Ancona (Fig. IV.11). Something of this attitude, or at least that concern for explicit representation that characterizes the old tradition, seems to influence many of Tiberius' less bland portraits, possibly because by virtue of his great lineage he was the last of the Republicans. Nevertheless, these portraits must have been executed at court and by artists of the highest quality, given the Imperial necessity and also the excellence of Tiberius' own education.

Therefore even at the highest levels a taste for acute and unsweetened observation lingered on, contrary to the Augustan fashion. Resurfacing in the 20s and 30s, this interest grew, if the mourning (Louvre) and mad (Fig. VI.27) portraits of Caligula are any indication. Indeed, the portrait of the deranged (?) Caligula carries with it some of the harsh intensity of old Brutus (Fig. VI.10), while its penetrating, specific individuality finds echoes in the unflattering portraits of the Imperial ladies named Agrippina (Fig. VI.26), as well as in the more modest private portraits of Pompeians. Such a continuous tradition then provides a background for the sobriety of a Corbulo (Louvre) in contrast to his master Nero (Fig. VI.29), although both portraits clearly respond to the renewed desire for personalized description and psychological immediacy far removed from the transcendental Augustus (Fig. VI.21), honoured by all Julio-Claudians but abandoned by the Roman artists.

Yet this change does not seem to occur under self-indulgent, iconoclastic Nero, but rather during the reign of modest, middle-aged, and tradition-ridden Claudius

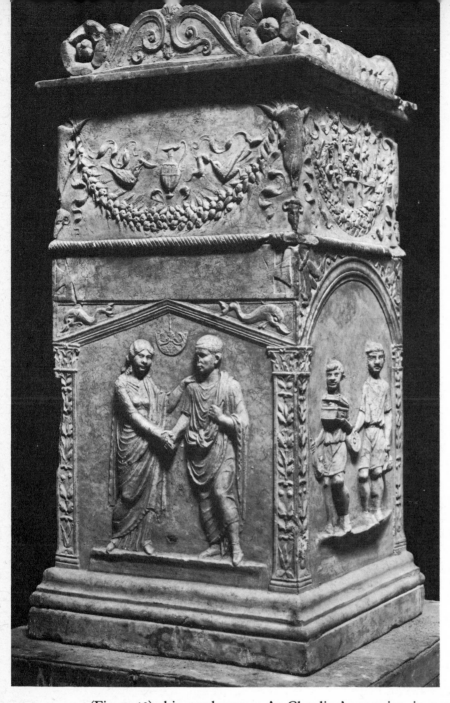

Fig. VI.25 Sepulchral
altar. A.D. 1–25. Rome,
Museo delle Terme

Fig. VI.26 Agrippina the
Younger. Marble statue.
A.D. 45–50. Naples, Museo
Nazionale

Fig. VI.27 'Mad'
Caligula. Marble
head. A.D. 39–41.
Copenhagen, Ny
Carlsberg Glyptotek

Fig. VI.28 Claudius.
Cistophoric portrait. Eastern
mint. A.D. 41

(Fig. IV.13), his predecessor. At Claudius' accession in A.D. 41 a number of heavy silver coins were struck at Roman mints located in Asia Minor, which have an unusual plasticity and corporeal freshness (Fig. VI.28). These vivid images recall to mind the vigorous, beautifully modelled portraits of Pompey (Fig. V.17) and Agrippa, both of them later replicas, made possibly as early as A.D. 50. Although the Roman mint was more sober and restrained in its treatment of Claudius, the Emperor's sculptured portraits from Italy (Fig. IV.13), from North Africa (Leptis Magna), and from Greece are both characterful and characteristic of the man. There is, however, no precedent in the Imperial tradition for the portrait of old Claudius in

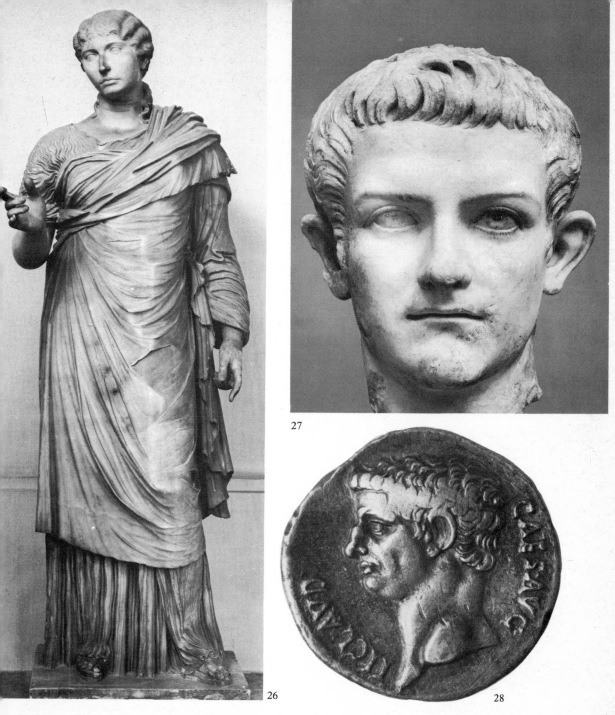

26

27

28

Toronto. Now there is no regal pretence but only the sympathetic depiction of an elderly man, beautifully portrayed with an emphasis on the subject as a feeling human creature and on the visual qualities of his physical appearance. Although acute observation is an old Roman trait, the techniques of representation, the broken, lively surface, and the variegated, colouristic modelling are all evident in Roman painting at mid-century. When the surface began to dissolve into dappled patterns, with strong highlights (Figs. VI.30; III.30) and rapid movements, then the closed forms established in Roman art under Augustus were ruptured, and the way was prepared for the plastic, contrasting style of the Flavians.

d. From the Flavians to Hadrian Flavian artists quickly took advantage of the invigoration of form initiated in late Julio-Claudian art, and moved toward the enriched plastic modelling of the Vespasianic portraits (Fig. IV.25) with their coarse vitality and heightened immediacy. Perhaps it was the painters who most completely exploited the exciting possibilities of the new style with their eagerness to combine a solid, fully dimensional shape and a lively, even impressionistic surface. Yet the scintillating heads of Achilles and Briseis from the painting in the House of the Tragic Poet at Pompei (Fig. VI.30) have very much in common with those intensely physical but elegant portraits of the Young Domitian (Fig. VI.31) and of the Flavian court beauty in the Capitoline (Fig. IV.19). In the latter portrait, the superb contrast between the smooth, lovely face and the open, airy coiffure is very effective in presenting the visual confirmation of a beautiful woman, but it reveals as well the sculptor's great interest in maximizing the textural interplay between hair and skin as surfaces and as natural forms, while demonstrating his virtuosity as a stone-carver. The result is especially pictorial in character, with its dependence on continual changes in the intensity of reflection, an effect more prominent originally when the artist tinted the face, the lips and eyes, and hair with colour, perhaps in the manner of a late first-century encaustic portrait from the Fayuum (Fig. II.13a). But the Flavian sculptor never lost sight of his medium with its own physical properties. Therefore, despite his evocative treatment of the optical possibilities of his surface, these effects have been directed toward the enhancement of the substantial, tactile essence of the stone, and in the balance of these effects the artist suggests the potential transformation of the medium itself into its representation.

29a 29b

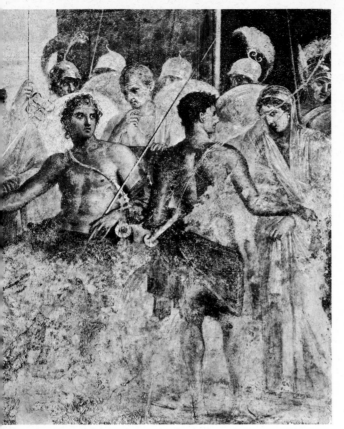

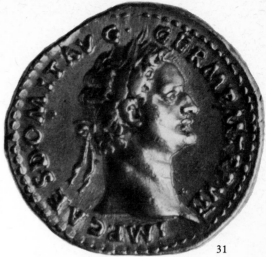

31

Fig. VI.29a–b Young Nero. Marble head. About A.D. 54. Rome, Museo delle Terme

Fig. VI.30 Achilles and Briseis. Detail. Wall-painting from the House of the Tragic Poet, Pompei. Mid-I century A.D. Naples, Museo Nazionale

Fig. VI.31 Gold coin (aureus) with the portrait of young Domitian. A.D. 71–75. London, British Museum

In this lies the extraordinary immediacy of Flavian art between A.D. 70 and 95 and the basis of the rich, solid, part-of-life images with which the Emperors filled the world. By the end of the first century A.D., however, that warmth had begun to cool (Fig. VI.33).

The visual energy discharged by the two magnificent triumphal reliefs in the passageway of the Arch of Titus in Rome (Fig. II.1a, b), probably commissioned by Domitian, draws on the same Flavian sources of pictorial suggestion (cf. Fig. VI.30) and dynamic plasticity. In addition, the forms of the marching figures, of the horses, and especially of the Emperor Titus in his triumphal chariot, crowned by Victory, are all expansive, as if they were colossal (cf. Fig. VI.32), thus conveying an impression of direct physical presence. An unknown but distinguished master has released this expansive vitality by giving great depth to the relief, thereby providing its own real, not implied space as a locus of action and movement. This, too, takes the form of illusion realized, perhaps based on the same pictorial sources used thirty years later as models for a number of the most vivid mosaic panels in Hadrian's Villa at Tivoli (Fig. III.17). However, the natural heirs of these Flavian historical reliefs are the panels in the Trajanic Arch at Benevento (Fig. II.39) with their classic mixture of history and allegory (see pp. 119ff.). Although these panels come closest to their Flavian predecessors, signs of a profound change in form are evident in them and even more so in the panels on the façades (Fig. VI.35). The figures have been

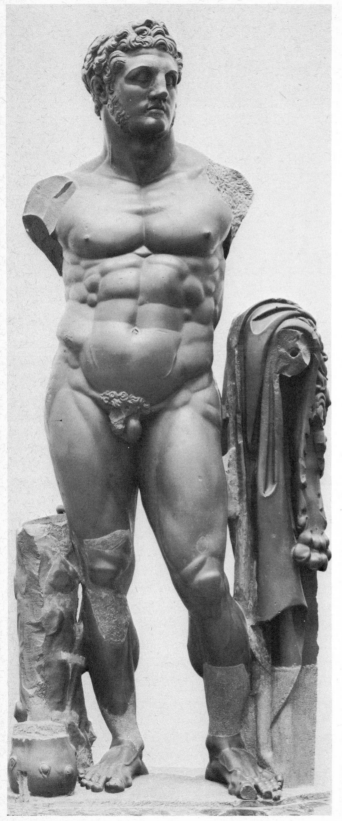

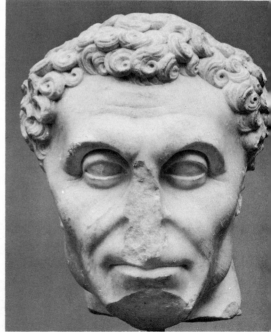

Fig. VI.32 Colossal statue of Hercules.
A.D. 75–100. Parma, Museo Nazionale

Fig. VI.33 Nerva. Marble head. End of
I century A.D. Copenhagen, Ny Carlsberg
Glyptotek

32

33

compacted much more tightly and then compressed against the ground of the relief, thus reducing the inner space of the panel as well as the dynamism of the composition. Furthermore, the demands of a celebrationist iconography with its emphasis on schematic, ceremonial arrangements and hieratic imagery have triumphed over illusion, transforming the façade of the Arch into a ritualized, artful proclamation of Imperial achievement, dominated visually by the prominent figure of the Emperor at every level. Clearly this reduction of spatiality, combined with the strengthening of an hieratic imagery, recalls certain patterns in Augustan iconography, but the attic panels of Trajan's Arch with their stolid, formal images, carved in high relief, indicate that the sculptor did not revive Augustan style. Instead, he has continued the development of a classicizing tendency, previously manifested in a number of Domitianic monuments.

Domitianic classicism has none of the transitory delicacy that characterizes Augustan art, even when it was most reminiscent of the past in the Cancelleria Relief (Fig. v.5), the Flavian response to the Ara Pacis as dynastic history and political message. Rather, late first-century Hellenism seems to have been the creation of a court artist, in tune with his patron's cultured taste, who revived fourth to third century Greek forms without entirely losing the characteristic vigour of the Flavians. Perhaps the motive for this classicizing current lay in Domitian's revival of Minerva as his tutelary deity, culminating in the adornment of the Forum Transitorium, *c.* A.D. 95, with a rich architectural decoration (Fig. III.5), containing both a Greek frieze and a panel relief representing the goddess. Beyond the unquestionably Greek source of Minerva's image, an academic conception of Hellenic purity seems to have led to the novel isolation of her figure, set against a clear ground and neatly contained within a precisely delineated, rectangular frame. This isolating, reductive design subsequently took hold of several symbolic, hellenizing reliefs in Trajanic and Antonine architecture, while it stimulated the concentration of effects within a simplified composition in the attic panels at Benevento (Fig. vi.35) and in the majestic portraiture of Trajan himself (Fig. iv.26). The last full descendant of this type of refined panel composition may be found in the Province Reliefs from the Hadrianeum in Rome (Fig. v.9), probably completed in the 140s. However, in these panels the use of the running drill, which leaves deep, dark channels and holes, has begun to affect the substantiality of the isolated figures and breaks the intimacy of their visual connection with the relief ground.

Late Flavian classicism and its dependants preceded but did not determine the direction of Hadrian's intensive preoccupation with a neo-Hellenic renaissance, principally because Hadrianic classicism was both academically correct and elegiac in mood. This Emperor surrounded himself with copies of Greek masterpieces in his Tivoli Villa (Fig. v.16) and initiated a period of classical reproductions perhaps unequalled in Roman history. And yet it is his nostalgic indulgence in a Winckelmann-like reverie for the fourth century B.C. that most characterizes his taste, whether revealed in the sleek images of his favourite Syrian, Antinoüs (Fig. v.6), or in his own moving portraits (Fig. vi.34). Strangely enough, the images of Sabina (Fig. iv.14),

his wife, are much more substantially presented. However, this elegiac mood, more sorrowful than sombre, permeates the Hadrianic-Antonine Spada reliefs (Fig. v.10), which combine great elegance of execution and attenuated, youthful figures with a dream-like but intense landscape environment.

Looking closely at Hadrianic portraiture, one marks the sudden introduction of the drilled pupil, which symbolizes the revelatory function of the eye as the opening into the soul within. Yet before this time in Roman sculpture the surface of the eyeball had been maintained as a solid on which the pupil was indicated by colour. Drilling a hole created a spot of darkness, in appearance closely resembling the dark pupil of the eye but in fact a negative, thus beginning that revolutionary process whereby Roman artists could suggest the presence of forms by optical means alone (pp. 253 ff.). Similarly, the discordant compression of the Spada Reliefs tends to bring the texture of the surface to the viewer's attention, and only subsequently does he recognize, even better decipher, the forms as a special representation of nature— a landscape with figures. Apparently, the sculptor has arranged his surface as a field of contrasting textures, originally heightened by painting, which set off the smooth skin and draperies of his actors against the roughness of rock and trees, but the spatial separation of forms has been largely disregarded. This, too, derives from a new interest in the exploitation of tactile suggestion, offered by subtle visual effects rather than by the description of actual forms in nature. Effectively, Roman artists have begun to abandon the plastic evocation of form. They turned, instead, to the manipulation of the vision of the beholder through the reconstruction of a convincing appearance without reference to that reproductive actualization of natural substances and shapes which had governed classical art for centuries.

Intimations of this profound change also occur in many private monuments made around the turn of the century (Fig. I.64), where an occlusion of the surface and a practical disinterest in spatial construction can be observed. In addition, among popular adaptations of the Flavian female hair-style, the drill seems to have been freed from its primary task of cutting stone in order to carve forms into desired shapes and converted into a device for making holes, thereby creating a pocked, sponge-like material, sprinkled with black dots, barely recognizable as hair curled on top of the head. Such free use of the drill destroys both the material density of the surface and the substance of the forms beneath. Nevertheless, this technique of drilling was very attractive, as indicated by its frequent use in forming the metopic reliefs of the Trajanic Trophy at Adamklissi (Fig. vi.36), erected in Dacian territory, a local, rude equivalent of Trajan's Column in Rome.

Perhaps this Column may be rightly considered the classic Roman monument Figs. II.43, 44) within the classic Roman architectural environment (Fig. I.31). It is the most complete of all Roman historical reliefs but without real precedent, eminently visible and with enormous impact but carefully composed of discretely coherent scenes (Fig. IV.36a–c), a perfect mixture of painting and sculpture, making pictorial forms tangibly real and placing relief in the service of scenographic construction. Trajan's Column is also the summation of the Roman figurative and iconographic tradition in the state monument: the trophaic reliefs on the base

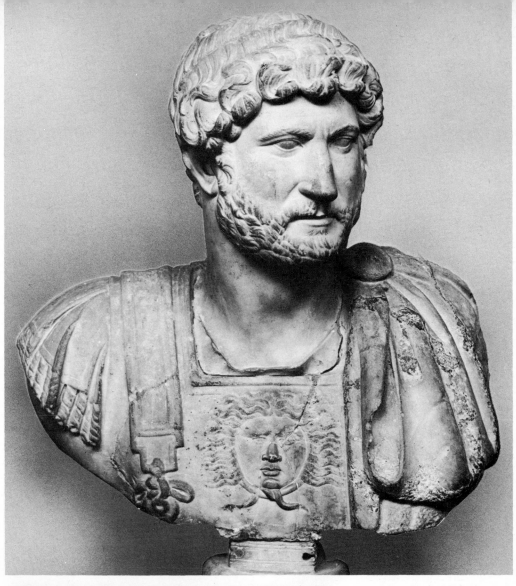

34

35

Fig. VI.34 Hadrian. Marble bust. About A.D. 120. Rome, Museo delle Terme

Fig. VI.35 The Majesty of Trajan. Attic panel on the Arch of Trajan, Benevento. A.D. 114–118

Fig. VI.36 Roman
cavalryman. Panel f
the Trajanic Troph
at Adamklissi. Abou
A.D. 110

directly symbolize the spoils taken from the enemy after battle, the column form
itself is an honorific type hallowed by Republican usage, and the events described
in the narrative reliefs (see pp. 192 ff.) are deeply embedded in traditions of Roman
historicism and triumphal painting. Detailed observation leads to the reproduction
of the factual situation as proof of achievement but without obscuring the unitary
nature of the Column as the *celebratio* of Trajan, who constantly appears, ultimately
in the form of a gilded statue placed on top (Fig. I.66). However, all these precisely
detailed representations of individuals, racial types, costume, architecture, and land-
scape, and even the careful framing of scenes in coherent perspective or the orderly
construction of the narrative, were perverted by the invisibility, relative or actual,
of much of the relief. The Column, therefore, must be understood as a unitary sym-
bol of triumph, thoroughly permeated by the Imperial presence, manifest as the
source and guarantee of victory. Indeed, the personified Victoria herself appears on
the helical relief, placed in the middle between the narrative of the two Dacian cam-

paigns, and writing the heroic account of Trajan's deeds on the *clipeus virtutis*, a motif taken from the Augustan statue of Victory in the Curia Senatus (see pp. 111 ff.). For these reasons, if the Column of Trajan contains within itself the ideological and formal achievements of one hundred and fifty years of Roman art, the burgeoning techniques of tendentious selection, hieratic presentation, and symbolic redundancy prepare the way for the next century when historicism was to be sacrificed for iconolatry.

e. From the Antonines to the Last of the Severi Marcus Aurelius' life in power spanned the years between 140 and 180, when the golden age of security initiated by Trajan began to break up, eroding the Romans' confidence in the stability of society and in its traditional institutions. Perhaps even more than the eclectic but mercurial Hadrian, Marcus combined in himself both the Greek and Roman heritages of the Empire, maintaining his commitment to moral obligation (Fig. II.33) in the performance of his duties as Emperor (Fig. IV.21), while at the same time revealing his personal ethic as a suffering, enduring human being (Fig. IV.22). If the transition in his biographical portraiture from youthful radiance (Fig. IV.20) to haggard old age indicates the progressive weakening of the Imperial mask, permitting the sensitive spirit of the man to become visible, then this difficult journey also symbolizes artistically the contemporary passage of the collective Roman psyche from a condition of confident strength to that of crumbling anxiety. Equally striking is the release of the court artists from the former restrictions on their freedom of interpretation. They rapidly developed new themes and modes of representation, responsive to the altered psychological climate of retreat, exacerbated by the renewed barbarian pressures on the frontier (Fig. IV.37). Although unknown to us, these artists must have possessed qualities of genius, since in effect they revolutionized Roman art, changing its direction from the substantial, exterior world of tangible forms to a radiant inner world of impalpable appearances, from the physical reproduction of shapes to the recreation of their visual characteristics alone, and from deductive to inductive methods of presentation. All this was accomplished, apparently, with Imperial favour, but not completely at the expense of the Hellenic tradition in the official monuments of the state.

Marcus Aurelius and his co-Emperor, Lucius Verus, erected a memorial column dedicated to their predecessor Antoninus Pius in the Campus Martius, Rome, in the early 160s. The sculptured base of the Antonine Column has been preserved in the Cortile Belvedere of the Vatican and consists of a handsomely lettered inscription on one side, two identical reliefs describing the Decursio (Fig. VI.37) or funeral games on parallel sides, and on the principal face, the Apotheosis of Antoninus Pius and his wife Faustina I (Fig. VI.38). The styles and imagery of the Decursio and Apotheosis panels seem as different as the two friezes on the Altar of Domitius Ahenobarbus (Fig. V.1a, b), created almost three centuries earlier (see pp. 197 ff.). However, despite these obvious differences in technique and in the selection of traditional figurative sources for the descriptive and allegorical themes, the compositions of both panels reveal a common movement toward conceptualized schema, a patterned figure-

ground relationship, a greater use of the drill, and a noticeable irrationality in the treatment of space and scale.

In the Apotheosis panel, the busts of Antoninus and Faustina are shown, indicating that their spirits have been taken up into heaven on the back of a winged psychopomp, possibly Aion or some other agent of Jupiter, following their consecration in the Campus Martius, symbolized as the site of this uplifting ceremony by the topographical personifications along the lower edge of the relief. Perhaps because they are represented as spirits after death, the Imperial busts have none of the *inter vivos* freshness of many Roman sepulchral images, but rather exhibit a kind of simplified blankness found also in second-century funerary portraits at Rome or in Asia Minor, where the spiritual character of the deceased, that is to say their inner, undying quality, is represented. Strangely, something of this remoteness penetrates as well into the life portraiture of the young Marcus Aurelius (Fig. IV.20), not merely as a result of dull replication, and continues into the elegant, cool portraits of Faustina II and Commodus (Fig. IV.23), possibly as a reference to their supramundane character. Abstraction and the occluded, polished surface are here not in the service of a sepulchral image, as in second- and third-century Fayuum and Palmyrene portraits (Figs. II.13b, 14), but instead signal the non-physical qualities of spiritual representation. For the same reason, although the psychopomp in the Apotheosis panel appears as a winged figure, capable of flying, he is shown floating upward without any physical effort, expressing thereby the idea rather than the physical act of flying in much the same way as the spandrel Victories on triumphal Arches.

The use of traditional personifications and the presence of frontal figures in the Apotheosis panel recall the clarified composition of the attic panels in the Trajanic Arch at Benevento (Fig. VI.35), while the overt classical gloss, forced within the containment of precisely contoured figures placed starkly against the relief ground, brings to mind the Domitianic reliefs from the Cancelleria (Fig. V.5). Yet the stylistic connection lies closer to the Antonine province reliefs from the Hadrianeum (Fig. V.9), carved in the 140s. Their slightly flaccid athletic figures, pathetic expressions, and proportional distortions carry on throughout the century, although tempered in the Antonine Column Base; similar, however, is the use of the marble-devouring drill, applied along the edge of forms, in the undercutting of hair and drapery, and in the exaggerations of textural contrasts. The evident successor to this indolent classicism, weakened by inattention to the organic construction of the body and corroded by the plunging drill, is the statuary group of Commodus and Crispina as Mars and Venus (Fig. IV.17), carved in the 180s under the influence of a mid-Antonine revival of fourth-century Greek sculpture like the Vatican Meleager. The replication of such elegant Greek originals may also have contributed to the exaggerated contrasts between skin and hair, even when not fully dependent on the drill, evident in certain marble heads of Lucius Verus (Fig. VI.39) and in several private portraits of A.D. 160–180. This type of late Antonine expressionism, based fundamentally on a corrupt but elegant Hellenic model, the clarity of whose forms has been broken by the drill, reaches its final phase in the pedestal reliefs of the Severan

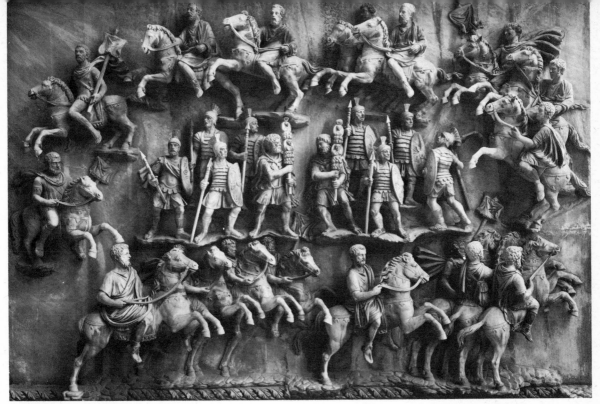

Fig. VI.37 Parade of Roman cavalry ('decursio'). Relief on the base of the Column of Antoninus Pius, Rome. About A.D. 161. Vatican, Belvedere
Fig. VI.38 The Apotheosis of Antoninus Pius and Faustina. Relief on the base of the Column of Antoninus Pius, Rome. About A.D. 161. Vatican, Belvedere.

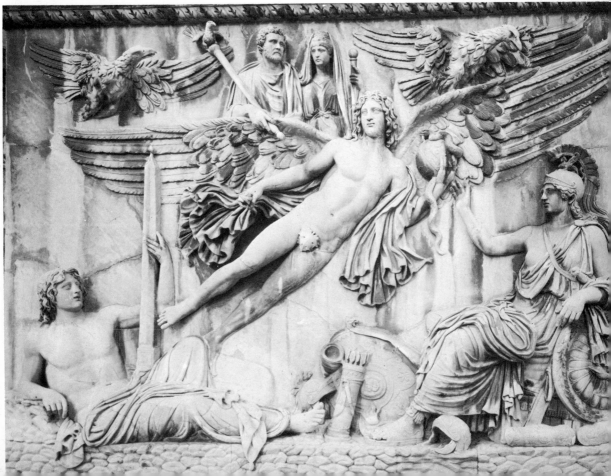

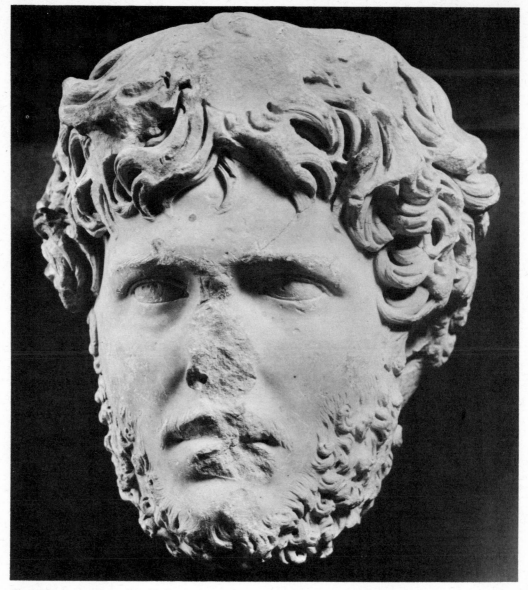

Fig. VI.39 Lucius Verus. Marble head. A.D. 161–169. Rome, Museo delle Terme

Arch in the Roman Forum, carved by a workshop still imbued with the plastic traditions of an earlier time.

These new modes came together in the latter part of the second century with another perverted Hellenic current, based on the visual interest and physical concealment offered by the male beard, introduced by Hadrian (Fig. VI.34), and by the associated heavy draperies that so overcrowd the relief-space in the monument from Ephesos (Fig. IV.4). If such developments further deprived the human body of corporeal substance, they also complicated the visual integrity of the figure, increasingly lost behind complicated surfaces, riddled and channelled by dark shadows or interrupted by disconnected high-lights. Artists working in this new manner, many of them apparently from the hellenistic cities of Asia Minor, found themselves deal-

ing with a new kind of space, since in relief sculpture there was less and less possibility for the development of effective illusion. One solution was to dispense with illusion altogether and abandon even the natural overlap of figures standing on a common ground, still evident in the Ephesos relief. Thus a simplified scheme was created, sophisticated in its generation but primitive in its conception, which eliminated crowding and uncertainties of location by the introduction of superposition, so that in a double file, *above* came to mean *behind*, as in the attic reliefs from the Severan Arch at Leptis Magna, dated A.D. 203 (Fig. V.15). Of course, such a solution required a separation between the natural order of the physical world and artistic representation, a separation rejected in Greek art from its inception but long familiar in the ancient arts of non-Greek peoples or of those only superficially hellenized.

The sculptor of the Apotheosis panel (Fig. VI.38) also continued that tendency to compress the figure-ground relationship more tightly, reducing the real space of the relief, while effecting the separation of the figure by sharp contours, reinforced by dark channels seen as black outlines. Such an outline, however, is a pictorial device that replaces modelling, reducing the plastic dimensions by one as it detaches the figure from the ground; gradually in the second and third centuries this line drew ever greater attention to itself as an independent form rather than as a design function in relief sculpture as well as in contemporary painting and mosaics. But an artist could also achieve compression by placing very active figures within a constricting box-like frame, seen or sensed on five sides (the sixth open to the viewer) as in the Amendola sarcophagus (Fig. VI.40), dated A.D. 150–160. The energetic battle motif of this sarcophagus comes from the Greek repertory; probably developed in Pergamene art, it proved attractive to Antonine sculptors as a source of compositions and copies in part because its mixture of violence and pathos was useful to the burgeoning industry of battle sarcophagi (see pp. 107 ff.) in the latter half of the second century. When compression increased, as in the battle sarcophagus recently found at Farfa, dated A.D. 170–180, the figures although still distinct become more and more subject to patterning, not only in repetitive shapes but also in rhythmically fluctuating intensities of light, progressively turning the description of action into a series of flickering forms.

This effort of compression reached its climax by the middle of the third century in the Great Ludovisi Battle Sarcophagus (Fig. II.27). Tangled masses of Romans and barbarians, superbly carved in very high relief, were locked in the vortex of battle within a shallow field disposed around the soaring image of the triumphant commander, possibly Hostilianus. The relief ground is no longer visible, but it is still sensed as a force projecting forward from within against the relief plane at the front; figures and the intervals between them become shapes in a pattern of shapes, ordered by high-light and shadow, thus transforming an actual relief into the semblance of a two-dimensional illusion. Black-and-white mosaics of the second and third centuries similarly reveal this redirection of the powers of illusion (Figs. III.13, 14), as did third- and fourth-century painting (Figs. II.13b, 15). Moreover, this astounding reversal of the traditional orientation of classical relief sculpture in the

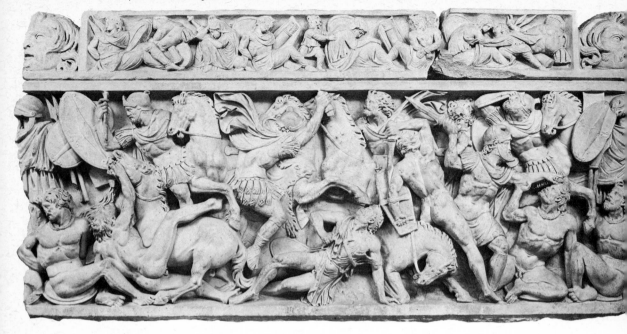

Fig. VI.40 Amendola sarcophagus. A.D. 150–160. Rome, Museo Capitolino

Ludovisi Sarcophagus was aided by interweaving other patterns on the surface in colour (now lost) and in texture, the latter still evident in the dappled masses of curling hair, which catch the eye as dense, arresting forms, more abstract than descriptive, more visual accent than natural substance.

Some anticipation of the visual properties of the Ludovisi Sarcophagus occurred in the looming portrait of Commodus wrapped in the mantle of Hercules (Fig. IV.18). The highly polished surface, the deeply shadowed face, and the lavish use of the plunging drill, which mark this portrait, were perhaps the contribution of some great artist in the late Commodan court who understood the psychology of illusion and the dramatic effectiveness of a mysterious, partially lit figure as an image of awesome power. The masterly sculptor of the Ludovisi Battle Sarcophagus then adapted this technique of dramatic lighting to the surface enrichment of a work whose exterior face has already been energized by compression. Within this third-century context of revived Antonine Hellenism (cf. Fig. IV.4), extending from *c.* A.D. 235–270, the movement toward ever greater abstraction is evident in the contrast between the sculpturesque but overloaded Acilia sarcophagus, probably used in the time of Gordian III, and the superbly gelid forms of the Gallienic 'philosophical-career' sarcophagus in Naples (Fig. V.19). The linear fall of drapery, a glory of previous Roman sculpture (cf. Figs. IV.3; V.5), has been purified, tightened, and freed from the demands of nature by its dependence on an accentuated scheme of pendulous and broken curves. In the Gallienic sarcophagus the sculptor has exposed his crowded shapes, interrupted by shadowy ravines and a busy network of dark, solid lines which offer their own spatial logic in substitution for the greatly reduced real space within the relief. And underneath is a rigid structure of shape and interval, abstractly conceived, recalling the formulaic patterns of a much

earlier time (Fig. II.17) when the classical norms were also precariously established.

The perennial Roman fascination with the ambivalent character of worked surfaces (see pp. 79 ff., 129 ff.) became even more intense in the composition of the Decursio panels of the Antonine Column Base (Fig. VI.37). Ostensibly representing the ceremonial equestrian exercise in honour of the consecrated Emperor, with stubby, almost toy-like figures recalling the small friezes on the Arches of Titus and Trajan (Fig. II.39), the composition seems to exploit deliberately the spatial and decorative possibilities of the figure–ground relationship. Given the old-new convention that 'up equals behind', it is clear that the ring of horsemen should be seen in depth as if riding *on* a parade ground, although presented to the viewer in both parallel and oblique perspective. If this is so, then the ground of the relief has been transformed into a field *on* which the horsemen ride, and yet the extent of the smooth background surface and its power to frame the circle of horsemen is so great that the eye also registers that surface as the relief ground *behind* and not *beneath* the riders, arranged in a circle like some honorific wreath placed in dedication against the wall of the monument. Although this very complicated composition does not achieve figure–ground reversal, it does suggest both the ultimate destruction of illusionistic space as well as the transformation of the forward plane of the relief into a surface dominated by lateral movement and pattern, largely affected by textural contrasts. This tendency to remove the unambivalent spatial distinctions between figure and ground and to restate these distinctions as purely visual separations, created by abrupt contrasts in textures and/or between light and dark, is also present in the earlier Spada Reliefs (Fig. V.10), in the contemporary Amendola sarcophagus (Fig. VI.40), and in second- and third-century geometric mosaics (Fig. III.13). Perhaps this absorption in rendering the figural instability of surface forms as a basis of design complemented that growing apperception of an unstable reality, translated into a world of ever-changing appearances, that struck the Romans in the late second and third centuries. Whatever the reason, this transformation of the surface into an energized field for patterned alternation, long familiar in architectural decoration (see pp. 135 ff.), greatly affected Roman art. It might tend toward a bubbling interlace of writhing forms, as in the late Antonine battle sarcophagus from Portonaccio (Fig. II.18), or busy the surface with patterned, projecting clutter in an early third-century sarcophagus, representing the Indian Triumph of Bacchus (Fig. II.24), or in the contemporary Hercules sarcophagus (Fig. II.23) indulge in the elegant visual delights proffered by the sinuous, oblique movements developed by highly polished limbs. The relative unimportance of a stabilized space in this system of design partly explains the apparent incoherency of topographical representation, suggested by a number of sarcophagi which describe the salient features of Ostia or some other port (cf. Fig. VI.41); perhaps the satisfaction provided by the inventory, where completeness and discrepancies in scale are symbolically important, can be justified by the cartographic method of presentation, which is primarily two-dimensional. Similarly, the great panels on the Severan Arch in the Forum (Fig. IV.35), derived in part from Roman triumphal painting and in part from a translation of the Aurelian Column (Fig. IV.37), take on the visual character of a relief tapestry, possibly

demonstrating the great influence of textile design itself (cf. Fig. III.9) on Severan architectural ornament at Leptis Magna (Fig. VI.42). In the decorated pilasters of the basilica from the Severan Forum, despite the deep undercutting, indeed possibly because of it, the ground of the relief has been lost, and in its place there is a dark shadow, on which play the thin, light forms of near-phantoms.

The Aurelian panels in the attic of the Arch of Constantine (Fig. II.42) and in the Conservatori (Figs. V.14; VI.43) were taken from a triumphal arch or arches of Marcus Aurelius, probably commissioned in the 170s. The sculptors responsible were aware of current developments in the compression of space, the heightening of hieratically oriented schemes of distinction, and the increased patterning of the surface by dark-light contrasts. Perhaps they moderated their adoption of these features because they felt still bound to the old conventions established in such official, allegorical programmes under Trajan and even before. Nevertheless, some genius, possibly influenced by the renewed interest in texture and attracted to the functions of the drill as a creative instrument, explored the possibilities of negative modelling, that is to say the removal of stone, taken abruptly from a surface in order to provide the convincing illusion that what has been taken away is, in fact, present; this consummates the figure–ground reversal, and suggests that less can be more. He did so either by creating the illusion of surfaces modelled fully in the round by painting in broad dark brush-strokes, using the running drill as his brush (Fig. VI.45), or as in the head of Pompeianus (Fig. VI.50), friend and companion of the Emperor, by gouging beneath the surface in such a way as to suggest by the quick, stippled patterns of shadow that something—hair—lay above the surface. Therefore this artist and his fellow sculptors abandoned the traditional vocabulary of plastic sculpture, which relied on the positive modification of surface forms by the shaping

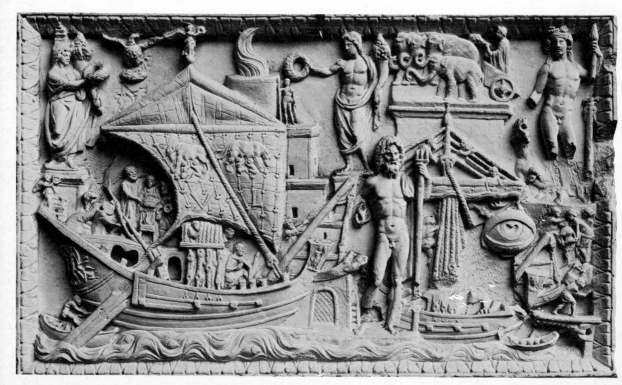

Fig. VI.42 Pilasters of the Severan Basilica, Leptis Magna. About A.D. 205

Fig. VI.41 Votive relief representing the port of Ostia. Early III century A.D. Rome, Museo Torlonia

Fig. VI.43 The Triumph of Marcus Aurelius. Panel from a lost triumphal arch, Rome. About A.D. 175. Rome, Palazzo dei Conservatori

of material, and instead came to rely on negative modelling, which used sharp differences in light to transform a surface, suggesting that what was not there at all appeared to be. This last technique, coupled with a reductive, closed shape, led to the so-called 'hard style', progressively evident in the portraits of Caracalla (Fig. IV.30), Balbinus (Fig. II.10), Gordian III (Fig. IV.31), Maximinus Thrax (Fig. VI.44), Trebonianus Gallus (Fig. IV.6), touching the coinage of Decius in mid-century, and then reaching ultimately to the Tetrarchs (Figs. IV.33; VI.48).

Complementary to this discovery of negative modelling, and like it of great importance in the third century, was the invention of what can be called 'the bridge', that small span of stone deliberately left in the channels of the hair, connecting two ribbons of hair but not representing hair itself. This bridge of stone has no other purpose than to catch light, interrupting the dark line of the separating groove, and thus contributing to the luminous agitation of the surface. This

invention, anticipated possibly in late Flavian art (cf. Fig. v.5), seems to have taken place in the time of Marcus Aurelius (Fig. vi.45), was intensified under the Severans (Fig. iv.29), and became very prevalent throughout the third century (Fig. vi.46).

Most of these features, from pathos to pattern, were summed up in the helical reliefs of the Aurelian Column (see pp. 194 f.), probably completed just before the death of Commodus. The unknown master has, however, improved his Trajanic model (Fig. ii.44) by increasing the visibility of the entire relief, since the Aurelian Column was placed in a large open square and not crowded among buildings. Furthermore, he emphasized the ceremonial and hieratic scenes, composing them as set tableaux Fig. iv.37b) with signal devices (Fig. iv.37c) calculated to draw the eye of the spectator below to the Imperial presence above, thus ignoring the apparent narrative progression of this record of Marcus' German wars. But most important of all, this artist set the imagery of timeless majesty in frontal poses (Fig. iv.37a), breaking the barrier between image and recipient, and thus established the principle of hieratic rapport that dominates the late art of Rome.

f. From the Mid-Third Century to Constantine Historians have treated the third century as an age of political and moral crisis, as a step-child of the classical world, whose own progeny in the fourth century followed another way. Such aphoristic judgements are very neat but inadequate to describe the accelerating break-up of an old order, which stubbornly refused to pass away without resistance. Admittedly, the political condition became chaotic until Diocletian's stultifying solution, the humanistic, worldly tradition of the Greek legacy was subverted by disinterest, disrespect, and disbelief, and the urban civilization of Rome fell into decay, little alleviated by the survival of a few great cities and the salons of some diehard intellectuals. Between the Severans and Diocletian Imperial commissions were few, but Roman art thrived in portraiture, in sepulchral monuments, and in the ever more sumptuous private establishments (see pp. 49 ff., 133 ff., 142 ff.). The directions of change, the taste in revivals, even the favourite themes of the third century, had been determined to a very large extent by that creative epoch in Roman art, the second half of the second century, but an informed, concerted exercise of patronage was missing. This factor, a direct product of ruinous wars and civil strife of the period, perhaps more than any other deprived Roman artists of both creative opportunities and stimulating models. Therefore until the coming of Tetrarchic absolutism (Fig. iv.33) and the subsequent Constantinian instauration (Figs. ii.46; vi.52), Roman art followed the paths charted earlier, always, however, tending to move further and further away from the figural and stylistic traditions that pre-dated the Antonine revolution.

The 'hard style' (see p. 261) perhaps reached its apogee between A.D. 230–260 in a number of seemingly realistic portraits with a Republican flavour (Fig. v.18) or in the brutalized portraits of Philip Arabs (Fig. iv.32) and Trebonianus Gallus (Fig. iv.6). Although this style seemed to tighten, as if the skin were drawn ever more closely over the rounded bony skull (cf. Fig. vi.10), a compact wiry beard appeared in the 260s, perhaps in recognition of Gallienic Hellenism; at the same time women

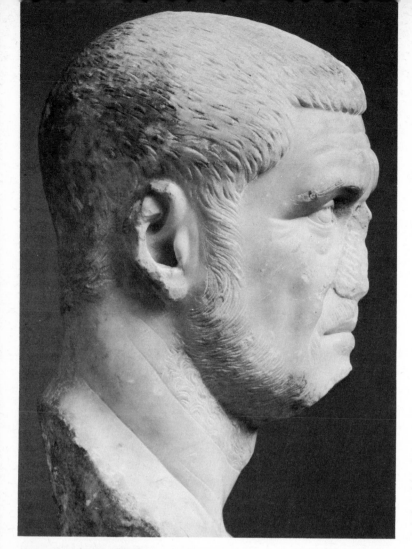

Fig. VI.44 Maximinus
Thrax. Marble head.
A.D. 235–238.
Copenhagen, Ny
Carlsberg Glyptotek

Fig. VI.45 'The Bridge'.
Detail from a panel of
Marcus Aurelius. About
A.D. 175. Rome, Palazzo
dei Conservatori

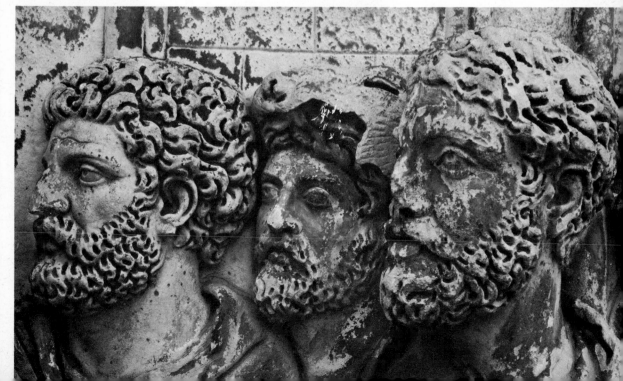

lost the wig-like mop of the Severan hair-style (Fig. IV.15) and adopted a simple, tailored fashion, pulled back symmetrically away from the face (Fig. V.19), ever so faintly classical in manner. This hard-tight style lasted in the West until the end of the century and beyond, becoming progressively more descriptive (Figs. VI.47, 49), but in the eastern Empire this style was displaced by Tetrarchic cubism, with its dense, harsh, symmetrical forms, with solid, heavy features, abrupt, almost metallic changes of plane, and laid-on textures (Fig. VI.48). Although this Tetrarchic style may have originated in Roman Egypt, because in statuary it preferred the hard porphyry reserved for Imperial use (Fig. IV.33), the mints of Antioch also adopted this manner in portraits of Galerius, 293–302, and of Maximinus Daza in 311. However, it was not popular at Rome, where a somewhat simplified version of the tight-hard style survived, appearing in the numismatic and sculptured portraits of Constantius Chlorus on the Arch of Constantine, in the heads of Constantine on the same Arch, and even in the portrait statue of Maxentius at Ostia. The distinction between these early fourth-century portraits and their predecessors lies in the ever greater density of the forms, the reappearance of the stippled surface (cf. Fig. VI.50), perhaps in response to the eastern Tetrarchic style, and a new grimness, marked by tight lips, firm jaws, and baggy eyes. Constantinian art after A.D. 315, however, puts an end to this style.

An attenuated classical current also pervades the art of this period, frequently of a surprising freshness as in the paintings from the Catacomb of S. Sebastiano in Rome, *c.* 235–240, but more often cold and spaciously correct as in the elegant Philosopher sarcophagus in Naples, dated 260–270 (Fig. V.19). Compression and the influence of the tight-hard style become evident in two distinguished 'classical' sarcophagi of the 270s, the Plotinus Sarcophagus in the Vatican (Fig. II.29), which does

46

47

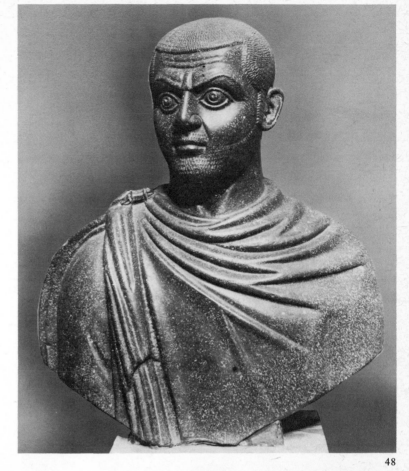

Fig. VI.46 'The Bridge'. Detail from a III century Lion sarcophagus. Rome, Museo S. Sebastiano

Fig. VI.47 Gold coin (aureus) with portrait of Probus. A.D. 276–282. London, British Museum

Fig. VI.48 Galerius (or Maximinus Daza). Porphyry bust. Early IV century. Cairo.

Fig. VI.49 Diocletian. Marble head. About A.D. 300. Rome, Museo delle Terme

Fig. VI.50 Pompeianus. Detail from a panel of Marcus Aurelius. About A.D. 175. Rome, Palazzo dei Conservatori

48

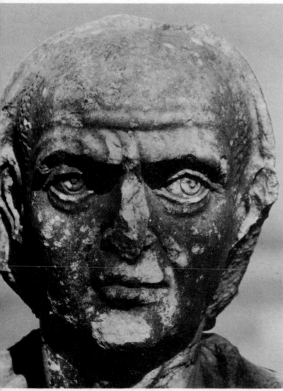

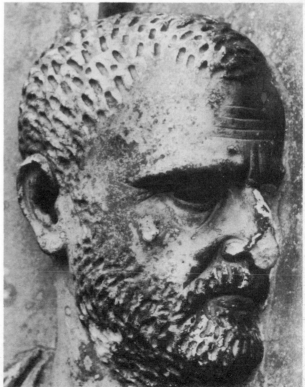

49

50

not represent Plotinus, and the Annona Sarcophagus in the Terme, which does refer to the *praefectus annonae*, the high official in charge of the food supply of Rome; in both these sarcophagi a ground-covering drape has been used, pushing the figures forward, and emphasizing the self-conscious effort of presentation. Third- and fourth-century Roman mosaics from North Africa exhibit similar schematizations of classical models, especially in the use of figural pastiches with each element frozen in place, locked as it were to its own cast shadow. Eventually this motionless, arrested classicism found its most complete late Roman expression in the Diocletianic Arcus Novus (Fig. VI.51), where large, dense forms, ostensibly 'antique', seem colossal because of the excessive simplification of shapes and the dominance of a rude symmetry. Nevertheless, they do represent the continuity of the classical tradition into the state monuments of the early fourth century even more effectively than the gross reproductions of classical statuary with which Constantine decorated his Roman Baths.

The last major art movement of the third century concerns the rapid, regressive development of Roman provincial art into sophisticated regional dialects, each one a subject of its own. These anti-rational (anti-Hellenic) regional styles were further complicated by the informing demands of class, cult, and location, all apparently

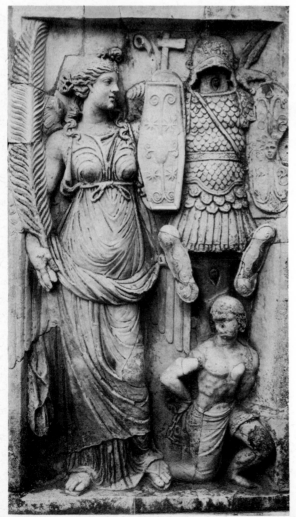

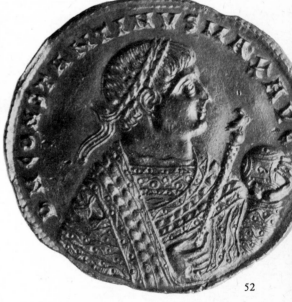

52

Fig. VI.51 Victory panel on a pier of the Arcus Novus from a lost triumphal arch of Diocletian, Rome. About A.D. 305. Florence, Boboli Gardens

Fig. VI.52 Gold medallion of Constantine. About A.D. 325. London, British Museum

Fig. VI.53 Porphyry sarcophagus of Helen. About A.D. 320. Vatican

51

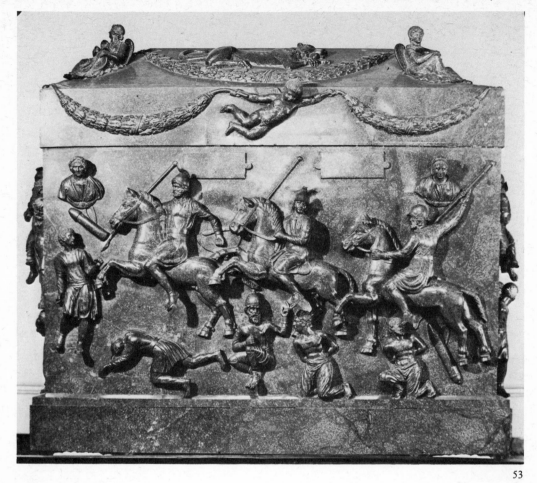

53

motivated by a desire to manifest the invisible constitution of the world through stark, symbolic means. Frontal compositions and symmetrically arranged icons seem to have been common devices to achieve this end in Roman provincial art.

But this was not the unique desire of primitives or provincials. Roman third-century hunt and battle sarcophagi (Fig. II.27) attempted to manifest the same magic in their conclusive, triumphant compositions, born of the doctrine of invincibility. So too did the terminal, ceremonial reliefs of the Arch of Constantine (Figs. II.46a–b), where the Emperor was presented to the Roman people as the majestic source of power and mercy, at the very hub of the world. Yet the iconographic pattern for this method of hieratic presentation was first fully articulated in the helical reliefs of the Aurelian Column (Fig. II.45), and frontality found its way into great monuments of the Severan age (Fig. V.15). At the same time, the reductive, compressed, cubistic style of the Constantinian relief (Fig. II.46) can be traced back into the third century and beyond (see pp. 262 ff.). What is new, and interruptive, in this narrative, ceremonial relief of Constantine is that they are all found together for the first time.

But Constantine was also a Roman, looking back to the past, to Augustus (Fig. VI.14) for his own millennial imagery (Fig. VI.52), to Trajan the conqueror (Fig. IV.26) for his own majestic portraits (Fig. IV.28). When Helen, his Christian mother,

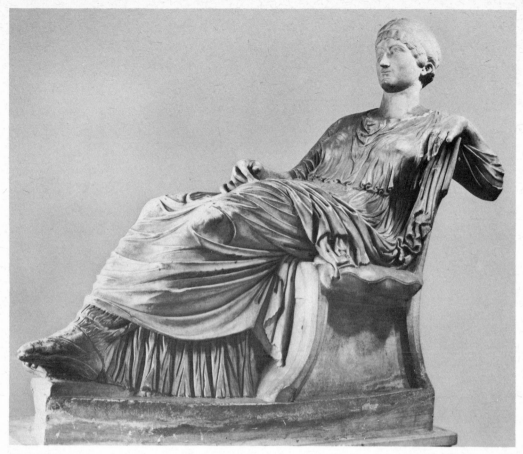

Fig. VI.54 So-called 'Agrippina Capitolina', now identified as Helen, mother of Constantine. About A.D. 320. Rome, Museo Capitolino

was buried, she was placed in a porphyry sarcophagus (Fig. VI.53) probably made in Egypt but full of pagan motifs, and representing on the sides that most Roman ceremony of consecration, the conquest, reminiscent of the Antonine Decursio (Fig. VI.37) almost two centuries earlier. She was also portrayed in her own likeness, dressed in the rhetorical role of an honourable Roman matron, little different from the worthy mother of Coriolanus. This statue, known as the Agrippina Capitolina (Fig. VI.54), like so many Roman works is based on a fifth-century Greek model, and her portrait in contemporary style is no more discordantly distinctive than other Roman sepulchral images similarly furnished. Incongruity, however, is an old characteristic of Roman art, even if Helen was a Christian. But the total loss of humanity is not (Fig. IV.28), nor is the transformation of the individual into a pure numen.

Constantinian art, then, stands at the crossroads.

'This statue fears no rainy squalls of winter or triple fire of Jove, nor the cohorts of Aeolus' prison-house, nor the long lingering years; it will stand while earth and sky abide, while Rome's sun endures.'

Statius, *Silvae* I.1.91 ff. (transl. J. H. Mosley)

Selected Bibliography

Introduction

G. Becatti, *Arte e gusto negli scrittori latini*, Florence 1951.

—, *L'Arte romana*, Milan 1962.

R. Bianchi Bandinelli, *Storicità dell'arte classica*, 2nd ed. Florence 1950.

—, *Rome: The Center of Power*, New York 1970.

—, *Rome: The Late Empire*, New York 1971.

O. Brendel, 'Prolegomena to a Book on Roman Art', *Mem. Amer. Acad. in Rome* 21 (1953), 9 ff.

P. Ducati, *L'Arte in Roma dalle origini al sec. VIII*, Bologna 1938.

C. C. van Essen, 'Précis d'histoire de l'art antique en Italie', *Collection Latomus 42*, Bruxelles 1960.

A. Frova, *L'Arte di Roma e del mondo romano*, Turin 1961.

A. Garcia y Bellido, *Arte romana*, Madrid 1957.

A. Grabar, *Christian Iconography. A Study of its Origins*, Princeton 1968.

H. Jucker, *Vom Verhältnis der Römer zur bildenden Kunst der Griechen*, Frankfurt 1950.

H. Kähler, *Wandlungen der antiken Form*, Munich 1949.

—, *Rome and its Empire*, New York 1963.

G. Kaschnitz-Weinberg, *Ausgewählte Schriften*, 3 vols., ed. H. von Heintze, Berlin 1965.

Th. Kraus *et al.*, *Das römische Weltreich* (Propyläen-Kunstgeschichte 2), Berlin 1967.

D. Levi, 'L'Arte romana, schizze della sua evoluzione e sua posizione nelle storia dell'arte antica', *Annuario Scuola Ital. Atene* 24/26 (1946/48), 229 ff.

H. P. L'Orange, *Art Forms and Civic Life in the Late Roman Empire*, Princeton 1968.

G. A. Mansuelli, *Arte e civiltà romana nell'Italia settentrionale dalla repubblica alla tetrarchia*, exh. cat. Bologna 1964.

—, *The Art of Etruria and Early Rome*, New York 1965.

M. Pallottino, *Civiltà artistica etrusco-italica*, Florence 1971.

C. Ch. Picard, *L'Art romain*, Paris 1962.

A. Riegl, *Die spätrömische Kunstindustrie nach den Funden in Oesterreich-Ungarn* I, Vienna 1901.

G. Rodenwaldt, *Die Kunst der Antike* (Propyläen-Kunstgeschichte 3), Berlin 1927.

K. Schefold, *Römische Kunst als religiöses Phänomen*, Hamburg 1964.

B. Schweitzer, 'Die europäische Bedeutung der römischen Kunst' (1950), in *Zur Kunst der Antike. Ausgewählte Schriften* II, Tübingen 1963, 198 ff.

O. Vessberg, *Studien zur Kunstgeschichte der römischen Republik*, Lund/Leipzig 1941.

F. Wickhoff, *Die Wiener Genesis*, Vienna 1895; 2nd ed., the introduction only, *Römische Kunst*, Berlin 1912, and *Roman Art*, London 1900, transl. by E. Strong.

J. J. Winckelmann, *Geschichte der Kunst des Altertums*, Dresden 1764; *History of Ancient Art*, transl. by G. Henry Lodge, Boston 1856.

Chapter I

M. Blake, *Ancient Roman Construction in Italy*, Washington, D.C., 1947.

—, *Roman Construction in Italy from Tiberius through the Flavians*, Washington, D.C., 1959.

A. Boëthius, *The Golden House of Nero*, Ann Arbor, Mich., 1960.

— and J. B. Ward Perkins, *Etruscan and Roman Architecture*, Harmondsworth 1970.

F. E. Brown, *Cosa I. History and Topography* (*Mem. Amer. Acad. in Rome* 20), 1951.

—, *Roman Architecture*, New York 1961.

G. Calza, *Scavi di Ostia* I, Rome 1953.

F. Castagnoli, *Orthogonal Town Planning in Antiquity*, Cambridge, Mass., 1971.

P. Chiolini, *I Caratteri distributivi degli antichi edifici*, Milan 1959.

E. Clark, *Rome and a Villa*, Garden City, N.Y., 1952.

G. Cozzo, *Ingegneria romana*, Rome 1928.

L. Crema, *L'Architettura romana*, Turin 1959.

R. Delbrück, *Hellenistische Bauten in Latium*, Strassburg 1907–1912.

H. Drerup, *Zum Ausstattungsluxus in der römischen Architektur*, Münster 1957.

—, 'Bildraum und Realraum in der römischen Architektur', *Mitt. d. deut. arch. Inst., Röm. Abt.* 66, 1959.

F. Fasolo and G. Gullini, *Il Tempio di Fortuna Primigenia a Palestrina*, Rome 1953.

G. Fuchs, *Architekturdarstellungen auf römischen Münzen*, Berlin 1969.

A. von Gerkan, *Der Stadtplan von Pompei*, Berlin 1940.

E. Hansen, *La 'Piazza d'Oro' e la sua cupola*, Copenhagen 1960.

H. Kähler, *Hadrian und seine Villa bei Tivoli*, Berlin 1950.

—, *Das Fortunaheiligtum von Palestrina*, Saarbrücken 1958.

—, *Der römische Tempel*, Berlin 1970.

D. M. Krencker, *Die Trierer Kaiserthermen*, Augsburg 1929.

P. Lavedan and J. Hugueney, *Histoire de l'urbanisme: antiquité*, Paris 1966

G. Lugli, *La Tecnica edilizia romana*, Rome 1957.

W. L. MacDonald, *The Architecture of the Roman Empire* I, New Haven 1965.

G. A. Mansuelli, *Le Ville del mondo romano*, Milan 1958.

—, *Urbanistica e architettura della Cisalpina romana fino al III sec. e. n.* (Collection Latomus 111), Bruxelles 1971.

R. Meiggs, *Roman Ostia*, Oxford 1960.

E. Nash, *Pictorial Dictionary of Ancient Rome*, 2nd ed. New York 1968.

G. Rickman, *Roman Granaries and Store Buildings*, Cambridge 1971.

A. L. F. Rivet, *The Roman Villa in Britain*, London 1969.

G. Rivoira, *Roman Architecture*, Oxford 1925.

D. S. Robertson, *A Handbook of Greek and Roman Architecture*, Cambridge 1954.

E. A. Baldwin Smith, *Architectural Symbolism of Imperial Rome and the Middle Ages*, Princeton 1956.

K. M. Swoboda, *Römische und romanische Paläste*, Vienna 1919.

B. Tamm, *Auditorium und Palatium*, Stockholm 1963.

H. H. Tanzer, *The Villas of Pliny the Younger*, New York 1924.

G. Wataghin Cantino, *La Domus Augustana*, Turin 1966.

Chapter II

A. Alföldi, *Die monarchische Repräsentation im römischen Kaiserreiche*, Darmstadt 1970.

B. Andreae, *Motivgeschichtliche Untersuchungen zu den römischen Schlachtsarkophagen*, Berlin 1956.

—, *Studien zur römischen Grabkunst*, Heidelberg 1963.

C. Barini, *Triumphalia*, Turin 1952.

G. Becatti, *La Colonna coclide istoriata*, Rome 1960.

F. Braemer, *Les Stèles funéraires à personnages de Bordeaux*, Paris 1959.

R. Brilliant, *Gesture and Rank in Roman Art*, New Haven 1963.

—, *The Arch of Septimius Severus in the Roman Forum* (*Mem. Amer. Acad. in Rome* 24), Rome 1967.

H. von Brunn and G. Körte, *I Rilievi delle urne etrusche*, 3 vols., Rome 1870–1916.

A. Caló Levi, *Barbarians on Roman Imperial Coins and Sculpture*, New York 1952.

C. Caprino *et al.*, *La Colonna di Marco Aurelio*, Rome 1955.

F. Cumont, *Recherches sur le symbolisme funéraire des Romains*, Paris 1942.

C. D. Curtis, 'Roman Monumental Arches', *Suppl. Papers of the Amer. School of Class. Studies in Rome* 2, 1908, 26 ff.

H. Dragendorf and E. Krüger, *Das Grabmal von Igel*, Trier 1924.

B. Florescu, *Monumentul de la Adamklissi*, Bucarest 1959.

—, *Die Trajanssäule*, Bonn 1969.

M. Grant, *From Imperium to Auctoritas*, Cambridge 1946.

—, *Roman Anniversary Issues*, Cambridge 1950.

P. G. Hamberg, *Studies in Roman Imperial Art*, Uppsala 1945.

F. J. Hassel, *Der Trajansbogen in Benevent*, Mainz, 1966.

T. Hölscher, *Victoria Romana*, Mainz 1967.

H. Kähler, 'Triumphbogen', Pauly-Wissowa, *Real Enzyklop.* 13 A, 1939, 373 ff.

—, *Die Augustusstatue von Primaporta*, Cologne 1959.

—, *Der Fries vom Reiterdenkmal des Aemilius Paulus in Delphi*, Berlin 1965.

K. F. Kinch, *L'Arc de triomphe de Salonique*, Paris 1890.

K. Lehmann, *Die Trajanssäule; ein römisches Kunstwerk zu Beginn der Spätantike*, Berlin 1926.

—, 'L'Arco di Tito', *Bull. Comm.* 62, 1934, 89 ff.

— and E. C. Olsen, *Dionysiac Sarcophagi in Baltimore*, New York 1942.

H. P. L'Orange and A. von Gerkan, *Der spätantike Bildschmuck des Konstantinsbogens*, Berlin 1939.

G. A. Mansuelli, *Le Stele romane del territorio Ravennate e del Basso Po*, Ravenna 1967.

H. Mattingly, *Roman Imperial Coinage*, London 1923 ff.

—, *Coins of the Roman Empire in the British Museum*, London 1923 ff.

F. Matz, *Die dionysischen Sarkophage* (Die antiken Sarkophagreliefs), 3 vols., Berlin 1968–1969.

H. G. Niemeyer, *Studien zur statuarischen Darstellung der römischen Kaiser*, Berlin 1968.

R. Payne, *The Roman Triumph*, London 1962.

G. Ch. Picard, *Les Trophées romains; contribution à l'histoire de la religion et de l'art triomphal de Rome*, Paris 1957.

C. Robert, *Die antiken Sarkophagreliefs. II. Mythologische Cyklen*, Berlin 1890; III. *Einzelmythen*, 3 vols., Berlin 1897–1919.

G. Rodenwaldt, *Die antiken Sarkophagreliefs. Die Meerwesen*, Berlin 1939.

H. von Roques de Maumont, *Antike Reiterstandbilder*, Berlin 1958.

L. Rossi, *Trajan's Column and the Dacian Wars*, London 1971.

M. Rotili, *L'Arco di Traiano a Benevento*, Rome 1972.

I. Ryberg, *Panel Reliefs of Marcus Aurelius*, New York 1967.

K. Scott, *The Imperial Cult under the Flavians*, Stuttgart 1936.

E. Simon, *Ara Pacis Augustae*, Tübingen 1967.

J. M. C. Toynbee, *Roman Medallions*, New York 1944.

—, 'The Ara Pacis Reconsidered and Historical Art in Roman Italy', *Proc. Brit. Acad.* 39, 1953.

—, *Death and Burial in the Roman World*, London 1971.

R. Turcan, *Les Sarcophages romains à représentations dionysiaques*, Paris 1966.

C. Vermeule, *The Goddess Roma in the Art of the Roman Empire*, Cambridge, Mass., 1959.

—, 'Hellenistic and Roman Cuirassed Statues', *Berytus* 13, 1959, 1 ff.

L. Vogel, *The Column of Antoninus Pius*, Cambridge, Mass., 1973.

M. Wegner, 'Die kunstgeschichtliche Stellung der Marcussäule', *JdI* 46, 1931, 61 ff.

—, *Die antiken Sarkophagreliefs. Die Musensarkophage*, Berlin 1966.

Chapter III

N. Alfieri *et al.*, *Ori e argenti dell'Emilia antica*, Bologna 1958.

B. Andreae, *Das Alexandermosaik*, Bremen 1959.

S. Aurigemma, *I Mosaici di Zliten*, Rome 1926.

E. C. F. Babelon, *Le Trésor d'argenterie de Berthouville*, Paris 1916.

J. Balty, *Apamée de Syrie (Fouilles d'Apamée)*, Bruxelles 1969.

G. Becatti, *Case Ostiensi del tardo impero*, Rome 1949.

—, *Scavi di Ostia II. I Mitrei*, Rome 1954.

—, *Oreficerie antiche*, Rome 1955.

—, *Scavi di Ostia IV. Mosaici e pavimenti marmorei*, Rome 1961.

—, *Scavi di Ostia VI. Edificio con "opus sectile" fuori Porta Marina*, Rome 1969.

E. Bethe, *Buch und Bild im Altertum*, Leipzig 1945.

H. G. Beyen, *Die pompejanische Wanddekoration vom zweiten bis zum vierten Stil*, 2 vols. The Hague 1938–1960.

R. Bianchi Bandinelli, *Hellenistic-Byzantine Miniatures of the Iliad (Ilias Ambrosiana)*, Olten 1955.

M. Blake, 'The Pavements of the Roman Buildings of the Republic and Early Empire', *Memoirs Amer. Acad. in Rome* 8, 1930; 13, 1936; 17, 1940.

P. H. von Blanckenhagen, *Flavische Architektur und ihre Dekoration*, Berlin 1940.

—, *The Paintings from Boscotrecase*, Heidelberg 1962.

—, 'The Odyssey Frieze', *RM* 70, 1963, 100 ff.

M. Borda, *La Pittura romana*, Milan 1958.

F. Braemer, *L'Art dans l'occident romain. Trésors d'argenterie, sculpture de bronze et de pierre*, Paris 1963.

L. Budde, *Antike Mosaiken in Kilikien*, Recklinghausen 1969–.

A. Burford, *Craftsmen in Greek and Roman Society*, London 1972.

M. C. Calvi, *I Vetri romani del Museo di Aquileia*, Aquileia 1968.

A. Champdor, *Les Ruines de Palmyre*, Paris 1953.

S. Charitonidis, *Les Mosaïques de la Maison du Menandre à Mytilène*, Bern 1970.

R. J. Charleston, *Roman Pottery*, London 1955.

E. Coche de la Ferté, *Les Bijoux antiques*, Paris 1956.

J. D'Arms, *Romans on the Bay of Naples*, Harvard Univ. Press 1970.

W. Dorigo, *Pittura tardoromana*, Milan 1966.

A. Driss, *Tunisia. Ancient Mosaics*, New York 1962.

O. Elia, *La Pittura di Stabia*, Naples 1957.

B. M. Felletti Maj, *Le Pitture delle Casa delle Volte Dipinte e della Casa delle Pareti Gialle*, Rome 1961.

A. Ferrua, *Le Pitture della nuova catacomba di Via Latina*, Rome 1960.

F. Fremersdorf, *Das römische Haus mit dem Dionysos Mosaik vor dem Südportal des Kölnerdomes*, Berlin 1956.

—, *Die römischen Gläser mit Schliff, Bemalung und Goldauflagen aus Köln*, 2 vols. Cologne 1967.

G. V. Gentile, *La Villa Erculia di Piazza Armerina. I Mosaici figurati*, Rome 1959.

S. German, *Les Mosaïques de Timgad*, Paris 1969.

R. Gnoli, *Marmora romana*, Rome 1971.

V. von Gonzenbach, *Die römischen Mosaiken in der Schweiz*, Basel 1961.

L. Guerrini, *Le Stoffe copte del Museo Archeologico di Firenze*, Rome 1957.

P. Gusman, *L'Art décoratif de Rome de la fin de la république au IVe siècle*, Paris 1908–1914.

J. W. Hayes, *Late Roman Pottery*, London 1972.

A. M. A. Héron de Villefosse, 'Le Trésor de Boscoreale', *Monument Piot* (Paris) 1895.

R. A. Higgins, *Greek and Roman Jewellery*, London 1961.

H. Hoffmann and V. von Claer, *Antiker Gold- und Silberschmuck* (Cat. Hamburg Mus. für Kunst und Gewerbe), Mainz 1968.

Inventaire des mosaïques de la Gaule et de l'Afrique, 3 vols. Paris 1909–1915.

C. John, *Arretine and Samian Pottery*, London 1971.

C. H. Kraeling, *Excavations at Dura Europos. Final Report VIII.1. The Synagogue*, New Haven 1956.

La Mosaïque gréco-romaine, Paris 1965 (Centre Nat. de la Recherches scient.).

I. Lavin, 'The Hunting Mosaics of Antioch and their Sources', *Dumbarton Oaks Papers* 17, 1963, 180 ff.

L. Lehmann, 'The Imagines of the Elder Philostratus', *Art Bull.* 23, 1941, 16 ff.

—, 'The Dome of Heaven', *Art Bull.* 27, 1945, 1 ff.

P. Williams Lehmann, *Roman Wall Paintings from Boscoreale in the Metropolitan Museum of Art*, Cambridge, Mass., 1953.

D. Levi, *Antioch Mosaic Pavements*, 2 vols. Princeton 1947.

H. P. L'Orange and P. J. Nordhagen, *Mosaics*, London 1966.

A. Maiuri, *La Casa del Menandro e il suo tesoro di argenteria*, Rome 1933.

—, *La Casa di Loreio Tiburtino e la Villa di Diomede in Pompei*, Rome 1947.

—, *Roman Painting*, Geneva 1953.

—, *Ercolano*, 2 vols. Rome 1958.

O. Marucchi, *Le Catacombe romane*, Rome 1933.

A. Mau, *Geschichte der decorativen Wandmalerei in Pompei*, Berlin 1882.

K. Michalowski, *Palmyre, fouilles polonaises 1959–*, Warsaw/The Hague, 1960–.

F. Neuburg, *Glass in Antiquity*, London 1949.

K. Parlasca, *Die römischen Mosaiken in Deutschland*, Berlin 1959.

B. Pfeiler, *Römischer Goldschmuck des ersten und zweiten Jahrhunderts v. Chr.*, Mainz 1970.

R. Pfister, *Textiles de Palmyre*, 3 vols. Paris 1934–1940.

T. Precheur-Canonge, *La Vie rurale en Afrique romaine d'après les mosaïques*, Paris n.d.

C. Ragghianti, *Pittori di Pompei*, Milan 1963.

L. Richardson, *Pompeii. The Casa dei Dioscuri and its Painters* (Mem. Amer. Acad. in Rome 23), Rome 1955.

G. M. A. Richter, *The Furniture of the Greeks, Etruscans and Romans*, London 1966.

—, *Perspective in Greek and Roman Art*, London 1970.

A. L. F. Rivet, *The Roman Villa in Britain*, London 1969.

D. M. Robinson, *Baalbek, Palmyra*, New York 1946.

G. Rodenwaldt, *Die Komposition des pompejanischen Wandgemälde*, Berlin 1909.

K. Schefold, *Pompejanische Malerei*, Basel 1952.

—, *Die Wände Pompejis: topographisches Verzeichnis der Bildmotive*, Berlin 1957.

—, *La Peinture pompéienne. Essai sur l'évolution de sa signification* (Collections Latomus 108), Bruxelles 1972.

V. Spinazzola, *Pompei alla luce degli scavi nuovi di Via dell'Abbondanza (anni 1910–1923)*, Rome 1953.

H. Stern, *Recueil général des mosaïques de la Gaule*, Paris 1957–.

D. E. Strong, *Greek and Roman Gold and Silver Plate*, London 1966.

P. Testini, *Le Catacombe e gli antichi cimiteri cristiani in Roma*, Bologna 1966.

M. L. Thompson, 'Monumental and Literary Evidence for Programmatic Painting in Antiquity', *Marsyas* 9, 1960/61, 37 ff.

M. Wegner, *Ornamente kaiserzeitlicher Bauten Roms. Soffiten*, Cologne 1957.

—, *Schmuckbasen des antiken Rom*, Münster 1965.

K. Weitzmann, *Ancient Book Illumination*, Harvard Univ. Press. 1959.

J. White, *Perspective in Ancient Drawing and Painting* (Soc. Prom. Hellenic St.), London 1956.

T. Wiegand, *Baalbek*, 3 vols. Berlin 1921–1925.

J. Wilpert, *Die Malereien der Katakomben Roms*, Freiburg im Br. 1903.

R. Wood, *The Ruins of Balbec*, London 1757.

Chapter IV

G. Becatti, *La Colonna coclide istoriata*, Rome 1960.

R. Bianchi Bandinelli, 'Il Ritratto', *Enc. dell'Arte Antica* VI, Rome 1965, 695 ff.

P. H. von Blanckenhagen, *Das Bild des Menschen in der römischen Kunst*, Krefeld 1948.

J. D. Breckenridge, *Likeness; A Conceptual History of Ancient Portraiture*, Northwestern Univ. Press, Evanston 1968.

R. Brilliant, *Gesture and Rank in Roman Art*, New Haven 1963.

—, *The Arch of Septimius Severus in the Roman Forum*, Rome 1967.

—, 'Temporal Aspects in Late Roman Art', *L'Arte* 10, 1970, 65 ff.

L. Budde, *Die Entstehung des antiken Repräsentationsbildes*, Berlin 1957.

R. Calza, *Scavi di Ostia V. Ritratti greci e romani fino al 160 circa d.C.*, Rome 1964.

G. Wataghin Cantino, 'Veduta dall'alto e scena a volo d'uccello', *R.I.N.A.* n.s. XVI, 1969, 30 ff.

M. Cheilik, 'Numismatic and Pictorial Landscape', *Greek, Roman and Byzantine Studies* 6, 1965, 215 ff.

G. Daltrop, *Die stadtrömischen männlichen Privatbildnisse trajanischer und hadrianischer Zeit*, Münster 1958.

R. Delbrück, *Spätantike Kaiserporträts*, Berlin, 1933.

E. Evans, *Physiognomics in the Ancient World*, Philadelphia 1969.

B. M. Felletti Maj, *Iconografia imperiale da Severo Alessandro a Carino (222–285)*, Rome 1958.

A. de Franciscis, *Il Ritratto romano a Pompei*, Naples 1951.

P. B. Franke, *Römische Kaiserporträts im Münzbild*, Munich 1961.

L. Goldscheider, *Roman Portraits*, London 1945.

W. O. Gross, *Bildnisse Traians*, Berlin 1940.

G. Hafner, *Späthellenistische Bildnisplastik*, Berlin 1954.

G. M. A. Hanfmann, *Observations on Roman Portraiture*, (Collection Latomus 11), Bruxelles 1953.

E. B. Harrison, *The Athenian Agora I. Portrait Sculpture*, Princeton 1953.

H. von Heintze, 'Studien zu den Porträts des 3 Jahrh. v. Chr.', *RM* 1955–1970.

R. P. Hinks, *Greek and Roman Portrait Sculpture in the British Museum*, London 1935.

M. Levi and A. C. Levi, *Itineraria Picta. Contributo allo studio della Tabula Peutingeriana*, Rome 1967.

H. P. L'Orange, *Studien zur Geschichte des spätantiken Porträts*, Oslo/Leipzig 1933.

—, *Apotheosis in Ancient Portraiture*, Oslo 1947.

—, 'Narration in Ancient Art', *AJA* 61, 1957, 43 ff.

W. J. T. Peters, *Landscape in Romano–Campanian Mural Painting*, Assen 1963.

F. Poulsen, *Römische Privatporträts und Prinzenbildnisse*, Copenhagen 1939.

V. Poulsen, *Les Portraits romains*, Copenhagen 1962.

G. M. A. Richter, *Roman Portraits*, New York 1948.

A. Sadurska, *Les Tables Iliaques*, Warsaw 1964.

S. Sambursky, *The Physical World of Late Antiquity*, London 1962.

C. H. V. Sutherland, 'The Intelligibility of Roman Imperial Coin Types', *JRS* XLIX, 1959, 46–55.

M. Wegner, *Die Herrscherbildnisse in antoninischer Zeit*, Berlin 1939.

—, *Plotina, Marciana, Matidia, Sabina*, Berlin 1956.

K. Weitzmann, *Illustrations in Roll and Codex*, Princeton 1947.

R. West, *Römische Porträtplastik*, 2 vols. Munich 1933, 1941.

A. N. Zadoks Josephus-Jitta, *Ancestral portraiture in Rome and the Art of the Last Century of the Republic*, Amsterdam 1932.

Chapter V

R. Austin, 'Quintilian on Painting and Statuary', *Class. Q.* 38, 1944, 17 ff.

H. L. Axtell, *The Deification of Abstract Ideas in Roman Literature and Inscriptions*, Chicago 1907.

H. Bardon, 'Le Goût à l'époque des Flaviens', *Latomus* 21, 1962, 732 ff.

J. Bayet, 'Les Origines de l'arcadisme romain', *MEFR* 38, 1920, 63 ff.

G. Becatti, *Ninfe e divinità marine* (Studi Misc. 17), Rome 1971.

R. Bianchi Bandinelli *et al.*, *Sculture municipali dell'area sabellica tra l'età di Cesare e quella di Nerone* (Studi Misc. 10), Rome 1967.

M. Bieber, 'Roman Men in Greek Himation (Romani palliati)', *Proc. Am. Philos. Soc.* 103, 1959, 374 ff.

H. Blanck, *Wiederverwendung alter Statuen als Ehrendenkmäler bei Griechen und Römern*, Rome 1969.

P. H. von Blanckenhagen, 'Ein spätantikes Bildnis Traians', *JdI* 59/60, 1944/45, 45 ff.

M. Borda, *La Scuola di Pasiteles*, Bari 195–.

D. M. Brinkerhoff, *A Collection of Sculpture in Classical and Early Christian Antioch*, New York 1969.

J. Charbonneaux, *L'Art au siècle d'Auguste*, Paris 1948.

F. Coarelli, 'L' "Ara di Domizio Enobarbo" e la cultura artistica in Roma nel II sec. a.C.', *Dialoghi di Archeologia* III, 1968, 1 ff.

P. Demargne, ed., *Le Rayonnement des civilisations grecque et romaine sur les cultures périphériques*, Paris 1965.

S. Ferri, *Arte romana sul Reno*, Milan 1931.

A. Furtwängler, *Masterpieces of Greek Sculpture*, London 1895; transl. E. Sellers.

G. M. A. Grube, *The Greek and Roman Critics*, London 1965.

G. M. A. Hanfmann, *The Season Sarcophagus in Dumbarton Oaks*, Cambridge, Mass., 1951.

H. von Heintze, *Juno Ludovisi*, Bremen 1957.

J. Isager, 'The Composition of Pliny's Chapters on the History of Art', *Analecta Romana* 6, 1971, 49 ff.

H. Jucker, *Vom Verhältnis der Römer zur Bildenden Kunst der Griechen*, Frankfurt a. M. 1950.

R. Kabus-Jahn, 'Die grimanische Figurengruppe in Venedig', *Antike Plastik* XI, Berlin 1972.

H. Kähler, *Seethiasos und Census*, Berlin 1966.

C. Laviosa, *Scultura tardo-etrusca di Volterra*, Florence 1964.

G. Lippold, *Antike Gemäldekopien*, Abh. Munich 1951.

Longinus, *On the Sublime*, ed. D. A. Russell, Oxford 1964.

Th. Lorenz, *Galerien von griechischen Philosophen und Dichterbildnissen bei den Römern*, Mainz 1965.

G. A. Mansuelli, 'Arte Provinciale', *Enc. dell'Arte Antica* VI, 1965, 519 ff.

A. Mócsy, *Gesellschaft und Romanisation in der römischen Provinz Moesia Superior*, Amsterdam 1970.

F. Muthmann, *Statuenstützen und dekoratives Beiwerk an griechischen und römischen Bildwerken*, Abh. Heidelberg 1951.

D. Pandermalis, 'Zum Programm der Statuenausstellung in der Villa dei Papiri', *AM* 86, 1971, 173 ff.

A. M. Patterson, *Hermogenes and the Renaissance. Seven Ideas of Style*, Princeton 1970.

C. Picard, 'Chronique de la sculpture etrusco-latine. Flavian', *REL* 29, 1951, 349 ff.

M. Pobé and J. Roubier, *The Art of Roman Gaul*, London 1961.

F. Poulsen, 'Die Römer der republikanischen Zeit und ihre Stellung zur Kunst', *Die Antike* 13, 1937, 125 ff.

G. M. A. Richter, *Three Critical Periods in Greek Sculpture*, Oxford 1951.

—, *Ancient Italy*, Ann Arbor, Mich., 1955.

A. Ross, *Pagan Celtic Britain. Studies in Iconography and Tradition*, London 1967.

M. Rostovtzeff, *Dura Europos and its Art*, Oxford 1938.

A. Rumpf, *Stilphasen der spätantiken Kunst*, Cologne 1957.

D. Schlumberger, 'Descendants non-méditerranéens de l'art grec', *Syria* 27, 1960, 131 ff.

A. Schober, 'Zur Entstehung und Bedeutung der provinzial-römischen Kunst', *ÖJh* 26, 1930, 1 ff.

H. Schoppa, *Die Kunst der Römerzeit in Gallien, Germanien und Britannien*, Munich, 1957.

E. Schwarzenberg, *Die Grazien*, Bonn 1966.

V. S. M. Scrinari, *Museo Archeologico di Aquileia. Catalogo delle Sculture Romane*, Rome 1972.

I. Sgobbo, 'La "Danzatrice" di Ercolano', *Rend. Acc. di Arch. Lett. e Belle Arti Napoli*, n.s. XLVI, 1971, 51 ff.

J. M. C. Toynbee, 'Some Notes on Artists in the Roman World', *Coll. Latomus* 6, Bruxelles 1951.

—, *Art in Britain under the Romans*, Oxford 1964.

G. Traversari, *Aspetti Formali della scultura neoclassica a Roma dal I al III sec. d.C.*, Rome 1968.

K. M. Türr, *Eine Musengruppe hadrianischer Zeit*, Berlin 1971.

M. Wegner, *Die Musensarkophage*, Berlin 1966; reviewed by K. Fittschen, *Gnomon* 44.5, 1972, 486 ff.

H. Wrede, *Die spätantike Hermengalerie von Welschbillig*, Berlin 1972.

Chapter VI

See also the bibliographies in preceding chapters.

R. Bianchi Bandinelli, *Storicità dell'arte classica*, 2nd ed. Florence 1950.

R. Bianchi Bandinelli, 'Naissance et dissociation de la koiné hellénistico-romaine', in *Le Rayonnement des civilisations grecque et romaine*, P. Demargne, ed., Paris 1965, 443 ff.

M. Bonicatti, *Studi di storia dell'arte nella tarda antichità e sull'alto medioevo*, Rome 1963

R. Brilliant, review of R. Bianchi Bandinelli, *Rome: The Center of Power; Rome: The Late Empire*, in *Art Bull.* 55 1973, 282–285.

I. Calabi Limentani, *Studi sulla società romana. Il Lavoro artistico*, Milan 1958.

T. Dohrn, *Der Arringatore*, Berlin 1968.

W. Fuchs, *Die Vorbilder der neuattischen Reliefs*, Berlin 1959.

—, *Der Schiffsfund von Mahdia*, Tübingen 1963.

A. Giuliano, *Il Commercio dei sarcophagi attici*, Rome 1962.

F. Goethert, 'Studien zur Kopien-forschung', *RM* 54, 1939, 176 ff.

G. Gullini, *Maestri e botteghe in Roma da Gallieno alla Tetrarchia*, Turin 1960.

H. Kähler, 'Dekorative Arbeiten aus der Werkstatt des Konstantinsbogen', *JdI* 51, 1936, 180 ff.

—, 'Konstantin 313', *JdI* 67, 1952, 1 ff.

G. Kaschnitz-Weinberg, *Die mittelmeerischen Grundlagen der antiken Kunst*, Frankfurt a. M. 1944.

G. Rodenwaldt, *Über den Stilwandel in der antoninischen Kunst*, Berlin 1935.

—, 'Zur Kunstgeschichte der Jahre 220 bis 270', *JdI* 51, 1936, 82 ff.

—, 'Art from Nero to the Antonines', *Cambr. Anc. Hist.* XI, 1936, 775 ff.

—, 'The Transition to Late-Classical Art', *Cambr. Anc. Hist.* XII, 1939, 544 ff.

Roma Medio-Repubblicana, aspetti culturali di Roma e del Lazio nei secoli IVe III a.C., exh. cat. Rome 1973.

K. Schefold, *Römische Kunst als religiöses Phänomen*, Hamburg 1964.

M. F. Squarciapino, *La Scuola di Afrodisias*, Rome 1943.

D. Strong, *Roman Imperial Sculpture*, London 1961.

M. Wegner, 'Die kunstgeschichtliche Stellung der Marcussäule', *JdI* 46, 1931, 61 ff.

A Chronological Companion

I. LEGENDARY FOUNDATION OF ROME

900 or 814 or 748 or, by agreement (Varro), 753 B.C.
Romulus and Remus, or Aeneas and his Trojans

II. THE KINGDOM, VII–VI CENTURY B.C.

A. Rome as 'the city of the Four Regions'

B. The Kings:

Romulus, the Founder

Numa Pompilius, father of Roman religious piety

Tullius Hostilius, lawgiver and political reformer

Ancus Marcius, expansionist and builder

Tarquinius Priscus, importer of Etruscan customs and founder of the Temple of the Capitoline Triad (Jupiter, Juno, Minerva)

Servius Tullius, intermediary between Rome and the Latins

Tarquinius Superbus, the last

C. Revolution: L. Junius Brutus and the Introduction of the Republic in 509 B.C.

III. THE ROMAN REPUBLIC, 509–27 B.C.

A. War and Progressive Expansion

1 Latium, V–IV century B.C.

Ostia founded 417 B.C.

Rome sacked by the Gauls 391 B.C., and subsequently Servian Wall built

2 Samnite and Oscan Wars, IV–III century B.C.

Conquest of central and southern Italy

Tarentum captured 282–272 B.C.

3 Northern Italy, II century B.C.

4 Punic Wars, 264–133 B.C.

Carthage taken 202 B.C., destroyed 118 B.C.

Rome controls the islands and shores of the western Mediterranean

Syracuse taken 211 B.C.

Spanish Wars, mid-II century B.C.

Mediterranean Gaul and its hinterland taken late II century B.C.

5 Macedonian Wars, III–II century B.C.

Greece 'liberated' 196 B.C.

Corinth taken 146 B.C.

Pergamon willed to Rome 133 B.C.

6 Asia and Egypt, II–I century B.C.

B. Colonization, City-Foundation, Road-Building, IV–I Century B.C.

C. Social/Political Problems

1 Struggles between patricians and plebeians, V–III century B.C.

Code of the XII Tables, mid-V century B.C.

Development of the *cursus honorum*

2 Extension of the nobility of wealth and the development of a middle, propertied class, the Equites, IV–II century B.C.

3 Unrest in Italy, late III–early I century B.C.

Social Wars, I century B.C.

Slave Revolt under Spartacus, I century B.C.

4 Exploitation of the provinces, II–I century B.C.

5 Creation of an urban proletariat on the dole in Rome and of a landless poor in the countryside, II–I century B.C.

6 Civil Wars: Marius v. Sulla; Pompey v. Caesar; Brutus and the Tyrannicides v. Antony and Octavian; Antony v. Octavian. c. 88–31 B.C.

D. Great Families, Distinguished Generals and Statesmen, Dictatorial Captains and the Pursuit of Authority and Respect, IV–I century B.C.: imperium, auctoritas, virtus, dignitas

E. Cultural and Intellectual Developments and Personalities

1 Events

Creation of the Roman Law, V century B.C.

Compilation of contemporary archives, late IV century B.C.

Emergence of a political machinery, IV–III century B.C.

Awareness of Greece and Greek civilization

Dedication of the spoils of Veio, taken in 396 B.C., to Apollo at Delphi

Greek cities of Campania taken, IV–III century B.C.

Art treasures and artists of Tarentum (272 B.C.), Syracuse (211 B.C.), Corinth (146 B.C.), and Pergamon (133 B.C.) brought to Rome

Scipionic circle patronizes Greek culture as the mark of education, II century B.C.

Appearance of the art collector, II–I century B.C.

Introduction of foreign gods into Rome

Cult of the Magna Mater 204 B.C.

Isis, II century B.C.

Bronze statue of Camillus, saviour of the state, set up in the Roman Forum, c. 296 B.C., together with the Roman Wolf suckling Romulus and Remus

2 Persons of distinction

Livius Andronicus, c. 284–204 B.C., first Latin playwright

Gnaeus Naevius, c. 270–201 B.C., Latin playwright, epic poet, and creator of plays on historical subjects

Quintus Ennius, 239–169 B.C., 'father of Roman poetry', author of the *Annals*, an epic poem on Roman history

Titus Maccius Plautus, c. 251–184 B.C., translated Greek New Comedy into the Latin language and Roman situations

Publius Terentius Afer, c. 195–159 B.C., polished Latin playwright who drew on Menander and other Greek sources

Quintus Fabius Pictor, III–II century B.C., wrote a history of Rome in Greek from a senatorial point of view

Polybius, c. 203–118 B.C., Greek soldier exiled to Rome where he became a member of the Scipionic circle; author of a *Universal History* in Greek on the period 220–144 B.C. to explain the rise of Rome

Carneades, 214–128 B.C., Greek sceptic philosopher and dialectician, lectured in Rome 156–155 B.C.

Marcus Porcius Cato, 234–149 B.C., Roman conservative and anti-Greek, author of treatises on agriculture, medicine, law, a history of Rome from Aeneas to his own time

Poseidonius, c. 135–50 B.C., Greek ethical philosopher active in Rome after 87 B.C., teacher of the Roman élite, and author of a moralizing history of Rome from the mid-II century B.C. to Sulla

Gaius Lucilius, c. 180–102 B.C., Roman satiric poet, who drew on contemporary life

Lucius Calpurnius Piso, II century B.C., Roman annalistic historian

Marcus Terentius Varro, 116–27 B.C., Roman encyclopedist and editor, essayist, and author of books on the Latin language, agriculture, Roman antiquities, religion, education, law, literature, architecture, etc.; greatest Roman scholar

Gaius Sallustius Crispus, 86–c. 34 B.C., monographic historian of his own time; great stylist

Gaius Julius Caesar, 100–44 B.C., historian of the Gallic conquest and of the Civil Wars, master of clear prose exposition and understatement

Marcus Tullius Cicero, 106–43 B.C., orator, master of the philosophical essay and dialogue, inveterate letter-writer, and literary critic; the creator of classical Latin prose

Gaius Valerius Catullus, c. 84–54 B.C., lyric and epigrammatic poet, familiar with Greek, especially Alexandrian models, but master of a sincere, personal style, expressive

of deep feeling and erotic
intensity

Titus Lucretius Carus, *c.* 94–55
B.C., didactic and poetic exponent
of Epicurean philosophy, author of
De Rerum Natura, long poem on the
physical and moral basis of the
world

Lucius Licinius Lucullus, *c.* 117–56
B.C., master of the elegant life-style

Pasiteles, II–early I century B.C.,
Greek artist, modeller and
metalworker who reproduced Greek
statues for Roman patrons and
wrote five books on artistic
masterpieces as a guide for their
taste

Arkesilaos, I century B.C., Greek
sculptor and dealer in Greek works
of art, patronized by Roman
collectors and commissioned to make
the statue of Venus Genetrix in the
Forum of Julius Caesar in 46 B.C.

Athenodorus of Tarsus, I century
B.C., Greek stoic philosopher who
taught Octavius

Vitruvius Pollio, I century B.C.,
Roman architect and military
engineer who wrote *De Architectura*,
ten books on architecture and
town-planning

IV. THE ROMAN EMPIRE,
27 B.C.–A.D. 337

A. Rulers, their Principal Associates and Military Activities

*1 Augustus, 27 B.C.–A.D. 14
(married to Livia)*

Marcus Vipsanius Agrippa, 63–13
B.C., principal minister

Gaius Cilnius Maecenas, d. 8 B.C.,
adviser of state and patron of
Horace and Virgil

military involvement in Spain,
Germany, Armenia, Parthia,
Maritime Alps

*2 Julio/Claudian dynasty, A.D.
14–68*

Tiberius, A.D. 14–37
Lucius Aelius Seianus, d. A.D. 31,
Pretorian Prefect
Pontius Pilatus, procurator of
Judaea A.D. 26–36

Gaius Julius Caesar Germanicus,
'Caligula', A.D. 37–41

Claudius I, A.D. 41–54 (married to
Messalina and later to Agrippina
the Younger) added Britain,
Mauretania, and Thrace as
provinces

Nero, A.D. 54–68 (married to
Octavia and later to Poppaea)
Burrus and Seneca ministers
Great Fire of Rome A.D. 64
military activity in Parthia and
Armenia under direction of
Corbulo

*3 Civil wars: Galba/Otho/Vitellius,
A.D. 68–69*

4 Flavian dynasty, A.D. 69–96

Vespasian, A.D. 69–79
military activity in Armenia,

Judaea, Germany, Wales, and
Scotland

Titus, A.D. 79–81
Pompeii and Herculaneum
destroyed by eruption of Vesuvius
A.D. 79

Domitian, A.D. 81–96 (Domitia)
military activity in Germany and
Dacia

*5 Senatorial intervention: Nerva,
A.D. 96–98*

*6 The 'Elect Emperors', 98–192, and
Commodus*

Trajan, 98–117 (married to Plotina)
military activity in Numidia,
Arabia Petraea (new province),
Dacia (new province), Parthia

Hadrian, 117–138 (married to
Sabina)
Antinous, *c.* 110–130, friend
Hadrian's Wall, Britain

Antoninus Pius, 138–161 (married
to Faustina I)
Antonine Wall, Britain

Marcus Aurelius 161–180 (married
to Faustina II)
pupil of Herodes Atticus and
Marcus Cornelius Fronto
distinguished jurists: Gaius,
Quintus Cervidius Scaevola
Tiberius Claudius Pompeianus,
adviser and field commander

Lucius Verus, 161–169,
associate in rule (Lucilla)
campaigns in Parthia and on the
middle Danube

Commodus (Lucius Aelius
Aurelius), 180–192 (married to
Crispina)

7 Civil wars, 193–197

8 Severan dynasty, 193–235

Septimius Severus, 193–211 (married
to Julia Domna)
Plautianus, Pretorian Prefect
Aemilius Papinianus, Pretorian
Prefect and great jurist
campaigns in Parthia (new
province) and north Britain

Marcus Aurelius Antoninus,
'Caracalla', 198–217
military activity along Danube,
and in Parthia
assassinated his brother Geta
212
granted Roman citizenship to all
communities inside Roman Empire
in 212

Interregnum: Macrinus and
Diadumenianus, 217–218

Elagabalus, 218–222 (real name:
Bassianus)
son of Julia Soaemias, grandson
of Julia Maesa
priest of the Sun god at Emesa
(Syria)

Marcus Aurelius Severus Alexander,
222–235
son of Julia Mamaea, grandson of
Julia Maesa
Domitius Ulpianus, Pretorian
Prefect and jurist

*9 Military anarchy, invasion, and
civil war, 235–284*

Maximinus Thrax, 235–238

Balbinus and Pupienus, 238

Gordian III, 238–244

Philip I, 'The Arab', 244–249

Trajanus Decius, 248–251
killed by the Goths in Moesia

Trebonianus Gallus, 251–253

Valerian, 253–260
captured by the Persians and
killed

Gallienus, 253–268 (son of Valerian)
fought off barbarians and rivals
along northern and eastern
frontiers from command post
at Milan

Claudius Gothicus, 268–270

Marcus Cassianus Latinius
Postumus, 259–268
independent insurgent ruler of the
West: Spain, Gaul, Britain, the
Rhine

Aurelian, 270–275
defeated barbarians on the Danube,
destroyed Palmyra, and reunited
the Empire of the West to the
Roman state
built the wall of Rome, 275

Probus, 276–282

*10 Tetrarchy and Constantine,
284–337*

Diocletian, 284–305
reform and reorganization; division
of Empire

Maximianus Herculius, 286–305

Constantius Chlorus, 293–306

Galerius, 293–310

Maxentius 305–312
defeated by Constantine at the
Battle of the Milvian Bridge,
outside Rome, in 312

Licinius, 308–324

Constantine 'The Great', 306–337
re-established the central
authority
conversion to Christianity (?) 312
Council at Nicaea, 325
founded and built Constantinople
325–330, as the New Rome

B. Social and Political Problems of the Empire

1 Government and society

Progressive rigidity in
administrative structure

Development of a vast, impersonal
bureaucracy, slowly under Augustus
and Claudius, more so under
Domitian, Trajan, Antoninus Pius,
strongly under Septimius Severus,
overwhelmingly under Diocletian

Tetrarchic system of near-absolute
controls on prices, wages, jobs, and
job-holders

Impairment of political, economic,
and social freedoms
class stratification leading to
increasing separation between
very rich and everyone else, II–IV
century; rural banditry as social
protest in III century

Intrusion of the army into politics
army behind the throne in I
century, makes Vespasian
Emperor, serves as primary
element of political strength from
Trajan to Septimius Severus,

dominant in III century, when membership is recruited from among barbarians who are coöpted to Roman civilization
Creation of *Latifundia* (plantations) and the origins of medieval feudalism
Active programmes of building and public works, strong from Augustus to Antoninus Pius and again under Septimius Severus, rapidly declines until partial revival by Diocletian and Constantine

2 Progressive impoverishment of resources

Depopulation in general and declining birth-rate
Shrinkage of provincial towns
Heavy taxation
Depletion of monetary metals, used in foreign exchange, subsidiaries (bribes) to barbarian tribes, hoarded

3 Provinces

Increased urbanization and prosperity, esp. in Western provinces, I–III century
Frontier stability begins to erode in late II century, re-established and fortified with great difficulty by late III–early IV century
Increasing barbarization and growth of local distinctions

C. Intellectual Movements

1 Triumph and retreat of Hellenism

Augustan classicism
Hadrianic neo-hellenism
Separation of Greek (east) and Latin (west) portions of the Empire, II–III century
 disappearance of bilingualism
 Breakdown of Latin into regionally spoken dialects, III century
Hellenism as an affectation of the aristocracy, IV century

2 Escapism

Development of the Greek narrative romance, II–III century
Isolation of the upper class into private luxury, II–IV century
The creation of a landed, villa-oriented gentry which never goes into town, III–IV century
Rise in mystery cults and supramundane preoccupations despite persistence of moralized stoicism
Appearance of Neo-Platonism and its other-worldly preoccupations

3 Religion

Proliferation of mystery and saviour cults, often charged with moral fervour, e.g. Sol Invictus, Mithras, Christianity, II–IV century
Multiplication of religions because of ingathering of provincials and barbarians

4 Tendency to codify evident in:

Law with the work of the great jurists (esp. Gaius, *Institutiones*), medicine (Galen) and astronomy (Ptolemy), popular philosophy and literature (Plutarch), Greek monuments (Pausanias)
Anthologies, handbooks, grammars, commentaries

5 Restriction of patronage and the decline of the cultivated classes

6 Persons of distinction

Virgil, 70–19 B.C., the national poet of Rome and laureate of the Augustan era, author of the *Eclogues, Georgics,* and *Aeneid*
Horace, 65–8 B.C., the second classic poet of Latin literature, master of the personal but controlled lyric poem (Odes), genial satirist, literary critic (*Ars Poetica*), patriotic hymner (*Carmen Saeculare*)
Gaius Asinius Pollio, 76 B.C.–A.D. 5, man of letters, critic, patron, founder of a public library
Ovid, 43 B.C.–A.D. 17 (?), champion of erotic poetry (*Amores, Heroides, Ars Amatoria*), elegant mythographer (*Metamorphoses*), who could turn even a calendar into a poem (*Fasti*), varied and imaginative in language
Livy, 59 B.C.–A.D. 17, the Augustan historian of Rome's greatness, expressed in a lofty style, dignified but vivid, from the depths of the Gallic destruction of Rome to the heights of Augustus' reign
Strabo, 64 B.C.–A.D. *c.* 21, a Greek from Pontus, inveterate traveller, historian, and important political-historical geographer (*Geography*)
Dionysius of Halicarnassus, active at Rome *c.* 30–8 B.C., critic of language and oratory, author in Greek of a history of Rome from its founding to the First Punic War
Philo of Alexandria, 30 B.C.–A.D. 45, hellenized Jew who combined both traditions in his writings, allegorical interpreter of Judaism to the Greco-Roman world
Demetrius, Greek critic of I century A.D., author of *On Style*
Longinus (?), most distinguished Greek literary critic of the Empire (I century A.D.?), author of *On the Sublime*
Valerius Maximus, early I century A.D., collector of curious historical anecdotes
Petronius Arbiter, mid-I century A.D., author of *The Satyricon*, a raffish, picaresque novel of vulgar, lower-class life, written with extraordinary vitality and humour
Quintus Curtius Rufus, mid-I century A.D., melodramatic author of a history of Alexander the Great
Lucius Annaeus Seneca, *c.* 5 B.C.–A.D. 65, stoic moralist, political profiteer, clever even malicious essayist, author of unplayable tragedies, highly emotional in nature
Marcus Annaeus Lucanus, A.D. 39–65, wrote a vehement epic poem on the Civil War (*Pharsalia*), marked by emotional display and a nostalgia for the bygone Republic
Lucius Junius Moderatus Columella, contemporary of Seneca, prose author of practical guides to productive farming (*De Re Rustica*)
Pliny the Elder, A.D. 23–79, encyclopedist and scientist who died in the eruption of Vesuvius, produced 102 catalogue-volumes including the extant *Naturalis Historia*, whose Books 33–36 contain information on arts and artists
Publius Papinius Statius, A.D. 45–96, creator of self-consciously dramatic epic poems (*Thebais, Achilleis*) and bright, polished occasional pieces on friends, their activities and their possessions (*Silvae*)
Silius Italicus, *c.* 26–101, connoisseur, collector, author of the rhetorical and learned epic, *Punica*, the (very) longest Latin poem
Valerius Flaccus, later I century A.D., epic poet (*Argonautica*) based heavily on Hellenistic Greek models
Josephus, 37/8–after 94, pro-Roman Jew who wrote a history of the Jewish wars and the Roman conquest of Judaea and later a history of the Jews from Genesis to A.D. 66 (*Antiquitates Judaicae*)
Marcus Fabius Quintilianus, 35/40–*c.* 100, greatest Roman professor, a doctor of humane letters whose work on grammar, language, and clear expression (*Institutio oratoria*) remained a didactic model for centuries
Sextus Julius Frontinus, *c.* 30–104, professional officer and administrator, author of technical treatises on land-surveying, military science and tactics, and on the water-supply at Rome (*De aquis urbis Romae*)
Marcus Valerius Martialis, 40–*c.* 104, shaper of witty, often satirical, occasionally obscene epigrams on the 'sweet life'
Juvenal, *c.* 50–after 127, greatest of the Roman satiric poets, master of parody and cutting invective, a critic of the social scene and of human weakness
Tacitus, *c.* 55–after 115, greatest Roman historian, gifted with an extraordinary command of language and a seductive power of characterization that has coloured forever our views of the I century A.D.
Suetonius, *c.* 69–140, biographer of Roman writers and of the Roman rulers from Julius Caesar to Domitian; his *De vita Caesarum* influenced the biographical turn in Roman history II–IV century A.D.
Pliny the Younger, 61/62–*c.* 114, high Roman official, like Cicero

a letter-writer for publication, including a correspondence with Trajan, to whom he also dedicated his *Panegyric*

Plutarch, *c.* 46–after 120, Greek *philosophe*, indefatigable essayist on religious, moral, and political issues, often presented in dialogue form, and biographer of the 'parallel lives' of Greek and Roman soldiers and statesmen, full of anecdote and moral judgement

Epictetus, *c.* 55–135, important stoic philosopher active in Rome, teaching the brotherhood of man and the importance of good works, influenced Marcus Aurelius

Aulus Gellius, *c.* 123–165, lawyer and learned man who wrote chatty pieces (*Noctes Atticae*) on a variety of subjects, comparable in profundity and display to cocktail-party conversation

Aelius Aristeides, *c.* 117–*c.* 170, Greek sophist and popular lecturer in an eloquent style with set pieces on many subjects including eulogies of Athens, Rome, and the Emperor (probably Marcus Aurelius)

Marcus Aurelius, 121–180. Roman Emperor and good man, as revealed in his *Meditations*

Marcus Cornelius Fronto, *c.* 100–166, high Roman official, tutor of Marcus Aurelius, with whom he corresponded for years, revealing a sincere, ethical, quiet mode of life

Flavius Arrianus, II century A.D., Roman soldier and governor, pupil of Epictetus, wrote military treatises and histories of Parthia, India, and Alexander the Great (*Anabasis*)

Appian of Alexandria, II century A.D., moved to Rome and became very patriotically Roman; wrote in Greek an account in annalistic detail of the Roman conquests of the world

Lucian of Samosata, *c.* 120–after 180, author in Greek of numerous dialogues and short pieces on contemporary topics, treated with wit, humour, and sarcasm

Apuleius of Madauros, *c.* 123–late II century A.D., famous for his Latin novel, *The Golden Ass*, on his adventures in black magic, converted into an observant ass and saved by the goddess Isis

Galen of Pergamon, 129–*c.* 199, greatest physician of Antiquity, superb diagnostician, anatomist, and physiologist, voluminous writer on medical theory and practice, clearly stated and infused with religious piety

Ptolemy of Alexandria, active 121–151, last great astronomer (*Almagest*) and geographer (*Geography*) of Antiquity

Philostratus, *c.* 172–245 member of the salon conducted by Julia Domna in Rome, where he wrote the *Life of Apollonius of Tyana* as the saintly biography of a travelling, teaching mystic; either he or his son-in-law of the same name wrote the *Imagines*, a rhetorical description of paintings in a Neapolitan collection

Tertullian, *c.* 160–225, from Roman Africa, Christian apologist (*Apologeticus*) who read and wrote Latin and Greek, developed the new Christian terminology in Latin, and commented negatively on contemporary taste for violent amusements (*De spectaculis*)

Aelian of Praeneste, *c.* 170–235, teacher of rhetoric at Rome and author of moralizing pieces and parables about animals (*De Natura Animalium*) and people (*Varia Historia*) in Greek

Athenaeus of Naukratis, early III century A.D., presented the philosophical salon of his time in *The Learned Banquet*, a crowded party lasting several days, in which intelligent and learned people discuss literature, law, philosophy, medicine, etc., but in essence a dramatized compilation of older material and current notions

Dio Cassius, late II–mid-III century, Roman governor and Senator, wrote in Greek a *History of Rome* from its beginning to 229 A.D., conceived as a political narrative by a practical politician

Herodian of Syria, III century A.D., wrote a moralizing, unintelligent *History of the Roman Empire* from Marcus Aurelius to Gordian III, characterized by rhetoric and rumour

Plotinus of Egypt (?), 205–269/70, the greatest pagan philosopher and teacher of the Empire, moralist, psychologist, reverential interpreter of Platonism, whose essays in Greek (the *Enneads*) were collected and published by his pupil Porphyry *c.* 300

Lactantius, *c.* 250–317, the 'Christian Cicero'

Eusebius of Caesarea, *c.* 260–340, Christian bishop and Roman patriot, first historian of the Church (*Church History*), biographer of Constantine, the shaper of Christian interpretation of Empire

Servius, the Grammarian, IV century A.D., commentator on Virgil and typical of those who would cherish and preserve Roman literature in the Middle Ages.

List of Illustrations

Sources of Photographs

Berlin, Staatliche Museen: III.36

Bonn, Rheinisches Landesmuseum: IV.31; V.23

Boston, Museum of Fine Arts: IV.16

Cologne, Rheinisches Bildarchiv: III.14

Copenhagen, Ny Carlsberg Glyptotek: IV.25; V.17; VI.27, 33, 44

Edinburgh, Royal Scottish Museum (photo Tom Scott): II.13a

Florence, Alinari: A; I.1, 5, 29a, 37a, 44, 55, 62; II.5, 14, 32, 39, 46a–b; III.3, 16, 17, 24; IV.1, 5, 9, 13, 17, 23, 33; V.2, 4, 10, 16, 20; VI.1, 3, 4, 7, 9, 41

— Anderson: I.11, 14a, 26a, 56, 64; II.1a–b, 8, 9, 17, 24, 26, 42; III.1, 11, 12, 29a–b, 34; IV.3, 18, 37c; V.3, 6, 14; VI.5, 30, 37, 39, 43

London, British Museum: III.9, 20, 35; V.21; VI.11a–b, 12, 14, 18, 19, 28, 31, 47, 52

London, Phaidon Press Archive: IV.19, 20, 27; VI.10

London, Warburg Institute: III.15

Munich, Antikensammlung: V.1b; VI.21

Munich, Hirmer: IV.15, 24

New York, Metropolitan Museum of Art: I.57; III.33; IV.6, 30

New York, Richard Brilliant: I.10, 40; II.16, 33, 34, 44; III.6; IV.28, 29, 37; VI.54

Paris, Giraudon: II.36

Paris, Musées Nationaux: p. 9; II.13b; V.1a

Rome, Felbermeyer: III.30

Rome, Fototeca Unione: I.2–4, 6–9, 13, 14b, 15, 16–20, 22–25, 30, 31, 35, 36, 38a, 39a, 41–43, 46–52, 54, 58–61, 63, 65, 66; II.2–4, 6, 7, 30, 37, 38, 40, 41, 43, 45; III.5, 7, 8, 13, 22, 26, 27, 31, 32; IV.26, 35; V.8, 9, 11

Rome, Gabinetto Fotografico Nazionale: IV.11, 34; V.18; VI.1, 6, 13, 25

Rome, German Archaeological Institute: I.21, 27, 28, 33a, 53; II.10–12, 15, 18, 19, 21–23, 27–29, 31; III.4a, 10, 18, 19, 21, 23, 25; IV.2, 7a–b, 8, 10, 12, 21, 22, 36, 37a–b; V.5, 7, 12, 13, 15, 19, 22, 24; VI.8, 15–17, 20, 22–24, 26, 29, 32, 34, 36, 38, 40, 42, 45, 46, 48, 49–51, 53

Rome, E. Richter: I.34; IV.14

Rome, Vatican: II.20; IV.32

Vienna, Kunsthistorisches Museum: p. 9; II.35; IV.4

Washington, D.C., Dumbarton Oaks Collection: II.25

R. Bianchi Bandinelli, E. Vergara Caffarelli and G. Caputo, *Lepcis Magna*: I.33b, 38b; III.4b

A. Boëthius and J. B. Ward-Perkins, *Etruscan and Roman Architecture* (Harmondsworth 1970; Pelican History of Art, by courtesy of Penguin Books Ltd): I.19b, 29b, 37b

H. Eschenbach, *Pompeii* (Heidelberg 1970): I.26b

Carl H. Kraeling, *Gerash, City of the Decapolis* (New Haven 1938): I.45

W. Reusch, *Frühchristliche Zeugnisse im Einzugsgebiet von Rhein und Mosel* (Trier 1965): III.2

B. Schulz and H. Winnefeld, *Baalbek*, I: I.32

Index